W9-AOX-221

The Brummer Collection of Medieval Art

The Brummer Collection
of Medieval Art

THE DUKE UNIVERSITY MUSEUM OF ART

By Caroline Bruzelius with Jill Meredith

Essays by Ilene H. Forsyth, Jean M. French, Dorothy F. Glass,

Dieter Kimpel, Jill Meredith, and Linda S. Roundhill

N 5963 .D87 D854 1991
Duke University. Museum of
 Art.
The Brummer collection of
 Medieval Art

PUBLISHED BY DUKE UNIVERSITY PRESS *Durham and London 1991*

IN ASSOCIATION WITH THE DUKE UNIVERSITY MUSEUM OF ART

WITHDRAWN
RITTER LIBRARY
BALDWIN-WALLACE COLLEGE

© 1991 Duke University Press

All rights reserved

Printed in the United States of America on acid-free paper ∞

Publication of this volume was supported by grants from Mrs. Ernest
Brummer, The Mary Duke Biddle Foundation, The Friends of the
Duke University Museum of Art, and The Office of the President of
Duke University.

Library of Congress Cataloging-in-Publication Data

Duke University Museum of Art.

The Brummer Collection of medieval art / Caroline Bruzelius with Jill Meredith.

Includes bibliographical references. ISBN 0-8223-1055-4

1. Art, Medieval—Catalogs. 2. Brummer, Ernest—Art collections—Catalogs.
3. Art—Private collections—North Carolina—Durham—Catalogs. 4. Art—North
Carolina—Durham—Catalogs. 5. Duke University—Museum of Art—Catalogs.
I. Bruzelius, Caroline Astrid. II. Meredith, Jill. III. Title.

N5963.D87D854 1991 709'.02'074756563—dc20 90-3300 CIP

To

Ella Baché Brummer

Douglas Knight

Mary Duke Biddle Trent Semans

Contents

List Of Illustrations

Foreword

The purchase of the Ernest Brummer Collection by Duke University in 1966 represented more than the acquisition of a major collection. It also signaled the university's realization of the cultural importance of real works of art in the education of students. Indeed, President Douglas Knight's leadership and vision in acquiring the collection from Ella Baché Brummer, Ernest Brummer's widow, was the catalyst for the founding three years later of the Duke University Museum of Art. Over the past twenty years the museum has grown to include some 12,000 objects—paintings, sculptures, drawings, and textiles—from cultures around the world. Yet despite this extraordinary expansion, the heart of DUMA's holdings remains the Ernest Brummer Collection.

In today's art market, even if one had unlimited funds, it would be impossible to assemble a group of objects comparable to those in the Brummer Collection. Their rarity, artistic quality, and historic significance rank them among the most important assemblies of medieval art in any university museum in the United States. For over two decades the Ernest Brummer Collection has introduced students to the glories of medieval art. It seems fitting that on the twentieth anniversary of the Duke University Museum of Art the catalogue of the collection has been completed for publication. The appearance of this important scholarly work will introduce the Brummer Collection to a wide public audience, giving it the recognition it deserves and making it an even more valuable resource.

We are deeply indebted to Professor Caroline Bruzelius, author of the catalogue and introductory essay and mastermind of this project. Her work on the collection over the years had resulted in countless new discoveries and insights that are a valuable addition to medieval scholarship. We are very grateful for her continuous dedication to the collection and supervision of this effort. She has been assisted ably in the latter by Dr. Jill Meredith, Consultative Associate Curator, who has prepared many individual catalogue entries and contributed an important essay on the Brummer *Bifrons*. Indeed, we thank all of the scholars whose articles appear in this volume. Their research has helped reconstruct the context of several major works from the collection, advancing our understanding of important areas of medieval art and history.

The appearance of this book is the second collaborative venture between the Duke University Museum of Art and Duke Press. We are grateful to Joanne Ferguson, Editor, for her help in making it possible. We would also like to acknowledge the assistance of the Mary Duke Biddle Foundation, the Friends of the Art Museum, and Ella Baché Brummer for their support in the production of the catalogue. We believe that it will be a lasting contribution to the understanding and appreciation of one of the great American collections of medieval art.

<div style="text-align: right;">

Michael P. Mezzatesta
Director
Duke University Museum of Art

</div>

Acknowledgments

When I arrived at Duke in 1981 I discovered that the Brummer Collection of medieval sculpture was far larger and more varied than I had been led to expect. In addition to the better-known objects upstairs in the gallery, some of which had appeared in the census of Romanesque Art in America published by the International Center for Medieval Art in *Gesta*, there were many more undiscovered treasures in the basement. In my first semester I began to incorporate the Brummer sculpture into my teaching; by the following year I taught the first of a series of seminars on the collection. In the first of these the students prepared a small exhibition that moved some of the pieces out of storage. We also published a small catalogue, *Rediscoveries* (1983), with a title that in a quiet way acknowledged that this remarkable collection had languished, largely ignored and unstudied, since the exhibition at the North Carolina Museum of Art in 1967 and the accompanying catalogue by Robert Moeller. Since then, students in subsequent seminars have rediscovered many more pieces, adding important insights to the collection and often bringing a freshness of vision, a delight in working with objects, and a great deal of humor to the study of medieval sculpture. My happiest memories as a teacher are of my classes sitting on the floor in the upper gallery of the museum, surrounded by books, examining a work of sculpture from all sides to determine what it could have been part of, what it was stylistically related to, and what it represented. Probably the best class I have ever taught at Duke was the one in which my unsuspecting students struggled to make sense of and report on objects that are almost certainly fakes. Their attempts to reconcile the variety of problems presented by these objects was in some ways as instructive as working on authentic pieces, for it taught them that the difficulties of iconography, architectural context, and style they were encountering were in themselves significant. If the purpose of an art historical education is to make students perceptive and thoughtful about works of art, then the value of this collection for teaching cannot be underestimated.

A catalogue on the present scale, however, is a larger effort, one that has called upon the expertise and knowledge of many other people both here at Duke and elsewhere. I would like to thank first of all the scholars who contributed essays to this publication: Ilene H. Forsyth, Jean M. French, Dorothy F. Glass, Dieter Kimpel, Linda S.

Roundhill, and of course my colleague and collaborator, Jill Meredith. Their in-depth examinations of five objects in the collection immeasurably enrich this catalogue; their comments on other objects in the collection have also been very helpful. Michael Mezzatesta, Director of the Duke University Museum, has been a joy to work with; every one of my suggestions, from the statement that the collection was in urgent need of reinstallation to the symposium that celebrated the completion of that process, has been enthusiastically supported. He brought to Duke Adrian Martinez, who designed a wonderfully sympathetic new installation for which Jill Meredith wrote the labels. Louise Brasher, Assistant Curator, who has worked on and thought about the collection over the years, shared her notes and suggestions with us and was of great assistance in the reinstallation. Jessie Petcoff, the registrar, has also helped resolve any number of small problems. Our art librarian, Edith Hassold, is continually resourceful, helping not only our students, but also Jill and myself as we have worked through the collection. Linda Roundhill has cleaned and consolidated many of the pieces; her conservation revealed their beauty, while her expertise and knowledge expanded our vision and understanding of materials and condition.

We might not have made much progress in writing the catalogue had it not been for the assistance of William Broom, who undertook any number of delicate negotiations with our computers. David Page, photographer for the Art Department, worked long and hard rephotographing the collection for us; his often ingenious solutions to balancing many of the heavy stone objects to be photographed made this process a good deal more exciting than I had expected. His handsome images are a vital part of this book.

When medievalists come through Durham, we inevitably rush them to the museum so that they can give us their thoughts and opinions. The fall 1986 meeting of the board of the International Center of Medieval Art here at Duke was thus extremely useful for us, as we were able to gather in the same room groups of scholars with expertise on various objects to advise us. We thank them all, particularly Walter Cahn, Paula Lieber Gerson, Madeline H. Caviness, Nigel Morgan, Amy Vandersall, Dorothy Gillerman, Pamela Z. Blum, Peter Barnet, Charles T. Little, Ann Morganstern, Stephen Scher, William W. Clark, Marilyn Stokstad, Carl Barnes, Christine V. Bornstein, and Robert G. Calkins, for sharing their thoughts on various

objects on that and other occasions. Our colleagues in North Carolina have assisted us many times in many ways: at Duke, Annabel Wharton and Kathryn Horste, now at the J. Paul Getty Center; Harry B. Titus, Jr., of Wake Forest University; and C. Edson Armi and Jaroslav Folda at the University of North Carolina at Chapel Hill.

In preparing the catalogue we have also written to or visited a number of scholars to ask their opinion and their advice. We are especially grateful to Fabienne Joubert, Léon Pressouyre, Anne Prache, and Françoise Baron in Paris; Valentino Pace in Rome; Francis W. Cheetham and Neil Stratford in England; and Ann Terry, Anne Zielinski, Michael Cothren, Jane Hayward, Elizabeth Pastan, Ruth Blumka, and Richard H. Randall, Jr. here in the United States. We also thank Mel Turner of the Department of Botany at Duke University for helping us analyze the wood, and Mary Clerkin Higgins, who restored several stained glass panels so that they could be installed in the gallery.

Research for the catalogue was made possible by generous support from the National Endowment for the Arts in 1986–87, a grant initiated by the former director of the Duke University Museum of Art, John Spencer. He and the Dean of Trinity College, Richard White, provided matching funds in the form of released time from teaching for one semester; we owe them both a great debt. The Department of Art and Art History at Duke University has also supported this project in many ways; I am especially grateful to Mary Cash and Betty Rogers for their assistance. In addition, I am deeply indebted to the Duke University Research Council, which funded a research trip to Paris in 1988.

Pamela Blum has been a constant source of advice and counsel to us; above all, her careful reading of the manuscript immeasurably improved its prose. We also thank Joanne Ferguson, Tom Campbell, and Mary Mendell at Duke University Press for their help with this long and complex process.

Caroline Bruzelius

Introduction

Patrons, collectors, and donors of art collections have been the object of many studies.[1] Only rarely, however, do we read about the vital role of the intermediary, the art dealer, in the formation of collections and the shaping of taste. Ernest and Joseph Brummer, dealers *par excellence,* are no exception. In spite of the quantity and quality of the works of art that passed through their hands into the great collections in this country, they, like numerous other dealers, have remained ghostly presences behind the creation of the American museum and private collection.[2] Although men like Ernest and Joseph Brummer were conduits for the transportation of works of art from Europe to the United States, and therefore played an essential part in the shaping of American medieval collections as well as of aspects of our taste for the Middle Ages, their profession demanded a certain discretion.

The collecting of medieval art in the United States is a modern phenomenon; the reasons are not hard to find. Indeed, even in Europe, the collecting of medieval art is relatively recent. There were, it is true, some individuals, such as Horace Walpole, who in the early to mid-eighteenth century avidly collected medieval glass, sculpture, and enamels,[3] but for the most part this remained the purview of a small elite with esoteric tastes. A wider interest in medieval art began only in the early nineteenth century with the Gothic Revival, which was from the outset a movement whose roots lay in the literary works of Walpole himself as well as those of more popular authors such as Sir Walter Scott. The taste for things medieval appeared somewhat later on the European continent; ironically, one of the earliest museums of medieval sculpture in France was initiated in the late eighteenth century as a response to the vandalism of the French Revolution.[4] For the most part, institutions with galleries or collections devoted to the Middle Ages coincided with the arrival of the Gothic Revival on the continent, which began in the third decade of the nineteenth century. The Louvre initiated its medieval holdings with the purchase of the Durand and Révoil collections in 1825 and 1829, respectively,[5] followed by the creation of the Cluny Museum in 1843,[6] the Bayerisches Staatsmuseum in Munich in 1852, and the Victoria and Albert Museum (first called the Museum of Manufacture) in London, also in the early 1850s.[7] During the second half of the nineteenth century,

other European museums began to acquire important collections of medieval objects. For the most part the impetus for these was historic and nationalistic;[8] indeed, they were often founded by local antiquarians largely as museums of local history, as was, for example, the Musée des Antiquités de la Seine Inférieure in Rouen, which remains today much as it was when created in 1831. This phenomenon was of special significance in France, where the Revolution had destroyed so much art that had formed a fundamental part of local history and tradition. The museum of medieval art was thus often an attempt to retrieve a lost past (in France it was therefore also sometimes tinged with royalist and sporadically with religious connotations), but it also came to play an increasingly important role in the current reformist ideas about craftsmanship and labor exemplified in the Arts and Crafts Movement.[9]

Until the late nineteenth century America seemed largely indifferent to collecting medieval art. The Middle Ages had, after all, played no part in the familiar American landscape. Indeed, Americans, exhilarated by liberation from the yoke of England in the eighteenth century and confident of the limitless possibilities of the future, had no reason to cultivate a nostalgia about a past that had at one time meant servitude and injustice.[10] To the contrary, it was towards the architecture of democracy, the neo-classical versions of Greek prototypes, that they turned. Sometimes, too, medieval art might have seemed too redolent of Catholicism. Large-scale medieval sculpture was architectural and in this country divorced from its original context; it thus had the disadvantage of appearing fragmentary, incomplete, and therefore unsatisfactory to the American eye.[11] The Renaissance conception of the Middle Ages as the age of barbarism seemed confirmed by the broken fragments of large-scale medieval sculpture, while its anonymity frustrated the collector who searched for the works of a known master. With the exception of a few enlightened souls and a taste for the "Gothick" in country houses and Episcopal churches, an indifference to the art of the Middle Ages continued until the first decades of our own century, when the combined influence of a new phase of the Romanesque and Gothic Revival in the buildings of Henry Hobson Richardson and Stanford White (among others) along with the publication of Henry Adams's *Mont Saint-Michel and Chartres* in 1903 began to create a taste for the Middle Ages in the United States.[12] One of the early steps in this direction was Isabella Stewart Gard-

ner's impressive collection of medieval sculpture built into the walls of Fenway Court, her Venetian palazzo in Boston, which was initiated in 1896 and opened to the public in 1903. The Gardner Museum was a tour-de-force of interior decoration rather than a collection of medieval art *per se*, however, inasmuch as her medieval sculpture was used primarily to give an air of suggestiveness and authenticity to her house on Fenway Court in Boston.[13]

In our own century, the first important steps toward collecting the art of the Middle Ages were taken with acquisitions by The Metropolitan Museum of Art in 1908 and 1909, when John Pierpont Morgan presided over the Board of Trustees. The Boston Museum of Fine Arts acquired its first works of Romanesque sculpture in 1919, The William Hayes Fogg Museum at Harvard obtained its head from the west portals of Saint-Denis in 1920, and The Philadelphia Museum of Art purchased in 1923 some panels from a north Italian pulpit.[14] By the twenties collecting medieval art had become noteworthy in this country for private collectors and donors as well. Following in the footsteps of Isabella Stewart Gardner, several great magnates participated in this movement and played a vital role in the formation of medieval collections in America: aside from J. P. Morgan, William Randolph Hearst decorated his "castle" at Saint Simeon and other residences with medieval sculpture; Henry Walters collected early Christian, Byzantine, and medieval manuscripts and objects, and in 1925 John D. Rockefeller presented the Metropolitan Museum of Art with the money to purchase and maintain most of the collection of medieval sculpture accumulated by George Grey Barnard. The Barnard Collection, at that time perhaps the most extensive of its kind in America, was first opened to the public in 1914; in 1926 it was rearranged and reopened in a new building as a branch of the Metropolitan Museum—The Cloisters, in Fort Tryon Park, New York. Part of the appeal of The Cloisters is the extent to which it recreates a medieval environment by incorporating entire cloisters and chapels into the structure of the museum, thereby mitigating the "fragmentary" quality medieval art seemed to take on in the eyes of American audiences. Since the twenties and thirties, important medieval collections have been assembled in a number of major museums across the country; aside from those mentioned above, one thinks of the collections in the museums of Toledo, Cleveland, and Detroit, as well as private collections now open to the public (the Glencairn Museum in

Bryn Athyn, Pennsylvania, for example) and the important collections of university museums such as our own.

Medieval objects have appeared here in the United States largely as the result of several tragic chapters in the history of art, particularly religious art.[15] In eighteenth-century France, for example, the efforts of cathedral canons to "modernize" their churches led to the destruction of many furnishings, including tombs, choir screens and stalls, and stained glass.[16] The enchanting head of the Virgin from Chartres Cathedral (plate 14) is an example of this destruction; it once formed part of the panel of the Adoration of the Three Kings in the choir screen (*jubé*) of the cathedral. The screen was destroyed in 1763, and much of its debris was used as fill under the cathedral pavement. Other fragments found their way into private hands, where they served a variety of purposes; the head of the Virgin from Chartres, for example, was embedded in the wall of a house in the city of Chartres from which it was removed only early in this century.

Yet the destruction wrought by the canons was a minor misfortune compared to the wholesale destruction wrought by the French Revolution at the end of the century. Most of the remarkable series of Gothic heads in the Brummer Collection were knocked down from their settings on portals by Revolutionary zealots. Our head, associated by Dieter Kimpel with the north transept facade at Notre-Dame in Paris (figures 6.1–6.4), is an example of such destruction, as is the hauntingly beautiful head of one of the elders from the archivolts of the central portal at the Collegial church of Mantes (plate 11). The damage of the Revolution in rural settings usually exceeded the anti-royalist and anti-clerical destruction at major urban sites; whole monasteries were placed in the public domain and sold to entrepreneurs, called at the time *la bande noire*, who dismantled them and sold off the stone to huge profit.[17] Sculptural elements were frequently the least valued; they did not provide smooth building surfaces, so they were often left to decay at the site or taken by the local population to serve a variety of humble uses—to fill in foundations, for example. The most notable example of this destruction was the abbey church of Cluny, but it should be recalled that similar vandalism occurred throughout France at churches large and small, with isolated abbey churches, which had often symbolized the oppression of the peasant class, particularly vulnerable. The vandalism of the Revolution did not pertain only to architecture and sculpture, however; secularization of monasteries and churches led to the dispersal of huge numbers

of liturgical objects and libraries. Many were destroyed, defaced, or dismembered, while others gradually found their way into the hands of museums and private collectors throughout the world.

Unfortunately, the end of the Revolution did not mean the end of the destruction. Although an important and powerful group of preservationists emerged in France in the 1830s, Haussmann's redesigning of Paris in the second half of the nineteenth century entailed the destruction of numerous churches and medieval houses throughout the city. In our own century, the two world wars have caused inestimable damage, the first mostly to the east and northeast of Paris, the second more to the north (for example in Caen, Normandy, and in Beauvais, north of Paris). As late as the 1920s, the remains of the partially ruined abbey of Vauclair in the Aisne were being used as fill in the reconstruction of nearby roads after the damage of the First World War.

In Italy the situation was very different, but often the chances of survival were equally slim. Here nature herself has seemed to conspire in the process of destruction, for the south in particular has been afflicted by numerous earthquakes, and in the north, cities like Venice and Florence have been awash with floods and high water. The successive earthquakes of south Italy weakened and possibly damaged the old cathedral of Alife, from which the marvelous arch discussed by Professor Glass comes (figures 4.1–4.7). At the same time, man's destruction has been equally devastating; the triumphal gateway and its sculptures at Capua, with which the Janus heads can perhaps be associated (colorplate XIII and figures 5.1–5.4) has been repeatedly vandalized, dismantled, and repaired since the Renaissance.

In Germany, England, and the Netherlands, the Reformation and religious wars led to the wholesale destruction of all kinds of religious art. Wooden objects (altarpieces and small statuary, well represented in our collection) suffered particular damage; as a response to the iconoclasm of the Reformation and the later religious wars, a vast quantity of such works were piled up in front of churches and burned. Everywhere in Europe, from time immemorial, it has been taken for granted that travelers, peasants, and literati would avail themselves of the debris of destroyed or decaying monuments, either as building materials, souvenirs, or as *objets d'art*. We are reminded that this is an ancient phenomenon by the reverse of our own Alife arch (figure 4.1), which contains fragments of a Late Antique architrave and a Roman standing figure recut to serve as the archivolts of a Romanesque arch.

The attentive visitor to museums across the United States cannot fail to note that the Brummer name appears with great frequency on labels and catalogues of medieval collections as well as in galleries devoted to Greek, Roman, Egyptian, and Near Eastern antiquities.[18] The wide range of works of art sold by the two brothers reflects the breadth of their interests and their knowledge, and the objects here at Duke and in many other American museums attest to their discerning eyes and deep sensitivity to the visual arts. Among their primary interests were the art of classical antiquity and of the Middle Ages. The quantity of medieval objects that passed through their hands is staggering. For example, in the first volume of the series *Romanesque Sculpture in American Collections*, of the approximately 141 entries for separate objects or groups of objects with the same provenance, about 88 passed through the Brummers' hands; in the more recent first volume of *Gothic Sculpture in American Collections*, of 309 objects listed, almost a third can be traced to the Brummers.[19] Between about 1920 and 1940, they sold more than 400 works from various epochs to The Metropolitan Museum of Art alone.[20] Their role in the building of medieval collections was, however, especially important, inasmuch as their period of greatest activity—the twenties—coincided with the vital formative years of many important medieval collections in museums or private hands.

The Brummer Collection was acquired by Duke from the widow of Ernest Brummer, Ella Baché Brummer. Her late husband was born in 1891 in Zombor, Hungary (now part of Yugoslavia), and subsequently went to Paris to study at the Sorbonne and the École du Louvre. During the First World War he served in the French army and was cited for gallantry. Soon after the war, he became increasingly involved in the art world, travelling widely and collecting objects in Europe and Asia, which were sold through his gallery in Paris. Meanwhile, his older brother, Joseph (d. 1947), and a younger brother, Imre (d. 1928), had established a large gallery in New York, which collaborated with Ernest's gallery in Paris. With the outbreak of the war, Ernest fled Paris and joined Joseph in New York, but the latter died shortly afterwards. In 1947 Ernest published with Adolphe Basler a book in Paris on pre-Columbian art, *L'Art Précolombien*.

After the death of Joseph Brummer in 1947, a large sale of the sculpture in his estate was organized at the Parke-Bernet Gallery (1949). A number of important stone objects that eventually came to Duke were listed in the Parke-Bernet catalogue but not sold; they constituted the

nucleus of the collection, kept either in the apartment of Ernest and his wife Ella Baché in Manhattan or in one of several warehouses.[21] Until Ernest Brummer's death in 1964 some of these formed a private collection for personal enjoyment; the others were kept in storage. The Duke collection thus includes a number of pieces that once belonged to Joseph Brummer, as well as objects acquired by Ernest; their close collaboration as well as their scanty records often make distinctions between the two collections impossible. It should be noted that the history of the collection has much to do with its character as we now see it here at Duke University: many of the pieces installed in the gallery, such as the Samson monolith (figures 2.1–2.5) and the Alife arch, are anomalous or highly unusual, which might have discouraged a potential buyer. Whereas numerous museums have sought to acquire "a typical" example of a certain regional style or period, our collection, through the vagaries of the art market and the anxieties of collectors, often consists of *a*typical and slightly eccentric work —harder for the scholar to "pin down" but all the richer and more rewarding for study.

The collection amassed by the Brummer brothers was remarkable for the range and variety of objects represented. The works vary in scale and materials from monumental stone pieces to small-scale objects in wood, ivory, or metal for domestic or liturgical use. They were precocious in their acquisition of numerous examples of pre-Romanesque sculpture in the 1920s and 30s, long before much interest had developed in this material (see, for example, plates 1–3).[22] Important works of sculpture in the Duke University Museum of Art can now be identified with major monuments; others, equally beautiful, remain elusive testaments to some important phases of the history of art.

The acquisition of the Ernest Brummer Collection at Duke was the result of the vision and happy collaboration of several figures important to the history of this university. Two key figures in the recent history of this institution, President Douglas Knight and Mary Duke Biddle Trent Semans, understood the vital importance of a museum with original works of art for study by students at Duke. They initiated the long and arduous process of bringing the collection here and remodeling the facility in which the collection presently is kept.[23] The Brummer Collection had been brought to their attention by William S. Heckscher, former chairman of the Department of Art. Ernest Brummer's widow, Mrs. Ella Baché Brummer, and her nephew, Dr. John

Laszlo (formerly of the Duke University Medical Center), desired above all to keep the objects together as a study collection for students. This particular conjunction of personalities, mutual interests, and circumstances made the acquisition of the Brummer Collection possible, and these people's combined efforts and devotion to that goal made the vision of a museum at Duke a reality.

Acquired in the spring of 1966, two years after Ernest Brummer's death, the Brummer Collection formed the nucleus of the Duke University Museum of Art. Until the remodeling of the present museum on East Campus was completed in 1969, the collection was stored provisionally in the basement of the Duke Chapel. During that period, Hanns Swarzenski, curator of Medieval Art at the Boston Museum of Fine Arts, stated in a letter to William Heckscher, "I left [Duke] with the impression that your Department cannot be congratulated and praised enough for its acquisition of the Brummer Collection. As you know, among the whole lot there were many items I coveted for the Boston Museum of Fine Arts."[24] A selection of objects was exhibited with a catalogue by Robert C. Moeller III at the North Carolina Museum of Art in Raleigh in May 1967. At the opening, Rudolf Wittkower gave the inaugural address, the text of which was published in the *Art Journal*, accompanied by an essay on the collection by William Heckscher and Robert Moeller.[25] In his address Wittkower stressed the vital importance of the new Duke museum to the teaching of undergraduates, stating that "a university museum is the ideal training ground for students of art history. . . . The closer the collaboration between the campus museum and the department—indeed, the more the museum has been integrated into the department —the better service will it give."[26] President Knight, Ella Brummer, and Mary Semans had had exactly such close cooperation in mind when they arranged for the acquisition of the collection the previous year; this catalogue and the symposium that preceded it (on September 26, 1987) testify to the fact that such cooperation is very much in operation. Since 1966 Mrs. Ella Brummer has given a number of other works of art to the Duke University Museum of Art, including some stained glass (several panels are included here) and additional ancient and medieval sculpture (for example, the fine Gothic seated figure in plate 18).[27]

It is largely as the result of two separate sets of circumstances, then, that there is medieval art in America and at Duke University. The first was the tragic destruction and devastation of monuments through

human or natural causes; the second, the happier modern phenomenon of collectors' and dealers' gathering together the remains of these monuments and making them accessible to museums and thus also to students and scholars. In keeping with the original spirit of the acquisition of the Brummer Collection as part of a university museum, our task as historians, scholars, and teachers is to reconstruct the origins and contexts of those displaced fragments; it is with the hope of furthering that process that we offer this catalogue of the collection.

This catalogue aspires to bring to the attention of the public important new discoveries on the origins of many of the works in the Brummer Collection, the results of research by scholars of medieval art. The extended essays on individual pieces are the contributions of five medievalists whose research includes sculpture in the Brummer Collection. Dr. Jill Meredith and I made a selection of the other most important pieces for extended entries. In the hope of stimulating further research, and of assisting scholars putting together the "dossiers" of other sites and programs, the catalogue also includes a checklist with small photographs of the other objects acquired in 1966 that have not as yet been the object of extended study. The catalogue thus consists of three sections. The first consists of six essays; the second, of catalogue entries on other important objects in the collection; the third, of the checklist. Five of the essays were presented as papers in a symposium on the Collection held in September 1987 to celebrate the reinstallation of the Brummer Collection by the new director of the Museum, Dr. Michael Mezzatesta. Professor Ilene Forsyth's essay on the Samson monolith establishes a provenance for that masterpiece in our collection—the venerable Cluniac Abbey of St.-Martin de Savigny. Professor Dieter Kimpel's essay associates a fine, though severely weathered, head in the collection with the north transept of Notre-Dame in Paris. For the handsome arch from Alife discussed by Professor Dorothy Glass, on the other hand, the provenance was well established, as Émile Bertaux had published it in 1904 while still *in situ* at Alife, yet the historical and artistic context of the Alife arch remained mysterious until this new examination of the Campanian setting from which it emerges. Dr. Jill Meredith has determined that the handsome Janus heads come from the brilliant artistic circle of Frederick II, and in a *tour de force* of modern interdisciplinary scholarship, Professor Jean French has tracked down to very narrow geographical confines the origins of our four Romanesque apostles. Because the cleaning and restoration carried out by our conservator,

Linda Roundhill, so improved the appearance of the collection, we also asked her to write a short introductory essay on the problems she encountered in her cleaning and restoration of the objects (mostly stone) in the collection. It is hoped that the illustrated checklist will be of use to scholars of medieval art in universities and museums around the world, and that the publication of this material in a preliminary form here may serve as the source for future study here at Duke and elsewhere.

Notes

1. See, for example, Aline B. Saarinen, *The Proud Possessors: The Lives, Times and Tastes of some Adventurous American Art Collectors* (New York, 1958). See also, specifically on the collecting of medieval art, the more recent essay by Paul Williamson, "The Collecting of Medieval Works of Art," *The "Thyssen-Bornemisza Collection: Medieval Sculpture and Works of Art* (London, 1987):9–19.

2. See Walter Cahn and Linda Seidel, *Romanesque Sculpture in American Collections*, volume I (New York, 1979):1–16. For the Brummers themselves, there is William H. Forsyth's introductory essay, "Acquisitions from the Brummer Gallery," in the exhibition catalogue *The Grand Gallery at the Metropolitan Museum of Art* (New York, 1974), as well as Jane Hayward's comments about Joseph Brummer's role in the formation of the Pitcairn Collection in Bryn Athyn, Pennsylvania, in her introduction to Hayward and Cahn, *Radiance and Reflection* (New York, 1982): 38ff. The singular career of George Grey Barnard, the sculptor-turned-dealer who acquired the several cloisters forming The Cloisters in New York, has received more attention; see, for example, Cahn and Seidel (1979):12–3, and J. L. Schrader, "George Grey Barnard: The Cloisters and the Abbaye," *The Metropolitan Museum of Art Bulletin* 37 (1979): 2–52.

3. Williamson, 9.

4. The most striking example was Alexandre Lenoir's "Musée des Monuments français," founded in 1793 but suppressed in 1816; a summary of Lenoir's career and the Musée des Monuments français can be found in the exhibition catalogue *Le "Gothique" retrouvé avant Viollet-le-Duc* (Paris, 1979):75–84. His was not the only attempt to found such a museum; numerous other "historical" museums were established in French towns in the 1790s to preserve part of the local heritage—for example, the "Museum du Midi de la République" in Toulouse, which later became the "Musée des Antiques" under the direction of Alexandre du Mège in 1832 (see *Le "Gothique" retrouvé*, 85–91).

5. *Le "Gothique" retrouvé*, 92–94; this was essentially a collection of enamels.

6. Alexandre du Sommerard had begun collecting medieval art early in the century; in 1832 he purchased the Hôtel de Cluny to house himself and his growing collection. After his death in 1842 it was purchased by the state and became a museum. Du Sommerard's six-volume *Les Arts au Moyen-Age* (1838–46) was one of the earliest scholarly works on medieval art and received wide dissemination in Europe. On Lenoir and du Sommerard, see Stephen Bann, *The Clothing of Clio* (Cambridge, 1984):76–82.

7. See the brief discussion of the history of the collection of medieval art in Germain Bazin, *The Museum Age* (New York, 1967):218–33.

8. The Victoria and Albert seems to have been founded to provide samples of highly skilled craftsmanship for artisans; hence its first name.

9. This found unexpected reflection in the important collection assembled by John and Raymond Pitcairn in Bryn Athyn, Pennsylvania, which was established to help workmen engaged on the construction of a church and school they founded emulate the techniques of medieval craftsmen.

10. George Mead, *Movements of Thought in the Nineteenth Century* (Chicago, 1936): 55, 64. Robert Mane, in *Henry Adams on the Road to Chartres* (Cambridge, 1971): 5, notes that Thomas Jefferson, "gazing whole hours at the Maison Carrée like a lover at his mistress," never once mentions a Gothic monument.

11. Thus one sees that early collectors of medieval art, such as J. Pierpont Morgan (1837–1913), tended to buy manuscripts or metalwork.

12. See, for example, Mane, *Henry Adams*.

13. Williamson, 13, notes that Gardner's collecting was in the manner of Walpole and his contemporary, William Stukeley.

14. Cahn and Seidel, 10.

15. For a general survey of the periods of destruction, see Louis Réau, *Les Monuments détruits de l'art français* (2 volumes) (Paris, 1959).

16. For example, all the stained glass at the Cathedral of Notre-Dame in Paris, with the exception of that in the three rose windows, was destroyed in 1741 and replaced by clear glass bordered by fleur-de-lis.

17. See P. Frankl, *The Gothic: Literary Sources and Interpretations Through Eight Centuries* (Princeton, 1960): 564.

18. See W. H. Forsyth, "Acquisitions," 1–5.

19. Dorothy Gillerman, ed., *Gothic Sculpture in America. 1. The New England Museums* (New York and London, 1989).

20. See the foreword by Thomas Hoving in *The Grand Gallery*.

21. Their storage in warehouses, often recorded in the Brummer files now in the Metropolitan Museum of Art in New York, was confirmed in a discussion between the author and Mrs. Ella Brummer.

22. Kautzsch's seminal articles on Lombard reliefs appeared only at the beginning of the war, in 1939 and 1941; see the bibliography.

23. There are occasional remarks on the acquisition of the collection in Douglas M. Knight, *Street of Dreams: The Nature and Legacy of the 1960s* (Durham, 1989). I would like to thank Dr. H. Keith H. Brodie for permitting access to the confidential files on the acquisition of the collection and Dr. William E. King, University Archivist, for bringing other important material to my attention.

24. Letter of June 8, 1967, in the Duke University Archives.

25. Rudolf Wittkower, "The Significance of the University Museum in the Second Half of the Twentieth Century," *Art Journal* 27/2 (1967): 176–79; and Heckscher and Moeller, "The Brummer Collection at Duke University," ibid.: 180–90.

26. Wittkower, 178.

27. In this catalogue we have chosen to write long entries on only the most important objects in the Brummer collection. A few other medieval pieces given by Mrs. Ella Brummer since 1966 have also been included. We have not included the many ancient pieces that Mrs. Brummer gave to Duke University unless they formed part of the original lot acquired in 1966. The checklist at the end of this volume includes only the sculpture and decorative art acquired in 1966. In order to assist further scholarship on the collection, we have included a small photograph with each entry on the checklist.

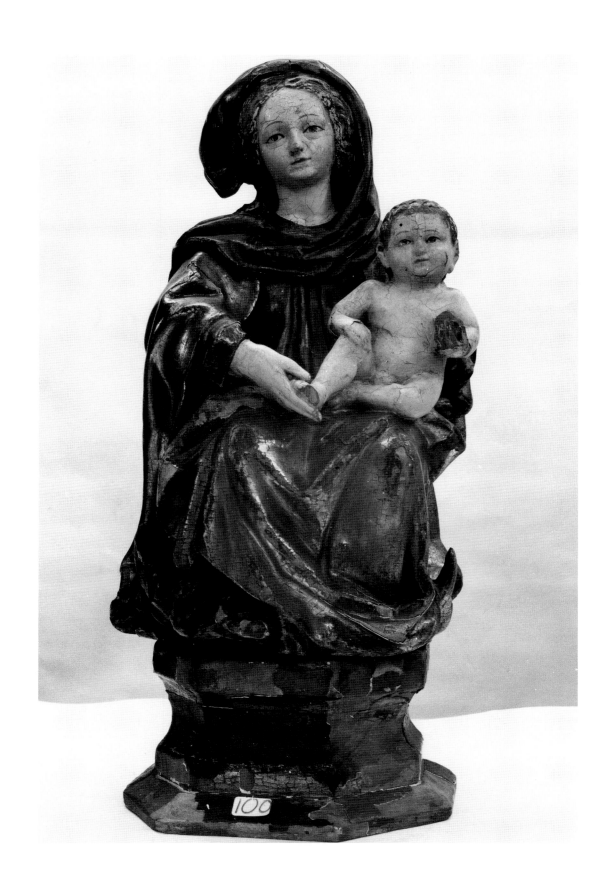

Comments on the Conservation of Selected Objects in the Brummer Collection

Linda S. Roundhill

The conservation of the Brummer Collection at the Duke University Museum of Art has presented many interesting and challenging problems. The collection had been stored in various locations since its acquisition by Duke in 1966, and many pieces were on display, at first in the basement of Duke Chapel and then from 1969 onwards in the museum itself. Each sculpture had the usual accumulation of sooty grime caused by our modern industrial environment as well as special problems associated with the history of each piece before it arrived here. Much of the pre-acquisition history of an object can only be deduced from its condition and appearance. When fifty-four pieces from the collection were selected for reinstallation in the museum's South Gallery, a plan was devised to treat the objects in greatest need of conservation before those whose general appearance would be most improved by cleaning.

Conservation is the science dedicated to the preservation of cultural artifacts in their myriad forms—paintings, works on paper, textiles, historic and archival materials, archaeological objects, architecture, and decorative art. There is a specialty field within conservation for each of these categories of cultural material, although of course there is a certain amount of crossover between fields.[1]

Objects conservation, which is my area of expertise, is considered a field on its own, but it encompasses many subgroups dedicated to, for example, furniture, archaeological objects, stained glass, and outdoor sculpture—each requiring a special knowledge of materials and techniques. In all conservation work the primary aim is the physical preservation of the object. This may involve mending, consolidation, reinforcement, deacidification, desalination, chemical treatment, protective coatings, or merely special environmental control.

While it is of paramount importance that works of art are physically able to withstand the stresses of being on display, it is also important that the artist's handiwork be understood and appreciated. Old, yellowing varnishes, corrosion, incrustations from burial, or extensive losses to painted designs may all contribute to the misinterpretation of the object's original appearance. As a result, conservation treatments usually involve cleaning, and occasionally the restoration of missing parts or painted designs (based, of course, on existing information). It is essential that treatments be as reversible as possible, do not destroy or alter the object in any way, and do not obscure important details.

◄Figure 1.1
Seated Virgin and Child before conservation (1966.100)

During the course of treatment, scientific analysis is often required to identify components, pigments, manufacturing techniques, or history of use. Photodocumentation is made for each item at various stages of the treatment, and all information is recorded and kept on file for future reference. For example, all condition and conservation records at DUMA are kept in the registrar's file with other pertinent information on each object.

In 1987 we treated a total of thirty-nine objects in preparation for reinstallation in the new Brummer Gallery. Most of these were stone pieces that needed only surface cleaning to remove dust, soot, and the remnants of modern paint. I shall discuss three of the more difficult and interesting objects in detail to give the reader of this catalogue some idea of the problems we encountered and how we dealt with them.

Virgin and Child (1966.100) (colorplate I and figure 1.1)

Polychrome wood sculpture presents some of the most challenging problems to conservators. In the original construction process, a wood carving was typically coated with a white gesso layer, followed by thickly applied paints; if the object was to be gilded, a clay bole was applied to the gesso before leafing. This composite layer is fairly inflexible and becomes brittle with time. The wood, on the other hand, is not a static material, for it shrinks or swells with changes in humidity. If the wood was not extremely well seasoned before the paint was applied, the sculpture will undergo an overall shrinking as the wood slowly loses water molecules from the cells within.

This marriage of incompatible materials can have disastrous consequences for an object. As the wood changes shape, the polychrome layers crack, buckle, and eventually detach in large flakes. In extreme cases, the polychrome can become a shell floating several millimeters above the wood interior. Conservation of such an object requires a carefully controlled environment as well as immediate treatment and continual monitoring of condition. Treatment, however, may be further complicated by insect damage, deterioration of paints, oxidizing of metal leafing and previous attempts at treatment.

One of the most beautiful pieces in the Brummer Collection, the *Virgin and Child* from Germany (ca. 1500 A.D.), exhibited most of the classic forms of deterioration of polychrome wood sculpture (figure

1.1). Though it had been treated in the past for paint loss, many fragments had been permanently lost and many more were in danger of detaching. The previous treatments had not been well executed, and the adhesives used had trapped grimy dirt on the painted surfaces. The gilded areas were dull and severely abraded, and losses had been toned in with dark brown paint.

Before the sculpture could be cleaned, many loose fragments of paint had to be secured. This was accomplished by injecting an acrylic resin beneath each flake. Cleaning required the use of a variety of solvents and techniques in order to remove old adhesives and general grime. One of the challenges was to remove the unwanted discolorations from the gilding without removing the original toning.

Toning was often a dark, translucent, water-soluble wash applied to areas of shadow to enhance the three-dimensionality of the sculpture. Most aqueous treatments would not distinguish between toning and grime. I consulted a specialist in the field of polychrome sculpture conservation, Annette Breazeale of Sarasota, Florida. She divulged to me what could be considered a "trade secret": it seems that human saliva is quite a good solvent for the discolorations normally found on gilding, although it is much less effective on antique toning.

Thus, after testing this somewhat unorthodox treatment method, small swabs dampened slightly with saliva were rolled gently across the surface of the gilding to remove grime. Areas of toning appeared as darkened areas resistant to cleaning, and these were left intact as they became visible.

A test cleaning of the Virgin's hood and drapery revealed surprising results. Beneath the unattractive, muddy brown layer was a glossy, metallic, blue-black layer over a thin, red clay bole. This proved to be what was left of metallic silvering that had been almost entirely converted to corrosion products. Water would have removed these corrosion products effectively, but it also would have dissolved the clay bole and destroyed the remaining silvering. A technique was developed whereby minute quantities were deposited on the surface of water by means of condensation. The softened tarnish layer was then removed safely with a nonaqueous solvent. After cleaning in this way, an acrylic lacquer was applied to protect the remaining silvering from further deterioration.

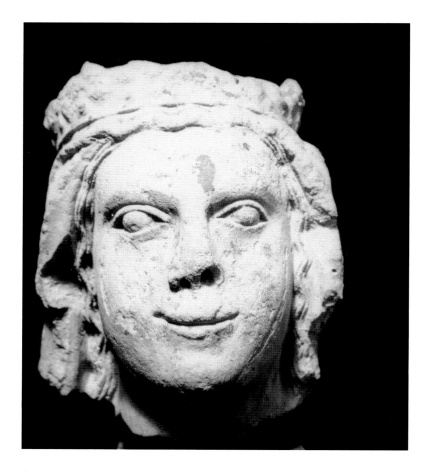

Head of the Virgin Mary (1966.74) (figure 1.2 and plate 14)

Stone pieces in general present fewer problems to the conservator and usually respond well to cleaning treatments. The treatment chosen depends upon the type and condition of the stone and the nature of the deposit. For instance, severely weathered or soft stone cannot be cleaned in the usual ways or damage will result. Sometimes soluble salts are present that must be removed to prevent damage to the surface from crystallization. Aqueous cleaning methods are usually chosen, though various solvents and chemicals may be required. Poultices (made of fine clay or cotton wool) are useful for general cleaning, softening incrustations, reducing stains, or removing harmful substances.

Mechanical cleaning is often required to remove incrustations, modern paint, or other insoluble accretions. The *Head of the Virgin Mary* from Chartres Cathedral required mechanical cleaning with a surgical scalpel under magnification to remove a dark mineral crust that had formed from exposure to air pollution and rain water. The presence of this crust indicates that the head may have been used for decorative purposes in an outdoor setting after it was knocked from its original

Figure 1.2
Head of the Virgin from the Chartres *jubé* before conservation (1966.74)

position in the Cathedral.[2] After the removal of the incrustation, the object responded well to gentle cleaning with a mild detergent. No evidence of original paint was found before, during, or after cleaning. There were also four intense black spots on the Virgin's face and crown. These appeared to be drips of tar, or some tarlike substance, which had penetrated deep into the porous limestone and could not be removed. In order to decrease the distracting effect of the spots, they were sealed with an acrylic resin and cosmetically disguised with acrylic paints.

Four Apostles (1966.147–150) (colorplate XVI and figures 1.3 and 3.1–3.4)

Occasionally, stone pieces require a large amount of time and attention to stabilize and prepare for display. The limestone relief sculptures, the *Four Apostles*, were not only very weathered and dirty; they were also covered with extensive, disfiguring patches of colorful lichen growth. Through the years, the organic acids produced by the lichen reacted with the cementing substance in the stone (calcium carbonate), leaving it soft and friable. Fortunately, good storage conditions over the last twenty years have kept the lichen dormant and restricted additional damage to a minimum.

The reliefs themselves, however, had a long history of use before entering the museum.[3] Consequently, there were several layers of plaster and sometimes polychromy over the original stone surface. This fact, combined with the lichen growths and sooty deposits, made the appreciation of the carved details impossible, since they were almost totally obscured in many places. There was no doubt that these objects should be cleaned, but the fragile nature of the stone surface and the rare discovery of the remains of original paint precluded the use of vigorous or aggressive cleaning techniques. The basic cleaning procedure chosen for these important objects is outlined below.

A fine mist of water was used to remove loose dust and dirt and to make the surface accretions easier to interpret. The flowery lichen growths were easily lifted off with dental tools. Heavy plaster and mortar remains were removed mechanically, where possible, with a surgical scalpel, to reveal the carved details below. As the remains of painted decoration were uncovered, those areas were noted and then avoided in later cleaning stages.

The removal of the lichen revealed another type of fungal residue

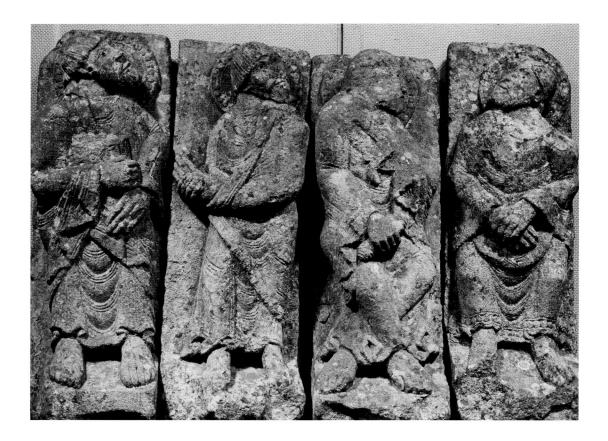

that gave the appearance of many greasy, black stains. These spots could not be easily lifted off, and had to be excavated from the tiny pores in the stone with the tip of a very sharp scalpel blade. The remaining black stains which could not be removed in this way without damaging the stone were treated with a bleaching agent (hydrogen peroxide) to reduce their distracting visual impact. This treatment was only partially effective and some black residue remains.

Mild detergents and solvents were used on sooty deposits and gentle brushing was used where it was safe to do so. As we were working with considerable time limitations, it was not possible to remove all the surface accretions from the *Four Apostles*, but at least it is now easier to see the delicate drapery, expressive gestures and, perhaps most important, the remnants of polychromy that were uncovered.

The oldest remains of the polychrome decoration were thin, almost translucent colors applied directly to the stone with no visible undercoat. It appears that the backgrounds of each relief slab were painted dark blue; the halos were yellow, the hands (and probably faces and feet also) were painted a peachy skin-tone, and the drapery seems to have been red and/or blue.

Figure 1.3
Romanesque Apostles before conservation (1966.147–150)

Very little of the original polychrome decoration survives. It appears to have mostly weathered away before the relief carving was resurfaced some years later with thick plaster. The replastered surfaces appear to have been painted with colors closely matching the originals, but even less of this polychrome decoration survived. There is evidence of a second plaster resurfacing, and presumably this was also painted, but extensive weathering and lichen activity has obliterated the evidence.

Though we had thought that any original paints found would require treatment in order to be preserved, this proved not to be the case. With a proper environment and suitably low light levels, these surviving remnants should remain intact, though they will have to be examined periodically. It is generally desirable to withhold treatment unless absolutely necessary, and this situation is a good example of that principle. Future analysis of paints and pigments can be hampered by the substances used for consolidation or surface coatings.

Conservation is never an exact science. There are no formulas or magical incantations that will work for every project undertaken. Each object must be assessed on an individual basis by examination, analysis, and research. Treatment plans are based on knowledge, experience, test results, and consultation with other professionals. It is advisable that art objects be left untreated until a trained conservator is consulted; unfortunately, at least fifty percent of a museum conservator's work usually involves dealing with past attempts at treatment and the damage unwittingly caused by good intentions. Consequently, the treatments briefly outlined above are only intended to inform generally and are not to be considered as guidelines for the conservation of any work of art.

Notes

1. Plenderleith and Werner's *The Conservation of Antiquities and Works of Art*, second edition (London, 1971), is still the only comprehensive reference work on the subject of conservation, although it is now very much out of date. More recent information may be obtained from the publications and book lists available through professional organizations such as the American Institute for Conservation (AIC).

2. See figure 1.2 and plate 14.

3. See the article by Jean French, "Search for a Provenance: The Duke University Apostles," in this volume.

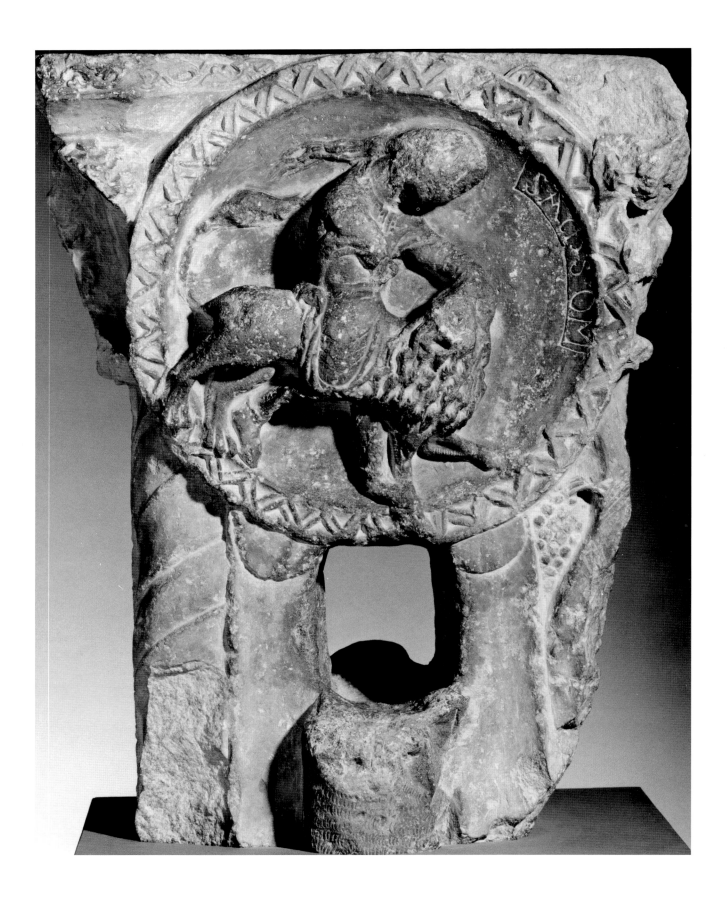

The Samson Monolith

Ilene H. Forsyth

Among the many fine works of medieval sculpture in the Brummer collection is a monolith with scenes of the life of Samson.[1] When the "Duke Samson" was first exhibited at the North Carolina Museum of Art in Raleigh in 1967, Robert Moeller wrote that the style indicated a date in the first half of the twelfth century and an origin in the Rhône Valley, perhaps not far from Vienne or Condrieu.[2] This attribution was supported by Walter Cahn in his entry for the corpus of Romanesque sculpture in America published by the International Center of Medieval Art. Cahn also thought the style of the piece pointed to the Rhône Valley or Provence as likely areas of origin, and noted that Joseph Brummer had acquired the curious monolith from Jacques Couëlle, at that time a collector in Aix-en-Provence.[3] An entry in a small catalogue for an exhibition in 1983 prepared by Duke undergraduates under the supervision of Caroline Bruzelius also named the Rhône Valley as the sculpture's probable place of origin.[4] None of these authors emphasized two important features of the piece: it is a monolith, with both the capital and shaft carved from one piece of stone; and it presents an unusual iconography for the Samson story.

The judgements regarding origin are right on the mark. I propose in this paper to refine them by demonstrating that the sculpture comes from a specific site in the Rhône Valley, the famous abbey of Saint-Martin at Savigny, about thirty kilometers west of Lyon and northwest of Vienne and Condrieu. A number of outstanding features of the Duke piece provide stylistic evidence for this precise attribution. The sculpture is remarkable; carved from high quality, densely grained limestone,[5] it combines capital and shaft in a block that is a rectangular oblong in plan. The lower part of the block has been broken, but it is likely that the height of the entire piece was originally slightly over a meter. The upper portions present a capital-like form with concave roundels carved on the two broad faces and rectangular reliefs carved on the narrower sides. The first of the large roundels depicts the scene of the Old Testament hero of Judges 14:5–6, Samson overwhelming the lion of Timnath, and is inscribed SAMSOM (figure 2.1). The group is set within a large medallion that is bordered with a double zigzag or sawtooth motif. There are broken clusters of foliage above and a rinceau pattern fills the abacus. The shaft's corner motifs simulate

◄Figure 2.1
Samson and the Lion
(1966.187)
H: 71–75 (28–29 ½")
W: 48.3–50 (19 ⅛–19 ¾")
D: 25.2–28 (10 ⅛–11")

spiral colonettes that actually form part of the stone block; that on the left of the lion scene is paired on the right with a vine, heavy with thick clusters of fruit, that twists upward in columnar fashion, a variant of the spiral colonette. Between them, smooth, slightly concave flutes of stone, topped by semicircular lappets, originally enframed a simian animal. The animal's head has been cut away but would formerly have risen up to overlap slightly a curious, almost square hole that traverses the shaft. The form of the animal can be inferred from the shape of its better-preserved pendant on the opposite broad side of the block (figure 2.4). Linda Roundhill's fastidious examination of the piece during its recent conservation has helped to clarify a number of the problematic aspects of the work, including the original configuration of this lost head.[6] After the cleaning of the sculpture the elegance of numerous details, such as the checked clavus ornamenting Samson's tunic and his nattily striped leggings, each stripe displaying a different pattern, became evident. The sculptor's expressive gift can also be seen in the composition of the roundel, especially in the firm positioning of Samson's left foot on the horizontal, since everything else—the lion's legs and Samson's flying hair and cloak—seems askew. The sculptor dramatically interprets this first demonstration of Samson's wondrous physical strength. Commanding his mount with his legs, Samson sits astride the lion, as a medieval knight would sit astride his charger, and his bare hands force open the threatening jaws of the lion. The beast is totally subdued by Samson's easy might.

The spiralling vine motif continues to the adjacent narrow side of the shaft to the right (figure 2.2). On this second face it is paired with another vine scroll at the opposite corner. The vines frame a smooth concave flute, again topped by a lappet, followed by an astragal and another carved scene about half the height of the carved roundels on the adjacent wide sides of the shaft. On this narrow side, however, the vines continue to undulate upward behind the astragal and then entwine with the "capital"'s subject, a Herculean nude. The head of the figure is damaged and the arms are almost totally broken away, yet the athletic rib cage, muscular thighs, and powerful splay of the legs reveal a male form based on antique prototypes for heroes. The nude form recalls, for example, the dynamic diagonals of many figures in ancient sculpture, except for the engagement with the vines and the presence of a large leaf, significant additions I shall discuss below. An enigma in this Samson cycle, the nude male will require

Figure 2.2 ▶
Nude figure

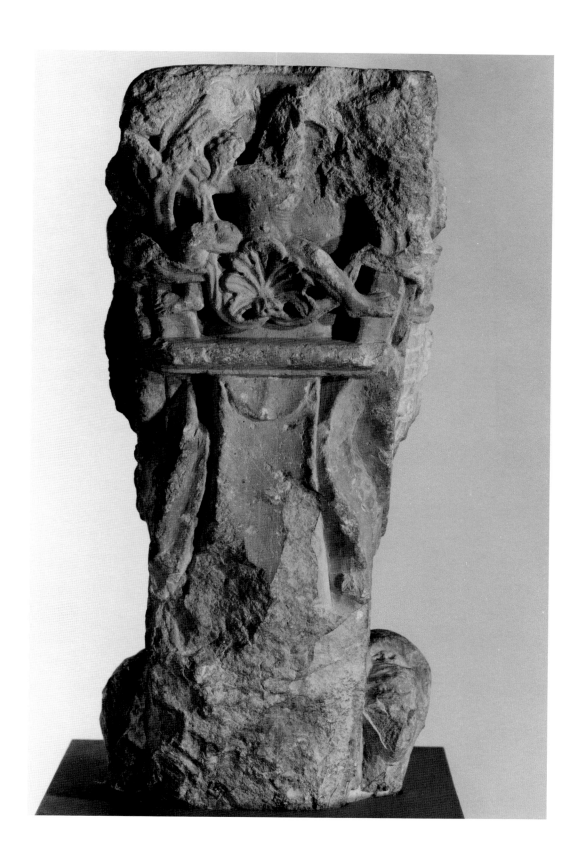

special explanation. It is critical to the piece's iconography that the figure—presumably Samson—thrusts his weight against the vines and wrestles himself free from them, as if they were fetters. The pressure of his left foot is particularly visible.

In leaping over the top, so to speak, the narrative continues on the opposite narrow side of the shaft, with the blind Samson (figure 2.3). The original finish of the salient bulgings of the corner colonettes and the subtle concavity of the central smooth flute are particularly apparent on this side. The figures' drapery, which is worked into high, sharply defined ridges and whorls and set against surfaces chiseled with feathery strokes, conveys with great finesse textures of amazing variety. Animating the figures' physiognomies and intensifying their expressions, deeply drilled eyes typical of sculpture from Savigny are set against broad, smooth foreheads. In contrast to Samson as an heroic nude or as the mighty lion killer, this face of the "capital" shows the tragically impotent Samson after his betrayal by Delilah and his blinding by the Philistines. Here, sightless and lumbering, Samson trustingly puts his large hand on the shoulder of a boy who leads him by a cord, now broken but originally attached to Samson's staff. This scene represents the moment (Judges 16:26) just before Samson's death when he asks the boy to lead him to the pillars that support the great temple of the Philistine god Dagon.

Moving in the same direction as those figures, the narrative continues to the left on the last wide side of the shaft, where a large medallion appears with foliage spilling over the upper sides of its zigzag border (figure 2.4). The spiraling supports, bearing fruit clusters at the left, are visible below the scene; between them a second ape's head overlaps the square hole. The head, though damaged and worn, nonetheless preserves a simian look. Deep drilling at the ears, the eyes, and the mouth enhances its features. It is tilted back and turned at a right angle to the pier. In the roundel above, the dramatic climax of the Samson story dominates this side of the shaft (figure 2.5). Samson avenges his blindness by pulling the temple of the Philistines down upon himself and the enemies who so brutally mutilated and mocked him. Within the smooth concavity of the medallion, we see the temple, its roof, its apsidal arcading, and its voussoired arch atop its two critical supports, the columns, and we see the prominent seismic explosion of ashlar masonry. The sculptor carefully rendered decorative details, such as the chisel marks on the surfaces of the

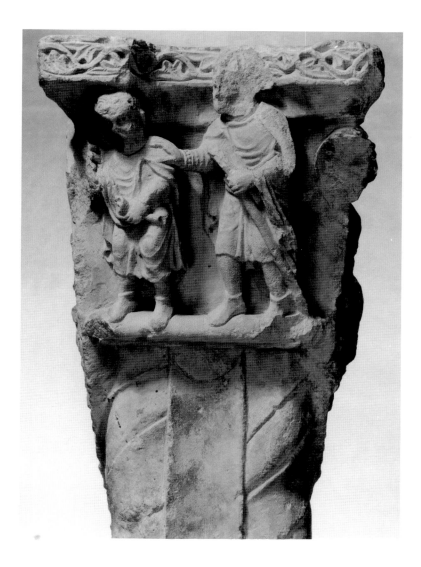

ashlar blocks and even the detail of tiny balls or discs in the spandrels
of the arcade. Most of all, we respond to the dramatic instinct of the
sculptor in eliminating Samson, save for his powerful legs. Having
regained their force, they replicate the pose in the scene of the nude
on the other side of the shaft. Here their leverage seems irresistible.
One leg wraps about the column in a fatal embrace; the other pushes,
inexorably collapsing the columns and bringing the massive masonry
down in a shower of vengeful death.

The formal artistry here is a tour de force, enabling the viewer to
grasp the significance of the story. Before I propose a fuller expli-
cation of the narrative, however, the claim I make for the origin of
the piece requires further discussion. The formal description just pre-
sented has revealed stylistic features that link the work to Savigny—

Figure 2.3
The blind Samson led by
a boy

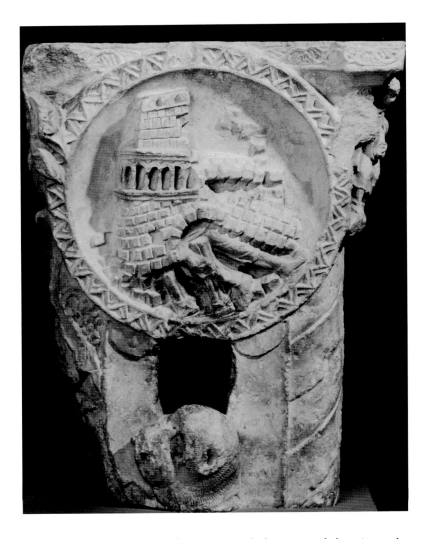

notably the monolithic and monumental character of the piece; the prominent medallions of unusual size, concavity, and placement; the vigorous action of the characters; the decorative enrichment, such as border motifs, spirals alternating with smooth flutes, and fruit clusters; the forms of the micro-architecture; the carving techniques, including the ready use of the drill; and, finally, the rich variety of figure types and drapery. Although the figure style is generally characteristic of Rhône Valley sculpture (often described as the Rhodanian style), particularly as it is known at Vienne, Lyon, and Charlieu,[7] other features point specifically to Savigny.

A few comparisons for these features at Savigny may be cited. Around the middle of the twelfth century, the abbey of Saint-Martin, reputedly restricted to noble families of highly cultivated tastes and ample means, was one of the wealthiest and most powerful in France.

Figure 2.4
Samson destroys the Temple
of the Philistines

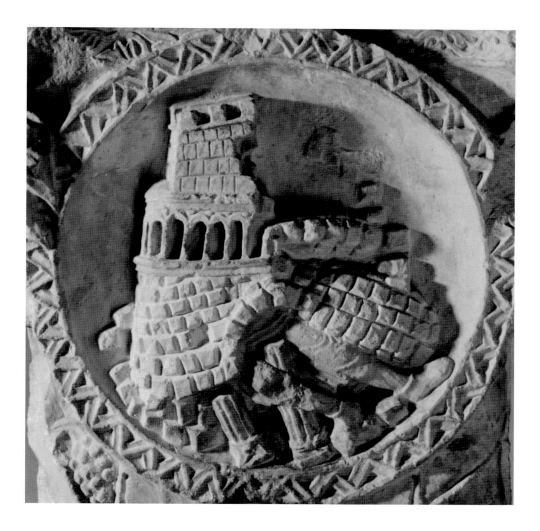

We shall see this reflected in the elaborate and richly carved sculptural decoration of the abbey. Like Cluny, the abbey was suppressed at the end of the eighteenth century. Its Romanesque structures, once including church, cloister, chapter house, and elaborate conventual buildings, were systematically destroyed and its sculptures mutilated and thrown aside.[8] A few of the most imposing pieces were salvaged and are preserved in the Gadagne Museum in nearby Lyon; others are still at Savigny; more still have been widely scattered into private collections. A number "migrated" to America. Although I am handicapped by having only a fraction of the pieces at hand, I have been studying them for some time and am attempting to reassemble the pieces of a very large puzzle.

Among these Savigny remnants are other particularly striking monoliths; they are a most unusual, and surely very costly form

Figure 2.5
Samson destroys the Temple of the Philistines, detail

27 The Samson Monolith

of architectural sculpture. One fragmentary example is the massive, almost octagonal pier with seated figures of apostles in the Lyon Museum (figure 2.6),[9] whose capital and shaft form one piece. More telling than the Rhodanian style in the draperies of the damaged apostle figures in relation to those of the Duke Samson is the sculptor's penchant for rather free play with medallions in the overall design. Outsized, as at Duke, these medallions overlap the capital area and form a series on axis down one long side of the piece. The salient astragal as well as the alternating concave and convex flutes with terminal lappets also resemble forms in the Duke work, though they are different in configuration.

A third massive monolith from Savigny, on loan from a private collection, is currently exhibited at The Cloisters in New York (figure 2.7).[10] The entire shaft is preserved. Although very hefty, its height (138 cm) corresponds to the usual height for cloister columns and is exactly that of those in the Saint-Guilhem cloister where it is currently installed. The surface of the slightly tapered, cylindrical shaft is articulated by alternatingly concave and convex forms in a zigzag pattern, topped by lappets set diagonally. Ornamental fruits are visible in the filling at the bottom next to the base of the shaft, recalling certain decorative motifs of the Duke piece. The Rhodanian figure style links The Cloisters monolith with mid-twelfth-century work from Charlieu, Tournus, and Vienne.[11] The capital presents the Adoration of the Magi, with the Madonna and the three kings each occupying one of the four sides. Between them are four angel-atlantes, one supporting the abacus at each of the corners. The frequent drilling and the lush carving of the draperies enlivening the figures readily evoke the manner of the Charlieu north portal and their counterparts in the Duke monolith, especially Samson and the boy. In The Cloisters sculpture the kings advance from the house of Herod toward the enthroned Madonna and Child, shown within an elaborate miniature palace. The micro-architecture of these two structures recalls the similar rendering of buildings at Charlieu, Tournus, and Vienne. The micro-architecture of The Cloisters monolith offers particular evidence of linkage with the Duke sculpture. The Virgin's palace (figure 2.8) is delineated by arcades and columns strikingly similar to those of the temple depicted in the climactic scene of the Duke Samson narrative (figure 2.5); even the chisel marks of the ashlar masonry are common to both.

Another monolith that belongs in this discussion, a rectangular

shaft now in Hartford, Connecticut, forms a capital-column in the shape of a pier.[12] Carved with four standing figures—perhaps evangelists—on its four faces, it has the diamond borders often used in Lyon and Condrieu, prominent micro-architecture, a favorite theme in Vienne and its environs, as well as other Rhodanian details, including the distinctive carving of leaves with a double stroke and drill hole. All of these features have close approximations at Savigny, the probable origin of the pier.[13]

Figure 2.6
The Apostles, Musée
Gadagne Lyon

29 The Samson Monolith

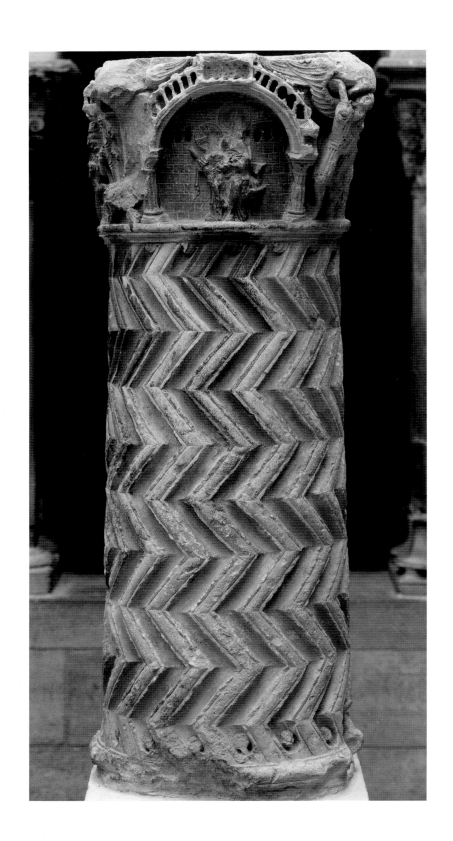

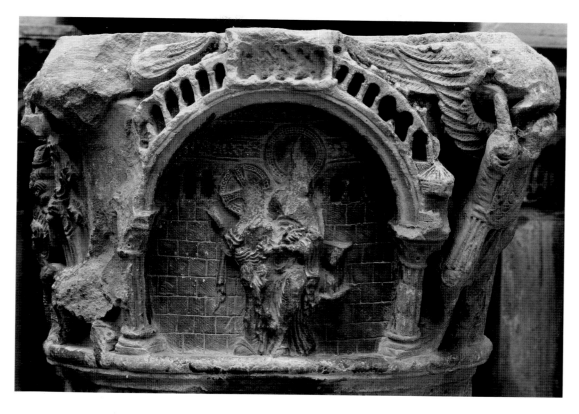

In addition to the large monoliths, there are also smaller capital-columns that have survived in fragmentary form from Savigny. They too are freestanding shafts topped by four-sided capitals but they measure about half the girth of their more massive counterparts. One in a private collection has four concave medallions with figures, probably representing ecclesiastics, and a fanciful version of classical fluting, with inserted ornament of the sort seen in the monolith at The Cloisters.[14] Another particularly imposing example, also in a private collection, has a shaft decorated with spiral grooves (figure 2.9).[15] Above the astragal, the capital shows Christ and his companions on the way to Emmaus. Here too the figures are set within concave medallions. They share Rhodanian propensities in their rendering, notably in their draperies and in their drilled eyes. The micro-architecture of the Emmaus scene, with its ashlar masonry, chisel marks, and arcade, provides decisive evidence for my attribution (figure 2.10). As in the arcade of the temple in the Duke sculpture, tiny round discs decorate the spandrels of the Emmaus cityscape (figure 2.5). The fruit clusters of the vine scroll also compare with their Duke counterparts (figure 2.11, cf. figure 2.4). Old photographs, preceded by even earlier published verbal descriptions as well as sketchy engravings, record the presence of both the Emmaus and the Magi monoliths at Savigny in the late nineteenth and early twentieth century.[16] All three were in-

◄Figure 2.7
The Adoration of the Magi, The Cloisters, Metropolitan Museum of Art, New York, on loan from a private collection

Figure 2.8
The Adoration of the Magi, detail, The Cloisters, Metropolitan Museum of Art, New York, on loan from a private collection (above)

cluded in an exhibition of Romanesque art from private collections held in Aix-en-Provence in 1935.[17]

The Duke monolith is related to two more Savigny sculptures in American collections: the piece now in the Wellesley College Museum (figure 2.12), a musician with eyes and hair especially comparable to those of the boy leading the blind Samson (figure 2.3); and the beautiful Savigny acrobat now at The Cloisters (figure 2.13).[18] The Savigny provenance of the acrobat and the musician has been demonstrated a number of times, first by Robert Moeller and then by Léon Pressouyre, who considers them two sides of a single work.[19] Both scholars observed that the leaf pattern common to the two sculptures is a key detail linking them to each other and to Savigny.[20] The same peculiarities—for example, the double chisel stroke and drill hole shaping the leaves on these pieces—characterize the large leaf used as a modest covering for the nude in the Duke Samson sculpture (figure 2.2).[21] The attribution of the musician and acrobat to Savigny is secure because both are close in dimensions as well as in style to the King Solomon capital still in Savigny (figure 2.14), in the Coquard Museum.[22] All three pieces—the Duke Samson, the Wellesley musician, and the Cloisters acrobat—were acquired at the same time and from the same source.[23]

The date of execution of this group of Savigny sculptures can only be surmised. Documents provide no precise chronology, and a number of distinctive styles were represented at the abbey. The Rhodanian style ran its course from about 1140 to 1170. It affected many monuments in the Rhône Valley beyond those considered in the present discussion and can be traced farther north in Burgundy to sites such as Saint-Julien-de-Jonzy, Préty near Tournus, and Autun. Current scholarly opinion considers the style to have centered in Vienne at the churches of Saint-Maurice and Saint-André-le-Bas. In the latter, an inscription enables scholars to assign a *terminus post quem* date of 1152. Within this broad geographic range, the group of monuments showing closest affinity to the Savigny sculptures are the Charlieu north portal, Préty, and the Tournus cloister, as well as related sites in the Vienne-Lyon area, such as Île-Grelonges, Mamelas, Saint-Julien, and Romans. On the basis of those stylistic relationships, it seems likely that the Savigny sculptures under discussion were carved in the 1150s or 60s. If so, the Samson monolith would fall within these two decades.[24]

◄Figure 2.9
The Way to Emmaus, monolith, private collection, France

33 The Samson Monolith

RITTER LIBRARY
BALDWIN-WALLACE COLLEGE

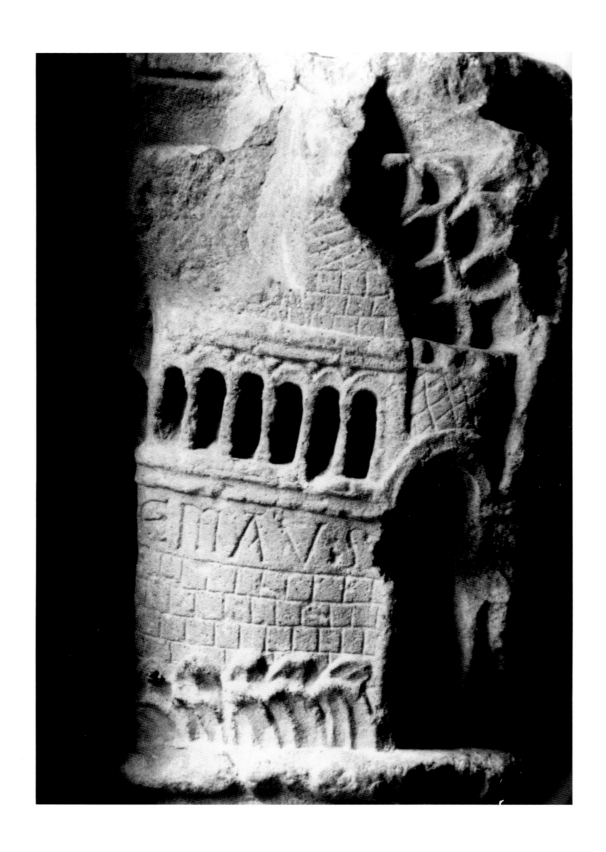

The placement of the Samson sculpture within the Savigny abbey is difficult to determine. Given the present state of our knowledge one can only put forward conjectures. Documents on the abbey are few and they are not illuminating with regard to sculpture. For example, a plan from the abbey's *Cartulaire* of the seventeenth century gives only a summary indication of the church, chapter house, and gardens of the abbey precinct.[25] Basing her work on both surviving fragments and scanty written sources, Denise Cateland-Devos has traced what is known of the cloister.[26] Located on the south side of the church, the cloister was described in the eighteenth century as vast but ruined in its eastern part except for the chapter house vault, which was still in good condition at that time.[27] Systematic destruction of the cloister began in 1780 and continued into the early nineteenth century. A few arcades were still visible in 1844 when Abbé Roux recorded his

◄Figure 2.10
The Way to Emmaus, detail, private collection, France

Figure 2.11
The Way to Emmaus, detail of vine scroll, private collection, France (above)

terse observations.[28] Considering the large number of sculptures that apparently come from the cloister, it must have been luxuriously ornamented with figurate carvings. A drawing showing the nearby cloister at St. Bernard, Romans, prior to its destruction, may throw light on the design of the cloister at Savigny.[29] Its east gallery had a scheme of claustral supports similar to the Savigny monoliths. One massive cylinder in the Romans cloister arcade had an emphatic chevron motif like that of the Magi monolith in New York, and other square piers at Romans recall the Hartford pier. They reinforce the conjecture that the massive freestanding shafts preserved from Savigny might once have served as supports within a cloister arcade. If so, perhaps the large monoliths alternated with smaller ones in the arcade program.

Figure 2.12
Musician, capital, Jewett Art Center, Wellesley College, Wellesley, Massachusetts

The larger monoliths are all roughly 50 centimeters square in plan at abacus level, whereas the small monoliths are half that. However, the height of all their capitals is the same, about 30.5 to 34 centimeters (measures are approximate because of abrasion), so that one can imagine a combination of massive and slender supports with a uniform rhythm for the capitals.

The dimensions of the Duke shaft differ significantly from the other

Figure 2.13
Acrobat, capital, The Cloisters, Metropolitan Museum of Art, New York

Figure 2.14
King Solomon, capital,
Musée Coquard, Savigny

monoliths under discussion, however. Its proportions are slighter, and
with the height of its two "capitals" (figures 2.2 and 2.3) much less
than those others, the entire shaft would have been noticeably shorter.
The top surface of the shaft measures about 50 centimeters on its
wide side and around 27 centimeters on its slender side. The height of
its two capital-like reliefs measures around 27 centimeters versus 34
centimeters for the other monoliths; therefore, even though the Duke
Samson is stylistically compatible with the other Savigny sculptures
reviewed here, it may have come from a different location, probably
one suitable to its freestanding character allowing access from all
sides. A possible place would have been one of the window openings of
the facade of the chapter house on the inner side of the cloister gallery.
In the usual three-bay chapter house facade, with a central entrance
passage and two flanking, unglazed windows, a stone mullion often
divided each window opening. Surmounted by an elongated capital
and impost, the mullion formed the central member in a design of two
small arches within a larger embracing arch. The narrow, rectangu-
lar shape of the Duke monolith would suit this purpose. One might
consider the scheme for the windows of the chapter house from the
Benedictine priory at Le Bas-Nueil now in the Worcester Museum, or
at Beaulieu (Corrèze), analogous.[30] The Samson sculpture so located
would have been visible to monks passing in the gallery of the cloister
or sitting on benches in their morning chapter meetings.[31]

The distinctive iconography of the sculpture speaks more clearly.
The four Samson scenes—Samson subduing the lion, the heroic nude

Samson, the blind Samson led by a boy, and Samson's vengeance—constitute an unusual Samson cycle that omits standard episodes from the hero's story.[32] There is no hint of the tragic flaw in Samson that perhaps first comes to mind today—his taste for women and his lack of judgment with regard to them. There is no reference to Samson's wife, the woman of the foreign people of Timnath whose action unleashed a series of events leading to Samson's slaughter of a thousand Philistines with the jawbone of an ass, a scene repeatedly illustrated elsewhere but ignored here. Nor is there any portrayal of Samson escaping his enemies after visiting the harlot of Gaza by carrying off the gates of the city on his shoulders. After the lion episode (which is repeatedly interpreted in typological terms as Samson prefiguring Christ in triumphing over the devil), the Gaza scene is probably the most common of the cycle (figure 2.15). In the Klosterneuburg enamel

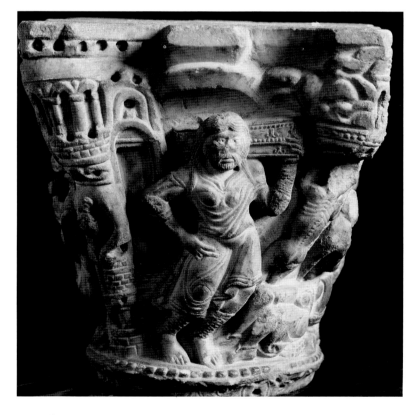

Figure 2.15
Samson with the Gates of Gaza, capital from the cloister of Notre-Dame-des-Doms, Avignon, Fogg Art Museum, Cambridge, Massachusetts

Nicholas of Verdun paired the event with Christ's resurrection from the dead. Christ, having broken the gates of hell and thrown off the confinement of his tomb, mounts to heaven; he is prefigured by Samson bearing the gates and mounting the hill before Hebron. The Gaza scene has frequently been so interpreted.[33]

Nor, finally, does the Duke Samson cycle include Delilah's betrayal of Samson by means of the famous haircut. We see her often in medieval art, in Paris manuscripts such as the *Sacra Parallela* of John of Damascus and the *Homelies* of Gregory, both of the ninth century; in the eleventh and twelfth century octateuchs; and in Romanesque sculpture.[34] French Romanesque examples include Aulnay, where Delilah's shears overwhelm the work; Cunault; Saint-Aubin at Angers; Arles; and a particularly fine rendering on a Fogg Museum capital from Avignon in which Samson stretches languidly in Delilah's lap (figure 2.17).[35]

On the other hand, two of the scenes included in the Duke narrative prove less usual within a Romanesque Samson cycle. In place of

Figure 2.16
Samson with the Gates of Gaza, detail of nude figure, capital from the cloister of Notre-Dame-des-Doms, Avignon, Fogg Art Museum, Cambridge, Massachusetts

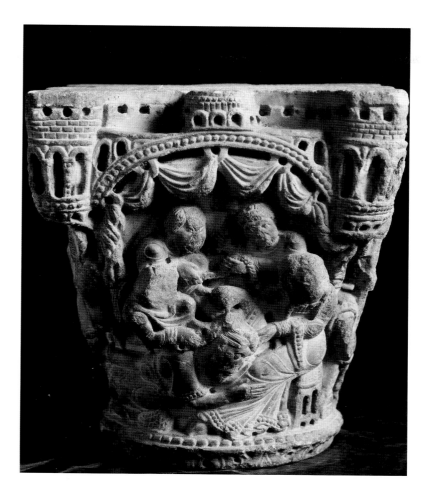

the brutal blinding of Samson we have the scene of the already blind Samson being led by a boy (figure 2.3); this is a subject also depicted at Pécs, rather far afield; in a relief in Naples; and in a well-known capital at Autun.[36] In the Duke rendition the mutilated and humiliated Samson is reduced to a lumbering invalid, in sharp contrast to his former athletic figure capable of superhuman feats.

Particularly rare in Samson cycles is the assignment of a full side of the sculpture to representation of an heroic nude figure, who must surely be Samson, wrestling with vines (figure 2.2). It has been suggested that this curious scene might depict Samson uprooting a tree,[37] but the text of Judges, which all the Samson cycles including ours follow rather closely, relates no such event. Still, the subject appeared sporadically in Romanesque art. Study of the example at Pécs has revealed others at Alspach, Remagen, and a slightly later wall painting with a Samson inscription at Limburg.[38] A less well-known example on a bronze lamp in Erfurt includes a tree-pulling event as part of a five-episode Samson cycle.[39] The iconographic meaning of such a

Figure 2.17
Samson and Delilah, capital from the cloister of Notre-Dame-des-Doms, Avignon, Fogg Art Museum, Cambridge, Massachusetts

scene remains somewhat problematic, although a reference to Samson's strength or to the testing of his might seems implicit. In all of the instances enumerated so far, Samson appears fully clothed, whereas at Duke the figure is nude. One other little-noted example of a nude figure occurs on the famous Samson capital from Avignon, not far from Savigny, discussed above. At the corner of the Avignon capital, between the Gaza and Delilah episodes, the nude male is seen from the back (figures 2.15–2.17). He lifts his right arm to grasp a vine over his head as in the Duke relief; with the other arm he supports a towering weight above, like an atlante or the Atlas in the Apples episode of the Hercules cycle. The nude thus introduces a subtheme in the Avignon capital by making an allusion to Hercules. Positioned between the harlot of Gaza and Delilah scenes, the nude also suggests the more vulnerable and masculine qualities of Samson. Like the vine entwined with the curtains of Delilah's boudoir, the nude seems intentionally ambiguous, a bi-valent vehicle for reference to both the physical strength and the lusty, emotional weakness of the male figure. In both the Avignon and the Duke sculptures the nude figure clearly suggests the heroic, physical force of Samson, albeit in an innovative way. In the biblical account, Samson demonstrates his extraordinary strength many times—most dramatically through the wondrous act of freeing himself from fetters of various kinds. He allows himself to be bound with cords that fall away when he proceeds to slay the Philistines (Judges 15:13–16). In the Delilah episodes, he is bound three times following Delilah's insistent questioning about the secret source of his strength. These trials manifesting his strength immediately precede Samson's tragic downfall. Our relief graphically suggests the first trial, whereby he is bound with green wythes, equated with green bowstrings or sinews. In the second he is bound by new ropes; finally, he is bound with the seven locks of his own hair woven into Delilah's loom and fastened with a huge pin. From all these snares Samson easily wrestles himself free. The interweaving of the limbs of the Duke figure with the twisting vines of foliage (figure 2.2) seems particularly apt as a reference to the first of these trials, in which Samson loosens himself from the green bowstrings or wythes. Yet all three incidents seem implied, as if the nude figure were a generalized portrait of Samson's physical prowess in surmounting all these constraints. The nudity and the pose follow the traditional formula for representing such prowess inherited from the antique models of clas-

sical heroes, especially Samson's mythological counterpart Hercules. The nude figure at Duke thus seems to have a double role in the cycle: to evoke the narrative episodes during which Samson dominated his bonds, and to allude to Samson in generic terms as an exemplar of strength in the guise or mode of Hercules.

Investigation of twelfth-century literature reveals the recurrent pairing of these two heroes. An anonymous tenth-century poet compared the deeds of the two men, and the theme became more prominent in the twelfth century, when Messias wrote of the two heroes in a longer poem. They feature most markedly as a duo in the schoolbooks, such as Theodulus's *Eclogues*, used for instruction in classical mythology.[40] These present a dialogue featuring classical and biblical personalities as analogues—in our case Hercules and Samson, linked by the lion incident as well as by their betrayals: Hercules is undone by the treachery of Deianira; Samson is betrayed by Delilah. Ovid's tale of Hercules's wife Deianira, with regard to Nessus (*Metamorphoses* IX: 131), is relevant because of the words in the ancient myth, "I shall not die unavenged," recalling Samson's motives in sacrificing himself in his death. Quoting Ovid's lines and using an illustration of Samson bringing down the temple, the emblem books of the later Middle Ages took up this association.[41] The *Eclogues* of the Carolingian Theodulus directly juxtaposed the two heroes' exploits.[42] Bernard of Utrecht's commentary on Theodulus's *Eclogues* became particularly popular in the twelfth century, and a number of Theodulus manuscripts including it survive from this period. There the association of Hercules with Samson is moralized, as in the later *Moralized Ovid*. The literary tradition coupling pagan and Hebrew heroes can be traced back to Augustine, who associated Samson, Judge of the Hebrews, with Hercules, because of his wonderful strength; the same association was made by other early writers such as Eusebius and Philastrius. Boethius, Fulgentius, and Isidore all made similar attempts to "christianize" or moralize Hercules. The debate as to whether the Greeks stole the idea from the Hebrews or vice versa still goes on and may account for the popular expression, encountered today, that calls Samson "the Jewish Hercules."[43]

Hercules and Samson are often paired in Romanesque art. They appear on the companion bowls engraved in the mid-twelfth century and were featured in sets of carved ivory tablemen used for the game of tables, a kind of backgammon. A set recently studied by Vivian

Mann (done by the "Samson Carver" in Cologne about 1150) had fifteen gamepieces representing the exploits of Samson in ivory stained blood red, and fifteen pieces representing the deeds of Hercules kept white. The particularly relevant pieces show Samson destroying the temple of the Philistines and the nude infant Hercules strangling the snakes—the latter is especially reminiscent of the nude in our relief.[44]

The accumulated evidence suggests that the Duke nude represents a generic portrait of Samson that borrows the nudity of his classical counterpart to illustrate the hero during the phase of the narrative when his physical strength was at its height. Carrying with it reminiscences of many ancient heroes, such a "portrait" might function in a nonrestrictive, overlapping way, as a quasi-allegory of physical fortitude,[45] with the further formal function of making the weakness of the blind giant in the scene opposite all the more poignant. The enormous leaf in the scene of Samson in the vines perhaps discreetly suggests Samson's weakness for women and his pleasure in them which is his undoing; the looming apes, medieval symbols of lust, surely imply the same message.[46] Lust distracts Samson from his role as a Nazarite, as a child of God; it distorts his judgment as he covets the woman of Timnath (he says: "Get her for me; for she pleaseth me well"; Judges 14:3), despite his father's injunction to marry from his own tribe. This sets in motion the series of events that lead inexorably to his downfall and reduce him finally to such impotence that a boy must lead him about with a cord. In this interpretation the apes function not only in the structural sense explained above, but also symbolically, by indicating the tragic flaw that undermined Samson's strength. To the monks in the cloister of Savigny the moralizing admonition of the apes and the nude could be well understood.

If we pursue this line of reasoning, the final scene of Samson's death becomes all the more dramatic (figure 2.5). In the ninth-century rendition of the vengeance episode (the Paris *Homelies* of Gregory), along with most other versions, Samson is shown full-figure, his hair has grown long, and he grasps both columns of the palace temple in which the Philistines are seen feasting.[47] The text of Judges says: "And Samson took hold of the two middle pillars upon which the house stood, and on which it was borne up, of the one with his right hand, and of the other with his left. And Samson said, Let me die with the Philistines (AV, 16:29–30)." In the Fogg capital (figure 2.18) Samson is also shown as a large, long-haired figure, and at Autun, though bowed

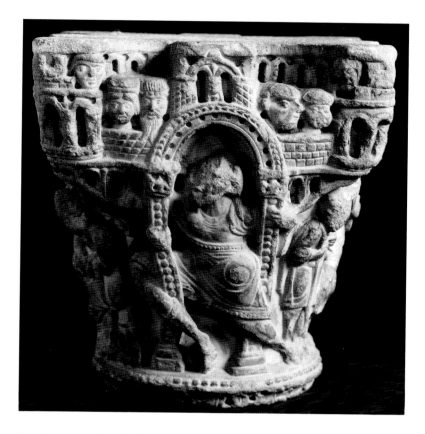

by the enormity of what he attempts, his large form is emphasized.[48]
At Savigny, on the contrary, there is no reference to his hair, to his
sightless eyes, or even to the Philistines. The Philistines are sometimes
summarily shown (at Autun, in the boxlike temple, and at Avignon,
where several heads on the roof represent them), but they are usually
included, for they will be killed with Samson. It was a stroke of genius
on the part of the Savigny sculptor to omit these things and show
only the legs of Samson. They make viewers both laugh and cringe
—how much more horrifying the personal tragedy of the collapse of
the temple when one sees only a part of Samson's great body left, as it
is about to disappear into the rubble. But in this very part of Samson,
his legs, resides his vital force. This seems implied by the fact that the
sculptor gives them the same powerful pose as the Savigny figure of
Samson nude.

A final question: Would this scene, which makes it absolutely clear
that Samson has been undone, also appear to a Romanesque viewer
as a *triumphal* vengeance? Could Samson's suicide have been under-
stood as both an end and a beginning, as a living triumph? For
Romanesque exegetes this was no problem. Turning again to twelfth-
century literature for aid in understanding contemporary views on
such questions, we find that exegetical texts give both a moral and

Figure 2.18
Samson destroys the Temple
of the Philistines, capital
from the cloister of Notre-
Dame-des-Doms, Avignon,
Fogg Art Museum, Cam-
bridge, Massachusetts

a spiritual emphasis to the Samson story. These include commentaries on Judges, paraenetical texts, and homilies, some of which paraphrased St. Augustine, who devoted an entire sermon to moralizing the Samson story and who was then repeated by Caesarius of Arles (c. 470–542) and others.[49] Gregory the Great and John of Damascus (c. 675–749) also provided exegetical models.[50] Twelfth-century authors who took up this tradition and elaborated it with great originality include the Abbot Gottfried of Admont (d. c. 1165), who gave the text in Judges a particularly close symbolic reading; the famous Benedictine Rupert of Deutz (d. 1135); the "New Augustine" of Saint-Victor, Hugh (d. 1173); Hervaeus of Déols (d. c. 1149/1150); Thomas the Cistercian; Peter Comestor; Alan of Lille; Peter the Venerable; and Julian of Vézelay, among others.[51] The author of the *Glossa*, Rabanus Maurus, and Peter Damian served as some of the intermediaries for the transmission of such ideas from patristic sources to the twelfth-century schoolmen.[52] Only a few examples can be cited here. In a sermon of Abbot Gottfried from the middle of the twelfth century, all the details of the Samson narrative are interpreted symbolically, primarily with regard to viewing Samson as prefiguring Christ. Gottfried underscores the humbling of Samson through his mutilation and the purification of his soul through the experience of his imprisonment leading to his final triumph. In his vengeance over his enemies, he killed more Philistines, as the text of Judges says, than he had during his entire lifetime. Gottfried emphasizes that it was possible for Samson to shake and destroy the temple not simply because his hair had grown again, but because Samson prayed fervently to God as he was being made sport of by the Philistines, and because in His mercy God heard his prayer: "And Samson called upon the Lord and said, O Lord God, remember me, I pray thee, and strengthen me, I pray thee, only this once, O God, that I may be at once avenged of the Philistines for my two eyes" (AV, Judges 16:28). God is merciful and answers his prayer. The temple comes down.

Hugh of Saint-Victor wrote in a vein similar to Gottfried, both echoing Augustine and Caesarius of Arles and also rationalizing a number of the negatives in Samson's actions as the work of the Holy Spirit who moved Samson to them as part of the Divine plan. The hero had thus in effect descended into the hell of the harlot's house and risen from it tearing away its gates, and he was later seized as Christ was seized and mocked as Christ was mocked. In extending his arms

to the two columns of the temple, likening himself to the cross, he killed his enemies; his suffering brought the death of his persecutors. Samson's suicide was thus impelled by God. With it he rose up against those who worship false gods, such as the Dagon of the Philistines' temple. Their destruction was thus a part of the Divine Will. Most interesting was Hugh's more mystical interpretation of Samson the Nazarite in relation to God. Samson's hair mystically symbolized the close relationship of a child dedicated to God. When Samson lost his hair because of his own pride, he lost his communion with God. His special relationship was severed and he became vulnerable. When he regained his faith and his hair at the time of his final prayer, God came to his aid.[53] Before 1135 Rupert explained the story in even greater detail, allegorizing the locks of Samson's head and the columns of the temple, likening the blinding of Samson to Christ's agony in the Garden, his betrayal by Delilah to the Betrayal by Judas, and Samson's death to Christ's death on the cross.[54]

The impact of this exegetical tradition on the visual arts is attested by the writing of the anonymous twelfth-century author of the *Pictor in Carmine*. In his preface he advises artists and "those who supervise such matters" that the painted wall may declare the wonderful works of God and that "the stones may cry out"; he advised avoidance of "misshapen monstrosities" in preference for subjects which allow contemplation of "the deeds of the Patriarchs, the rites of the Law, *the deliverances wrought by the Judges* [italics mine], the symbolic acts of the Kings," and the "revealed mysteries of the gospel." He said he had drawn up chapters and verses to allow the application of "events from the Old and New testaments" and "explain the Old Testament subject and apply it to the New." Following the title of his chapter ci, *Crucifigitur Christus*, the applications included: *Samson concussus duabus columpnis moritur et opprimit principes Philistinorum.*[55]

The core of this exegetical tradition was thus strong and current at the time the Savigny sculptures were created. To claim that scholastic allegorizing was implicit in them is not to expect that any one such meaning would be considered discretely from others. Overlappings, ambiguities, and antitheses were often sought by scholastics, as truth was believed to reside sometimes in paradoxes, *viz.* death yielding life, the essence of Samson's riddle. The recurrent thread that runs through all the various interpretations in the literature is the insistence that Samson triumphed over the Philistines in the end because of his

prayer which reunited him with God and because of the strength of his faith in God's mercy to grant his prayer. The legacy of the *Sacra Parallela* of John of Damascus on the efficacy of prayer may be seen in this reasoning. The authority of Paul added further weight. Very important for the twelfth-century exegetes was the inclusion of Samson with Old Testament representatives of faith in Paul's famous verses in Hebrews 11:32, where Samson is numbered with David, Samuel, and others who "through faith subdued kingdoms . . . [and] out of weakness were made strong."[56]

According to the interpretation of this paper, then, Samson would have provided a powerful model, both moral and spiritual, for both monks and canons. His story would have been appropriate for chapter house or cloister. His prowess could be celebrated, as in the Savigny carving, as a triumph over the evils of the devil, and his moral weakness known to be an example to be avoided at all costs. Even more, in this particular work of art, the Romanesque religious could emulate Samson, who in extreme adversity regained faith in God and found prayer to be the vehicle for converting the loss of physical force into the gain of spiritual strength.

Notes

This study, which has grown out of a paper presented at the Duke University Symposium on the Brummer Collection on September 26, 1987, has benefited greatly from the assistance, particularly with photographs, of a number of scholars. Their exemption from responsibility for its errors is taken as a matter of course while their advices for its improvement are gratefully acknowledged. They include Edson Armi, Caroline Bruzelius, Walter Cahn, Lois Drewer, Dorothy Glass, Rosalie Green, Kathryn Horste, Charles Little, Vivian Mann, and Neil Stratford.

1. From the collections of E. Brummer, J. Brummer, and J. Couëlle. New York, Parke-Bernet Galleries, *The Classical and Medieval Stone Sculptures, Part III, of the Joseph Brummer Collection* (1949):133, no. 563. Joseph Brummer's records indicate that the shaft was acquired from the Couëlle collection in Aix-en-Provence in 1928.

2. Robert C. Moeller, *Sculpture and Decorative Art* (Raleigh, 1967):20–25; William Heckscher and Robert Moeller, "The Brummer Collection," *Art Journal* (1967–68): 182.

3. Walter Cahn, "Romanesque Sculpture in American Collections, XIV, The South," *Gesta* XIV/2 (1975): 68–69; see also his "Romanesque Sculpture in American Collections, I, Hartford," *Gesta* VI (1967): 47–48, and Walter Cahn and Linda Seidel, *Romanesque Sculpture in American Collections*, volume I: *New England Museums* (New York, 1979): 18–20, figures 2–3.

4. Caroline Bruzelius, ed., *Rediscoveries: Selections of Medieval Sculpture at the Duke University Museum of Art* (Durham, 1983): 8–11, no. 2 by George Johnstone.

5. Rather than marble as was once thought; Cahn, "Romanesque Sculpture . . . XIV," 68.

6. Traces of deep drilling for the ear and eye indicate that it would have been the mirror image of the preserved head on the opposite side. Warm thanks are due to Mrs. Roundhill for assistance with a number of such problems; see her essay on the conservation of the collection in this volume.

7. Among the many studies of the art of this area, see Georges Gaillard, "Essai de classement des sculptures delphino-rhodaniennes au début de l'époque romane," *Actes du XVII. Congrès international d'Histoire de l'Art* (Amsterdam, 1952): 139–42; Victor Lassalle, "Les rapports de la sculpture romane bourguignonne et de la sculpture romane lyonnaise," *Centre international d'Études romanes, Bulletin* IV (1958): 7–10; Robert Moeller, "Notes sur l'iconographie du narthex de Charlieu," *Actes des journées d'études d'histoire et d'archéologie, organisée à l'occasion de Xe centenaire de la fondation de l'abbaye et de la ville de Charlieu* (Société des Amis des Arts de Charlieu, 1973): 35–45; Willibald Sauerländer, "Eine trauernde Maria des 12. Jahrhunderts aus dem mittleren Rhonetal," *Berliner Museen* XIV (1964): 2–8; Neil Stratford, "Chronologie et filiations stylistiques des sculptures de la facade nord du porche de Charlieu," *Actes des journées d'études*, 7–13; Jean Vallery-Radot, "La limite de l'école romane de Bourgogne," *Bulletin monumental* XCV (1936): 273–316; Ricki D. Weinberger, "The Romanesque Nave of St. Maurice at Vienne," Ph.D. dissertation, Johns Hopkins University (1979), and "St. Maurice and St. André-le-Bas at Vienne: Dynamics of Artistic Exchange at Two Romanesque Workshops," *Gesta* XXIII/2 (1984): 75–86; and Jochen Zink, "Zur dritten Abteikirche von Charlieu (Loire), insbesondere zur Skulptur der Vorhalle und ihrer künstlerischen Nachfolge," *Wallraf-Richartz Jahrbuch* XL (1983): 57–144.

8. With the exception of a small museum, virtually no architectural remains now survive at the site itself, though excavation might reveal foundations and possibly uncover additional sculptural fragments. See L'Abbé J. Roux, "Savigny et son abbaye," *Album du Lyonnais* II, s.l. (1844): 153–203; Denise Devos, "L'Abbaye de Savigny: Plan et architecture des édifices," *Mélanges de travaux offerts à Maitre Jean Tricou* (Lyon, 1972): 139–57; and Denise Cateland-Devos, "Sculptures de l'abbaye de Savigny-en-Lyonnais du Haut Moyen Age au XVe siècle," *Bulletin archéologique du Comité des Travaux historiques et scientifiques* N.S. VII (1971): 151–205.

9. Cateland-Devos, "Sculptures," 169–70, figure 17; Léon Pressouyre, "St. Bernard to St. Francis: Monastic Ideals and Iconographic Programs in the Cloister," *Gesta* XII (1973): 87, n. 42; Monique Ray, *Le Musée Historique* (Lyon, 1957): salle IV.

10. 1979.95; New York, Metropolitan Museum of Art, *Annual Report* (1979–80): 40; Aix-en-Provence, Chapelle des Pénitents Bleus, *Exposition d'art roman organisée par la Decoration Architecturale, 16 mars–8 avril 1935* (exhibition catalogue): 48, no. 5; Lucien Bégule, *Antiquités et richesses d'art du département du Rhône* (Lyon, 1925): 139; Cateland-Devos, "Sculptures," 166–68, figures 14–15; H. M., "Sculptures anciennes de Savigny (Rhône)," *Bulletin historique du diocèse de Lyon* (1924): 326–27, (1925): 59–61, plates following 61, 159–61; F. Thiollier, "Vestiges de l'art roman en Lyonnais," *Bulletin archéologique* (1892): 396–411.

11. Victor Lassalle, "Cinq figures romanes provenant de l'église Saint-Pierre-et-Saint-Paul d'Ainay au Musée Historique de Lyon," *Bulletin des musées et monuments Lyonnais* (1975/3): 409–12, figure 6; Raymond Oursel, "La sculpture romane de Tournus," *Société des Amis des Arts et des Sciences de Tournus* LXXVIII (1979): 3–40, figures 33–36; and Stratford, "Chronologie et filiations stylistiques," no. 4, plates III–V.

12. Cahn, "Romanesque Sculpture . . . I," 47–48; Cahn and Seidel, *Romanesque Sculpture*, 18–20.

13. In the 1949 Brummer sale (III. 143, no. 599) the pier was said to have come from the Savigny abbey, a report confirmed to Professor Cahn by M. Bonnepart in Savigny (Cahn and Seidel, *Romanesque Sculpture*, 19). Brummer's original records on this piece have been lost and I have not yet been able to track them down.

14. Aix-en-Provence, *Exposition*, no. 10.

15. Aix-en-Provence, *Exposition*, no. 14; Cateland-Devos, "Sculptures," 169, figure 16; Ilene H. Forsyth, "The *Vita Apostolica* and Romanesque Sculpture: Some Preliminary Observations," *Essays in Honor of Whitney Snow Stoddard, Gesta* XXV/1 (1986): 78, figure 5; H. M., "Sculptures," 59, plates following 61, 328; and Thiollier, "Vestiges," 405. Special thanks are extended to Neil Stratford for his gracious permission to publish his photographs of this sculpture (plates 2.9–2.11). Another fragment of a capital-column in a private collection represents the Nativity (Aix-en-Provence, *Exposition*, no. 6; Cateland-Devos, "Sculptures," 186–88, figures 26–27; H. M., "Sculptures," 59, plates following 61; Rosalie Green, "The Missing Midwife," *Romanesque and Gothic: Essays for George Zarnecki* (Woodbridge, Suffolk, 1987): 105, plates 4–5.

16. Archives photographiques 002P1029; Bégule, *Antiquités*, 139–40; H. M., "Sculptures," plates following 61, 328; Roux, *Album*, 201; and Thiollier, "Vestiges," 405–6, figure 6.

17. *Exposition*, nos. 5, 10, 14 (see note 10 above).

18. Parke-Bernet, *The Notable Art Collections Belonging to the Estate of the Late Joseph Brummer* I (New York, 1949): 141, no. 562; Walter Cahn, "Romanesque Sculpture in American Collections. III," *Gesta* VIII/1 (1969): 56–57; Cahn and Seidel, *Romanesque Sculpture*, 56–57; Charles T. Little, "Romanesque Sculpture in North American Collections. XXVI. The Metropolitian Museum of Art, VI," *Gesta* XXVI/2 (1987): 157–58 (with the earlier literature).

19. Robert C. Moeller III, in *The Renaissance of the Twelfth Century*, Stephen Scher, ed. (Providence, 1969): 134–37, nos. 47–48; Léon Pressouyre, "Expositions," *Revue de l'art* VII (1970): 98–100.

20. The block with the musician appears cut back along the right side while the acrobat block is cut sharply along the left, in both cases reducing somewhat the fullness of the leaf (compare the King Solomon capital, figure 2.14) and suggesting that the sculptures originally formed two sides of a pilaster capital, as Pressouyre has proposed. See Stephen Scher's comment on the joining of the two blocks at the time of the exhibition in Providence in his " 'The Renaissance of the Twelfth Century' Revisited," *Gesta* IX/2 (1970): 60.

21. Also visible in the Hartford pier; see note 13 above.

22. Cateland-Devos, "Sculptures," 190–93, figure 31. The Solomon sculpture was observed by Roux as part of a wall at Savigny in the 1840s (*Album*, 201); he considered it part of the main portal of the church.

23. Brummer's records indicate the same acquisition data for them (the same collector in Aix-en-Provence, the same date of purchase and arrival, as well as the same lot number and a single lot price). Also from this source came the "Spinario" in the Duke collection which I have also attributed to Savigny (Cahn, "Romanesque Sculpture . . . XIV," 70, no. 3). Its drapery represents a more "Cluniacizing" style also known at the Savigny abbey, best illustrated by sculptures still in Savigny, such as the standing figure of an "abbot" (Cateland-Devos, "Sculptures," 183–85, figure 25), a group of

"wrestlers" (*ibid.*, 162–63, figure 10), and some small capitals (*ibid.*, figures 11–12). (Editor's note: see our entry on this piece here in the catalogue, pp. 148–53.)

24. This would be the period of Abbot Odilon at Savigny (his tenure in the forties and fifties lasted approximately twenty years, following the abbacy of Ponce, 1111–39/40) or the period of Abbot Milon (1162–72); the latter seems more appropriate to the style of the sculptures. The abbey's cartulary does not help us to be more precise. Auguste Bernard, *Cartulaire de l'abbaye de Savigny* (Paris, 1853): xc–xci. This dating agrees with recent scholarship; see, for example, Little, "Romanesque Sculpture," 157–58; Stratford, "Chronologie" and "Postscriptum: un groupe de sculptures 'rhodaniennes' à Autun," *Le Tombeau de Saint-Lazare* (1985): 122–29, and "Autun and Vienne," *Romanesque and Gothic: Essays For George Zarnecki*, 193–200; Weinberger, "St. Maurice"; and Zink, "Zur dritten Abteikirche von Charlieu"; see also note 7 above. Other relevant sites would include Champagne, Condrieu, Salles, and Valence (Bégule, *Antiquités*).

25. Paris, Bibliothéque Nationale, MS lat. 100035.

26. Devos, "L'Abbaye"; Archives du Rhône, cote no. 38 (for the 1795 sale of the abbey's structures); Benôit Mailliard (1431–1506), Neufborg, ed., *Chartes du Forez antérieur au XIVe siècle* 18 (Lyon, 1966): 15.

27. Lyon, Bibliothèque Municipale, *Fonds Coste*, no. 3314, MS 393, s.d. (c. 1766).

28. Roux, *Album*, 201–2.

29. Jacques Thirion, "L'Ancienne collégiale Saint-Bernard de Romans," *Congrès archéologique* CXXX, 1972 (Paris, 1974): 397, figure 30.

30. Cahn and Seidel, *Romanesque Sculpture*, 43–44; Joan Evans, *The Romanesque Architecture of the Order of Cluny* (Cambridge, 1936): 142, figure 245.

31. Careful examination reveals that the perplexing cutting, piercing the shaft like a small tunnel (c. h.9 x w.11 x d.18 cm.), is original and not a later alteration. The interior surfaces behind the two apes' heads, which partially block its two entrances, have been shaped and finished with great care as an integral part of the original design of the whole. Wear around the edges of the two entrances indicates long use, perhaps by the insertion of wooden timbers. The tunnel is not a straight, uniform horizontal cylinder as might have been expected for a rigid horizontal beam. Actually it is carved to allow some maneuvering space; this is indicated by a slight dip in the floor of the cavity, a contraction in the center, and slight bulges near the entrances. This curious undulation of the tunnel surfaces appears designed to receive and lock in place the inner ends of two horizontal members of wood or metal meeting in the center, each of which must have been shaped to hook against the inner sides of the apes' heads, which would then have served as supports and locking devices for them, preventing their extrusion. The practical function of such an hypothetical system is still unclear, although some arrangement for protection from heavy weather has been suggested if the shaft were part of a cloister arcade (Léon Pressouyre, noted in *Rediscoveries*, 9). It has also been suggested that the Samson monolith might have been part of a tomb or an altar canopy (Walter Cahn, "Romanesque Sculpture . . . XIV," 69). Although the massive character of the piece seems to this writer to call for an architectural context rather than for use in liturgical furnishings, on occasion Romanesque tombs could be exceptionally monumental and quasi-architectural in form (Autun, Musée Rolin, *Le Tombeau de Saint Lazare* [1985]). Use of the shaft in a fountain house within the claustral area or in some other amenity of the cloister might also be considered.

32. In addition to the standard guides (W. Bulst, in *Lexikon der christlichen Ikono-*

graphie, volume IV, E. Kirschbaum, ed. [Rome, 1972]: 30–38; K. Künstle, *Ikonographie der christlichen Kunst*, volume I [Freiburg im Breisgau, 1928]: 297; L. Réau, *Iconographie de l'art chrétien*, volume II/1 [Paris, 1956]:236–48), also useful are: Paul Clemen, *Romanische Monumentalmalerei in den Rheinlanden* (Düsseldorf, 1916): 139–55 (for representation of Samson in the mosaics from St. Gereon and the chapter house at Brauweiler, 139–55, 361–64); Josepha Weitzmann-Fiedler, *Romanische gravierte Bronzeschalen* (Berlin, 1981): 54–58 (for the bowls with Samson cycles in Udine, Museo Civico, and in Cologne, Schnütgen Museum, 80).

33. This critical scene may be represented on another sculpture at Savigny, on the side of the large capital with a lion and dragon (Cateland-Devos, "Sculptures," 197, figure 36). Representations of the subject in sculpture come from Avignon, Chartres, Déols, Ghent, Malmesbury, Monreale, Nivelles, Sagra di San Michele, Saint-Benôit-sur-Loire, and others; manuscripts include the *Sacra Parallela*, the Rippoll Bible, and the Byzantine octateuchs; enamels include panels in the British Museum, the Alton Tower Triptych in the Victoria and Albert Museum, and the Stavelot Altar in Brussels, as well as the famous Klosterneuburg example (studies by Dieter Kötzsche and Nigel Morgan in *Rhein und Maas*, volume II [Cologne, 1973]: 191–236, 263–78 are particularly useful; also H. Buschhausen, *Der Verduner Altar* [Vienna, 1980]: plate III). There are also examples in ivory (Vivian Mann, "Romanesque Ivory Tablemen," Ph.D. dissertation, New York University [1977]: no. 129) and mosaic (St. Gereon, Cologne; Clemen, *Romanische Monumentalmalerei*, 142). Ambrose (*Patrologia Latina* [hereinafter *PL*] XVII, 774) and Augustine (*PL* XXXIX, 1642), followed by many later authors, interpret the subject typologically.

34. Kurt Weitzmann, *The Miniatures of the Sacra Parallela, Parisinus graecus 923* (Princeton, 1979): figures 93–102; Sirarpie Der Nersessian, "The Homilies of Gregory Nazianzus," *Dumbarton Oaks Papers* XVI (1962):218, 222, figure 14; Leslie Brubaker, "The Illustrated Copy of the 'Homilies' of Gregory of Nazianzus in Paris (Bibliothèque Nationale, Cod. gr. 510)," Ph.D. dissertation, Johns Hopkins University (1983):505; *idem*, "Politics, Patronage and Art in Ninth-Century Byzantium: The Homilies of Gregory of Nazianzus in Paris," *Dumbarton Oaks Papers* XXXIX (1985):1–13; Vatican, Cod. gr. 747; Vatican, Cod. gr. 746; Mount Athos, Vatopedi, MS 602. For an ivory in Florence, see Mann, "Ivory Tablemen," no. 95. For the tympanum of St. Gertrude, Nivelles, see Lisbeth Tollenaere, *La sculpture sur pierre de l'ancien diocèse de Liège à l'époque romane* (Louvain, 1957):plate XVII. For the "ambo" relief at Sta. Restituta in Naples, see Émile Bertaux, *L'Art dans l'Italie méridionale* (Paris, 1903):775–78, plate XXXIV; the Samson series of this relief is being studied anew by Dorothy F. Glass in her forthcoming book, *Romanesque Sculpture in Campania*. Numerous capital sculptures include Monreale: see Roberto Salvini, *Il chiostro di Monreale* (Palermo, 1962):N21; Carl Sheppard, "Iconography of the Cloister at Monreale," *The Art Bulletin* XXXI (1949):159–69.

35. Ferdinand Werner, *Aulnay de Saintonge* (Worms, 1979):figure 287; Marie-Thérèse Brincard, *L'Église de Cunault: Ses chapiteaux de XIIe siècle* (Paris, 1937): plates LII, LXII; Whitney Stoddard, *The Facade of Saint-Gilles-du-Gard* (Middletown, 1973):figure 407; Cahn and Seidel, *Romanesque Sculpture*, 160–62. For an example engraved on a bronze lamp at Erfurt, see Hans Meyer, *Eine Sabbatampel im Erfurter Dom*, Studien zur Kunstgeschichte 16 (Hildesheim, 1982):figure 18; I owe this reference to the kindness of Vivian Mann.

36. Géza Entz, "L'Architecture et la sculpture hongroises à l'époque romane dans leurs rapports avec l'Europe," *Cahiers de civilisation médiévale* IX (1966):10, figures

11–12; Melinda Tóth, "La cathédrale de Pécs au XIIe siècle," *Acta Historiae Artium* XXIV (1978): 55; Bertaux, *L'Art dans l'Italie*, 777, plate XXXIV; Denis Grivot and George Zarnecki, *Gislebertus, Sculptor of Autun* (London, 1961):plates 22 a–b. An ivory gamepiece recently acquired by the Metropolitan Museum of Art in New York also appears to depict the subject; Charles T. Little, "Medieval Art and the Cloisters," *Recent Acquisitions, A Selection, 1988–1989, The Metropolitan Museum of Art Bulletin* XLVII/2 (1989), 15.

37. Johnstone, *Rediscoveries*, 9.

38. There is also a later example in Maienfeld; Alexander Scheiber, "Samson Uprooting a Tree," *Jewish Quarterly Review*, N.S. L (1959):176–80; *idem,* "Further Parallels to the Figure of the Tree-Uprooter," *Jewish Quarterly Review*, N.S. LII (1961): 35–40; J. Makkay, "Remarks on the Iconography of 'Samson Uprooting a Tree,'" *Archaeologiai értésitö* XCI (1964):215–17; E. Tompos, "Samson Uprooting a Tree," *Archaeologiai értésitö* XC (1963): 113–18; R. Will, "Recherches iconographiques sur la sculpture romane en Alsace: Sculptures illustrant des épisodes de la légende de Samson," *Cahiers techniques de l'art* I (1947): 46, figure 13.

39. Meyer, "Eine Sabbatampel," figure 15; see note 35 above.

40. Arthur Giry, *Récueil des facsimilés à l'usage de l'école de Chartes* (Paris, 1880): no. 159, for the tenth-century poet; M. Manitius, "Die Messias des sogenannten Eupolemius," *Romanische Forschungen* VI (1891): 542; Weitzmann-Fiedler, "Romanische Bronzeschalen mit mythologische Darstellungen: Ihre Beziehungen zur Mittelalterlichen Schulliteratur und ihre Zweckbestimmung," *Zeitschrift für Kunstwissenschaft* X (1956):109–52. For Theodulus, see notes 42–43 below. See also Abelard's poem, *PL* CLXXVIII, 103.

41. Arthur Henkel and Albrecht Schöne, *Emblemata: Handbuch zur Sinnbildkunst des XVI. und XVII. Jahrhunderts* (Stuttgart, 1967):1849; Th. A.G. Wilberg Vignau-Schuurman, *Die emblematischen Elemente im Werke Joris Hoefnagels* (Leiden, 1969): 71–72. For a discussion of the moralized Ovid in relation to Romanesque sculpture, see Ilene H. Forsyth, "The Ganymede Capital at Vézelay," *Essays in Honor of Sumner McKnight Crosby, Gesta* IV (1976):241–246.

42. Joannes Osternacher, *Theoduli ecolgam*, Fünfter Jahresbericht des bischöflichen Privat-Gymnasiums am Kollegium Petrinum in Urfahr (Urfahr-Linz, 1902):41–42; August Beck, *Theoduli eclogam* (Sangerhausen, 1836):38–39; and *Theodulus cum commento* (London, 1505):16ff.

43. For Bernard of Utrecht's commentary, see Joseph Frey, "Über das mittelalterliche Gedicht 'Theoduli ecloga' und den Kommentar des Bernhardus Ultraiectensis," *Jahresbericht über das Königliche Paulinische Gymnasium zu Münster* XLVIII (1904):2–19; Osternacher, *Theoduli eclogam*, 13–23; G. L. Hamilton, "Theodulus, A Medieval Textbook," *Modern Philology* VII (1909–10):169–73. For the association of Hercules and Samson, see Augustine, *City of God*, 18.19; Eusebius, *Chronicorum Canonum Libri Duo*, volume II, A. Schöne, ed. (Berlin, 1866):54; Philastrius, *Liber de Haeresibus* 8 (*PL* XII, 1122); Otto, Bishop of Freising, *The Two Cities: A Chronicle of Universal History to the Year 1146 A.D.*, C. Mierow, tr. (New York, 1966):144–45; Frey, *op. cit.* 18; F. Michael Krouse, *Milton's Samson and the Christian Tradition* (Princeton, 1949):44–45. For the moralizing of Hercules, see Boethius, *Consolation of Philosophy* IV, vii; Fulgentius, *Mythologiae*, I.2, *Mythographiae*, II, 1 (H. Liebeschütz, *Fulgentius Metaforalis, Ein Beitrag zur antiken Mythologie im Mittelalter* [Leipzig-Berlin, 1926]); Isidore, *Etymologiae*, 3.71, 27; J. Fontaine, *Isidore de Seville et la culture classique dans l'Espagne wisigothique* (Paris, 1959):534, 694. See also

G. Karl Galinsky, *The Herakles Theme* (1972):190–91. For an example of the Greek-Hebrew debate, see Gary Cohen, "Samson and Hercules," *Evangelical Quarterly* XLII (1970):131–41.

44. Vivian Mann, "Samson Vs. Hercules: A Carved Cycle of the Twelfth Century," *The High Middle Ages*, ACTA VII (1980):1–38, especially figures 9 (the Destruction of the Temple, Luton Hoo, Wernher Collection, no. 278) and 12 (the nude boy Hercules strangling serpents, British Museum, no. 1291, 6.4.1); Mann, "Ivory Tablemen," nos. 101, 102 (see note 33 above). Adolph Goldschmidt, *Die Elfenbeinskulpturen aus der romanischen Zeit, XI.–XIII. Jahrhundert* III (Berlin, 1923): no. 179; Weitzmann-Fiedler, *Bronzeschalen*, 54 (for the Samson cycles, 54–58, plates 48–54, figures 20 a–f, 21 a–h, nos. 20–21); *idem*, "Romanische Bronzeschalen mit mythologischen Darstellungen," 115–23, for the Hercules cycle on the British Museum bowl.

45. As in Nicolo Pisano's nude *Fortitudo* in the guise of Hercules, about 1260; see Erwin Panofsky, *Studies in Iconology*, revised edition (New York, 1962):156–57.

46. Horst Janson, *Apes and Ape Lore in the Middle Ages and the Renaissance*, Studies of the Warburg Institute 20 (London, 1952).

47. B. N. Cod. gr. 510, fol. 347v; see note 34 above. Other prominent ninth- to twelfth-century examples of Samson's death scene include the following: *manuscripts* —*Sacra Parallela*, B. N. Cod. gr. 923, fol. 161v (Weitzmann, *Miniatures*, figure 102); Psalter of Saint-Bertin, Boulogne-sur-Mer, Bibl. Mun. MS 20, fol. 63v (K. Galbraith, "The Iconography of the Biblical Scenes at Malmesbury Abbey," *Journal of the British Archaeological Association* XXVIII [1965]: plate XXIII.1); Ripoll Bible, Vat. Cod. Lat. 5729, fol. 82v; *octateuchs*—Vat. Cod. gr. 747, fol. 251r; Vat. Cod. gr. 746, fol. 495r; *mosaic pavement*—Cologne, St. Gereon (Clemen, *Romanische Monumentalmalerei*, figure 109); *sculpture*—Autun, Saint-Lazare, nave capital (Zarnecki, *Gislebertus*, plates, 22a–22b); Avignon, capital from Notre-Dame-des-Doms, Cambridge, Fogg Museum of Art (Cahn and Seidel, *Romanesque Sculpture*, 160–62); Déols, capital now in Châteauroux, Museum (M. de Salies, "Rapports sur l'excursion faite à Déols," *Congrès archéologique, XL, Châteauroux, 1873* [Tours, 1874]:394–95; Patricia Duret, *La Sculpture romane de l'abbaye de Déols* [Issoudun, 1987]:190–92; Gerona, cloister capital (J. Puig y Cadafalch et al., *Arquitectura Romànica a Catalunya* [Barcelona, 1918]:III, figure 276); Lund, Cathedral, crypt (noted by Réau, *Iconographie*)—probably does not specifically represent Samson (Richard Hamann-MacLean, "Kunstlerlaunen im Mittelalter," *Funktion und Gestalt: Skulptur des Mittelalters* [Weimar, 1987]:435–37); Malmesbury Abbey, south porch, voussoirs (Galbraith, "Iconography," plate XIX.5); Monreale, cloister (Salvini, *Il chiostro*, N21); Murbach, exterior (Will, "Recherches iconographiques," 46, figure 13); Naples, Sta. Restituta (Bertaux, *L'Art dans l'Italie*, 777, plate XXXIV); Nivelles, St. Gertrude, column-statue of the portal (Tollenaere, *Sculptures*, plate XXVB); Pécs, relief from the Cathedral crypt, now in Budapest Museum (Tóth, "La Cathédrale," figure 12); Sagra di San Michele, Zodiac portal (C. Verzár, *Die romanischen Skulpturen der Abtei Sagra di San Michele: Studien zu Meister Nicolaus und zur 'Scuola di Piacenza,'* Basler Studien zur Kunstgeschichte, n.f., X [Berne, 1968]:figure 25); *metalwork*—Aachen, Ludwig Collection, enamel panel from a Mosan cross (Cologne, Kunsthalle, *Weltkunst aus Privatbesitz*, A. von Euw, ed. (1968):D. 28; *Rhein und Maas* II, 208); Erfurt, lamp (Meyer, *Ein Sabbatampel*, 69, figure 19); Munich, coin (Weitzmann-Fiedler, *Bronzeschalen*, 58, text figure 6); *ivory*—Luton Hoo, Wernher Collection (no. 278, Mann, "Ivory Tablemen," no. 101). Of this group of examples, those from Autun, Monreale, Nivelles, Pécs, and the ivory gamepiece clearly represent the temple with only a single column, which Samson grasps

firmly, pulling it toward his chest (a later example from around 1200 can be seen in the Leiden Psalter, H. Omont, *Miniatures du psautier de S. Louis* [Univ. Bibl. MS Lat 76A, fol. 14v] [Leiden, 1902]:plate VIII; see also, in relation to mid-thirteenth-century examples, H. Stahl, "The Iconographic Sources of the Old Testament Miniatures, Pierpont Morgan Library, M. 638," Ph.D. dissertation, New York University [1974]:205–6); in the more usual iconography the temple has at least two columns, toward which Samson extends his arms as described in the Judges text. Our Savigny example and the depictions of the theme from Avignon and from Saint-Bertin are more ambiguous; two columns are indicated but Samson struggles primarily with one of them, thrusting his leg about it (at Sagra di San Michele, Samson also pulls at one of the columns but the action is shown from the side; the Naples relief is unclear regarding this point— at Erfurt, according to Meyer, the single column pulled down by Samson is a window mullion [Meyer, *loc. cit;* see the discussion regarding a possible window location for the Savigny Samson, note 30 above]). To my knowledge, the Savigny sculpture is unique in showing only a portion of the body of Samson.

48. Cahn and Seidel, *Romanesque Sculpture,* 160–62; Zarnecki, *Giselbertus,* plates 22 a–b.

49. Augustine, Sermon 364, *PL* XXXIV, 1642; perhaps a conflation by Caesarius of Arles of several of Augustine's works (*Selected Sermons of St. Augustine,* Q. Howe, Jr., tr. and ed. [New York, 1966]:118–24, no. 17); see also *PL* XLVI, 820 and XXXVII, 1126; Ambrose, *PL* XVII, 774; Isidore, *PL* LXXXIII, 389.

50. Gregory, *PL* LXXV, 710–11, 787, 1024–25; *PL* LXXVI, 491; John of Damascus, *PG* XCV, 1435–36.

51. Gottfried of Admont, *PL* CLXXIV, 275–88; Rupert of Deutz, *PL* CLXVII, 1041–55; Hugh of Saint-Victor, *PL* CLXXV, 263, 680 (for the latter passage, the attribution may more correctly be to a contemporary of Hugh); Hervaeus of Déols, *PL* CLXXXI, 1658; Thomas the Cistercian, *PL* CCVI, 59–60; Peter Comestor, *PL* CXCVIII, 1285–90; Alan of Lille, *PL* CCX, 210–12, 344. See also the references by Peter the Venerable (Giles Constable, *The Letters of Peter the Venerable* [Cambridge, 1967]:I, 34) and by Julian of Vézelay (*Sermons,* D. Vorreux, tr. [Paris, 1972]:638–41, no. 27).

52. For the debate regarding the roles of Walafrid Strabo and Anselm of Laon in the authorship of the *Glossa,* see Beryl Smalley, *The Study of the Bible in the Middle Ages* (Notre Dame, 1964):56–57; Rabanus Maurus, *PL* CVIII, 531, 1194, 1198; Peter Damian, *PL* CXLV, 1089–90. Note that Hervaeus of Déols is said to have committed texts of the fathers, including Augustine and Gregory, to memory (L. Deslise, *Rouleaux des morts du Xe au XVe siècle recueillis et publiés par la Société de l'Histoire de France* [Paris, 1866]:356, studied recently by M. Kupfer in "The Romanesque Frescoes in the Church of Saint-Martin at Nohant-Vicq," Ph.D. dissertation, Yale [1982]:250).

53. Hervaeus of Déols, *PL* CLXXXI, 1658; Hugh of Saint-Victor, *PL* CLXXV, 263; Peter Lombard, *PL* CXCII, 497. See the overview of this question in Krouse, *Milton's Samson,* 48–49.

54. *PL* CLXVII, 1041–55, especially 1053–55.

55. M.R. James, "Pictor in Carmine," *Archaeologia or Miscellaneous Tracts Relating to Antiquity,* Society of Antiquaries, London, XCIV (1951): 141–42, 161–62.

56. John of Damascus, *De oratione, PG* XCV, 1435–36; Hervaeus of Déols, *Comment. in Epistolas Pauli. In Epist. Ad Herb., PL* CLXXXI, 1658.

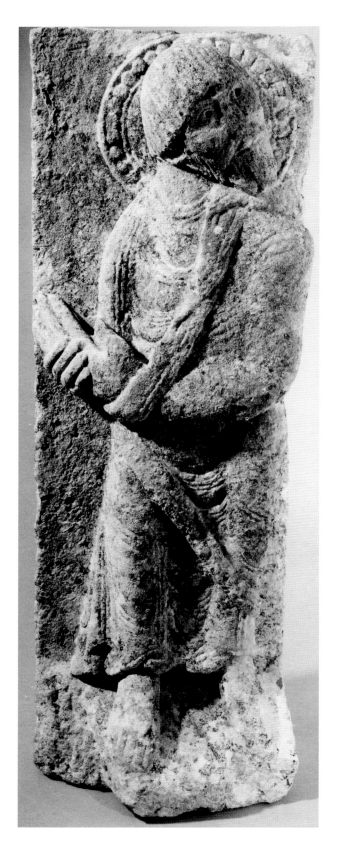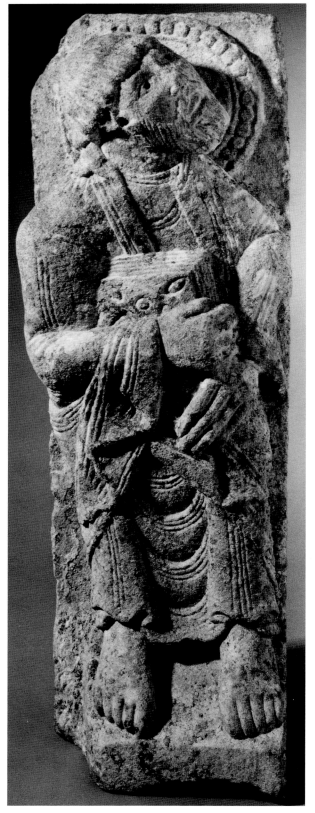

Search For a Provenance:
The Duke University Apostles

Jean M. French

Outstanding among the objects in the Brummer Collection of medieval art are four French apostle reliefs whose provenance, until recently, was relatively unknown. Carved in limestone, each on a separate block, the figures are of exceptional quality. Two of the apostles are standing: one clutches his hands in wonderment (figure 3.1), the other hugs a book (figure 3.2). Both gaze upward as though witnessing a celestial vision. The other two apostles, of somewhat heftier proportions, are seated. One, judging from the direction of his rapt expression, was located to the right of the standing apostles (figure 3.3), while the fourth apostle, holding a scroll in his right hand, turns to a companion and eloquently points above his shoulder (figure 3.4). The poses and gestures of all four apostles convey a sense of interaction, excitement and awe.

The original format of the composition would have probably included an upper zone depicting the Christ of the Ascension flanked by two dynamic angels forming a dramatic link between the upper and lower zones. Similar arrangements are popular on the tympana of Romanesque churches in south central France (Mauriac, Collonges, Saint-Chamant, and Cahors) or adorning the facades of monuments further to the west (Angoulême, Ruffec, and Pérignac).

Despite the obvious compositional association with extant French monuments, the Duke University apostles form a unique group. They share certain formal and stylistic features: the rectangular block of approximately the same size (ranging from 33¼ to 35⅛ inches in height and 11½ to 11¾ inches in width); the inclined ledge; the large figures (of the same degree of projection) barely contained within the confines of the block; haloes with pearled borders; incised eyes; and the double and triple-ridged systems of drapery patterns. Particularly distinctive are those family characteristics which appear at the same time both naive and expressive: the squat torsos; the twist of the upper bodies with one shoulder in relief and the other deeply undercut and free of the block; the upturned heads and thick necks; the sometimes ungainly poses (for example, the slight suggestion of contrapposto in the standing figure clutching his hands [figure 3.1], and the inordinate length of the lower crossed leg of the pointing seated figure). They also share the same simplicity of chiselled hairstyles ("rag doll," in the case of the standing figures; on the seated figures, drawn back from the forehead in parallel strands), as well as trim beards which follow the contours of their broad faces, their high cheekbones, and

◄Figure 3.1
Apostle (1966.148) (left)
H: 87.7 (34 ½")
W: 29.8 (11 ¾")
D: 21.5 (8 ½")

◄Figure 3.2
Apostle (1966.150) (right)
H: 85.8 (33 ⅝")
W: 29.5 (11 ⅝")
D: 16.5 (9 ¼")

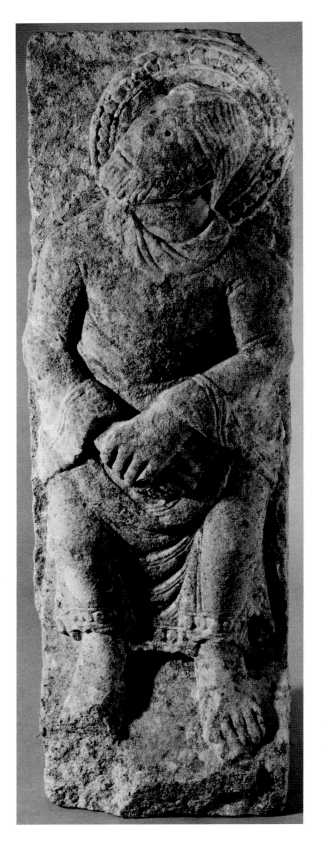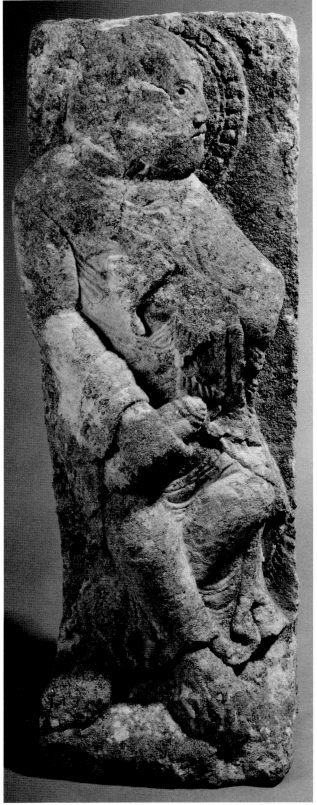

the peculiar raised juncture of their foreheads and noses. Equally telling are their large hands and feet and expressively elongated fingers. Aspects of the styles of the Rouergue, Limousin, Quercy, and even western France have been variously cited,[1] but the stocky proportions of the Duke apostles, as well as their awkwardly endearing poses and gestures, have eluded classification within any particular school.

Although the reliefs have been in the United States since 1929,[2] it is only within the last two decades, after Duke's 1966 acquisition of a large part of the Ernest Brummer collection, that they have begun to receive significant attention. In 1967 they were exhibited along with other selected works from the Brummer Collection at the North Carolina Museum of Art in Raleigh;[3] in 1969 they were included in a major exhibition of sculpture in American collections, "The Renaissance of the Twelfth Century," held at the Museum of Art of the Rhode Island School of Design.[4]

In his catalogue entries for the two exhibitions, Robert C. Moeller III, then associated with Duke University, revealed an important discovery—the identification of five more reliefs housed in three other American collections as part of the same original sculptural ensemble as the Duke University apostles.[5] An engaging St. Peter (figure 3.5), his right hand raised toward the viewer and his left grasping a large key, was purchased from Joseph Brummer in 1937 by the Smith College Museum of Art. Two apostles had been purchased in 1941 by the Museum of Art at the Rhode Island School of Design (figures 3.6 and 3.7), and a dynamic angel similar to those found at Saint-Chamant and Collonges (Corrèze) was acquired in 1943 by the Memorial Art Gallery at the University of Rochester (figure 3.8).[6] An eighth apostle, also at Rochester, came from the Brummer estate sale in 1949 (figure 3.9). At the time of each sale, no mention seems to have been made of the existence of other reliefs from the same group.[7]

Until the "Renaissance of the Twelfth Century" exhibition, the reliefs had been viewed in relative isolation. Relegated to their separate museums, they constituted representative examples of early twelfth-century French sculpture, but all sense of their history and context had been lost. In 1969 the Duke, Rhode Island, and Smith apostles were exhibited together for the first time along with photo-murals of the Rochester reliefs. As a group, they constitute the largest ensemble of Romanesque figural sculpture in this country.

The reliefs show the effects of time and the elements in varying de-

◄Figure 3.3
Apostle (1966.147)
H: 89.3 (35 ⅛")
W: 29.2 (11 ½")
D: 17.8 (7")

◄Figure 3.4
Apostle (1966.149)
H: 84.5 (33 ¼")
W: 29.8 (11 ¾")
D: 19 (7 ½")

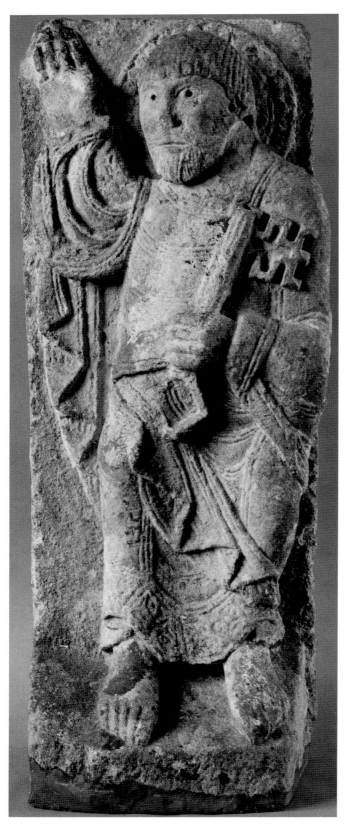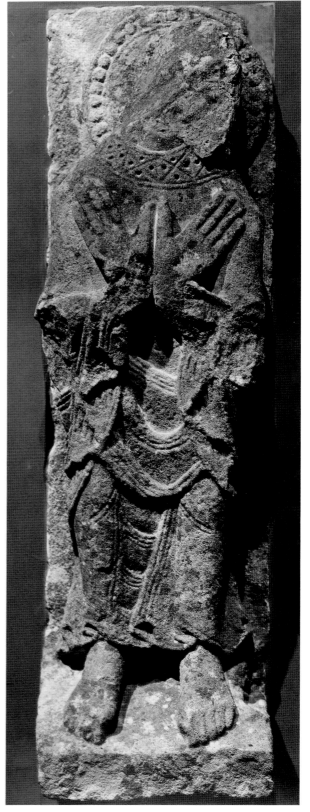

grees. Although patches of burnt sienna and flakes of other pigments are still visible on several of the reliefs, most of the original paint has worn away.[8] Three of the heads have suffered severe damage, one of the RISD blocks has a horizontal break across the lower figure, and some of the reliefs have undergone minor retouching and infilling. In all other respects, however, the reliefs are remarkably well preserved and have lost none of the energy of their original conception.

Other than cards in the Brummer files indicating that Joseph Brummer had purchased the reliefs from the dealer Altounian in Mâcon (Burgundy) in late 1928 and cryptic references to the department of Tarn-et-Garonne, nothing was known of the origin of this important group. Robert Moeller attempted to localize the reliefs; on the basis of certain stylistic similarities with capitals of the church of Saint-Martin in Brive (Corrèze), he attributed the reliefs to a portal of the church of Saint-Martin, or, alternatively, to that of a nearby church.[9]

Moeller's identification of the nine reliefs as part of the same program was not wholly accepted. Certain stylistic discrepancies within the group and the variations in clarity and surface detail produced by weathering as well as a lack of further corroborative evidence prompted questions concerning the composition of the group.[10]

In addition, Moeller's admittedly tentative attribution of the reliefs to the church of Saint-Martin in Brive appeared untenable. Beautiful but little-known fragments from a monumental "Descent into Limbo" discovered in 1878 during the demolition of the masonry of the western porch at Saint-Martin and now in the Musée Rupin in Brive show little stylistic affinity with the group in the United States.[11] More important, the stone of the Brive portal fragments, as well as that of the Saint-Martin capitals, is distinctly different in composition from that of the American reliefs. Furthermore, the stone of the latter reliefs is inconsistent with any stone to be found in the immediate environs of Brive.[12]

The objections outlined above raised two basic questions which form the basis of the present study: Do all nine reliefs in the American collections indeed form a single homogeneous group? What was the original location in France of this monumental complex? Since more traditional art historical methods seemed unable to resolve these questions at this point, analysis of the stone of the reliefs appeared to be a promising area of investigation.

The stone of the American reliefs is rather distinctive. It is a "sandy"

◄Figure 3.5
Saint Peter, Smith College Museum of Art, Northampton, Massachusetts (1937:12–1)

◄Figure 3.6
Apostle, Museum of Art, Rhode Island School of Design, Providence (41.045)

61 The Duke University Apostles

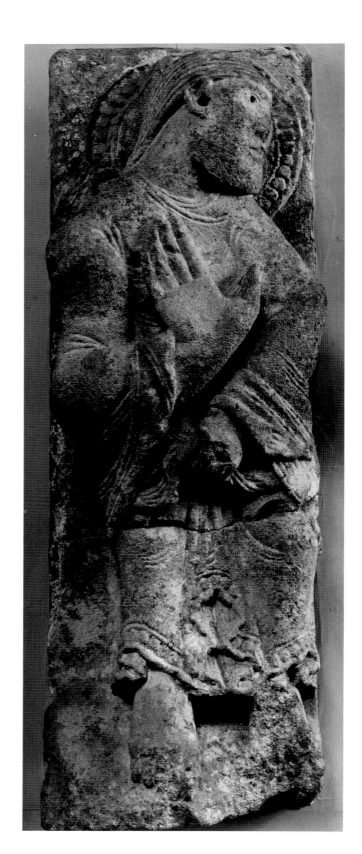

Figure 3.7
Apostle, Museum of Art,
Rhode Island School of
Design, Providence (41.046)

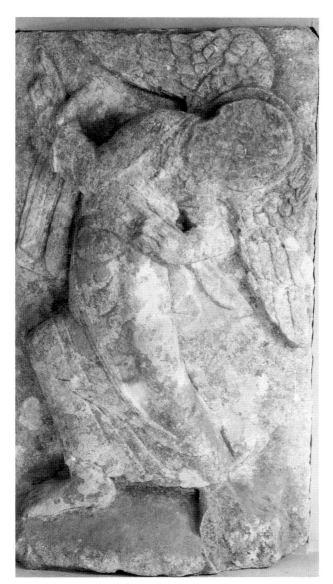

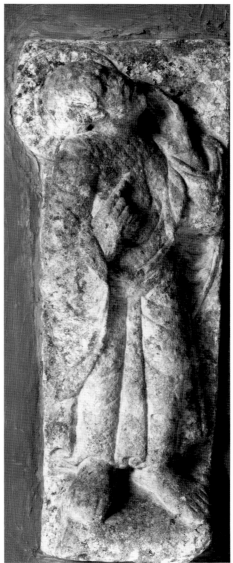

limestone of a golden color that weathers grey and contains a high percentage of quartz. The quality of the limestone, however, is not comparable to the fine-grained stone of some of the famous portals of, for example, Quercy, and it is not of a quality to warrant transportation any real distance. Given these limitations, a local origin for the stone could be presumed.[13]

One of the more promising scientific methods employed in recent years in the study of art objects and artifacts is that of neutron activation analysis or, more specifically, trace element analysis. In 1977 a pilot study by P. Meyers and L. van Zelst, based in part on a group of Spanish Romanesque and Gothic limestone objects in the Metropoli-

Figure 3.8
Angel, Memorial Art Gallery, University of Rochester, Rochester, New York (43.35)

Figure 3.9
Apostle, Memorial Art Gallery, University of Rochester, Rochester, New York (49.6)

tan Museum of Art in New York, had indicated that characterization of limestone by trace elements could be of use in determining provenance.[14]

In collaboration with Lambertus van Zelst and Edward V. Sayre of the Research Laboratory of the Museum of Fine Arts in Boston and Brookhaven National Laboratory, respectively, it was decided that neutron activation analysis of samples from the American reliefs, in conjunction with analysis of comparative samples from French quarries, might provide invaluable evidence in determining the character of the group and in attempting to localize the origin of the monument. As an additional measure, Judith Rehmer Hepburn of Waban Geoscience Associates was asked to conduct a petrographic study of the samples.

In the first stage of analysis, one of the Providence reliefs (RISD 41.045) was sent to the Research Laboratory of the Museum of Fine Arts in Boston. Powder samples of various sizes were taken from the back of the relief at three different locations to establish the relative homogeneity of elemental compositions within one block—in other words, to determine whether a single sample taken from each of the other blocks would be representative of the entire object.

Subsequent analysis of samples from the lower back of all nine blocks demonstrated that the concentrations in the reliefs are remarkably similar.[15] These findings were complemented and corroborated by petrographic analysis which revealed that thin sections of all nine reliefs were consistent in texture and mineralogy.[16] In summary, both neutron activation analysis of the trace element compositions of the reliefs and petrographic study of their thin sections demonstrated that they form a tightly knit group. These results reinforce Robert Moeller's assertion that the reliefs once belonged to the same monumental complex.

The second stage of this investigation—determining the quarry area in France and hence the probable site of the original sculptural complex—presented more difficulties. The style and format of the apostle reliefs, as indicated earlier, suggested the south central or western areas of France; the reliefs, however, had been purchased by Brummer in Burgundy. Thus no potential site was ruled out in advance. Careful examination of detailed geological maps of France, quarry inventories, and samples and thin sections from French monuments in the collection of the Centre de Recherches sur les Monuments Histo-

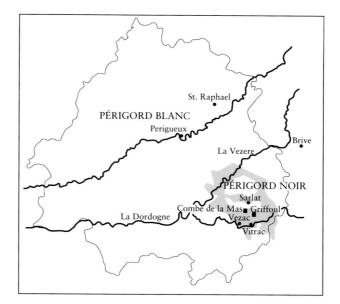

St. Raphael

PÉRIGORD BLANC

Perigueux

Brive

La Vezere

PÉRIGORD NOIR

Sarlat

Combe de la Mas Griffoul

La Dordogne

Vezac

Vitrac

Figure 3.10
Map of the Périgord region,
France; the shaded area
delineates the limestone
formation discussed in
the text.

riques, followed by consultation with French sedimentary geologists
and by examination of both active and abandoned quarries, eventually
narrowed the search to the present-day department of the Dordogne
(roughly the area of old Périgord).

The third largest department in France, the Dordogne (figure 3.10)
lies between the Massif Central to the east and the lowlands of the
Aquitaine Basin to the west. The vast central plateaus are made up for
the most part of Cretaceous limestones. The northern section of this
central region, Périgord Blanc, takes its name from the frequent out-
crops of chalky limestone reflected in the churches of its major city,
Périgueux; Périgord Noir, to the southeast, is a region well known
for its numerous rock shelters dating from Paleolithic times. In this
region, bounded by the Vézère and Dordogne rivers, the limestone
takes on a yellowish or golden cast. It is here that stone most closely
resembling that of the American reliefs is found.

This latter area, Périgord Noir, with extensions to the west, south-
east, and south, became the focus of the first survey. The purpose of the
survey was to characterize and analyze the general source area and to
attempt to further localize the stone. Samples were taken from aban-
doned and modern quarries at various locations within the region.
Analysis of these samples showed a particular limestone formation in
the region of the city of Sarlat to be most compatible with the stone
of the reliefs (figure 3.11).[17]

The objectives of the next survey were threefold: to confirm these
findings by taking other samples from the Sarlat area; to define the
limits of this particular formation; and, most important, to attempt
further to localize the source or quarry within the formation.

65 The Duke University Apostles

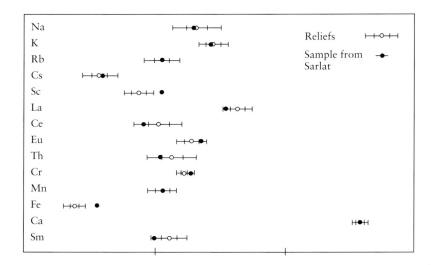

With the aid of geologists from the Université de Bordeaux and the Bureau de Recherches Géologiques et Minières, the limits of the particular formation under investigation were defined. (The formation, representing an area approximately 30 by 36 kilometers, is shaded in grey in figure 3.10.) During the following months this formation was sampled at numerous sites and at different levels of deposition, and comparative samples were taken from beyond the formation.[18] A crate of more than one hundred samples was shipped to the United States for neutron activation and petrographic analysis.

Results of subsequent trace element analysis were presented at the Fifth International Seminar on Application of Science in Examination of Works of Art at the Museum of Fine Arts in Boston in 1983 and have been published in the Proceedings. The findings relevant to the present discussion can be summarized as follows:

First, trace element analysis showed the elemental compositions to be characteristic of this particular formation; in other words, there is a consistency within the formation. Secondly, samples from outside the formation either fell out immediately on the excessively high or low absolute values of their trace element concentrations or were shown by means of multivariate statistical techniques to fit none of the quarry groups and none of the groups formed by combinations of quarry samples. (Included among the "outsiders" were samples from the Brive basin, mentioned above in connection with the sculpture of the church of Saint-Martin, as well as samples from a capital and torso in the Williams College collection from the church of Saint-Raphael near Excideuil, also in the Dordogne.)[19]

Figure 3.11
Means with one and two standard deviation limits for the group of nine reliefs, compared to a sample near Sarlat.

Finally, and crucial to this study, the chemical evidence indicated that the stone of the nine reliefs does originate from the Sarlat formation; in addition, certain samples within the formation were found to be more compatible with the core group of reliefs than others. Nonetheless, the exact location within the formation was not determinable at this point by neutron activation analysis.

On the other hand, when petrographic analysis was brought into the picture, a further refinement seemed possible. When thin sections of all samples from the formation were examined, once again a consistency was found within the formation. However, in close comparison with thin sections from the reliefs, a number of samples could be ruled out, while others were found to be "moderately close" and "close" to the reliefs. Only samples from the abandoned quarries of Combe de la Mas and Griffoul, both to the south of Sarlat, were found to be "virtually identical" with the reliefs.

Since the remains of these two quarries are approximately two kilometers apart, it can be assumed that this particular stone was once quarried extensively in the immediate area. It can be best studied today at Combe de la Mas where the building stone for a small twelfth-century church was quarried on the site;[20] unquarried limestone on the same site was even utilized to form part of the foundation wall of the church. Thin sections taken from the base rock of this church, from a capital flanking one of its former portals (figure 3.12), from one of the Combe de la Mas galleries, as well as from the oldest section of the Griffoul quarry, were found to be "virtually indistinguishable" from thin sections of the American reliefs. Since the chemical composition of both quarries had been shown to be consistent with that of the reliefs, it could be concluded that the source rock of the Duke University apostles and the five related reliefs in other American collections had been localized to a particular formation in the southeastern section of the Dordogne—and within that formation to the region immediately south of Sarlat: the Sarlat-Vezac-Vitrac triangle (figure 3.10).

The final stage of this study, which is still in progress, signalled a return to the traditional approaches of the art historian coupled with some of the methods of the amateur detective. Its prime objectives included further corroboration of the designated source area, identification of the original monument and reconstruction of the composition, and formal and stylistic comparison with related monuments.

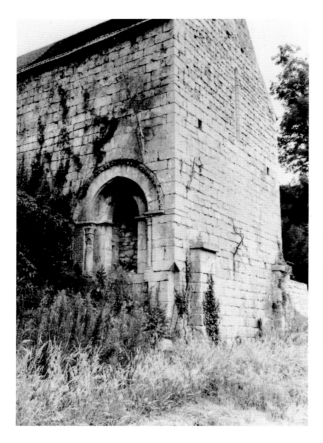

The first objective has been realized. Seeming validation of the source area came first with the chance discovery of information regarding a large group of apostle reliefs (presumably from a local church) once located in the immediate vicinity of the Combe de la Mas and Griffoul quarries. For many years they had been in the collection of a local family, and they had been used at one time to decorate a small nineteenth-century chapel in the garden of the family chateau. Two of the reliefs—a St. Peter and another apostle—had been mounted on either side of the portal; the others rested on bases along the side of the chapel. This mysterious group, bought by a French dealer and thought to have been destined for the United States, had disappeared in the early part of this century; no further information was available. However, various clues, including the approximate date of the sale, the measurements of the mountings on the facade (figure 3.13), and the measurements of traces from the reliefs along the side wall of the chapel, suggested that this group of reliefs was the same as the subject of this study.[21]

During the summer of 1986 this hypothesis was confirmed. Old photographs found in the family archives show the same nine reliefs

Figure 3.12
Twelfth-century church situated near the Combe de la Mas quarry

Figure 3.13
Mounting holes in the facade of a chapel from the region of Sarlat

in the entrance hall of the chateau prior to their sale. The first photograph (figure 3.14) shows one of the standing Duke apostles holding his book and gazing upwards; to the right is the Smith St. Peter, one hand raised, the other clasping his key. Another photograph (figure 3.15) represents the Rochester apostle, also looking up and pointing to the vision; next to him is one of the seated Duke apostles. The last photograph (figure 3.16) shows the remaining five reliefs: another Duke apostle; one of the RISD apostles, hands spread in ecstasy; in the center, the Rochester angel, pointing to the Christ of the Ascension; the fourth Duke apostle, excitedly conversing with a neighbor; and the last Providence apostle, his huge hand raised, the break in the block visible across the figure.

In conclusion, the combination of neutron activation analysis, petrographic analysis, and art historical methodology has posited the existence in the early twelfth century in the immediate region of Sarlat of a major sculptural ensemble with important stylistic, iconographic,

Figure 3.14
The Apostles: Duke University (1966.150) and Smith College (1937:12-1)

Figure 3.15
The Apostles: University of Rochester (49.6) and Duke University (1966.147)

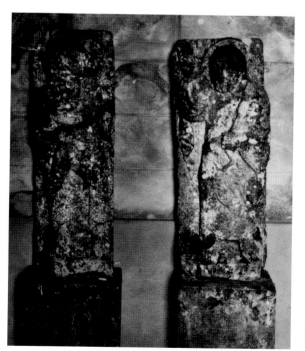 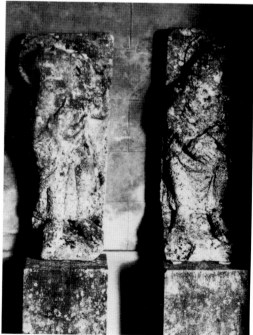

and formal links to extant monuments in south-central and western France. Previous art historical literature, including Jean Secret's careful study of the sculpture and architecture of Périgord,[22] had asserted that the Dordogne, or old Périgord, had little large-scale figural sculpture during the Romanesque period. These reliefs—eight apostles and an angel—along with other sculptural programs in the region currently under study, indicate that the art of monumental sculpture did indeed flourish in Périgord and suggest that the time has come for a reassessment of the role of these monuments in the development and dissemination of Romanesque sculpture in France.

Notes

This study was carried out in collaboration with Edward V. Sayre, Senior Research Chemist at the Conservation Analytical Laboratory of the Smithsonian Institution (formerly Senior Scientist in the Department of Chemistry at Brookhaven National Laboratory, and Director of Research at the Museum of Fine Arts in Boston) and Lambertus van Zelst, Director of the Conservation Analytical Laboratory of the Smithsonian Institution (formerly Director of Research at the Museum of Fine Arts in Boston); they should be considered equally the coauthors of this article.

Results of neutron activation analysis of the relief and quarry samples were initially presented at the Fifth International Seminar on Application of Science in Examination of Works of Art at the Museum of Fine Arts in Boston in September 1983 and

Figure 3.16
The Apostles and Angel: Duke University (1966.148); Rhode Island School of Design (41.045); University of Rochester (43.35); Duke University (1966.149); and Rhode Island School of Design (41.046)

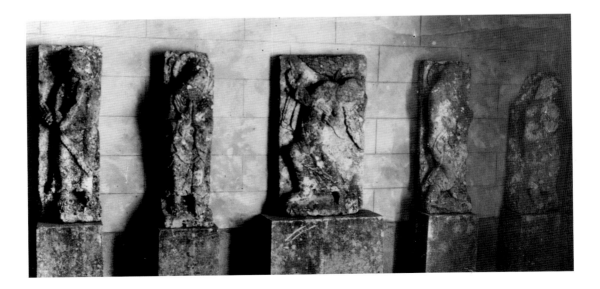

subsequently published in J. M. French, E. V. Sayre, and L. van Zelst, "Nine Medieval French Limestone Reliefs: The Search For a Provenance," *Application of Science in Examination of Works of Art* (Boston, 1985): 132–41. In most instances, the present article summarizes the technical data; repetition occurs where necessary for the clarity of this presentation and for an understanding of the methods employed in localizing this important group of reliefs.

This investigation formed part of collaborative efforts between the Museum of Fine Arts, Boston, and the Department of Chemistry, Brookhaven National Laboratory. Work at the latter institution was conducted under the auspices of the U. S. Department of Energy and supported by its Office of Basic Energy Sciences.

The research for this project was financed in part by grants from the American Philosophical Society, the National Endowment for the Humanities, and the Bard College faculty research fund.

Many people have contributed to the success of this project: Dr. Judith Rehmer Hepburn, who performed the petrographic analyses of the relief and quarry samples; Ms. Elaine Rowland and Dr. Ronald Bishop, who assisted in carrying out the analyses of the limestone; the curators and staffs of the Museum of Art of the Rhode Island School of Design, the Smith College Museum of Art, the Memorial Art Gallery of the University of Rochester, the Duke University Art Museum, and the Williams College Museum of Art; Mrs. Ernest Brummer, who kindly permitted access to the Brummer files; Prof. Whitney S. Stoddard of Williams College; Mme. Annie Blanc of the Centre de Recherches sur les Monuments Historiques; Professors Louis Humbert and Paul Lévêque of the University of Bordeaux; Mr. Jean Pierre Platel of BRGM (SGR Aquitaine); Mr. Fonquernie, architecte en chef des Monuments Historiques; Mr. Jean Beauchamps and Mr. Bernard Lourdon, architectes des Batiments de France de la Dordogne; the late Mr. Roger Delmas, Conservateur du Musée des Pénitents Blancs at Sarlat; Mr. Maurice Gaston for his technical assistance in the preparation of this manuscript; and Mr. Alain Blanchard, without whose help this project would not have been possible.

1. E. H. Payne, "A Romanesque Statue of Saint Peter," *Bulletin of the Smith College Museum of Art* 18–19 (June, 1938): 3–6; R. C. Moeller III, *Sculpture and Decorative Art: A Loan Exhibition of Selected Works from The Brummer Collection at Duke University* (Raleigh, 1967): 8–17, and an essay in *Renaissance of the Twelfth Century*, S. Scher, ed. (Providence, 1969): 50–58; W. Cahn, "Romanesque Sculpture in American Collections," *Gesta* VII (1968): 53–54; *Gesta* VIII (1969): 56; *Gesta* X/1 (1971): 51; *Gesta* XIV/2 (1975): 67–68; L. Pressouyre, "Chronique: sculptures romanes des collections américaines. Providence et Worcester," *Bulletin monumental* CXXVII (1969): 246; *idem*, "La renaissance du XII siècle," *Revue de l'art* VII (1970): 98–99; see also the letters and notes contained in dossiers of the reliefs in the respective museums.

2. Records of purchase in the Brummer files; the reliefs were purchased in late 1928 and arrived in the United States in 1929.

3. Moeller, *Sculpture and Decorative Art*, 8–17.

4. Moeller, in *Renaissance of the Twelfth Century*, 50–58.

5. Ibid.; W. Heckscher and R. C. Moeller III, *Art Journal* XXVII (1967–68): 182–84. See also, at approximately the same time, W. Cahn, "Romanesque Sculpture in American Collections. II. Providence and Worcester," *Gesta* VII (1968): 53–54, and "Romanesque Sculpture in American Collections. III. New England University Museums," *Gesta* VIII (1969): 56.

6. The angels at Saint-Chamant and Collonges are included within a tympanum format. Although the poses are similar to that of the Rochester angel, the conformation of the blocks is not. Despite the inclusion of two heads which complete the composition of the upper tympanum at Saint-Chamant, the blocks of the angels on both monuments are either curved or angled to conform to the shape of the tympanum. The rectangular shape of the Rochester block, as well as the more contained pose of the figure, might appear to argue for a facade format, despite the use of the rectangular block in the tympanum of Cahors. This controversy will be discussed more fully in a forthcoming study. (See Cahn 1968; Pressouyre 1969; Moeller 1969; Pressouyre 1970; Cahn 1971 and 1975.)

7. Museum files (including correspondence with J. Brummer) and interviews with former museum personnel.

8. In her essay in this volume, the conservator Linda S. Roundhill discusses the recent removal of lichen growth as well as plaster and mortar residue from the Duke University reliefs. This procedure, in conjunction with the subsequent cleaning, revealed further vestiges of the original polychromy and details of carving hitherto obscured.

9. Moeller, *Renaissance of the Twelfth Century*, 56–57.

10. These doubts are recorded in letters and notes in museum dossiers and in the papers of Robert C. Moeller III. I wish to thank Robert Moeller for his generosity in making his files available to me and for encouraging me to carry further the study of the American reliefs. Having worked for some time in the Corrèze on another project, during the course of which I had been involved in a comparative study of the Brive fragments and of other sculpture in this region and in the Lot, I was particularly interested in his attribution of the reliefs to Brive.

11. L. Bonnay, "Description des découvertes archéologiques faites a l'église Saint-Martin de Brive," *Bulletin de la Société Scientifique, Historique et Archéologique de la Corrèze* I (1878): 223–38.

12. For discussion of the Brive stone and comparison with that of the U.S. reliefs, see French, Sayre, and van Zelst, "Nine Medieval French Limestone Reliefs."

13. For a more complete petrographic description of the stone of the reliefs, see French, Sayre, and van Zelst, "Nine Medieval French Limestone Reliefs," 133–34; the question of transportation must be taken into consideration in provenance studies of fine-grained limestones.

14. P. Meyers and L. van Zelst, "Neutron Activation Analysis of Limestone Objects: A Pilot Study," *Radiochimica Acta* 24 (1977): 197–204.

15. See French, Sayre, and van Zelst, "Nine Medieval French Limestone Reliefs," 135, for analysis of major, minor, and trace components in the individual reliefs. In fact, the spread in results among the nine separate reliefs is not significantly different from the spread in results among the multiple analyses of the single RISD relief initially tested (table 2). (These and subsequent samples were analyzed by neutron activation analysis at the Department of Chemistry at Brookhaven National Laboratory.)

16. Modal analyses bear out the similarities in a particularly convincing way. Carbonate-quartz ratios vary very little and even the subcategorizations are extraordinarily similar (for example, the dominance of pellets over discrete fossil fragments, the dominance of matrix spar over lime-mud, and the dominance of strained over unstrained and composite quartz).

17. Except for iron and scandium, all of the concentrations for this sample lie within the 95 percent confidence limits for the elements reported for this group of reliefs, and neither iron nor scandium values greatly exceed these limits.

18. Samples were taken from abandoned as well as from active quarries. Fortunately, this area is relatively undeveloped; in more populated areas, the older quarries may be covered by cities and suburbs.

19. See French, Sayre, and van Zelst, "Nine Medieval French Limestone Reliefs," 136–39 and figures 14 (Stone of Grammont for Brive area) and 16; figure 16 illustrates the pronounced difference between the composition of the stone of the two Williams College pieces and that of the apostle and angel reliefs of the Sarlat formation to the southeast.

20. The church, used over the years for diverse purposes, has undergone various modifications.

21. The measurements of the St. Peter in the Smith College Museum of Art correspond to the top and bottom holes to the right of the portal, which held the mountings for the relief.

22. Jean Secret, *Périgord roman* (La Pierre-Qui-Vire, 1967).

The Archivolts from Alife

Dorothy F. Glass

The two archivolts from Alife in the Duke University Museum of Art are superb, if eccentric, examples of Romanesque art from southern Italy (figure 4.1).[1] The smaller archivolt consists of a debased acanthus pattern, while the larger one is decorated with intertwined men and animals.[2] Although the circumstances that led to the rebuilding of the cathedral in which they were once placed are known, their original location, style, and meaning remain a conundrum.

Alife is in the mountainous northern part of Campania, the province south of Rome of which Naples is the capital. During the Roman era Alife was famed for its salubrious waters and fertile land.[3] Indeed, large tracts of Roman walls still remain. On the other hand little is known of Alife in the early Middle Ages; under the Lombards, the city gained some importance as part of the powerful diocese of Benevento, but in 865 it was invaded by the Saracens, who destroyed the cathedral of Santa Maria. Services were held in the small church of Santa Lucia for more than three centuries, until the new Romanesque cathedral was begun by the Norman count Rainulf III.[4]

Today, little of the fabric of Rainulf III's church remains.[5] By 1458 the Romanesque church was virtually in ruins; Bishop Antonio Moretto, who made extensive repairs, was described on his tomb as having "hanc basilicam destructam erexit."[6] The measure of Bishop Moretto's labors cannot be estimated, because in 1688 the building was severely damaged by an earthquake.[7] Except for the crypt, which contains some indifferent capitals, a third archivolt still at Alife, and the archivolts in the Duke University Museum of Art, the cathedral is a product of the eighteenth and nineteenth centuries.

Perhaps because of Alife's prominence in the Norman conquest of south Italy and Sicily, the historical circumstances surrounding the construction of the cathedral at Alife are better known than the remains of the medieval building itself. The Normans were established in Campania in 1031 when Sergius IV, the Duke of Naples, gave them the city of Aversa in thanks for their help in the defense of Naples. They later conquered the neighboring Lombard duchies and eventually also drove the Byzantines from southern Italy. The full extent of Norman domination in the south was acknowledged in 1130 when the antipope, Anacletus II, conceded the crown of Apulia, Calabria, and Sicily to Roger II, who was crowned king in the cathedral of Palermo on Christmas Day, 1130.[8]

The triumph of Roger II is closely related to the story of Alife, for Rainulf III, the new cathedral's patron, was married to Roger II's sister, Matilda. Rainulf III thus travelled in the highest Norman circles.[9] He nonetheless betrayed his oath of fealty to Roger II and found himself deserted by his wife, who demanded the return of her dowry, and besieged by his brother-in-law. Rainulf III demanded the return of both his wife and his properties at Avellino and Mercogliano; the chronicles do not tell us which he considered more important. The struggle continued for a number of years and ended only with Rainulf III's death at Troia on April 30, 1139. These internecine battles for power within the Norman empire in the South are recorded in lavish detail by Falco of Benevento and by Alexander, the abbot of the Benedictine monastery of S. Salvatore near Telese; the latter should be viewed with caution because it was commissioned by none other than Matilda herself.[10]

Abandoned by his wife and pillaged by his brother-in-law, Rainulf III found one of his remaining cities, Alife, beset by plague. He went to Rome in 1132 to ask for the relics of a saint who might protect Alife and serve as a patron for the cathedral. Later accounts relate that at about the time of Rainulf III's visit, a beam collapsed at St. Peter's and damaged an altar, inside of which a container with the relics of Sixtus I (c. 115–35) was found. Given the relics by the antipope Anacletus II, Rainulf III departed for Alife with the relics strapped to the back of a donkey.[11]

The subsequent part of the story is beset by controversy. The relics of Sixtus I are first mentioned in a 1584 source which states that they had been found in 1582 at Alatri—not Alife—during the course of work on the cathedral.[12] This account maintained that just after Rainulf III's entourage passed Anagni, the donkey veered off the road and headed for Alatri instead. The donkey halted on the steps of the cathedral at Alatri and refused to budge; but, taking pity on the suffering of the plague-stricken population of Alife, the bishop of Alatri gave that city one of Sixtus I's thumbs. Because of that donation, the account states, Rainulf III was able to begin the new cathedral at Alife.

Sources from Alife, on the other hand, maintain that although the reliquary was exposed at Alatri in 1582, the bishop of Alatri never took a proper inventory of the relics. Indeed, when the Alifitani opened what they claimed to be their reliquary containing the remains of Sixtus I it was found to contain, among other things, the

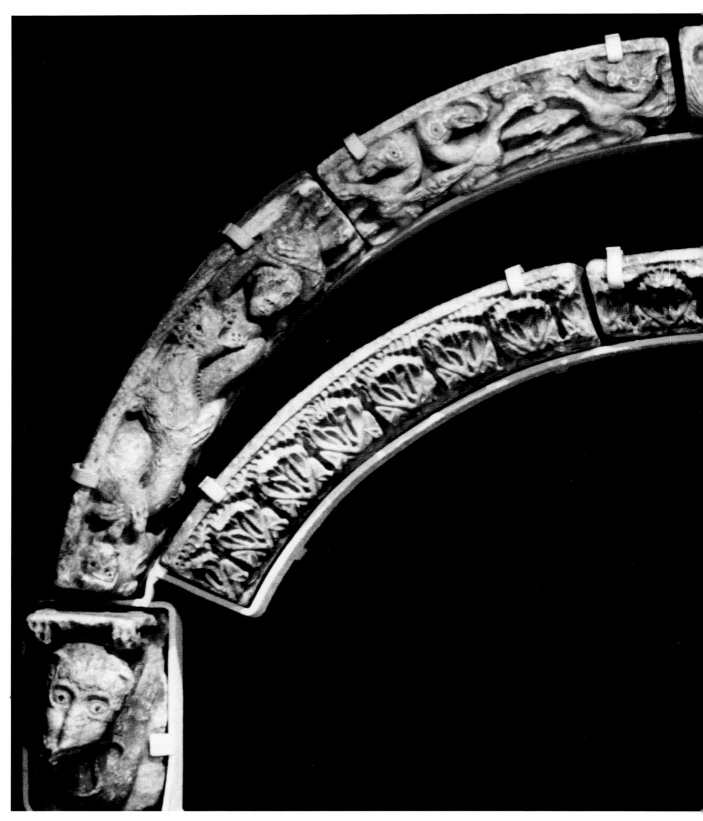

Figure 4.1 Archivolts from Alife (1966.10a–i) H: 137 (54″) W: 241 (95″) D: 49.5 (19 ½″)

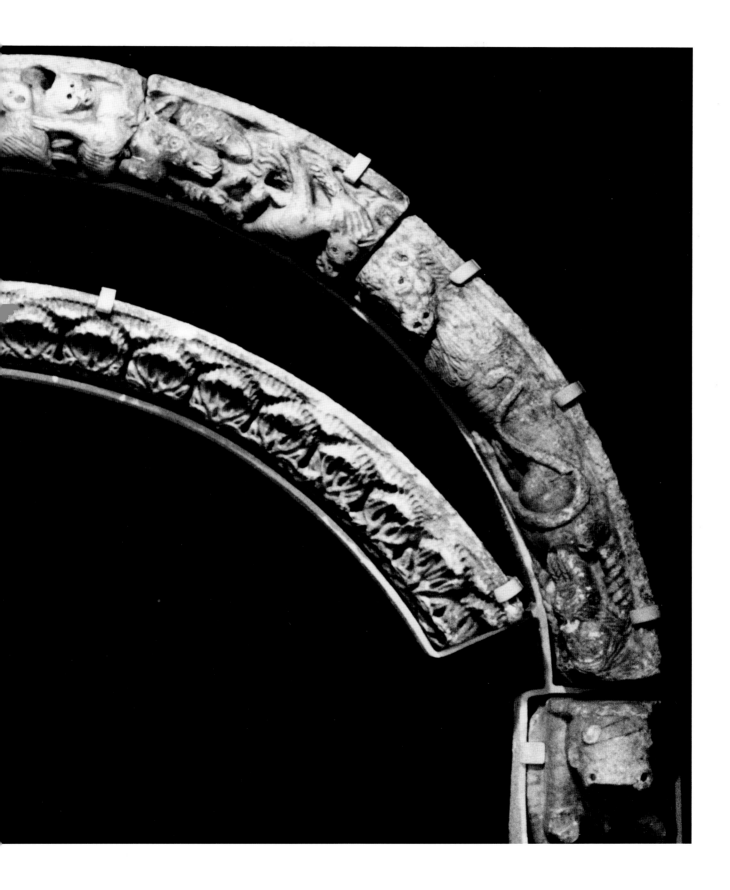

cranium, three vertebrae from the neck and five from the back, a finger, the left clavicle, a shoulder bone, some ribs, two kneecaps, and parts of the right leg, as well as unidentified bits of dust.[13] Alife thus claimed to have more than half of the remains of Sixtus I. Claims and counter-claims between Alatri and Alife continued for more than two centuries. Today, more level—and perhaps more secular—heads prevail; current opinion holds that Alife and Alatri share the relics of Sixtus I.[14]

The recent history of the Romanesque archivolts associated with the cathedral at Alife is fortunately less tortured than that of its relics. In 1860 two eminent German art historians, Heinrich Wilhelm Schulz and Ferdinand von Quast, mentioned a figured archivolt on the portal at Alife.[15] Their description is both brief and vague; they did not specify which portal of the façade they were referring to, nor did they describe in detail the archivolt in question. Nonetheless, it is clear that in the mid-nineteenth century at least one of the three Alife archivolts was still in place. But in 1904, little more than a generation later, the renowned French scholar Émile Bertaux noted that one of the archivolts was mounted in the first chapel of the right aisle of the cathedral (where it can still be found), while a second dismantled archivolt was in an obscure room in the campanile.[16] In other words, by 1904 at least two of the three Alife archivolts no longer graced their respective portals. The archivolt published by Bertaux is now in the collection of the Duke University Museum of Art. The small acanthus archivolt is not mentioned by any of the early scholars.

Because little medieval fabric survives in the cathedral at Alife and information concerning the medieval appearance of the building is sparse, it is impossible to reconstruct the original locations of the Alife archivolts. I strongly suspect that the medieval cathedral at Alife once had three portals, as is common in church design. Often richly decorated archivolts appear in Campania instead of sculpted tympana. To my knowledge, no Campanian Romanesque church was originally planned with a carved tympanum.[17]

The two archivolts now in the Duke University Museum of Art are displayed as concentric, freestanding arches (figure 4.1). Both bear witness to the antique heritage in Alife and throughout Campania, albeit in different ways. Some sections of the larger archivolt are carved from reused Roman marble (figure 4.2). On one piece, perhaps from an architrave, a standard late antique bead-and-reel motif

is clearly visible. The lower archivolt at Duke is, on the other hand, a dry medieval imitation of the popular Roman acanthus motif.[18]

The Duke figural archivolt is supported by two corbels, a lion and a much-damaged ox (figure 4.3). The lion corbel is not only three-dimensional; it is also twisted so that its forequarters seem to claw at the top of the block of stone, while its head is turned to confront the viewer. The sense of Romanesque design evident in the lion corbel is also seen in the first section on the left of the archivolt, for the human figure entwined with a serpent, a typical Romanesque motif,[19] occupies the entire voussoir and is conceived and designed in relation to its frame (figure 4.4).

Figure 4.2
Archivolt from Alife, detail of verso

79 The Archivolts from Alife

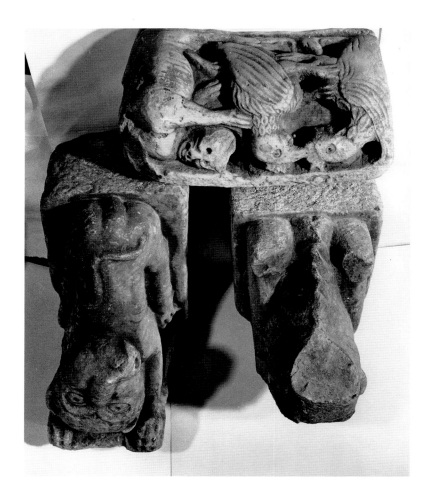

The second section of the Duke archivolt consists of three winged horses (figure 4.5). Despite the small scale, the composition is rhythmic and the individual parts are closely related. The small third section of the Duke archivolt contains birds with lightly incised wings (figure 4.6). The two sections on the right of this Duke archivolt echo the format of the left segment. A figure entwined with an ass is followed by an unidentifiable animal whose tail comprises a major design element (figures 4.6 and 4.7). The concept underlying the animal is similar to that of the lion corbel at the left.

The archivolt still at Alife is difficult to study because it is placed high on a wall of a dimly lit chapel. Two corbels support the archivolt, an elephant on the left and a damaged creature, perhaps a lion, on the right (figures 4.8 and 4.9). Exotic though it may seem, this elephant is not unique in Campania, for elephant corbels also appear on the center portal of the cathedral at Carinola (c. 1100).[20] Unlike the lion corbel of one of the archivolts at Duke, the Alife elephant corbel is characterized by bulbous, rather crude forms and by a lack of in-

Figure 4.3
Archivolt from Alife, detail

Figure 4.4 ▶
Archivolt from Alife, detail

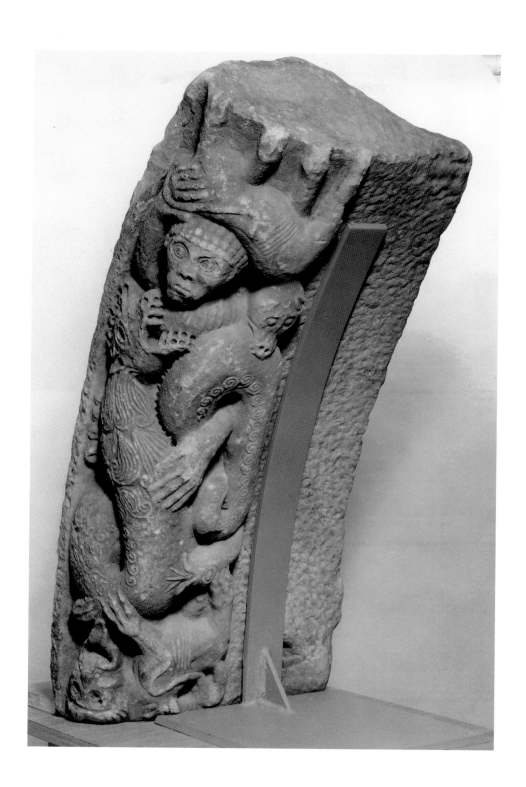

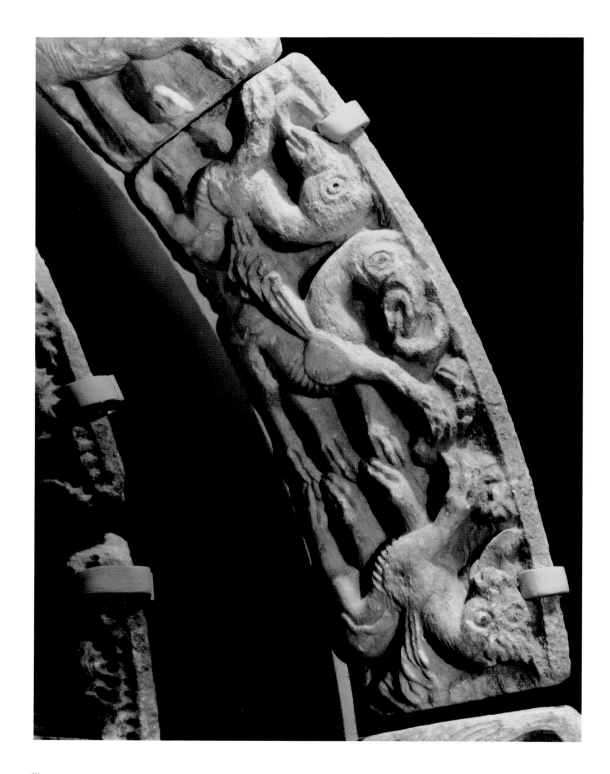

Figure 4.5
Archivolt from Alife, detail

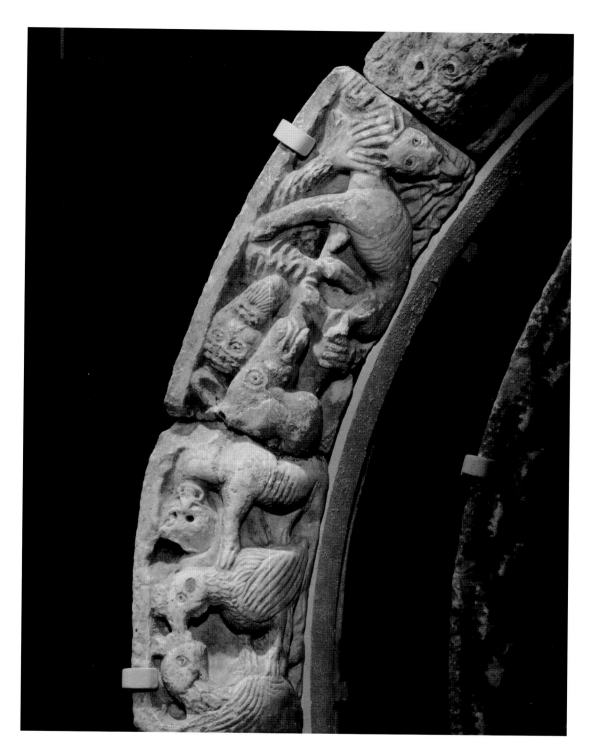

Figure 4.6
Archivolt from Alife, detail

83 The Archivolts from Alife

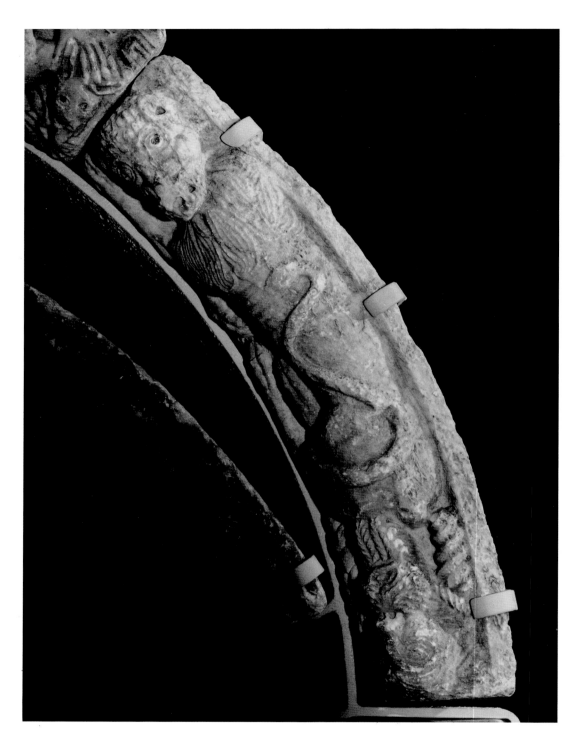

Figure 4.7
Archivolt from Alife, detail

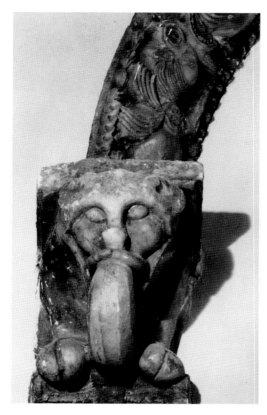

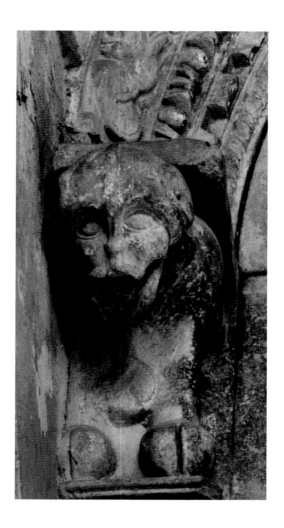

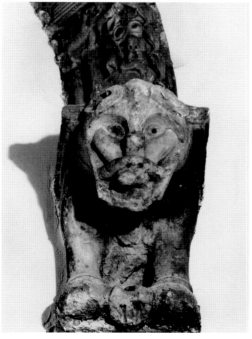

Figure 4.8
Archivolt in the first chapel
at the right, left corbel, Alife
Cathedral (Top left)

Figure 4.9
Archivolt in the first chapel
at the right, right corbel,
Alife Cathedral
(Bottom left)

Figure 4.10
Archivolt, left corbel of
facade portal, St. Mennas,
Sant'Agata dei Goti
(Top right)

terior articulation; these features find their stylistic parallel in the ram corbels of St. Mennas at Sant'Agata dei Goti (figure 4.10).[21] The relationship is not surprising, for Rainulf III was the son of the Norman Count Robert of Caiazzo, the patron of St. Mennas at Sant'Agata dei Goti, and must surely have been familiar with his father's foundation.

The archivolt still at Alife is carved by a hand different from that responsible for its corbels; its unusual style and content have no precedent in southern Italy. It consists of a series of individual vignettes with no thematic relationship to each other. At the far left, the gaping mouth of a leviathan emerges from the edge of the block (figure 4.8). The next block of stone contains a series of pecking and nipping birds and other unidentifiable animals interrupted only by a half-figure of a bearded man who holds the neck of the bird with his right hand and wields a large knife in his left (figure 4.11). The animals lack any interior definition except for their eyes. The rather crude parallel lines articulating the wings of the birds provide the only comparison with the archivolt at Duke. All these figures lack the plastic volumes evident in the corbel animals.

Figure 4.11
Archivolt in the first chapel at the right, detail, Alife Cathedral

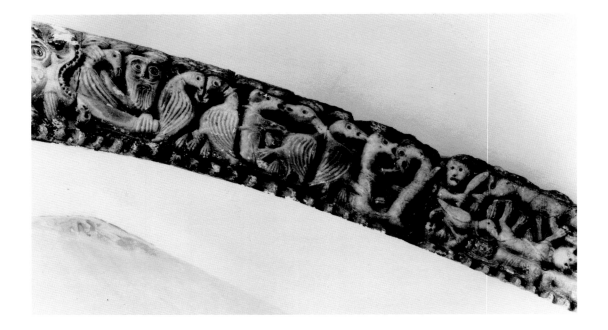

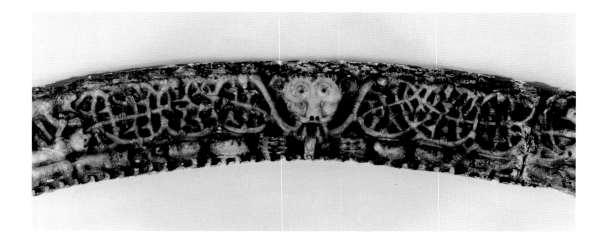

Figure 4.12
Archivolt in the first chapel
at the right, detail, Alife
Cathedral

The next section of the archivolt still at Alife consists of a complete human figure grasping a knife in his right hand and the hind leg of an animal in his left hand (figure 4.11); the decoration continues with one bird and a series of doglike animals who stride, lie upside down, and nip at each other. The apex of the archivolt displays a feline mask spewing a stylized vine scroll which descends symmetrically down the archivolt and terminates at the mouths of paired animals (figure 4.12).

Because of the dim light in the chapel, photographs cannot provide a completely legible image of the next section of the Alife archivolt; it is more readable in one of Bertaux's original, recently published drawings (figure 4.13).[22] Here, one sees feral animals nipping at each other and a human figure grasping the neck of a schematized bird, followed by a figure astride a horse who raises an oliphant to his mouth, and, next to him, the Agnus Dei. This is followed by two crudely carved angels; the one on the right holds a small book inscribed with an abbreviation of the name "St. Michael," an appropriate choice for South Italy, where the popularity of his cult inspired many images of the saint (figure 4.14).[23] Finally, after a few more nipping animals, the archivolt terminates on the right corbel.

Bertaux labelled only one element in his drawing, the oliphant, a type of carved ivory horn popular in medieval South Italy (figure 4.15).[24] The similarities between the small-scale motifs and incoherent organization of the Alife archivolt and those on ivory oliphants suggest that the sculptor at Alife may have first learned his craft by carving small objects rather than monumental sculpture, for the sculptor seems not to have been trained to think in terms of the decorative demands of a continuous archivolt. Iconographic elements often begin and end abruptly, resulting in individual vignettes arranged paratactically rather than linked serially. Even the intertwined figures appear to be placed next to and around each other without the typically Roman-

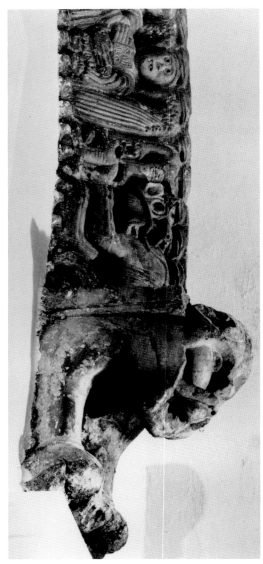

esque interdependence of form and structure. The possibility that the Alife sculptor was accustomed to carving on a small scale gains further support when it is realized that after the Roman era the production of monumental sculpture all but ceased in South Italy because neither the Lombards nor the Byzantines favored it. We can probably conclude that the archivolt still at Alife was produced by a local sculptor trained in another medium and format and here attempting something new.

The high quality of the figurated archivolt at Duke stands in sharp contrast to the archivolt remaining at Alife. Although contemporaneous, the two archivolts were surely carved by different sculptors,

Figure 4.13
Drawing of part of the archivolt in the first chapel at the right, Alife Cathedral
Figure 4.14
Archivolt in the first chapel at the right, detail, Alife Cathedral

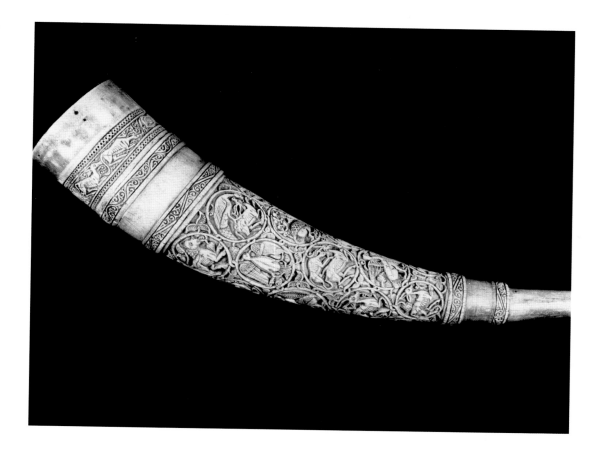

and the one at Duke is by far the more accomplished. Neither of the figured archivolts is typical of Romanesque sculpture in Campania noted for its classicism, which evolved from the reuse, close study, and imitation of antique sculpture. This tradition is easily demonstrated at the cathedral of Salerno where the architrave of the main portal is a reused Roman work from the *macellum* at Pozzuoli. Medieval carvers at Salerno then copied that Roman source for the architrave of the entrance to the atrium of the cathedral, the Porta dei Leoni.[25] The smaller acanthus-leaf archivolt at Duke also bears witness to the traditional Campanian interest in ancient forms.

Earlier I characterized the sculptor of the archivolt still at Alife as a local and unremarkable talent and pointed out that his work has no parallel in architectural sculpture in South Italy, but was based instead on experience with small-scale images. In contrast, the Duke University archivolt was carved by a more gifted sculptor experienced in monumental sculpture who was not trained in Campania.

Moreover, Duke's archivolt has no relationship to contemporane-

Figure 4.15
Oliphant from south Italy,
Royal Scottish Museum,
Edinburgh

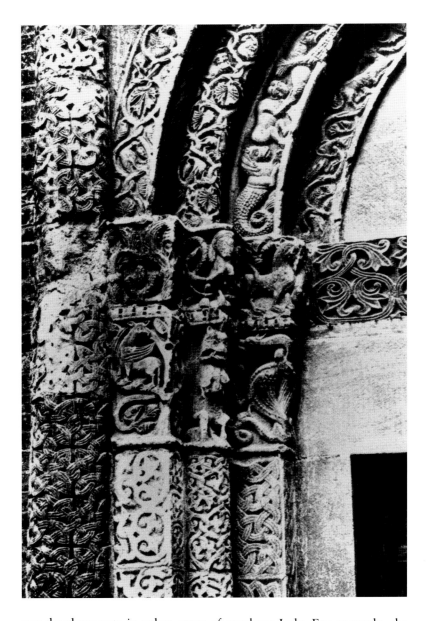

ous developments in other areas of southern Italy. For example, the
Cappella Palatina at Palermo, whose patron was Roger II, brother-
in-law and archenemy of Rainulf III of Alife, was begun in 1132, the
same year as the cathedral at Alife,[26] yet there could be no greater
contrast than that between the splendid mosaics of the Cappella Pala-
tina and the archivolts from Alife. This contrast also suggests that the
nature of Norman patronage in South Italy varied greatly; both Nor-
man artistic taste and Norman political policy may well be viewed as
pluralistic.

It is difficult to determine the origins of the sculptor of the Duke

Figure 4.16
Left jamb of center portal,
San Pietro Ciel d'Oro, Pavia

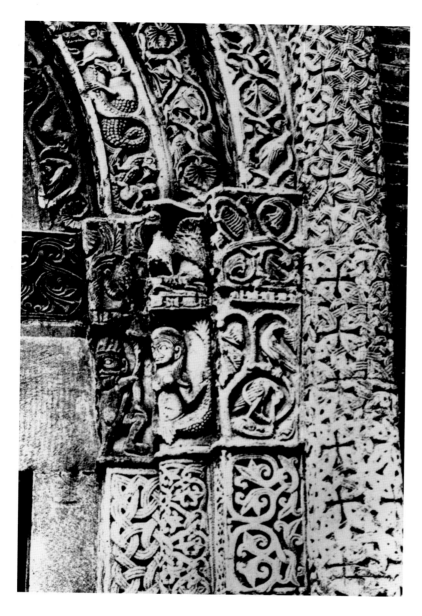

University archivolt because of the paucity of relevant stylistic comparisons. He may have been trained in Lombardy. The most telling comparison is the single portal of San Pietro Ciel d'Oro in Pavia, a building consecrated in 1132, the same year in which the cathedral at Alife was begun (figures 4.16 and 4.17).[27] The densely embellished archivolts swarming with intertwined forms at San Pietro Ciel d'Oro resemble those at Alife; note especially the nipping animals and the pecking birds. The forms at San Pietro Ciel d'Oro have greater density, but in both examples decoration takes precedence over meaning, with motifs juxtaposed rather than linked narratively.

Figure 4.17
Right jamb of center portal,
San Pietro Ciel d'Oro, Pavia

91 The Archivolts from Alife

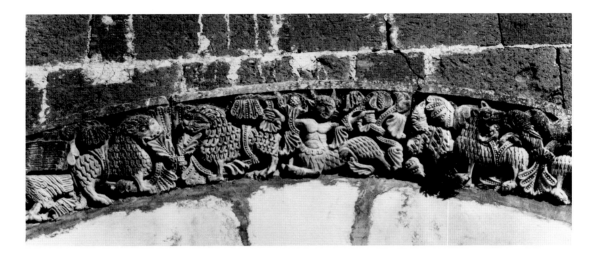

The stylistic predilections of the sculptor of the Duke University archivolt thus seem close to those of Lombard Romanesque sculpture, but I cannot identify the presence of his hand in any extant Lombard buildings. Perhaps trained in Lombardy, the sculptor seems to have become a journeyman and ventured south. This would not be unusual; in 1172, when the vast cloister of the cathedral at Monreale in Sicily was begun, many sculptors were imported from more northern parts of Europe.[28]

The sculptor who carved the Alife archivolt now in the Duke University Museum of Art did not initiate a new trend in Campanian Romanesque sculpture, nor does he seem to have had any immediate followers. Comparisons can be made, however, between the Alife archivolt and the archivolt of the center portal of the cathedral at Calvi Vecchia,[29] an analogy first suggested by Bertaux;[30] on his drawing of the archivolt still at Alife, he wrote "prototype de Calvi." Carved around the turn of the thirteenth century, the Calvi Vecchia archivolt restates the aesthetic of the Duke figurated archivolt in a more sophisticated form; the twisting, intertwined animals have greater salience and volume as well as more consistent rhythm (figure 4.18). Although chronology denies a direct connection between the Alife and Calvi Vecchia sculptors, this comparison suggests that the presence of foreign, possibly Lombard sculptors in Campania occurred on more than one occasion; this situation is not unexpected, for Lombard sculpture is acknowledged to have been influential throughout Romanesque Europe.[31] The Duke University Museum of Art is thus fortunate to own an excellent, if eccentric, example of Campanian Romanesque sculpture—indeed, the very best Alife has to offer!

Figure 4.18
Archivolt of center portal,
Cathedral, Calvi Vecchia

Notes

1. This paper is based on a lecture delivered at the Duke University Museum of Art on September 26, 1987. I am indebted to Associate Professor Caroline Bruzelius for inviting me to give the lecture and to Ms. Louise Tharaud Brasher, Assistant Curator of the Duke University Museum of Art, for generously providing me with photographs of the sculpture and a copy of *Rediscoveries, A Selection of Medieval Sculpture at the Duke University Museum of Art* (Durham, 1983); on page 13 of that publication, there is a brief discussion of the archivolt from Alife as well as a bibliography. The Duke University archivolt has also been catalogued by Walter Cahn in "Romanesque Sculpture in American Collections. XIV. The South," *Gesta* XIV/2 (1975): 72–73.

2. Though the present installation suggests that the archivolts were once part of the same portal, their somewhat different curvature intimates that they formed parts of two different portals.

3. G. V. Ciarlanti, *Memorie historiche del Sannio* (Isernia, 1644; reprint: Bologna, 1969): 31.

4. G. Trutta, *Dissertazioni istoriche delle antichità alifane* (Naples, 1776): 385–91.

5. The only monograph on the cathedral at Alife is by L. R. Cielo, *La cattedrale normanna di Alife*, Studi e Testi di Storia e Critica dell'Arte XVIII (Naples, 1984). See also D. B. Marrocco, "Note storiche sulla contea di Alife," *Annuario dell'Associazione storica del Medio Volturno* 4 (1975): 115–45.

6. H. W. Schulz and F. von Quast, *Denkmäler der Kunst des Mittelalters in Unteritalien*, volume 2 (Dresden, 1860): 160. See also F. Ughelli, *Italia sacra*, volume VIII (second edition: Venice, 1721): column 209.

7. L. R. Cielo, *La cattedrale normanna di Alife*, 19.

8. The classic work on the Norman conquest of South Italy remains F. Chalandon, *Histoire de la domination normande en Italie et en Sicile*, 2 volumes (Paris, 1907; reprint: New York, 1960).

9. On Rainulf, among other things, see G. A. Loud, "The Norman Counts of Caiazzo and the Abbey of Montecassino," *Monastica I. Scritti raccolti in memoria del XV centenario della nascita di S. Benedetto (480–1980)*, Miscellanea Cassinese 44 (Monte Cassino, 1981):199–217. Loud (214) points out that from 1132 onward Rainulf III took the side of Innocent II in the schism.

10. Falco of Benevento, *Chronicon*, in *Cronisti e Scrittori sincroni napoletani*, G. del Re, ed., *Storia della Monarchia*, volume I: *Normanni* (Naples, 1845): 157–276. Alexander, Abbot of Telese, *De' fatti di Ruggiero Re di Sicilia*, in *Cronisti e scrittori sincroni napoletani*, volume 1, 81–156. See also D. Clementi, "Alexandri Telesini 'Ystoria serenissimi Rogerii primi regis Sicilie,' Lib. IV, 6–10, Twelfth Century Political Propaganda," *Bullettino dell'Istituto storico italiano per il medio evo* 77 (1965):105–26; and M. Oldoni, "Realismo e dissidenza nella storiografia su Ruggero II: Falcone di Benevento e Alessandro di Telese," *Società, potere e popolo nell'età di Ruggero II, Atti delle terze giornate normanno-sveve. Bari, 23–25 maggio 1977* (Bari, 1979):259–83. For another account, see Romuald of Salerno, *Chronicon*, A. Garufi, ed., Rerum Italicarum Scriptores VII[1] (Città di Castello, 1935):214–26.

11. On the relics of Sixtus I, see G. A. Ferrari, *Vita di S. Sisto primo, papa e martire* (Ronciglione, 1659); N. Giorgio, *Notizie istoriche della vita, martirio, e sepoltura del glorioso San Sisto I, papa e martire* (Naples, 1721); L. de Persiis, *Del pontificato di S. Sisto I papa e martire, della traslazione delle sue reliquie da Roma in Alatri e*

del culto che vi ricevettoro dal secolo XII sino a' giorni nostri (Alatri, 1884); and D. B. Marrocco, *Il vescovato Alifano nel Medio Volturno* (Piedimonte Matese, 1979): 207–16.

12. The Alatri text of 1584 is published as an appendix in N. Giorgio, *Notizie istoriche della vita, martirio, e sepoltura del glorioso San Sisto I, papa e martire*.

13. D. B. Marrocco, *Il vescovato Alifano nel Medio Volturno*, 213.

14. Ibid., 214.

15. H. W. Schulz and F. von Quast, *Denkmäler der Kunst des Mittelalters in Unteritalien*, volume 2, 159–60.

16. É. Bertaux, *L'art dans l'Italie méridionale*, volume 1 (Paris, 1903; reprint: Paris/Rome, 1968) 473 and figure 203.

17. Campanian tympana usually have either mosaic or fresco images of saints as exemplified by those at Sant'Angelo in Formis and at the cathedral of Salerno; see M. D'Onofrio and V. Pace, *La Campania*, Italia Romanica, volume 4, Già e non ancora, arte, 16 (Milan, 1981): 153, plate 61; 155, plate 64; and 257, plate 124.

18. For the reuse of antique materials in Italy, see especially H. Wentzel, "Antiken-Imitationen des 12. und 13. Jahrhunderts in Italien," *Zeitschrift für Kunstwissenschaft* 9 (1955): 29–72; and A. Esch, "Spolien. Zur Wiederverwendung antiker Baustücke und Skulpturen im mittelalterlichen Italien," *Archiv für Kulturgeschichte* 51 (1969): 1–64.

19. W. Kemp, "Schlange, Schlangen," *Lexikon der christlichen Ikonographie*, volume 4 (Rome/Freiburg/Basel/Vienna, 1972): columns 75–81; and R. Wittkower, "Eagle and Serpent: A Study in the Migration of Symbols," *Journal of the Warburg and Courtauld Institutes* 2 (1938–39): 293–325, especially 312–21.

20. D'Onofrio and Pace, *La Campania*, 96, plate 36; 101–8.

21. On St. Mennas at Sant'Agata dei Goti, see L. R. Cielo, *Monumenti romanici a S. Agata dei Goti. Il duomo e la chiesa di San Menna* (Rome, 1980): 91–125; and, by the same author, "Cattedrale e reliquie nella Campania normanna. I 'tests' di Carinola, Caiazzo e Alife," *Rivista storica del Sannio* 1, fascicule 2 (1983): 9–22.

22. A. Prandi, ed., *L'art dans l'Italie méridionale. Aggiornamento dell'opera di Émile Bertaux*, volume 5 (Rome, 1978): 653, plate XVIII.

23. On the cult of St. Michael and its importance in South Italy, see E. Gothein, *Die Culturentwicklung süd-italiens* (Breslau, 1886): 41–111; O. Rojdestvensky, *Le culte de Saint Michel et le moyen age latin* (Paris, 1922): 9–17 and 41–46; C. Angelillis, *Il santuario del Gargano e il culto di San Michele nel mondo*, 2 volumes, Daunia VII–VIII, Collana di Monografie storiche (Foggia, 1955–56); A. Petrucci, "Aspetti del culto e del pellegrinaggio di S. Michele Arcangelo sul monte Gargano," *Pellegrinaggi e culto dei santi in Europa fino alla 1ª crociata, 8–11 ottobre 1961*, Convegni del Centro di Studi sulla Spiritualità Medievale IV (Todi, 1963): 145–80; and by the same author, "Origine e diffusione del culto di San Michele nell'Italia medievale," *Millénaire monastique du Mont Saint-Michel*, volume III: *Culte de Saint Michel et pélerinages au mont* (Paris, 1971): 339–54; F. Avril and J.-R. Gaborit, "'L'itinerarium Bernardi Monachi' et les pélerinages d'Italie du sud pendant le haut-moyen-age," *Mélanges d'Archéologie et d'Histoire* 79 (1967): 269–98; and W. von Rintelen, *Kultgeographische Studien in der Italia Byzantina. Untersuchungen über die Kulte des Erzengels Michael und der Madonna di Constantinopoli in Süditalia*, Archiv für vergleichende Kulturwissenschaft 3 (Meisenheim an Glan, 1968): especially 3–55.

24. On oliphants, see especially O. von Falke, "Elfenbeinhörner. I. Ägypten und Italien," *Pantheon* 4 (1929): 511–17; E. Kühnel, "Die sarazenischen Olifanthörner,"

Jahrbuch der Berliner Museen 1 (1959): 33–50; H. Swarzenski, "Two Oliphants in the Museum," *Bulletin, Museum of Fine Arts, Boston* 60 (1962): 27–45; and E. Kühnel, *Die islamischen Elfenbeinskulpturen. VIII–XIII Jahrhundert*, 2 volumes (Berlin, 1971).

25. D'Onofrio and Pace, *La Campania*, 255, plate 122 and 257, plate 124.

26. On the Cappella Palatina at Palermo, see O. Demus, *The Mosaics of Norman Sicily* (London, 1949).

27. A. K. Porter, *Lombard Architecture*, volume III (New Haven, 1917): 215–30; E. Arslan, "Note sulla scultura romanica pavese," *Bollettino d'arte*, 4th series, 40 (1955): 103–18; S. Chierici, *La Lombardia*, Italia romanica, volume 1, Già e non ancora, arte 1 (Milan, 1978): 360–61; M. L. Wood, "Early Twelfth Century Sculpture in Pavia," Ph.D. dissertation, Johns Hopkins University (1978); and A. Peroni, "Struttura e valori ottici nei portali romanici di Pavia," *Festschrift für Wilhelm Messerer*, K. Ertz, ed. (Cologne, 1980): 121–35. Bertaux (*L'art dans l'Italie méridionale*, 473) was the first to suggest the presence of a Lombard sculptor.

28. On the cloister at Monreale, see especially C. D. Sheppard, "A Stylistic Analysis of the Cloister of Monreale," *Art Bulletin* 34 (1952): 35–41; and R. Salvini, *Il chiostro di Monreale e la scultura romanica in Sicilia* (Palermo, 1962; English edition: *The Cloister of Monreale and Romanesque Sculpture in Sicily*, Laura Valdes and Rose George, tr. [Palermo, 1964]).

29. D'Onofrio and Pace, *La Campania*, 115–16, 137–41.

30. A. Prandi, ed., *L'art dans l'Italie méridionale. Aggiornamento dell'opera di Émile Bertaux*, volume 5, 652, figure XVII.

31. See for example E. Kluckhohn, "Die Bedeutung Italiens für die romanische Baukunst und Bauornamentik in Deutschland," *Marburger Jahrbuch für Kunstwissenschaft* 16 (1955): 1–120; Z. Świechowski, "Die Bedeutung Italiens für die romanische Architektur und Bauplastik in Polen," *Acta Historiae Artium Academiae Scientiarum Hungaricae* 10 (1964): 1–55; J. Raspi Serra, "English Decorative Sculpture of the Early Twelfth Century and the Como-Pavian Tradition," *Art Bulletin* 51 (1969): 352–62; by the same author, "Lapidici lombardi ed emiliani nel XII secolo a Maastricht in Olanda," *Commentari*, n.s. 21 (1970): 27–43; F. Mastropierro, "Elementi lombardi nella scultura lucchese intorno al XII secolo," *Arte lombarda* 17, part 1 (1972): 17–22; I. Wiegand-Uhl, *Figurale und ornamentale Bauskulptur der Romanik in Bayern und der Lombardei* (Munich, 1975); E. Marosi, "Esztergom e gli influssi del romanico lombardo in Ungheria," *Il romanico. Atti del Seminario di Studi diretto da Piero Sanpaolesi. Villa Monastero di Varenna, 8–16 settembre 1973* (Milan, 1975): 262–76; J. J. M. Timmers, "Influssi lombardi sulle chiese di Maastricht e di Rolduc," *Il romanico*, 249–54; and J. Meredith, "The Impact of Italy on the Romanesque Architectural Sculpture of England," Ph.D. dissertation, Yale University (1980).

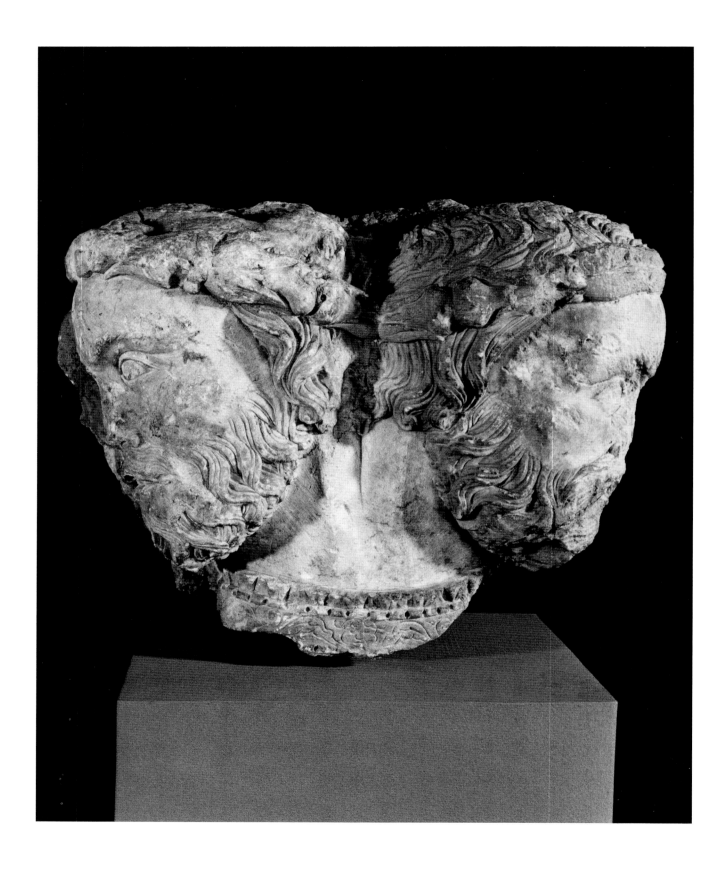

The *Bifrons* Relief of Janus: The Implications of the Antique in the Court Art of Emperor Frederick II

Jill Meredith

Twin male heads joined back-to-back comprise a superb but enigmatic piece of architectural sculpture in the Brummer collection of the Duke University Museum of Art (figure 5.1). Next to nothing is known about this work; Ernest and Joseph Brummer acquired the sculpture from the Parisian dealer Brimo de Laroussilhe in 1931, but it came without any record of its geographic or architectural origins.[1] This lack of a provenance and documentation as well as the unusual subject and style have presented a puzzle and even sparked questions regarding its authenticity. Recent conservation work has provided evidence of multiple carving phases and burial conditions to support the authentication of the piece. Its boldly carved facial and foliate details recall the naturalism of Greco-Roman sculptures and enhance the classicizing subject. The antique subject and figural style, although unusual in the Middle Ages, can be associated with the equally unusual artistic patronage of the Emperor Frederick II of the Hohenstaufen (1194–1250). A Frederician attribution would classify this work as an important and rare example of Hohenstaufen architectural sculpture in the United States.[2]

The two heads project in extremely high relief from a flat background still visible on the left side (figure 5.2). The unfinished surface of its reverse side indicates that this sculpture was originally embedded in a wall. The back of the heads and necks are joined, converging at a ruffled collar that accomodates the wide, ovoid neck. Viewed from the side in the present freestanding installation, each face appears slightly compressed against the background and therefore unnaturally attenuated and distorted. In the original architectural context the intended view would have been the frontal one; the two heads seen simultaneously in profile emphasize the identical nature of their physiognomy. Despite differing degrees of loss, the face and coiffure of each head are similarly executed, displaying a strong, prominent brow, curly locks of hair, and a beard. The intense gaze is enhanced by wide brows and large eyes surrounded by thick folds of flesh defined by creases. The irises, now smooth discs, probably were completed with polychromy. The better-preserved left head displays a meticulous attention to natural detail; the lips part slightly to reveal several teeth and the thick hair grows organically in varied, curving waves. Lush with leaves and plump fruit, a foliate garland rings each brow and contributes to the classical appearance of these heads. The sophisticated sculptural con-

Color plate XIII.
◄Figure 5.1
Bifrons relief of Janus
(1966.51)
H: 41 (17″)
W: 51 (20 ¾″)
D: 24 (9 ½″)

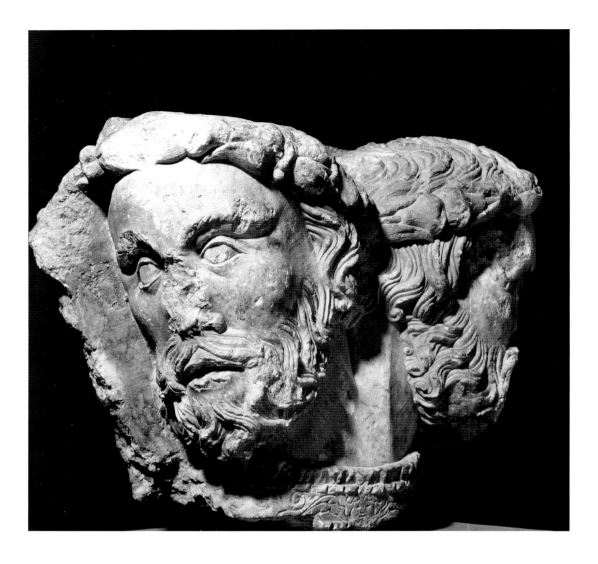

ception and execution are striking despite some severe breaks, surface corrosion, and evidence of subsequent surface recarving.

When the Duke University Museum of Art's conservator, Linda Roundhill, cleaned the piece in August 1987 she also examined and tested it chemically. The stone, once assumed to be marble because of its white color with grey veining, was found to be alabaster.[3] Much softer than marble and softer even than some limestone, alabaster is susceptible to harsh treatment and the ravages of weather. In addition to many small surface gashes, the left face has lost its nose, the front of the foliate wreath, and most of the surface detail of the top of the head. Running water, which easily corrodes alabaster, caused the heavy pitting, nearly obliterating the right face (figure 5.3). Only with raking light are the ghostly remains of details revealed as identical to those of the better-preserved left face. The corrosion patterns

Figure 5.2
Janus, left side

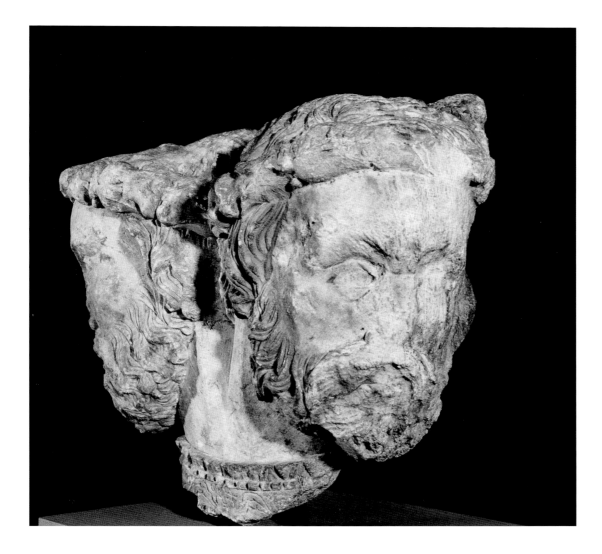

Figure 5.3
Janus, right side

suggest that the sculpture was inverted and buried, with only the right
face exposed to flowing water. Evidence of this burial includes the
mineral incrustation on much of the surface, still apparent in some
of the ridges articulating the beard, as well as in the badly discolored
portions, such as those on the right side of the neck. The incrusta-
tion, formed by waterborne minerals over a considerable period of
time, attests to the authenticity of the sculpture. During restoration
the heads were cleaned selectively so that the incrustation could be
tested at some later time and thereby possibly provide information
regarding the circumstances of burial.

The cleaning also enhanced the parallel ridges of tool marks across
much of the left head, especially around the eyes. The areas where
the two heads join (figure 5.4) still retain some incrustation on the
hair but also exhibit tool marks on portions of the leafy garland. As

Figure 5.4
Bifrons relief, center detail

the conservator observed, the tool marks stop at the incrustation, and thus postdate it. Since the stone is so soft, even a light touch would have left prominent ridges. This secondary recarving seems to have been a fairly recent surface freshening to remove incrustation and discoloration. The surface recutting has not resulted in any substantial stylistic changes, however, since the damaged right head, without similar recutting, exhibits a comparable physiognomy.

In between the original carving and the surface freshening, probably done in the early part of the twentieth century, there was another phase of recarving. The center of the collar band, between the ruffled border, now contains a naïvely rendered little angel head and wings. The collar was originally decorated with a vinescroll, portions of which are still visible on the sides. The front of the collar, however, was resurfaced and the *putto* incised. Although it is difficult to date, that crude version of a common Renaissance motif was inserted at some time after the original carving. Since burial discoloration and the modern tool marks continue across the collar, the *putto* evidently predates the piece's burial and the subsequent modern cosmetic surface recarving.[4] The *putto* may have been added when the paired heads had become *spolia,* that is, appropriated from their original architectural

context and reused, perhaps in the fifteenth or sixteenth century.

Prior to the present installation, the relief was exhibited in 1971 at the Ackland Art Center of the University of North Carolina at Chapel Hill. The exhibition catalogue attributed the piece to southern Italy in the mid-thirteenth century as the work of an artist, possibly French, associated with the court workshops of Emperor Frederick of Hohenstaufen.[5] The identity of the heads was left unresolved, although various possibilities mentioned included Janus and classical portraits of philosophers and historians, as well as the classicizing portraits of Frederick's courtiers.

The antique style and high quality of the carving are compelling qualities that argue for its association with the Italian court workshops of Emperor Frederick II. A great patron of the arts, he attracted the outstanding artists of the day and set them to copying and adapting Roman antiquities. This unusual artistic milieu produced small works such as cameos, engraved gems, coins, and medals, as well as monumental sculpture in an antique style that had no counterpart until the Renaissance.[6] From Frederick's proto-Renaissance emerged the great sculptors of the late thirteenth century, Nicola and Giovanni Pisano and their colleague, Arnolfo di Cambio.[7] Unfortunately only a small fraction of the art associated with Frederick has survived. The especially distinctive iconography of the heads, moreover, is entirely in keeping with the Frederician revivalist notions enunciated in the many works of art and literature that evoke the age of the Roman Emperor Augustus.[8]

The two-headed figure can be none other than the Roman god Janus described by Ovid and other Latin authors as *biceps* (two-headed) or, more commonly, *bifrons* (two-faced). Like most Roman deities, Janus was originally an abstract idea or supernatural power later given anthropomorphic form under the influence of Greek art and beliefs.[9] Like other uniquely Roman deities such as Vesta, the spirit of the hearth, Janus was initially a household god, the guardian of the beginning of all things. In the home he guarded the door—named for him, *ianua*—to prevent the entry of evil spirits. Ovid acknowledged his extreme antiquity: "The ancients called me Chaos, for a being from of old am I" (*Fasti*, I.103–4); only later was he conceived in human form, "a shapeless lump, assumed the face and members of a god . . . my front and back look just the same" (*Fasti*, I.111–14).[10] His sphere of influence later expanded to encompass the cosmos:

"Whatever you see anywhere—sky, sea, clouds, earth—all things are closed and opened by my hand . . . the guardianship of this vast universe is in my hands alone . . . my office regulates the goings and the comings of Jupiter himself. . . . Every door has two fronts, this way and that, whereof one faces the people and the other the house-god; and just as your human porter, seated at the threshold of the house-door sees who goes out and in, so I the porter of the heavenly court behold at once both East and West . . . and lest I should lose time by twisting my neck, I am free to look both ways without budging." (*Fasti*, I.117–44)

Janus's function also became more inclusive as the god of the beginning of all occupations and endeavors. When the Romans expanded their ten-month calendar to include twelve months, the month named for Janus, Januarius, preceded the others. By 153 B.C. January 1 commenced the civil year, the date when consuls and magistrates entered office. In this context, Ovid addresses Janus as "herald of a lucky year" and "two-headed Janus, opener of the softly gliding year" (*Fasti*, I.63–65).

In Roman and Late Antique examples of mosaic pavements and illustrated calendars depicting the months, the common January representation is not Janus, but a figure making a religious offering, possibly illustrating the activity associated with January 9, the cult day of Janus.[11] During the Middle Ages, calendar illustrations depicted a variety of monthly labors which were usually the appropriate seasonal rural occupations including the typical January depiction of a man warming himself by the fire.[12] This form occurs both in Romanesque manuscripts and in architectural sculpture. The labors of the months became popular in northern Italian church decoration during the twelfth and thirteenth centuries. The months were frequently depicted on church portals and porches to suggest the passage of earthly time by the representation of recurring mundane activities.[13] As typified by an early example from Modena Cathedral, the activities for January are warming by the hearth or feasting.[14] An example from around 1138 by the sculptor Niccolò on the entrance porch architrave of the church of San Zeno in Verona shows a figure warming himself as part of a monthly labors series which is sequentially arranged and framed by an arcade.[15] An early thirteenth-century counterpart, the porch frieze at Cremona Cathedral, depicts a warmly dressed, bearded man feasting.

In a few instances, the Roman god Janus was incorporated into the medieval calendar cycles for the month of January.[16] Nevertheless these are rare and distinctive versions which derive from antique literary sources, not antique artistic prototypes. In Ovid's *Fasti*, the poetic rendering of the Roman calendar of religious events that celebrated the religious revival by the Emperor Augustus, the section for January consists largely of an extended discourse between the narrator and Janus. Janus replies to the author's questions and describes at great length his origins, worship, and other associations, many of which I have already summarized. Later writers like Ausonius and the sixth-century Isidore of Seville were aware of this precedent; they, too, linked the double-faced or *bifrons* Janus with the closing of the old year and the opening of the new one.[17] A twelfth-century mosaic pavement from the Cathedral of Aosta in northern Italy literally illustrates these poetic descriptions with a Janus-figure between two buildings closing the door of the old year and opening the door of the new.[18]

There are also several highly imaginative medieval creations in which the more common warming or feasting activity has been combined somewhat anomalously with the Janus personification. Those versions have been concocted from the two-faced god of literary sources and from earlier artistic traditions, and then adapted to the practical requirements of the particular architectural context. The mid-twelfth-century portal archivolt at Parma Cathedral with a calendar cycle, for instance, illustrates a warming figure, with his two faces depicted side by side, squeezed into the narrow confines of the arch molding.[19]

Several elaborate sculptural programs of calendar cycles arose from the great wave of building activity in Emilia around 1225. At Parma and Ferrara large-scale reliefs depicting the labors of the months were originally installed within cathedral entrance porches, perhaps applied to the inner archway surface. The Parma and Ferrara calendar subjects are exceptional for their ambitious size (about four feet high), three-dimensionality, and naturalistic detail. The Parma reliefs of the monthly labors (now in the Baptistery), attributed to Benedetto Antelami, are joined by freestanding personifications of the seasons.[20] Two separate sculptures comprise the January representation: a modest relief of men cooking a feast and a seated figure. The latter is Janus, a bearded figure in a long flowing tunic rendered completely in the round (figure 5.5).[21] He sits positioned frontally, so his second face

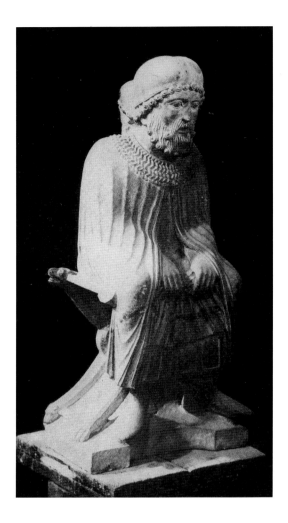
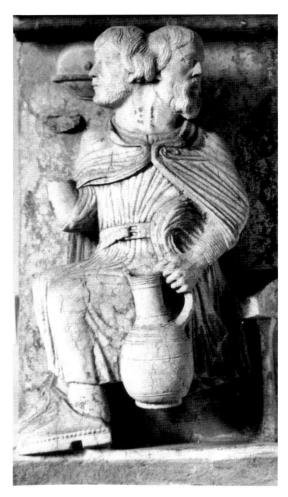

projects backwards, a detail not visible in most photographs. Follow-ing Ovid's description, he may well have served as the porter of the house of the Lord on the entrance porch of Parma Cathedral.

The south flank porch of Ferrara Cathedral, the so-called "Portal of the Months," once contained a similar series of calendar reliefs.[22] The extant monthly depictions are fairly consistent. Seasonal occupations and personifications have been carved in extremely high relief with some areas completely undercut and finished in the round. The high relief, naturalistically rendered details of plants and agricultural tools, and monumental scale contribute to the lifelike effect. The January figure at Ferrara (figure 5.6) is heavily dressed and holds a pitcher and a dish characteristic of the feasting activity, yet he also exhibits the twin countenance of Janus. The Duke relief bears an uncanny re-

Figure 5.5
January relief, Bap-tistery, Parma

Figure 5.6
January relief, Portale dei Mesi, Ferrara Cathedral

semblance to this example in several important ways. We see nearly complete heads, not just faces, displayed in profile to the viewer. These double heads join to yield a wide, ovoid neck accentuated by the collar. The plasticity of the Ferrara January is nearly identical to the Duke Janus. Moreover, both of these figures convey a sense of personality due to their naturalistic facial details. The naturalism here extends also to the foliage on some of the other monthly labors reliefs at Ferrara which is more botanically accurate than the stylized motifs of the Romanesque period. The Ferrara sculptures offer another interesting parallel to the Duke Janus: the ripe fruit on the tree in the month of August relief resembles the figs which garnish the foliate wreath of the Duke *bifrons*.[23]

The many comparable features of these sculptures at Ferrara help to fix a general attribution for the Duke Janus figure: Italy, in the second quarter of the thirteenth century, on a major architectural monument. Because of the close visual and technical similarities between these two works they seem to be parallel manifestations of the same formal and iconographic concerns and sources, although they are certainly not products of the same workshop or sculptor. In scale the works differ markedly. The Ferrara reliefs are about half lifesize, whereas the Duke *bifrons* relief is well over lifesize. It is therefore unlikely to have been part of a full-figure relief sculpture; rather, it was probably produced as a bust.

Moreover, in contrast to any medieval personification of January, including that at Ferrara, the Duke *bifrons* truly approximates the details of ancient Roman sculpture, even to the point of displaying a classical attribute, the foliate garland. This leafy wreath bulges with figs, the fruit commonly associated with the Roman god Janus, according to Ovid.[24] Because of those details and the bust format, it seems unlikely that the Duke Janus was part of a calendar cycle; rather it seems to have been created as an independent personification for some other purpose. The self-conscious classicism plays a pivotal role in this purpose by enhancing the antique qualities of the subject, the Roman god Janus, in a manner consistent with other monumental and literary works commissioned to promote the political ideology of the Hohenstaufen Emperor Frederick II.

Frederick, heir to the Holy Roman Empire and the Kingdom of the Two Sicilies, was unique among the secular and ecclesiastic rulers of the period.[25] His interests and aspirations reflect an unprecedented fas-

cination with classical antiquity that foreshadows that of Renaissance humanists. Talented, intelligent, and highly motivated, he mastered half a dozen languages and spoke and wrote to the leading experts in zoology, medicine, mathematics, and astrology as a colleague. At his court he gathered the leading literary, scientific, and artistic minds of the day into his imperial "think-tank." He sponsored their various projects, even participating in them, often as a colleague.[26] He wrote Latin poetry and a scientific treatise on the art of hunting with falcons that he also illustrated.[27] And he still found time to personally direct military campaigns and diplomatic missions to expand his world empire as well as numerous building projects that resulted in many castles, hunting lodges, and fortifications throughout southern Italy.[28] His personal ambition was to achieve his ancestral "destiny" and become a world ruler; this role was to be built on his unification of the kingdom of southern Italy, the Holy Roman Empire, and the Holy Land. Following the precedent of his German forebears going back to Charlemagne, he tried to project the public image of a Roman emperor—specifically, Caesar Augustus. He first asserted his renewal of the Augustan Age after his coronation as Holy Roman Emperor in 1220, when he revived ancient ceremonies such as the route of the Via Triumphalis and the distribution of largesse. By 1231 he had become "ever Caesar Augustus of the Romans Fortunate, Victor and Conqueror of Italy, Sicily, Jerusalem and Arles" to quote the preface of his newly formulated law code, the *Liber Augustalis*.[29] By framing the legal basis for the new order in his kingdom, he again followed Roman imperial models as a lawgiver and bringer of order and peace; he made this literal with the issue of a new coin type, an act unprecedented in the Middle Ages. The magnificent golden *augustalis*, inscribed "Imperator Romanorum Caesar Augustus," displays his laureate portrait accompanied by the Roman imperial eagle on the reverse.[30] On the reverse his name Fridericus is subdivided to stress its etymology—Fried: peace; Rich: rule—effectively declaring that in his renewal of the Augustan Age he too was Emperor of Peace.

Only the unique artistic and intellectual milieu of Frederick's imperial court could have produced the Duke Janus. This sculpture resembles other Frederician works both formally and iconographically, and it reflects the Emperor's expert knowledge of Roman art and literature as well. Like other artistic projects that Frederick himself designed or influenced, its form, antique style, and iconography derive

from his synthetic and intelligent approach to classical traditions.

 To promote his political ideology Frederick commissioned a number of imperial portraits which depict him in a manner similar to the *augustalis* coin, crowned with a laurel wreath and draped in a *chlamys*, that followed the precedent of countless ancient Roman imperial portraits.[31] The surviving examples, such as the half-figure bust from Barletta (figure 5.7), demonstrate the manner in which he made his supreme authority manifest throughout his kingdom.[32] Although the portrait heads vary stylistically, displaying classical as well as Gothic qualities, each emulates the antique in its combination of portrait likeness and Roman imperial motifs. For instance, the portrait head from his seated statue on his triumphal gateway at Capua combines his youthful good looks with the distinctive locks of hair across the forehead characteristic of portraits of the Emperor Augustus and his family.[33] The Duke Janus is similarly a pastiche of highly meaningful details.

 The Janus heads correspond in scale and specific features of the hair

Figure 5.7
Portrait bust of Frederick II,
Museo Civico, Barletta

Figure 5.8
Wreathed male head from
Bitonto, private collection

 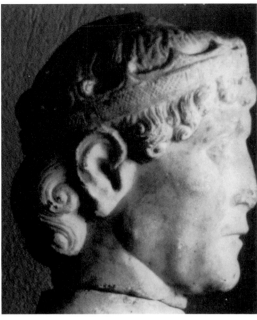

and face to several imperial portraits produced in Frederick's court workshops. One example, found in the Tiber River and now in Berlin, displays the unusual S-curve crease of the eyelid folds so characteristic of the Janus heads.[34] The hair and beard of another badly damaged laureate portrait head from Bitonto (figure 5.8) were produced by the distinctive carving technique used on the Janus head, in which wavy clumps of hair are articulated with a series of peaked ridges and deep grooves. The curving masses of thick hair above the wreath on the right Janus head also occur in identical form on the Bitonto head. The hair and beard of the Janus heads terminate in distinctive curly tips which spiral and coil in a varied, naturalistic fashion. These curling locks of hair recall not only the more orderly coiffure on the Barletta portrait, but closely follow the more organic versions on other Frederick portraits, notably a cameo copy of the Capua head, and especially on another imperial head now in a private collection in Milan (figure 5.9).[35] Not only do these similarities in technical details argue for an attribution of Janus to the imperial sculptural workshop, but stylistic similarities imply that the Emperor should be equated with his patron deity, just as he should be equated with his prototype, the Roman Emperor Augustus.

The Duke Janus relief also corresponds to the sculptures associated with Frederick's court workshops because its subject, a Roman deity, has been rendered in the appropriate antique style. This potent and meaningful interrelation of classicizing iconography and style occurs

Figure 5.9
(left) Raumer cameo, copy of Frederick II portrait from Capua Gateway, Museo di San Martino, Naples; (right) Portrait head of Frederick II, private collection, Milan

most notably in Frederick's triumphal gateway at Capua (figure 5.10), which was built between 1234 and 1240 to fortify the Roman bridge over the Volturno River and to mark the entrance to his kingdom along the Via Appia from Rome.[36] Patterned after Roman triumphal arches, it celebrated Frederick's military achievements in the north with sculptures of victories and trophies. The sculpture on the facade enunciated his imperial authority and role as judge with the unprecedented seated statue of the Emperor. The equal delegation of judicial authority to his high court judges is expressed by their identical portraits within roundels in the arch spandrels, following formal precedents of Augustan monuments, such as the Arch at Rimini.[37] The judges are Frederick's close advisors, Thaddeus Suessa and Petrus della Vigna (figure 5.11); both were poets, lawyers, and rhetoricians.[38] Each sports a beard and wreath, more like classical philosopher portraits than accurate likenesses of Frederick's courtiers, who were cleanshaven. Despite the lifelike detail these are not veristic portraits. They are depicted as twin brothers to emphasize their comparable official function. It is en-

Figure 5.10
Reconstruction drawing, aerial view, Capua Gateway

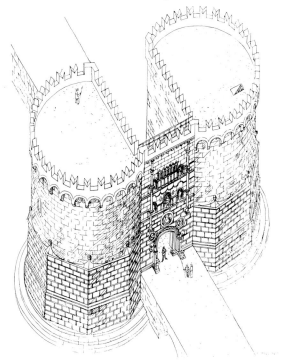

tirely appropriate that Suessa and della Vigna were depicted in classi-
cizing fashion—indeed flatteringly portrayed as classical philosophers
—since their poetry and rhetoric frequently quoted or drew upon
ancient authors such as Ovid.[39]

The Duke Janus heads resemble these portrait busts of the high
court judges, as first noted in the 1971 Ackland Museum exhibition
catalogue, not only in the general features of wavy beards and hair
ringed by a classicizing wreath, but also in the fleshy fold above the
eyes and curving crease around the eyelid. The somewhat narrower
facial proportions of the Janus heads, quite different from the judges,
recalls other Capuan male heads such as the so-called "terms" or
terminal male and female heads that ringed the tower bases. One ex-
ample displays the broad brow and narrow cheeks comparable to the
Janus faces (figure 5.12). Although its wavy beard and moustache ter-
minate in straight tips rather than curly locks like the Janus heads, the
hair has been articulated by broad peaked ridges and deep grooves.
This term also resembles the Janus heads because its lips part slightly
to reveal delicately cut teeth.

Another extant sculpture from the Capuan arch offers a close typo-

Figure 5.11
Bust of Petrus della Vigna,
Museo Campano, Capua

Figure 5.12
Term or male head from
tower base of Capua
Gateway, Museo Cam-
pano, Capua

logical parallel to the Duke Janus in the surviving head of a thirteenth-century sculpture of a Roman divinity. The center roundel, mediating between the enthroned Frederick above and the adjacent high court judges, once contained a bust-length antique-style female figure crowned with an ivy wreath, who can be identified as the Custodia, guardian of the state—the female personification of Capua (figure 5.13).[40] As the tutelary deity of the state, associated by inscription and

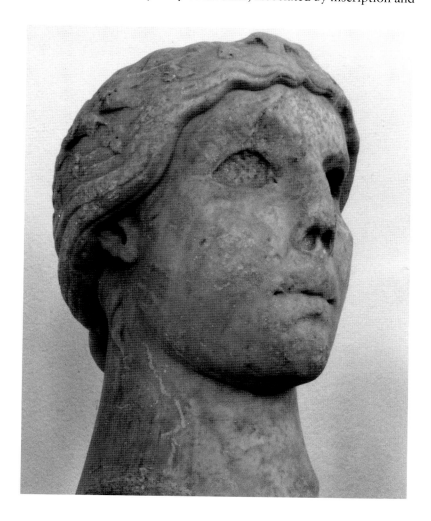

Figure 5.13
Female bust of Custodia or Capua from Capua Gateway, Museo Campano, Capua

architectural proximity to the seated figure of the Emperor Frederick in the zone directly above, the deity Capua/Custodia recalls the female personification of the Roman Empire, Dea Roma, who accompanies the Emperor Augustus in works such as the Gemma Augustea.

The inspiration for busts installed in Frederician architecture can be found in Roman Capua. The extraordinary assembly of bust-length divinities and theatrical masks carved in relief that enriches the outer arcade of the Roman amphitheatre of Capua Vetere includes deities of local significance such as Diana and the local river personified, Volturnus.[41] Frederick's arch was among other things a companion piece in medieval Capua to emphasize his *renovatio*, since it was fitted not only with classicizing busts of local personages but also with actual *spolia* from Capua Vetere. Architectural busts of mythological or locally appropriate figures became a popular, if unusual, feature of other Frederician monuments such as the busts on consoles at Castle Lagopesole and those on the vault springings and keystones at Castel del Monte.[42] Although typologically related to Roman examples, these Frederician busts display a more northern Gothic aspect in terms of their architectural function and style, attesting to the international character of his court workshop.

The relationship of the Janus *bifrons* to Frederician sculptures, however, goes beyond the compelling formal, technical, and iconographic parallels. Like other productions of Frederick's court artists, this work stems from the concerted effort to restore the Roman Empire of Augustus, a Golden Age of Peace. Frederick asserted this political agenda with the Capua gateway through its calculated programmatic use of Roman architectural design, actual reused Roman statuary and masonry, and several newly synthesized medieval "antiquities" such as the ones just mentioned. As a city gate and triumphal arch, it was an essential facet of Frederick's policy of reviving the ancient state life of Rome, which he did also through other works of art, public display and ceremony, court literature, and coinage. This *bifrons* relief of the Roman god Janus can be seen as yet another example of Frederick and his artists' coining an unprecedented "antiquity" whose subject and classical mode of representation would impress, arouse, and flatter the contemporary Roman aristocrats whose support he so desperately needed in his struggles with the Papacy and the northern Italian cities of the Lombard League. To appreciate fully the significance of Janus for Frederick and his court, it is useful first

to look into the available ancient literary and artistic sources, since this version of Janus so clearly differs from any other Janus/January image produced thus far in the Middle Ages.

Ovid undoubtedly provided the basic inspiration for both the image and its many levels of meaning. Not only is Janus two-headed, he also displays identical faces just as the god himself describes "my front and back look just the same" in the extended discourse of the *Fasti*. However, Frederick's sculptor added a novel detail, the foliate wreath with plump fruit—these figs are the prescribed cult offering to Janus according to Ovid (*Fasti*, I.185–86). Even the literary form of this portion of the *Fasti*, a monologue, shaped this Janus image. One of the most extraordinary features is the slightly open mouth of each head, defined by parted lips and prominent teeth. Janus appears to speak— he engages in a dialogue with the viewer analogous to the conversation between Janus and the author of the *Fasti*. This image illustrates in a literal fashion the passages which link Janus, the god of peace, to Augustus, the Emperor of Peace, an association that Frederick could not have overlooked. Janus concludes, "I had naught to do with war: guardian was I of peace and doorways," and then he explains his unusual shrine, the Temple of Janus, which Augustus undertook to restore in celebration of his establishment of a new era of peace:

> "My gate, unbarred, stands open wide, that when the people hath gone forth to war, the road for their return may be open too. I bar the doors in time of peace, lest peace depart, and under Caesar's star I shall be long shut up." He spoke, and lifting up his eyes that saw in opposite directions, he surveyed all that the whole world held. Peace reigned.[43]

Even Frederick the art collector and amateur archaeologist would have been hard pressed to find an artistic prototype, since Janus was generally not depicted in Roman monumental sculpture.[44] Yet Ovid's text conveniently provides a possible artistic source for the sculpture. When the author questions Janus regarding the other cult offering to him, copper coins, he accurately describes the Roman Republican coin known as the *as* which displays the two-headed image of Janus on the obverse side (figure 5.14).[45] These coins were extremely popular during the Roman Republic before they were replaced in Imperial times by coins bearing the emperor's portrait. Frederick, who closely imitated such Roman imperial coinage for his own issue, the *augustalis*,

Figure 5.14
Roman *as*, John Max
Wulfing Collection, Wash-
ington University, St. Louis

undoubtedly knew these ubiquitous "ancient coppers" with the double
image that Ovid identifies as Janus.

Another prototype that he would have known as a collector of an-
tiquities is the classical sculpture type known as a *herm*, which often
consisted of two addorsed male heads. Herms were often set up in the
peristyle or center of a house. Numerous examples of these works,
with bearded or youthful men displaying fruit and plant wreaths, must
have been available, especially in Campania. Herms generally depict
garlanded Dionysos or Silenus, but could easily have been mistaken
for Janus in the Middle Ages. Sculptures of this sort probably in-
spired the invention of Janus's unique fig wreath seen here. The herms
from the House of the Vettii at Pompeii exemplify the sculptural type
and its architectural context, surmounting a vine-covered freestand-
ing column.[46] Ancient sculptural prototypes such as these coins and
the herms lend support to the suggestion that the Janus relief was
never more than a bust-length representation. Although their relief
form indicates an original placement in a wall, perhaps, by analogy
with these herms, the heads also surmounted an engaged column or
pilaster.

The significance of the image of Janus to Frederick II lies within
the context of Roman history and literature, particularly Ovid's *Fasti*.
Frederick and his court *literati* were, of course, intimately familiar
with Roman writers such as Ovid, Vergil, and Horace, and looked
to them as literary models because their work glorified the imperial
family of Augustus. Such works were imitated deliberately in the vast

output of the imperial chancery. Frederick's court writers and rhetoricians directly quoted and followed the style of such works in countless letters and edicts. Roman literature even influenced Hohenstaufen architecture. As recently demonstrated, for the unusual polygonal design of his castle, Castel del Monte, Frederick drew upon Vitruvius's *De Architectura*, the ancient Roman authority on architecture, as part of his Augustan *"renovatio."*[47]

Since Frederick so frequently imitated Augustus in art and public ceremonies, he undoubtedly knew that the Temple of Janus had been restored by Augustus. The creation of this new "antiquity," a *bifrons* Janus, is yet another instance of Frederick restoring the world to the way it was under Augustus, Emperor of Peace. In its original architectural context this Janus relief would have followed ancient Roman precedent even more literally if it had been installed in a passageway, since the doors to the sacred precinct or passageway of Janus were closed ceremonially in times of peace as described in the *Fasti* (I.275–82).[48]

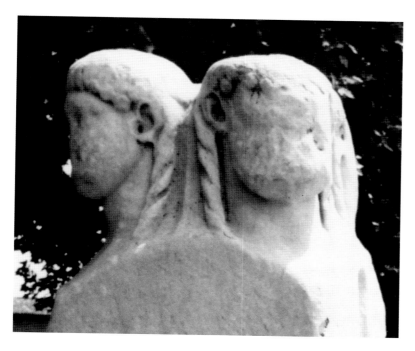

Figure 5.15
Herms on the balustrade of
Pons Fabricus, Rome

The *Bifrons* Relief of Janus

In this image, Frederick's sculptor has made the god appear propitiously, as he appears in Ovid's text, to herald a lucky year for military campaigns, to insure peace to the fruitful land, and to favor the senate and the populace, to use Ovid's expressions. These were all important concerns to Frederick and he likewise revived ancient Roman ceremonies to similar effect, most notably in the Roman battle cry "Miles Roma, miles imperator," the triumphal procession, and the trophy display in Rome which followed his victory at Cortenuova in 1237.[49] With his accurate knowledge of Roman religious and civic traditions, Frederick was probably also aware of Janus's important role in certain prayers and invocations. The Hymn of Salii extols Janus as *divom deus*, god of gods, heading the list of divinities even before Jupiter who are invoked to win victory for Rome.[50] This image may well be a comparable visual invocation to insure success by addressing the god of all commencement at the outset of one of Frederick's military ventures. In this way it relates also to Roman traditions for declaring war in which the *pater patratus* would invoke Janus, Jupiter, and other divinities, especially the personifications of boundaries and sacred law, in order to establish just cause and demonstrate the enemy's injustice.[51] Frederick, too, often used the epithet of *pater patratus*. To some extent even the Capuan gate's sculptural program can be interpreted in this manner, since the State and the Law have been personified here along with a head of Jupiter, whose exact placement on the arch is unknown.[52]

In other more subtle ways, the Capuan gateway suggests an iconographically appropriate context for the image of Janus. As Frederick's declaration of political objectives and accomplishments it resembles the ancient Roman inaugural activities described by Ovid on January 1, when new consuls, addressing the Senate and the Roman people, recalled personal and ancestral achievements and declared political views and aims. Since the gateway also celebrated the Cortenuova victory of 1237 and the beginning of his realization of the reborn World Empire of Peace, the inclusion of Janus, whom Ovid calls *custodia mundi* or guardianship of the world, would have served as a counterpart to the female personification of Custodia/Capua who protected the prototype and microcosm of this Empire, his hereditary kingdom of Sicily. The Capuan arch would have been a highly appropriate site for the image of Janus, not only as a city gate and symbolic doorway to Frederick's kingdom, but also as a *compita*, a

shrine at the sacred intersection of crossroads, here the old Roman highways the Via Flaminia and the Via Appia, which according to Ovid is venerated on the *Compitalia,* between January 3 and 5.

In this context the symbolism of the Capua arch and the Duke Janus *bifrons* coincide. L. A. Holland's formidable study discussed at length the various aspects of Janus and the significance of bridges —that is, roads crossing rivers—based on his ancient chthonic functions and later Roman use.[53] The monument Frederick built at Capua closely followed the form, function, location, and significance of a traditional Roman bridge-arch, a *ianua,* which marked where roads were carried over rivers.[54] Through Frederick's construction at Capua, the old Roman bridge where the Via Appia intersected the Volturno River was now open or *"pervius,"* allowing peaceable access to his kingdom. In antiquity a bridge-arch typically marked the approach—in this case Frederick's triumphal gateway. Moreover, following ancient precedents, his Capuan arch served also as a border marker denoting the beginning of Frederick's Sicilian kingdom, which relates to the role of Janus as guardian of the boundary.[55]

This is yet another way in which Frederick consciously emulated the ancient Roman emperors, who restored the Roman roads and built towered bridge-arches of marble with portrait sculptures. He could have known extant examples such as the Pons Aemilius in Rome or the Augustan arch at Rimini at the northern end of the Via Flaminia, also located near a bridge.[56] Other examples, described in detail in Roman literature, provided especially apt models, particularly the enterprises of Augustus such as the Rimini arch, the Milvian bridge-arch, and the arch of the Via Augusta in Spain, which is called *iano Augusto.*[57]

Frederick thus revived the traditional Roman architectural form built by ancient emperors, the towered bridge-arch at Capua, which functions honorifically as a triumphal monument and as an access-arch in the Janus tradition. To incorporate a sculptural image of the god Janus also would have been consistent with ancient Roman precedent. In his eagerness to evoke Augustan Rome, Frederick undoubtedly knew the historical accounts of Augustus's religious activities. Tacitus (*Ann.* 2.49), for example, mentioned a temple of Janus (*iano templus*) near the Theater of Marcellus among his list of ruined temples that Augustus began to restore. Pliny (N.H. 36.28) noted the cult image, a two-headed Greek sculpture, probably a herm, which Augustus brought from Egypt because Janus had not formerly been

depicted in Roman art. Frederick or his sculptors could well have known the rare but prominent example of Janus on a bridge in Rome —the Pons Fabricus across the Tiber river near the Theater of Marcellus, which still retains two of its original quadrifrontal herms on the balustrade, consisting of a pair of bearded heads, *pater* Janus, and a young pair, his associate Portunus (figure 5.15).[58]

There may never be any definitive archeological evidence to prove that the Duke Janus relief was installed in some portion of the Capua gateway. It provides a plausible architectural context, however, since the form and meaning of its architecture and sculptural decoration so eloquently complement the varied functions of Janus. The alabaster material of the Duke sculpture would have required an interior or protected placement. Perhaps it was set within one of the first-floor rooms of the towers adjacent to the arch's carriageway, where it would have imitated ancient descriptions of the image of Janus as guardian of his sacred precinct or passageway in ancient Rome.[59] But whether Janus once made his auspicious appearance at Capua or at another Hohenstaufen fortification or residence, this magnificent sculpture remains an important and unparalleled example of Frederick's unwavering goal to restore the Empire of the Caesars as expressed in his letter to the people of Rome following the Cortenuova victory:

> All powerful reason and nature which rules over kings make it our duty, in this moment of triumph, to extol the fame of the city which our predecessors exalted by the splendour of their triumphs and, in appropriate language we acknowledge our obligation. For if indeed the triumph is associated with the inevitable nature of its origin, we would not be able to exalt the imperial office unless first we extol the honour of the city which we recognize as the source of our *imperium*. . . . Accept, therefore, O Quirites, with gratitude the triumph of your Emperor! From this may your fondest hope be realized because, since we love to conform to the customs of antiquity, we aspire to the restoration of the ancient nobility of the city.[60]

What more suitable way for Frederick to restore the ancient nobility of Rome in the appropriate visual language, than to recreate for the first time in a thousand years an image of the quintessentially Roman deity, Janus?

Notes

I would like to thank my colleagues here at Duke—David Castriota, Caroline Bruzelius, and Michael Mezzatesta—as well as my co-contributors, Ilene Forsyth and Dorothy Glass, for their helpful suggestions during the preparation of this paper.

1. A recent inquiry to the firm by Caroline Bruzelius in May 1988 revealed no further information about its provenance.

2. Notable examples include composite capitals from Troia with four heads projecting from foliage and the bust of a princess at the Metropolitan Museum of Art in New York, which are reproduced in Württembergisches Landesmuseum, Stuttgart. *Die Zeit der Staufer. Geschichte Kunst, Kultur, Katalog der Ausstellung*, 4 volumes (Stuttgart, 1977), I, 665, no. 841, figures 623 and 671; no. 854, figure 632.

3. A scratch test was the telling clue since alabaster is soft enough to be lightly incised by a fingernail. A small sample was tested with dilute hydrochloric acid to confirm this identification. During the Middle Ages alabaster was used as a sculptural medium less frequently than the more durable limestone and marble. Alabaster's softness generally limited its use for interior embellishment, but this quality was hardly a liability since it could easily be carved in very fine detail. The surface can be highly polished and tinted to yield a work scarcely distinguishable from one produced in marble. While small-scale reliefs and tomb carvings were the most widely produced alabaster sculptures during the Middle Ages, in Tuscany its use goes back to Etruscan times, when it was used for cinerary urns. Regarding the Duke *bifrons,* the material still presents something of a puzzle. If the sculpture was produced in Capua or elsewhere in Campania the alabaster may have been imported from Tuscany. The question of why alabaster would have been imported rather than using the local marble and limestone is equally problematic, unless we assume that it was chosen as a cheaper and more quickly carved material. Stone samples were taken and studied in 1989 in the hopes of identifying the type and possible sources of alabaster in Italy or elsewhere in Europe.

4. Further study of the tool marks is intended to refine the relative and absolute chronology of the carving phases.

5. See Jaroslav Folda and John M. Schnorrenberg, eds., *A Medieval Treasury from Southeastern Collections,* catalogue for an exhibition at the William Hayes Ackland Memorial Art Center at the University of North Carolina, Chapel Hill, April 4–May 21, 1971 (Chapel Hill, 1971): 29, no. 27, for catalog entry by J. H. Knight.

6. See the exhibition catalog from the Württembergisches Landesmuseum, Stuttgart, *Die Zeit der Staufer,* for a range of objects and collected essays devoted to Hohenstaufen art; essays on a range of topics may be found in A. M. Romanini, *Federico II e l'arte del duecento italiana* (Atti della III Settimana di Studi di Storia dell'Arte Medioevale dell'Università di Roma) (Rome, 1980).

7. Hans Wentzel, "Antiken-imitationen des 12. und 13. Jahrhunderts in Italien," *Zeitschrift für Kunstwissenschaft* 9–10 (1955–56): 29–31, 69–70; Cesare Gnudi, "Considerazioni sul gotico francese, l'arte imperiale e la formazione di Nicola Pisano," *Federico II,* 1–18; Stefano Bottari, "Nicola Pisano e la cultura meridionale," *Arte Antica e Moderna* (1959): 43 ff.; M. L. Testi Cristiani, *Nicola Pisano e il Pulpito del Battistero di Pisa* (Pisa, 1984–86). See also Angiola Maria Romanini, *Arnolfo di Cambio* (2nd ed.) (Florence, 1980): 158 ff., and Martin Weinberger, "Arnolfo und die Ehrenstatue Karls von Anjou," in *Studien zur Geschichte der Europeischen Plastik* (Munich, 1965): 68–72, regarding the portrait statue of Charles of Anjou and its relation to the Frederick II statue from the Capua gateway.

8. Jill Meredith, "The Revival of the Augustan Age in the Court Art of Emperor Frederick II," in *Artistic Strategy and the Rhetoric of Power*, D. Castriota, ed. (Carbondale, Ill., 1986):39–56.

9. Franz Altheim, *A History of Roman Religion*, H. Mattingly, trans. (London, 1938): 194, regarding the specifically Roman nature of Janus as a divine force rather than in an anthropomorphic form.

10. All quotations from Ovid's *Fasti*, James George Frazer, trans. (Loeb Classical Library ed.) (London and New York, 1931).

11. See, for example, a Renaissance edition of the Calendar of 354, which shows a detailed version of this ritual activity, illustrated in James Carson Webster's *The Labors of the Months* (Princeton, 1938):14, 121, plate 3.

12. Webster, *Labors*, 134, plate 16, for illustrations from an eleventh-century manuscript from the Laurentian Library, Florence, MS Acq. e doni 181.

13. Webster, *Labors*, 57–66, 136–150, plates 25–29.

14. Roberto Salvini, *Wiligelmo e le origini della scultura romanica* (Milan, 1956): 171–75, figure 191, for the monthly labors from the Porta della Pescheria at Modena.

15. Webster, *Labors*, plate XXXIV. Regarding their chronology, see Evelyn Kain, "The Marble Reliefs on the Façade of S. Zeno, Verona," *Art Bulletin* LXIII/3 (1981): 358–73.

16. See Webster, *Labors*, 132–33, plates 14, 15, for examples in eleventh-century manuscripts of twin-faced January figures.

17. See Webster, *Labors*, 108, 114, for the complete calendrical poem by Ausonius (*Eclogues*, volume 3) which refers to January: "Iane nove, primo qui das tua nomina mensi. Iane bifrons, spectas tempora bina simul.," and the relevant passage from Isidore of Seville, *Etymologiae* V. xxiii: "*Ianuarius* mensis a Iano dictus, cuius fuit a gentibus consecratus; vel quia limes et ianua sit anni. Vnde et bifrons idem Ianus pingitur, ut introitus anni et exitus demonstraretur."

18. Webster, *Labors*, plate 21.

19. Webster, *Labors*, plate XXIX.

20. Gianni Capelli, *I Mesi Antelamici nel Battistero di Parma* (Parma, 1976); Geza de Francovich, *Benedetto Antelami, architetto e scultore, e l'arte del suo tempo* (Milan and Florence, 1952):177–88, 229–43, 265–77, figures 298–324; Anna Rosa Masetti, "Il Portale dei Mesi di Benedetto Antelami. I," *Critica d'arte* n.s. XIV (1967):13–31; A. C. Quintavalle, *Romanico padano, civiltà d'Occidente* (Florence, 1969):145–63, figures 304–24.

21. Capelli, *Mesi*, 45–46.

22. T. Krautheimer-Hess, "The original Porta dei Mesi at Ferrara and the art of Niccolò," *Art Bulletin* 26/3 (1944):152–74; Carlo L. Ragghianti, "Sculture del secolo XII a Ferrara. 2. Il Maestro dei Mesi," *Critica d'Arte* n.s. 25 (43) (1978):21–41.

23. Masetti, "Il portale," figure 6.

24. Ovid, *Fasti*, I. 185.

25. Excellent biographies include Ernst H. Kantorowicz, *Kaiser Friedrich der Zweite*, 2 volumes (Berlin, 1927–31; Erganzungsband 2. unveräderte Aufl.: Stuttgart, 1980); and Thomas C. Van Cleve, *The Emperor Frederick II of Hohenstaufen. Immutator mundi* (Oxford, 1972); David Abulafia, *Frederick II: A Medieval Emperor* (London, 1988). A major source for the extant imperial letters and edicts is J. L. Huillard-Bréholles, *Historia Diplomatica Friderici Secondi*, 6 volumes (Paris, 1852–61).

26. Antonino de Stefano, *La cultura alla corte di Federico II imperatore*, 2 volumes (Bologna, 1950); C. H. Haskins, "Latin Literature under Frederick II," *Speculum*

3 (1928):129–51; Van Cleve, *Frederick*, 299–332 and 585–86, for additional bibliography on the Latin literature and scientific learning at the imperial court.

27. C. A. Willemsen, ed., *Fredericus II, De arte venandi cum avibus*, 2 volumes (Leipzig, 1942); F. Mütherich, "Handschriften im Umkreis Friedrichs II.," in *Probleme um Friedrich II.*, J. Flekkenstein, ed. (Konstanzer Arbeitskreis, Vorträge und Forschungen 16) (Sigmaringen, 1974).

28. C. A. Willemsen, "Die Bauten Kaiser Friedrichs II. in Süditalien," in *Die Zeit der Staufer* III, 143–64.

29. James M. Powell, trans., *The Liber Augustalis; or Constitutions of Melfi, Promulgated by the Emperor Frederick II for the Kingdom of Sicily in 1231* (Syracuse, 1971).

30. Heinrich Kowalski, *Die Augustalen Kaiser Friedrichs II von Hohenstaufen* (Geneva, 1976).

31. Regarding Hohenstaufen portraiture, see H. Buschhausen, "Die Rezeption der Antike und der Einbruch der französischen Gotik in der unteritalienischen Plastik des 13. Jahrhunderts," *Studi di Storia dell'arte in memoria di Mario Rotili* (Naples, 1984):201–9; L. Quartino, "Un busto genovese di Federico II," *Federico II*, 325–38; C. A. Willemsen, *Die Bildnisse der Staufer. Versuch einer Bestandsaufnahme* (Göppingen, 1977); H. Buschhausen, "Das Altersbildnis Kaiser Friedrichs II.," *Jahrbuch der Kunsthistorischen Sammlungen in Wien* 70 (1974):22–38; G. Kaschnitz-Weinberg, "Bildnisse Kaiser Friedrichs II. von Hohenstaufen," *Mitteilungen des Deutschen Archäologischen Instituts. Römische Abteilung* 60–61 (1953–54):1–21, 62; (1955):1–52.

32. *Zeit der Staufer* I, 669–70, figure 627; A. Prandi, "Un documento d'arte Federiciana—Divi Friderici Caesaris Imago," *Rivista dell'Istituto Nazionale d'Archeologia e Storia dell'arte* n.s. 2 (1953):263–302.

33. The head is now lost but its appearance is known from drawings and a cameo (figure 5.10) made from the original. See *Zeit der Staufer* I: 665–66; III: figure 74; E. Langlotz, "Das Porträt Friedrichs II. vom Brückentor in Capua," *Beiträge für G. Swarzenski* (Berlin, 1951):45–50.

34. *Die Zeit der Staufer* II: figure 625.

35. Antonio Giuliano, "Motivi classici nella scultura e nella glittica de età normanna e federiciana," *Federico II*, 23ff., figures 12 and 13. The soft waves that fall around the sides of the head and beard also recall the head of King Henry II from the Adam portal at Bamberg Cathedral (before 1237) and related works which have already been compared to Frederician portraiture such as the Barletta head; see above, note 32. There is, in fact, little stylistic homogeneity within the *corpus* of sculptures associated with imperial patronage; this undoubtedly reflects the heterogenous background of the court artists, some of whom may well have come from the northern regions of the Holy Roman Empire. Concerning the larger problem of German Gothic sculpture and Hohenstaufen art of southern Italy, see most recently Otto von Simson, "Nuovi temi della scultura monumentale tedesca nell'età di Federico II di Hohenstaufen," *Federico II*, 391–401.

36. C. A. Willemsen, *Kaiser Friedrichs II. Triumphtor zu Capua* (Wiesbaden, 1953); C. Shearer, *The Renaissance of Architecture in Southern Italy* (Cambridge, 1935). For a recent discussion of the iconography of the Capua gateway sculptures as they relate to Frederick's Augustan *"renovatio,"* see Meredith, "Revival," 43–56. The undercurrent of Christian symbolism was considered recently in K. Bering, *Kunst und Staatsmetaphysik des Hochmittelalters in Italien: Zentren der Bau- und Bildpropaganda in der Zeit Friedrichs II.*, in Kunst-Geschichte und Theorie 5 (Essen, 1986):15–35.

37. William L. Macdonald, *The Architecture of the Roman Empire*, volume II (New Haven, 1986):figure 80.

38. See Willemsen, *Triumphtor*, 49–55, figures 50–68, for multiple and comparative views of these portrait busts.

39. Van Cleve (*Frederick*, 428) cites a typical example of della Vigna's calculated use of verses from Ovid's *Heroides* in a public address.

40. Her border inscription clarifies her identity and her association with Frederick: "Cesaris imperior regni custodia fio." ("By command of Caesar I am *custodia* [the protection or guardianship] of the kingdom.") See Meredith, "Revival," 50–51, figure 4.10, for illustration and detailed discussion; she is also reproduced in *Die Zeit der Staufer* III, plate LII, figure 74.

41. See my forthcoming article, "The Arch at Capua: the strategic use of *spolia* and references to the Antique," *Studies in the History of Art*, the National Gallery of Art, W. Tronzo, ed., 1990, and also Willemsen, *Triumphtor*, 17 ff., 56 ff. Some of the busts are still *in situ* while others were brought to Capua and immured in medieval structures. See Gennaro Pesce, *I rilievi dell'anfiteatro campano*, Studi Materiali del Museo dell'Impero Romano 2 (Rome, 1941).

42. C. A. Willemsen, "Die Bauten Kaiser Friedrichs II. in Süditalien," *Zeit der Staufer* III, plate XXXVII, figures 45, 46.

43. F. W. Shipley, "Chronology of the Building Operations in Rome from the Death of Caesar to the Death of Augustus," *Memoirs of the American Academy at Rome* 9 (1931):42 and 56, no. 14, regarding the temple of Janus in the Forum Holitorium (Tacitus, *Annals*, II.49).

44. Louise Adams Holland, *Janus and the Bridge*, Papers and monographs of the American Academy in Rome XXI (Rome, 1961):274–83.

45. Michael H. Crawford, *Roman Republican Coinage* II (Cambridge, 1974):715 identifies the Janiform image on the obverse as the Dioscuri. Nevertheless, according to Ovid (*Fasti*, I. 228–32) they depict Janus, which undoubtedly reflects current belief in Roman imperial times.

46. T. Kraus and L. von Matt, *Pompeii and Herculaneum* (New York, 1975): figure 88.

47. Tanja Ledoux, "Castel del Monte (1240–1246) e il 'De Architectura' di Vitruvio," *antichità viva* 23/1 (1984):19–25, discusses how and why this Roman literary work influenced Hohenstaufen architectural design. She noted medieval manuscripts of Vitruvius that Frederick, who personally supervised these plans, could have seen.

48. See Holland, *Janus*, 110ff., 129ff., regarding Augustus and rites associated with the opening and closing of the Janus temple based on the accounts of Roman historians Suetonius and Cassius Dio.

49. Regarding the revival of Roman imperial ceremonies, see Kantorowicz, *Friedrichs II.*, 401–16; Van Cleve, *Frederick*, 407–9.

50. H. H. Scullard, *Festivals and Ceremonies of the Roman Republic*, 61.

51. Altheim, *Roman*, 423–24, who cites Livy, I, 32 ff.

52. Willemsen, *Triumphtor*, figures 69, 70.

53. Holland, *Janus*, 286–309, regarding the later Roman imperial monuments. Throughout the author interprets the massive literary evidence regarding the cult of Janus, Janus monuments, and the topography of ancient Rome.

54. Macdonald, *Roman* II, 77, figures 72, 73.

55. Holland, *Janus*, 287.

56. See my forthcoming article on *spolia* and Frederick's arch at Capua.

57. Holland, 290–94. These are mentioned in Cassius Dio (53.22) and in the *Res Gestae* of Augustus (4.20) and also commemorated in his coins issued around 17–16 B.C., which depict arches displaying sculptures. The Roman poet Statius (*Silvae* 4., 3.78–97 ff.) describes yet another—the marble bridge-arch of the Emperor Domitian with a trophy display, specifically termed *ianua,* which was erected where the Via Domitiana intersected the Volturno river.

58. Holland, *Janus,* 212–18.

59. During excavations in 1930 the lower portions of pilasters and engaged columns were uncovered. For photographs and ground plans, see Shearer, figures 14.4 and 76.

60. Huillard-Bréholles, *Historia* V, pt. I, 161–63, as cited and translated in Van Cleve, *Frederick,* 410.

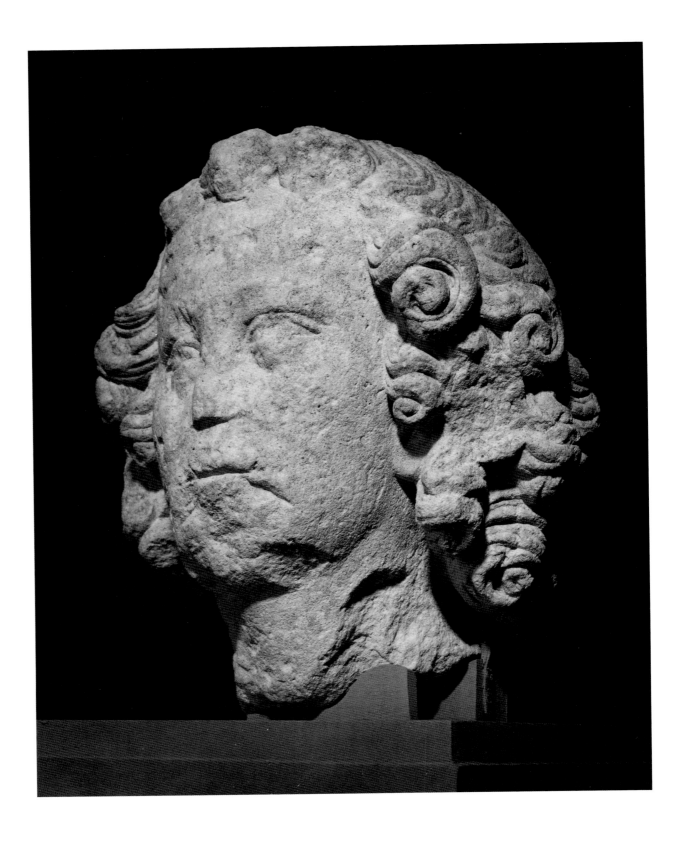

A Parisian Virtue[1]

Dieter Kimpel

When I came to Durham in October 1987 I was astonished to discover in the storage area of the Duke Museum of Art a large but battered Gothic head that had long escaped attention (figures 6.1–6.4). Purchased shortly before the war in July 1937 from a certain Madame Chassot, the head is described in the museum files as the "head of an angel, France, 1260s, Burgundy(?)." Although the head was very dirty when I first saw it,[2] there was no doubt as to its authenticity, or to its French origin, and the date proposed in the museum files was also approximately correct. Recent cleaning has confirmed my initial impression that the head is an important example of mid-thirteenth century sculpture from the Île-de-France, and on the basis of close examination I can now propose an even more exact attribution. The head is by the hand of the Parisian sculptor whose main work can be found on the north transept portal of the cathedral of Notre Dame in Paris (figure 6.5), and may well come from the west jamb of this same portal, which was carved about 1245 or shortly thereafter.

Unfortunately, the Brummer archives are extremely laconic and provide no details on the provenance of the head; we do not know, for example, how the head came into the possession of Madame Chassot, nor have we any information as to where it was before it entered her possession.[3] As far as I know, there are no other securely identified vestiges of the Virtues from the west jamb of the north transept portal, although various fragments now in the Cluny Museum have been associated with it.[4] The attribution proposed here represents work in progress, and certain aspects await further study and examination; an analysis of the stone may, for example, confirm or dismiss the attribution proposed here.

The remodeling of the north transept arm at Notre Dame took place shortly after the completion of the cathedral and represents one of the most important phases of the modernization of the church that took place in the second and third quarters of the thirteenth century.[5] The transept facade has long been attributed to Jean de Chelles, who subsequently (in 1257) began construction on the south transept facade. The north transept portal opened towards the cloister of the canons, located on the north side of the cathedral, which gave this portal the name of "Porte du Cloître" (figure 6.5). It was decorated with figures of the Virgin and Child on the trumeau, flanked on her right (the eastern doorjamb) by the Three Magi, and on her left (the western jamb)

◄Figure 6.1
Head from Notre-Dame,
left side (1966.179)
H: 30.5 (13")
W: 26.7 (12 ¼")
D: 23.5 (9 ½")

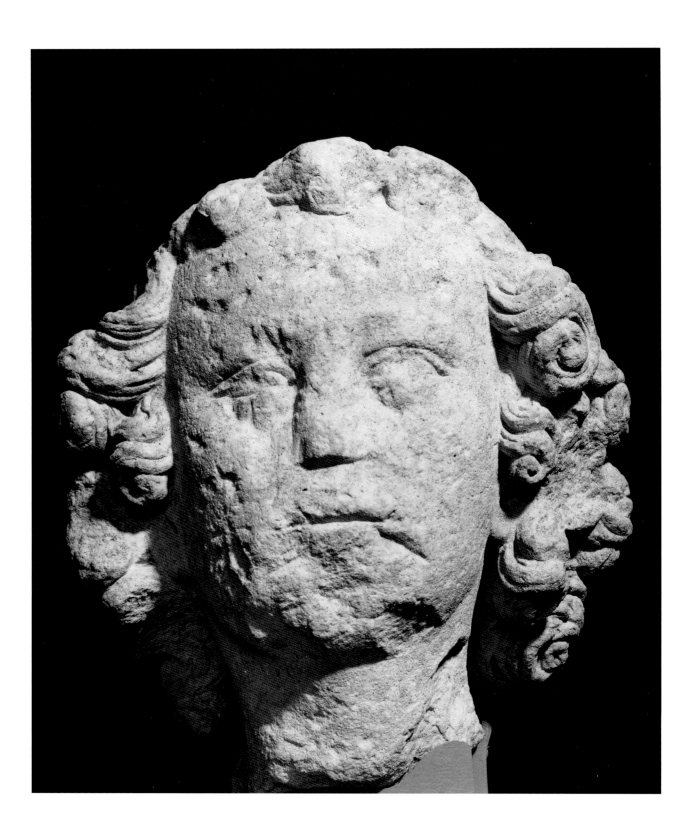

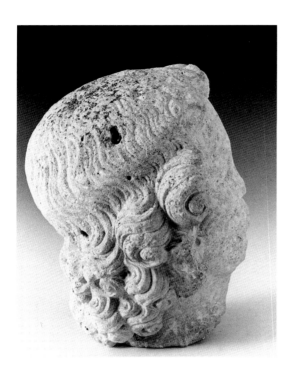

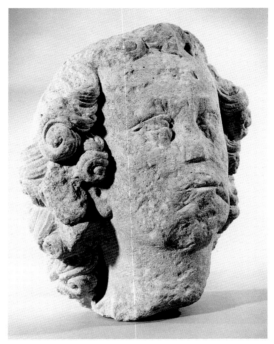

by the three theological virtues, Faith, Hope, and Charity.[6] Of these figures, only the Virgin survives in place; the rest of the program is known only through early descriptions.[7] Above the Virgin a tympanum contains scenes from the Infancy on the lowest register, while the two upper bands illustrate one of the Virgin's best-known miracles, the legend of Theophilus. The three densely carved archivolt arches contain, on their outer row, seated male prophets with banderoles; standing female figures, probably representing the Wise Virgins; and angels.[8]

The north portal introduced several novel features in Gothic sculpture. Here one can find the earliest examples of the use of the Theological Virtues as large-scale jamb figures. This is also the first known instance of figures standing within niches, rather than above consoles or shafts projecting from the wall structure; it thus represents an important new development in the design and character of Gothic

◄Figure 6.2
Head from Notre-Dame, frontal view

Figure 6.3
Head from Notre-Dame, right side

Figure 6.4
Head from Notre-Dame, three-quarter view

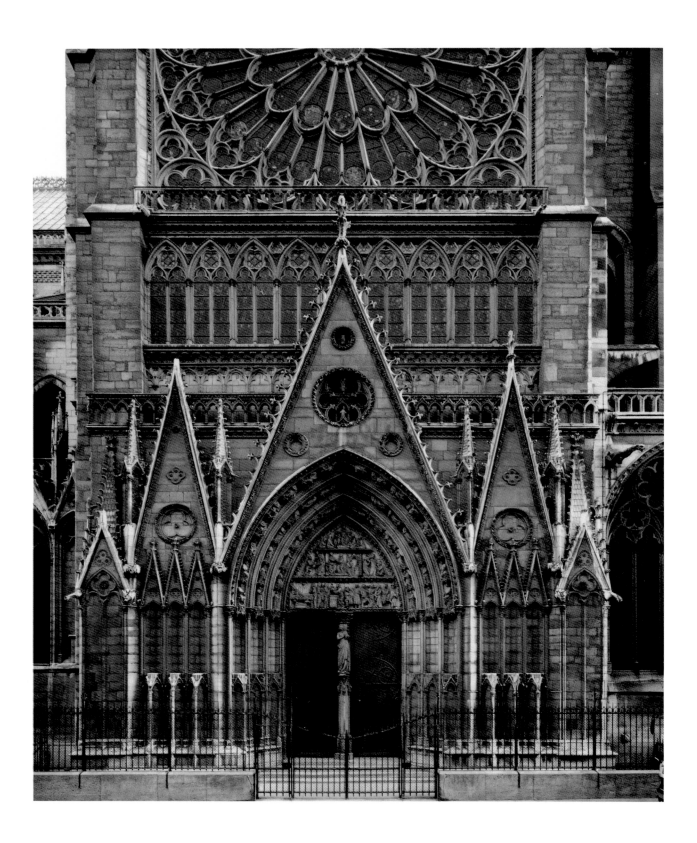

portals. The narrow niches are polygonal and topped by octagonal baldachins (figure 6.5), an arrangement that was very influential in the design of later Gothic portals. These details will be significant for our discussion of the head at Duke.

Let us begin with a close analysis and description of the motifs, style, and general character of the head at Duke which I associate with this portal. It is a fine example of the "Precious Style" identified and described by Willibald Sauerländer, which dominated sculpture in the area of Paris beginning in the 1230s.[9] A typical characteristic of this style is visible in the thick but elastic spiral locks that frame the head on each side (figure 6.1). Three more locks also projected above the brow but have been badly damaged. The eyes are broadly drawn; the eyeballs protrude, swelling outward from almost horizontal lower lids, while the upper lids rise upward at an angle. Underneath the eyes pronounced tear glands swell outward. The nose appears short, the lips are tightly pressed together, and the mouth cuts horizontally above a strongly projecting chin. The cheekbones are high and pronounced. Directly above the curling spirals the hair is indented (figure 6.2). This, along with the vestiges of drilled indentations for ironwork attachments immediately above the spiral locks, demonstrate that the head once wore a diadem or a crown, probably of metal. These details are important for the iconographic interpretation of the head, as I will demonstrate below. The gender of the head however, cannot be ascertained with certainty.

The head seems to look towards the right, and, in general, the sculptor appears to have been very concerned with the points of view from which the head would have been seen. The transitions from full-face to profile views in the temples and cheeks are rather abrupt. The ringlets in the frontal view and left profile are more fully finished and elastic, whereas the right profile is handled in a somewhat doughy, less finished manner (figure 6.4)—an indication that the head was primarily intended to be seen from two angles only. This characteristic reflects the original setting and context for the head proposed here.

The stylistic and iconographic aspects of the Duke head, its dimensions,[10] and the sculptor's use of a oolitic, somewhat porous limestone characteristic of certain phases of construction and decoration at the cathedral of Paris, suggest that the piece can be associated with the north transept portal of Notre Dame in Paris. I previously analyzed the sculpture of that portal in a lengthy study published in 1971.[11] On

Figure 6.5
North transept portal, Notre-Dame Cathedral, Paris

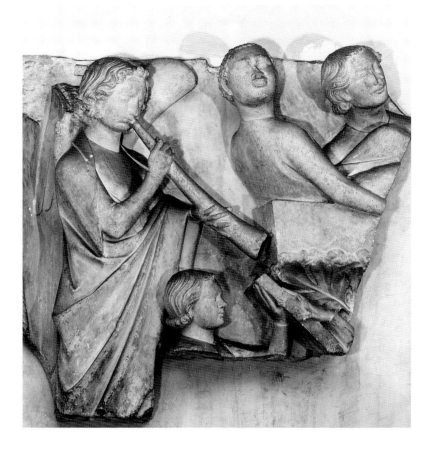

the basis of stylistic criteria I was able to demonstrate that the sculpture of the north transept was essentially divided between two masters and their assistants. One of them I called the "Master of the Virgin." To him I attributed the well-known Virgin from the trumeau and the Theophilus reliefs in the upper two zones of the tympanum—both still in place on the portal—as well as the Three Magi that once decorated the adjoining flying buttress pier just east of the north transept facade now in the Cluny Museum. I also attribute to this master the so-called "schoolboy reliefs" on the south transept facade. A torso of a king probably produced in the circle of this master can also be associated with the left jambs of the north transept portal.[12] The head of a king discovered in 1977 in the foundations of the Banque Française du Commerce Extérieur also belongs in this group (Cluny, number 23127),[13] as well as the head discovered in 1979 at the same site and still in the possession of the bank.[14] These works by the "Master of the Virgin" are of no further interest to us in our discussion of the head at Duke, however, for they are all the work of a different sculptor.

The head at Duke is apparently the work of the other master active

Figure 6.6
Fragment from the lintel of the central portal of the west facade at Notre-Dame, Paris, Musée national des Thermes et de l'Hôtel de Cluny, Paris (18.643)

on the north transept portal, the sculptor I identified as the "Master of the Childhood Scenes." This master seems to have been engaged at Notre Dame for a long time, for his work is not only traceable in the lower and upper parts of the north transept facade, but also in the considerably earlier work on the left lintel of the central portal of the west facade. The dating of the latter remains under discussion.[15] Some of the last sculpture to have been completed on the south transept facade can also be attributed to this master; his employment at the cathedral thus stretched out over somewhat more than three decades. So far as I have serviceable illustrations at hand, I propose here to draw a profile of this master's career and work, thereby suggesting the analogies with the head I discovered at Duke.

The trumpet-blowing angel in the left fragment of the lintel from the central portal of the west facade has numerous similarities with the Duke head (figure 6.6). These can be found in the handling of the locks of hair and especially in the general conception and details of the face—the straight pursed lips of the mouth, the heavy chin, the large and full cheeks, and the somewhat clumsy transition from the head to the neck.

Figure 6.7
Archivolt on the right side of the north transept portal, Notre-Dame, Paris

These characteristics are even more pronounced in the lower fig-
ures on the right archivolt of the north transept portal (figure 6.7).
They recur in the heads of the figures on the lintel and the lower
figure on the left archivolts, as well as in the somewhat doughy treat-
ment of the hair in the figure of Simeon in the Presentation scene on
the lower lintel (figure 6.8). The connections become clearer if we
consider the angel to the right of the north transept rose (figures 6.9–
6.10), the surface of which, however, was recently badly damaged
during the cleaning of this part of the church in 1969. The same hand
also carved two small tympana dedicated to Saint Martin above the
niches in the south transept facade (figure 6.11), as well as the figures
of Moses and Aaron at the level of the triforium passage under the
rose on the south side (figures 6.12–6.14).[16]

In 1977 a head of a woman (Cluny 23128) surfaced, which I would
likewise attribute to the "Master of the Childhood Scenes" (figure
6.15).[17] Although the hairstyle is rather different from that of the head
at Duke, the lower lids are more clearly curved, and the eyes are
etched with crow's feet, a glance at the other figures (the Simeon of
the Presentation, for example) demonstrates that this head nonethe-
less adheres to the stylistic characteristics of the same master, whose

Figure 6.8
Presentation in the Temple,
tympanum of the north
transept portal, Notre-
Dame, Paris

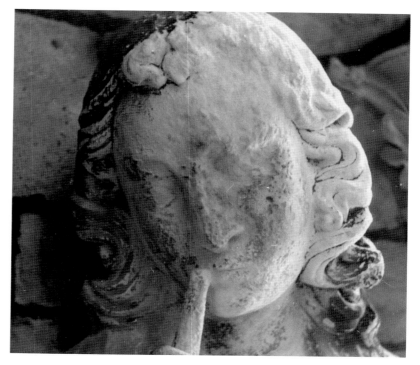

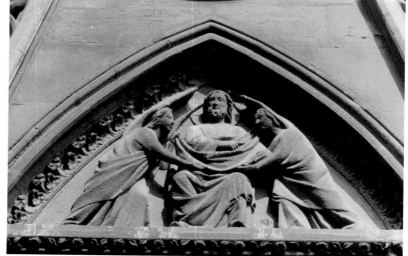

Figure 6.9
Trumpet blowing angel on the north transept
facade to the right of the rose window,
Notre-Dame, Paris (Above)

Figure 6.10
Trumpet-blowing angel, detail, Notre-
Dame, Paris (Top right)

Figure 6.11
Tympanum to the left of the portal of the
south transept facade, Notre-Dame, Paris
(Bottom right)

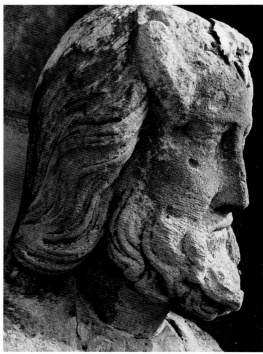

abundant repertoire of forms appears most plainly in the archivolt figures.

In discussing the female head (Cluny 23128), the authors of the Cluny catalogue placed it in the western (right) jamb of the north transept portal.[18] Old descriptions identified those jamb sculptures as the theological virtues, Faith, Hope, and Charity. It is highly likely that the head in Durham also belongs in this context. Certainly the material evidence would tend to confirm such an attribution. The character of the limestone is very similar (a somewhat porous, creamy-colored limestone with many fossil deposits). The dimensions are also strikingly close: the Paris head measures 33 by 26 by 26 centimeters, while the Duke head measures 30 by 26 by 23.5. The beautiful head of a king also now in the Cluny Museum (Cluny 23127) probably comes from the doorjamb opposite the Virtues (figure 6.16). It would have been the head of one of the three kings of the Adoration coming towards the Virgin from the left. The head measures 41 by 30 by 23 centimeters; these dimensions correspond closely to the other two heads, especially when one considers that the measurements include part of his shoulder.

There are other arguments in favor of the attribution of the head at

Figure 6.12
Head of Aaron, detail of figure to the right of the south transept rose, Notre-Dame, Paris

Figure 6.13
Head of Moses, detail of figure to the left of the south transept rose, Notre-Dame, Paris

Duke to the north transept portal of Notre Dame in Paris. If the head
in Durham still had the diadem that the holes and the ridge in its hair
suggest, it would conform well with the characteristics of a Virtue.
The well-known Virtues from Strasbourg have the same motif (figure
6.17); the latter were based on the Parisian prototype at Notre Dame
discussed here. Indeed, although the Strasbourg figures date to the end
of the thirteenth century, they help us reconstruct something of the
original appearance of the Virtues of the portal in Paris. Whether the
head in the Cluny Museum (figure 6.15) also wore a diadem I can-
not say for sure, and I share some of the uncertainties of my French

Figure 6.14
Figure of Moses to the left
of the south transept rose,
Notre-Dame, Paris

135 A Parisian Virtue

colleagues, who may be correct in thinking that the head in question might also have come from a figure in one of the niches in front of the north facade that adjoin the jambs.[19] On the other hand, the condition of head number 242 (figure 6.15) conforms to a location on the outermost niche on the right jamb of the north transept portal; the noticeable weathering on the left side would have occurred if the head had been placed towards the exterior of the portal. Although severely battered, the head at Duke shows none of this type of weathering, which suggests a location in one of the other two niches towards the interior of the portal.

My attribution of the Duke head is also supported by my earlier observation that it was designed to be seen from two points of view only —full face and the left profile. In my monograph on the transept portals of Notre Dame I demonstrated at length that such an approach to the handling of the face is a fundamental characteristic of the entire sculptural cycle of the north transept.[20] This treatment holds true not only for the Virgin of the trumeau, but also for the archivolt figures, and, I believe, for the king's torso (Cluny 18650) mentioned above.

If my attribution of this head at Duke as a Virtue from the north transept portal is correct, it would have been carved in about 1245 or shortly thereafter, and would have been one of the earliest works

Figure 6.15
Head of a woman (one of the Theological Virtues?), Musée national des Thermes et de l'Hôtel de Cluny, Paris (242)

Figure 6.16
Head of a king, Musée national des Thermes et de l'Hôtel de Cluny, Paris (240)

Figure 6.17 ►
The Theological Virtues, left portal, west facade, Strasbourg Cathedral

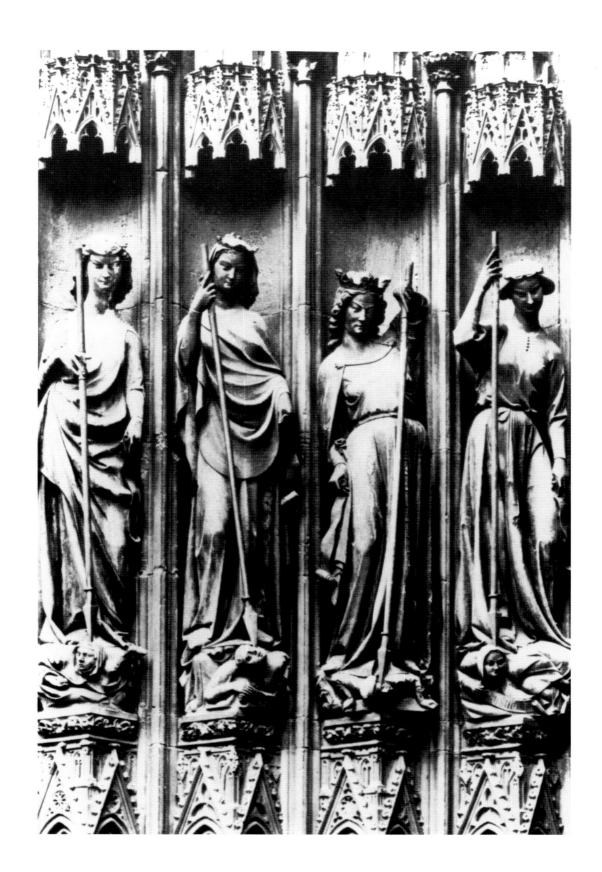

of the entire sculptural cycle on the north transept. To confirm this theory, an examination of the head alongside the fragments now in the Cluny Museum in Paris would be highly desirable; at least it is to be hoped that a plaster cast can be made and taken to France. Only direct confrontation with the various pieces associated with the portal will permit further progress on this most interesting head at Duke.

Notes

1. I would like to thank the Department of Art and Art History of Duke University for the invitation to deliver the Benenson lectures in October 1987, and especially my friend Caroline Bruzelius, at whose instigation I was invited. On that occasion I had the opportunity to visit the remarkable collection of medieval sculpture in the Duke University Museum of Art. I am grateful to the Director of the Museum, Dr. Michael Mezzatesta, and Ms. Louise Brasher, Assistant Curator, who gave me access to the storage areas and museum files and provided me with photographs of several of the objects. Caroline Bruzelius translated this essay.

2. No traces of the original polychrome survive. (Editor's note: the head is now on view in the medieval gallery.)

3. The damaged condition of this head is the result of the Revolutionary destruction of the sculptural decoration of the cathedral; see Alain Erlande-Brandenburg and Dominique Thibaudat, *Les Sculptures de Notre-Dame de Paris au musée de Cluny* (Paris, 1982):9–10; for the state of the sculpture before the Revolution, see Dieter Kimpel, *Die Querhausarme von Notre-Dame zu Paris und ihre Skulpturen* (Bonn, 1971):230–34, and Erlande-Brandenburg and Kimpel, "Le Statuaire de Notre-Dame de Paris avant les destructions révolutionnaires," *Bulletin monumental* (1978):213–66.

4. For example, Cluny 23128. See Erlande-Brandenburg and Thibaudat, *Les Sculptures*, 88–89.

5. For the construction of the transepts of Notre-Dame, see my revised doctoral dissertation, *Die Querhausarme*. A more general but somewhat dated survey of the entire cathedral is Marcel Aubert's *Notre-Dame de Paris: Sa place dans l'histoire de l'architecture du XIIe au XIVe siècle* (Paris, 1920; second edition, 1929). For a recent analysis of the construction of the main body of the cathedral, see C. Bruzelius, "The Construction of Notre-Dame in Paris," *Art Bulletin* LXIX (1987):540–69.

6. The terms "left" and "right" are always employed as the figure's left and right according to the medieval customs of representation.

7. See Abbé Lebeuf, *Histoire de la ville et de tout le diocèse de Paris*, volume I (Paris, 1754):8. See also the summary of the evidence in Erlande-Brandenburg and Thibaudat, *Les Sculptures*, 8–9.

8. For a lengthier discussion of the iconography, see Kimpel, 108–10.

9. See Willibald Sauerländer, *Gotische Skulptur in Frankreich 1140–1270* (Munich, 1970):57–59.

10. See figure 6.1 for the dimensions.

11. Compare with Kimpel, *Die Querhausarme*, 124–69. This dissertation was finished shortly before Sauerländer's remarkable book appeared, in which he comes to conclusions very similar to my own; See particularly Sauerländer, *Gotische Skulptur*,

154. I am still indebted to Professor Sauerländer for the guidance he gave me during my work, and I was of course very pleased to see that he and I had arrived at similar conclusions.

12. A photograph of the torso (Cluny 18650) may be found in Erlande-Brandenburg and Thibaudat, *Les Sculptures de Notre-Dame de Paris*, 90. For this attribution, see Kimpel, *Die Querhausarme*, 201–3, 282–83, and figures 204–6. My attribution to the northern transept portal has now been accepted (see, for example, Erlande-Brandenburg and Thibaudat, *Les Sculptures*, 90). On page 162 I had first attributed this torso to the other master.

13. Erlande-Brandenburg and Thibaudat, *Les Sculptures de Notre-Dame de Paris*, 87–88.

14. Ibid., 85, figure 29; see also their "Une tête inédite provenant du bras nord de Notre-Dame de Paris," *Mélanges d'archéologie et d'histoire médiévales en l'honneur du Doyen Michel Boüard, Mémoires et documents publiés par la société de l'École des Chartes XXVII* (Geneva/Paris, 1982):137–41.

15. Compare with Kimpel, *Die Querhausarme*, 166–67: "about 1230," and Alain Erlande-Brandenburg, "Nouvelles remarques sur le portail central de Notre-Dame de Paris," *Bulletin monumental CXXXII* (1974): 287–96; Erlande-Brandenburg and Thibaudat, *Les Sculptures*, 30: "the decade of 1240." I am still convinced of the earlier date. See also Sauerländer, *Gotische Skulptur*, 138, figure 146: "1220–30." This opinion is shared by Robert Suckale, *Studien zu Stilbildung und Stilwandel der Madonnenstatuen der Ile-de-France zwischen 1230 und 1300* (Munich, 1971).

16. I should note that most of the plates are my own; it would be highly desirable if the transept sculpture were competently and thoroughly photographed by a professional to assist in verifying the affinities suggested here.

17. Cluny 23128. Compare with Erlande-Brandenburg and Thibaudat, *Les Sculptures*, 85–88, and "Une tête inédite," 138–39, figure 4. I agree with Erlande-Brandenburg and Thibaudat, who, when comparing this piece with the bearded head mentioned above, describe the similarities in the motifs and then state: "Il existe cependant entre elles une différence qui mérite d'être soulignée: la largeur du visage de la femme tranche avec celle de la tête barbue. . . . Il s'agit là d'un canon commun qui ne permet pas d'y voir l'oeuvre d'un même artiste." See also his hesitancy on a secure attribution in the catalogue *Les Sculptures*, 85.

18. Ibid.

19. Erlande-Brandenbourg, "Une tête inédite . . . ," 137–41.

20. Compare with Kimpel, *Die Querhausarme*, 130–36, 155–57.

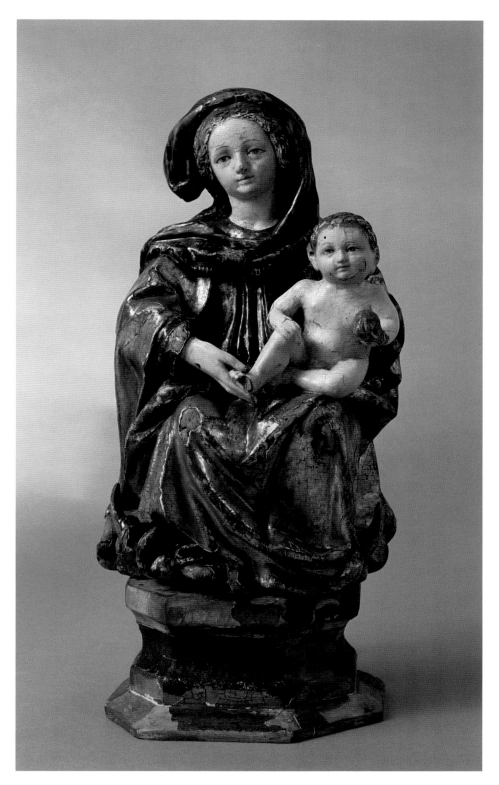

Plate I Seated Virgin and Child (1966.100), catalogue no. 37

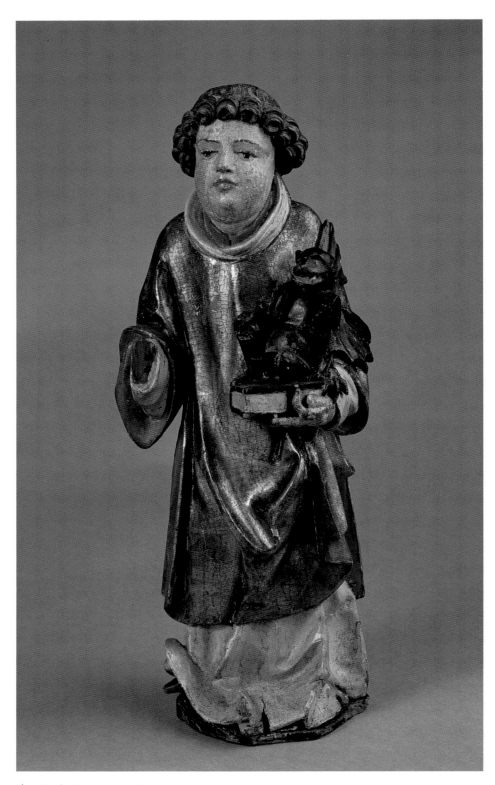

Plate II St. Cyriacus (1966.23), catalogue no. 35

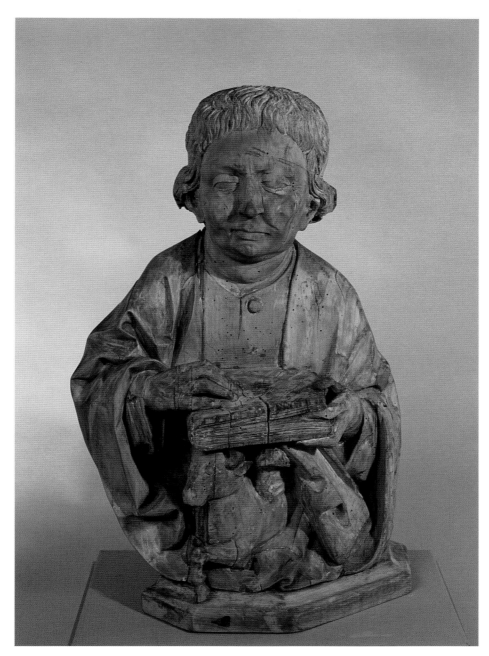

Plate III St. Luke (1966.101), catalogue no. 36

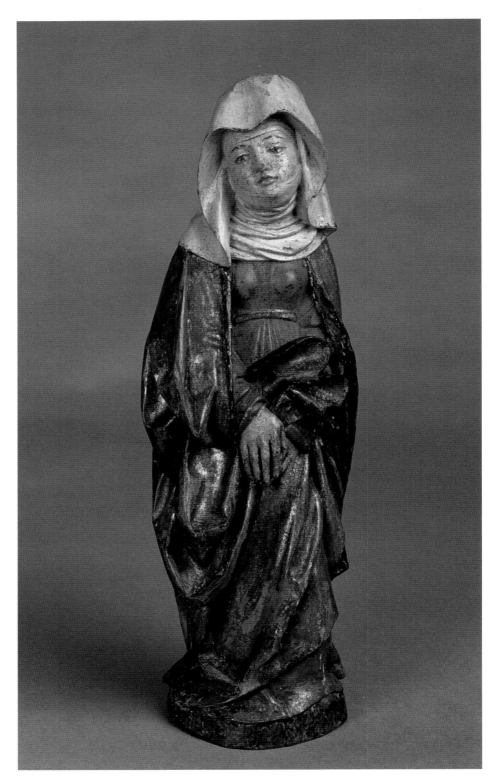

Plate IV St. Anne (?) (1966.22), catalogue no. 34

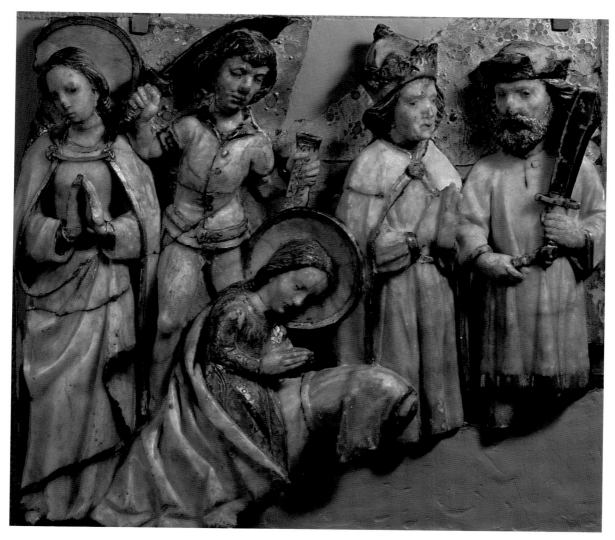

Plate V Alabaster relief of a martyrdom (1966.47), catalogue no. 29

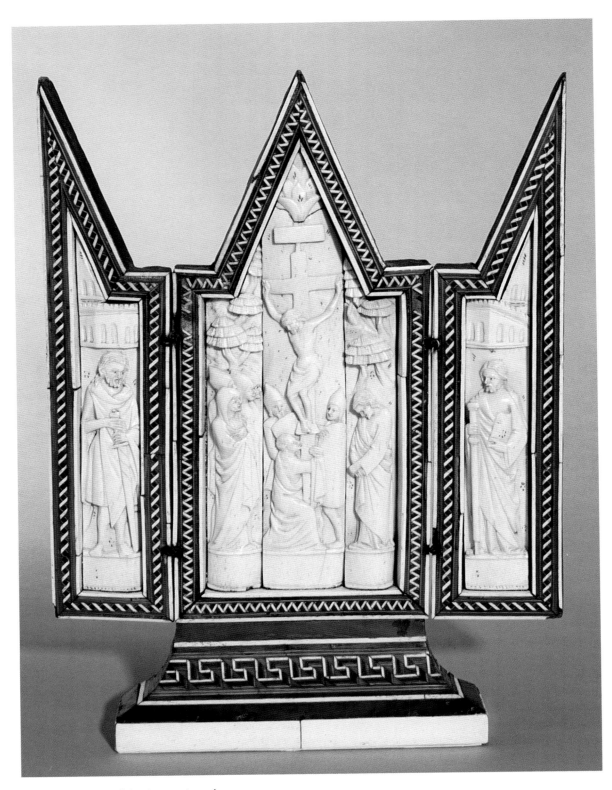

Plate VI Ivory crucifixion (1966.30), catalogue no. 27

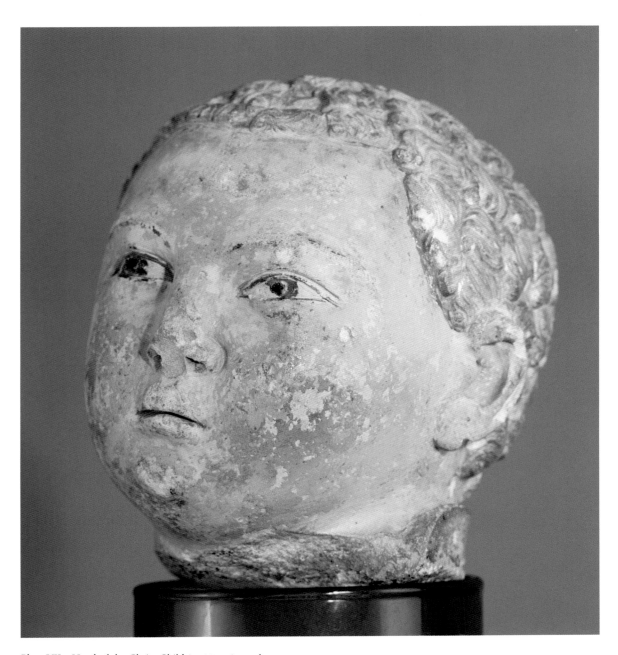

Plate VII Head of the Christ Child (1966.127), catalogue no. 22

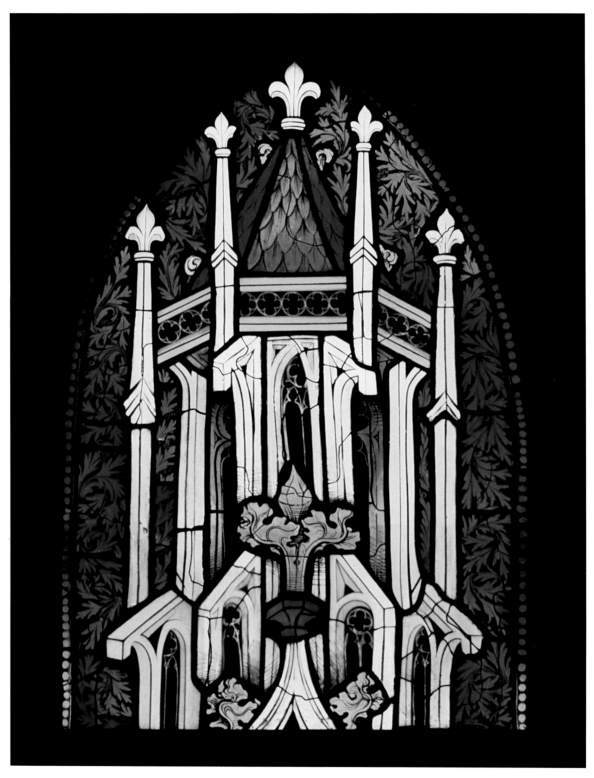

Plate VIII Architectural panel (1978.20.7), catalogue no. 25

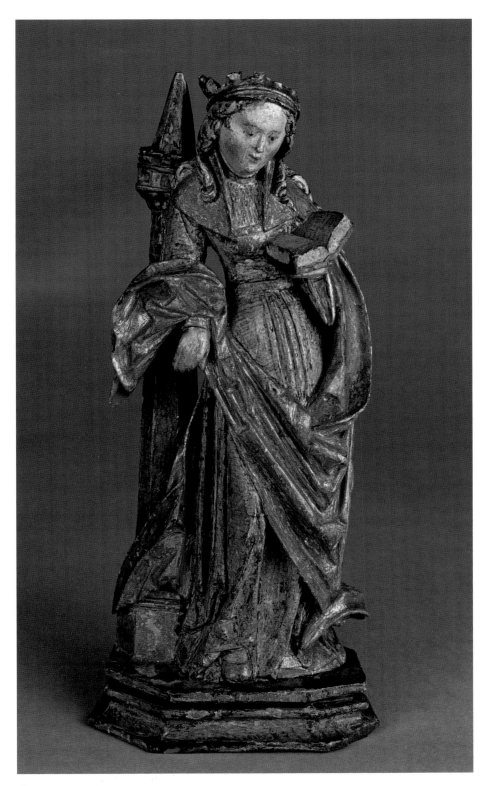

Plate IX St. Barbara (1966.108), catalogue no. 40

Plate X Visitation panel (1978.20.5), catalogue no. 23

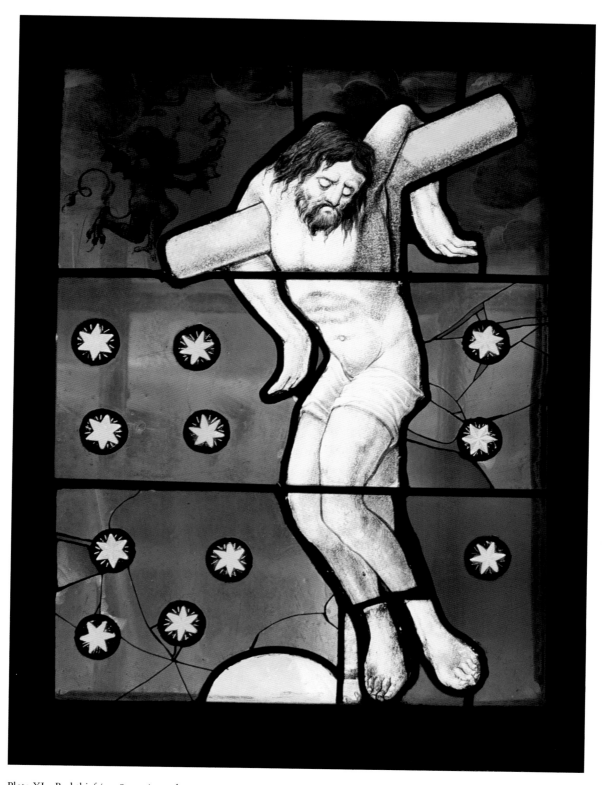

Plate XI Bad thief (1978.20.4), catalogue no. 33

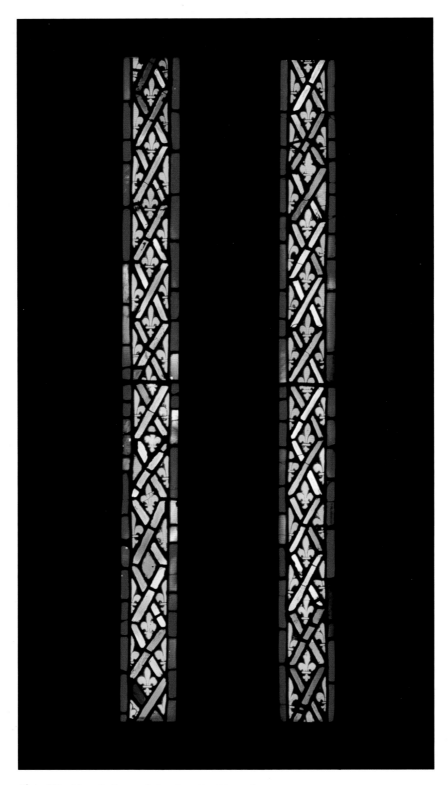

Plate XII Fleur-de-lis panels (1978.20.8 a–b), catalogue no. 20

Plate XIII Janus head (1966.51), figure 5.1

Plate XIV St. John (1966.173), catalogue no. 31

Plate XV Wild Man (1966.172), catalogue no. 38

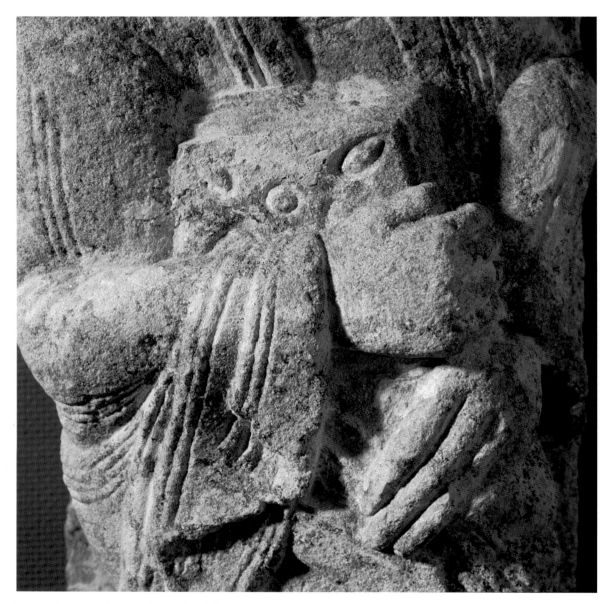

Plate XVI Detail of an apostle (1966.150), figure 3.2

Catalogue

Where possible we have reduced the number of footnotes by including abbreviated references for sources cited more than once in the text. Full references can be found in the selected bibliography at the end of the volume.

1. Impost Capital

1966.2
Central Italy (Rome?)
Eighth–ninth century
Marble
H: 18.7 (7¾")
W: 45 (17¾")
D: 19.8 (7¾")

Condition. Finegrained but slightly "mealy" marble, with some chipping on top and bottom edges.

This freestanding impost capital is decorated on the long sides with pairs of birds drinking from a chalice; each of the rounded short sides has a cross with scrolling terminals beneath a striated ridge. The simple symmetrical composition and low-relief, two-plane linear carving technique, as well as the decorative motifs, reflect early medieval traditions of church furnishings found throughout much of the Italian peninsula. However, the iconography, the sculptural technique, and the handling of the decorative motifs on the bodies of the birds can be most closely associated with Rome and its environs.

The images on the capital are typical of Early Christian themes of salvation. Each pair of doves, which represent the souls of the faithful, drinks from a Eucharistic vessel or "source of life," thus serving as an allegorical reminder of Christ's sacrifice reenacted in the sacrament of Communion.[1] The additional crosses with their scroll-like tendrils underscore the Christological significance of the bird composition, which in earlier versions of the theme often included a vine (Christ) sprouting from the central vessel. Sculptural examples of this theme occur as early as the fifth century, and from the seventh through ninth centuries pairs of confronted doves and peacocks were among the most popular figural subjects for sarcophagi, chancel screen panels, and altar canopies, as can be seen in the ninth-century canopy or *ciborium* with drinking birds from the church of San Basilio (Pani Ermini, 1974, no. 46, plate xxiv) and architrave fragment from San Saba (Cecchelli, 1976, no. 122, plate xlviii) in Rome. The motif of Latin crosses with scrolling terminals may be compared to a number of sculptural fragments in the vicinity of Rome, including a capital from

1. See Child, H. and Colles, D., *Christian Symbols Ancient and Modern: A Handbook for Students* (New York, 1972), 112 ff., regarding the meaning of these compositions and for the fifth- and sixth-century examples in Ravenna on sarcophagi and chancel screens.

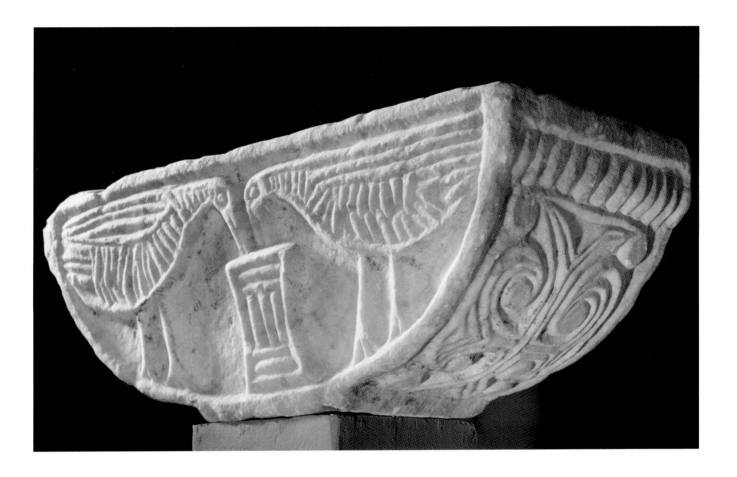

Sutri (Raspi Serra, 1974, no. 323, plate ccxxvi) and at Sant'Agnese, Rome (Broccoli, 1981, no. 125, plate xxxiii). The shape and scale of this capital resemble late-eighth-century examples in Lazio, for example at Sant'Oreste al Soratte (Raspi Serra, 1974, no. 118, plate lxxvii). The linear carving technique and geometric reduction of the forms typify work of this period throughout much of the region, as can also be seen in our transenna panel (1966.11).

Although the original context and provenance of this piece remain unknown, its scale, material, carving technique, and subject matter suggest that it once formed part of freestanding interior church furniture. The underside of the capital reveals that the supporting element was square in section, much like the vertical members of chancel screens. As the Eucharistic iconography would be appropriate for installation near an altar, it may well have once supported the arch of a chancel screen or *iconostasis*, like the ninth-century example at San Leone in Leprignano (Lazio) (Raspi Serra, 1974, no. 180, plate cxxx).

Provenance. Purchased from Pacifici, August 1937.

CB and JM

2. Transenna Panel

1966.11
Central Italy (Lazio? Rome?)
Late eighth–ninth century
Marble (*spolia*?)
H: 91.5 (36″)
W: 137 (54″)
D: 8.9 (3½″)

Condition. Generally well preserved, with some chipping on edges.

A fine example of the pre-Romanesque, or Lombard, style, this large transenna panel originally formed part of a parapet or screen in the interior of a church. The wide lower border was originally either partially sunken below pavement level or hidden by a plinth, thus concealing the shallow circular indentation in the lower-righthand side of the panel. This indentation suggests that the marble slab may have been *spolia.* The rectangular surface is carved in a low relief pattern of circling tendrils filled with spirals or rotating leaves,[1] all connected by a vine tendril motif that works its way diagonally across the surface. The interstices between the rosettes are filled with smaller spirals and occasional trefoil motifs. The tendrils are composed of three parallel lines, interrupted at frequent intervals by horizontal bands that link the strands together.

At first glance, the apparently static arrangement of the three horizontal rows of five rosettes tends to belie the dynamic motion generated by the swirling spirals inside the rosettes and the tendrils connecting them. The unpredictability of the design creates a composition filled with restless movement and energy, as the tendrils connect the rosettes in complex and unpredictable patterns, sometimes diagonally, sometimes horizontally. The eye is always searching out new relationships and patterns.

This panel is typical of a large body of similar sculpture found in central and northern Italy, a large number of which can still be found *in situ* or reused in the parapets of pulpits and other church furnish-

1. Kautzsch (1939) called these "*Wellenrundranken mit rotierenden Blättchen*"; see also his article on Lombard sculpture (1941):1–48.

144

ings. The swirling pinwheel motif is especially common in Lazio and Rome; there is a fine example of a transenna panel with this motif in Santa Sabina and another one in the church of San Giovanni a Porta Latina.[2] Many relief panels similar to the one at Duke have been associated by Kautzsch (1939) with the building projects carried out during the papacy of Gregory IV (827–44), but the style and decorative motifs can be identified already in the eighth century and persist through the ninth century.

Provenance. Purchased from de Cresci, August 1937.

Exhibitions and Bibliography. Moeller, *Sculpture and Decorative Arts* (1967):62–63, no. 23, figure 34; *Joseph Brummer* (1949):III, no. 542.

CB

2. See, for example, Trinci Cecchelli, *Corpus della scultura altomedievale, VII, La diocesi di Roma,* volume 4 (1976): no. 244 b–d; Raspi Serra (Spoleto, 1974): nos. 107 (Civita Castellana), 150 and 166 (Castel Sant' Elia), 362 and 363, (Tuscania, Santa Maria Maggiore), and 411 (Viterbo); and also Haseloff, 54 ff. and plate 60. Haseloff, 55, dates the Sta. Sabina reliefs to the papacy of Eugene II (824–27).

3. Impost Capital

1966.13
Southern Italy
Eleventh or early twelfth century
Marble
L: 61 (24″)
H: 29 (11½″)
D: 14 (5½″)

Condition. White marble with pronounced grey veins in straight lines; there are chips on the top, bottom, and corners. One side of the capital is considerably more weathered than the other and was stained with some black substance.

The long triangular surfaces of this impost capital are decorated with two rows of acanthus leaves; taller "stretched" versions of the same leaves sprout from the base to decorate the short sides. Volutes terminate the upper row of leaves, while those at either end of the lower row are cropped by the diagonal longer leaves that rise at an angle from the base. The surface of each leaf is incised with striations and the upper corners of each leaf have been drilled with two holes.

The volutes and acanthus leaves on this capital attest to the continued vitality of classical models in the Middle Ages. (Kautszch's remark that pre-Romanesque sculpture "in a certain sense is still the art of the Late Antique" [1939, 3], can thus in some instances be extended to the twelfth century.) Here the classical ornament has been flattened and applied to the Italo-Byzantine cushion impost form, or *pulvino*, found most frequently in southern Italy. Perhaps the best-known example of the extensive use of this form appears at the late twelfth-century cloister of Santa Sofia in Benevento (Giess [1959]: 249–56). As a highly debased version of the composite order, this capital thus testifies eloquently to the eclectic fusion of the Graeco-Roman, Byzantine, and Lombard traditions in South Italian sculpture even in the High Middle Ages. In spite of a superficial similarity to some Lombard capitals, the use of the drill (reviving a technique from antiquity), and the definition of the leaves as possessing some physical substance, sug-

gest a date in the eleventh or early twelfth century. The Duke impost
capital does not yet, however, exhibit the more volumetric conception
of form that characterizes the impost capitals in the cloister at Santa
Sofia in Benevento, dated between 1170 and 1180 (Giess [1959]:256).

The scale of this capital, its generic decoration, and the fact that
it is considerably more weathered on one side than the other suggest
that it may once have formed part of a cloister arcade.

Bibliography. Cahn (1975):73, no. 8; *Joseph Brummer* (1949):III, no.
545.

CB

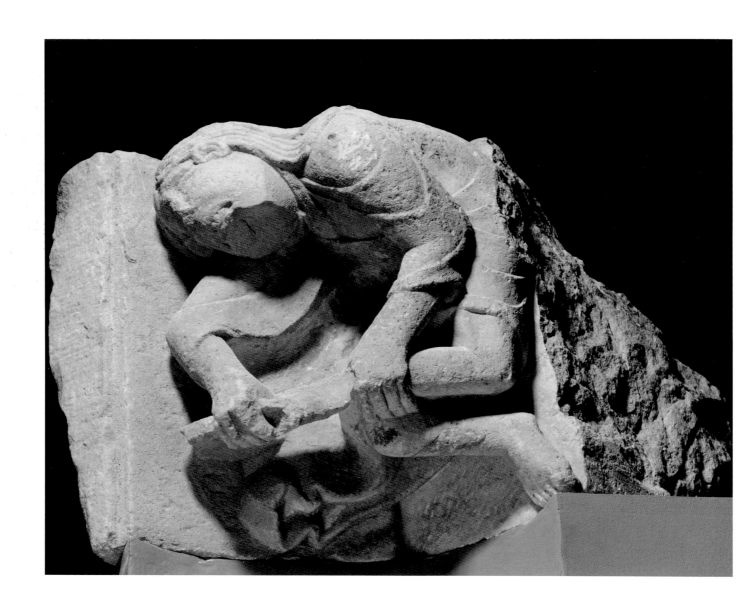

4. Thornpuller? (*spinario*)

1966.203
Fragment of a doorjamb
St.-Martin de Savigny
First quarter of the twelfth century
Limestone
H: 42 (16½")
L: 33 (13")
D: 60.5 (23¾")

Condition. Coarse, rich, buff-colored limestone, showing some general weathering, especially on the face. The lower jamb and the figure's left hip and left foot are broken. The upper part of the face, the top of the head, and the side of the figure are exceptionally well preserved; a large amount of grey mortar or cement adheres to the back of the piece.

This large block is decorated with a youthful figure bent over his raised left leg. He holds a grotesquely large instrument in his right hand, as though he were removing a thorn from his left foot, now missing. His discomfort is indicated by the exaggerated expression of anguish on his face; his large mouth is distorted downwards, revealing his upper teeth, while his eyes are set at an oblique angle. His ears are placed high and pressed forward towards the front of his face; long strands of hair sweep from the center of the forehead over the shoulders. The young man is clothed in a short garment that exposes his legs; it falls in catenary folds that create the effect of curving clapboards over his arms and upper torso, but flutters underneath his right hand.

Although this large piece of architectural sculpture has been identified as a fragment of a tympanum (Cahn [1975]:70), its straight left edge, set off by a narrow fillet, and its considerable depth indicate that it was instead a structural element in a building, most likely the upper section of a left doorjamb (*piedroit*) of a large portal. Carved doorjambs of this type once existed on the exterior portals of the church at Vézelay, but were removed in the nineteenth-century restoration.[1]

The style of the drapery is clearly related to that of the choir capitals and west portals of Cluny III (plate 4.2). The features of the face,

1. Saulnier and Stratford, *La Sculpture oublié de Vézelay* (Geneva, 1984):figure 41; see also plate 2 for a carved doorjamb and fillet molding similar to that at Duke.
2. I thank Edson Armi for this and other observations pertaining to Anzy-le-Duc. See Carol Prendergast, *The Romanesque Sculptures of Anzy-le-Duc* (Ph.D. thesis, Yale University [1974]): 368–69, who dates the work on the Anzy nave to around 1110–15; also her "The Lintel of the West Portal at Anzy-le-Duc," *Gesta* 15 (1976): 135–42; and Zehava Jacoby, "La Sculpture à Cluny, Vézelay et Anzy-le-Duc: un aspect de l'évolution stylistique

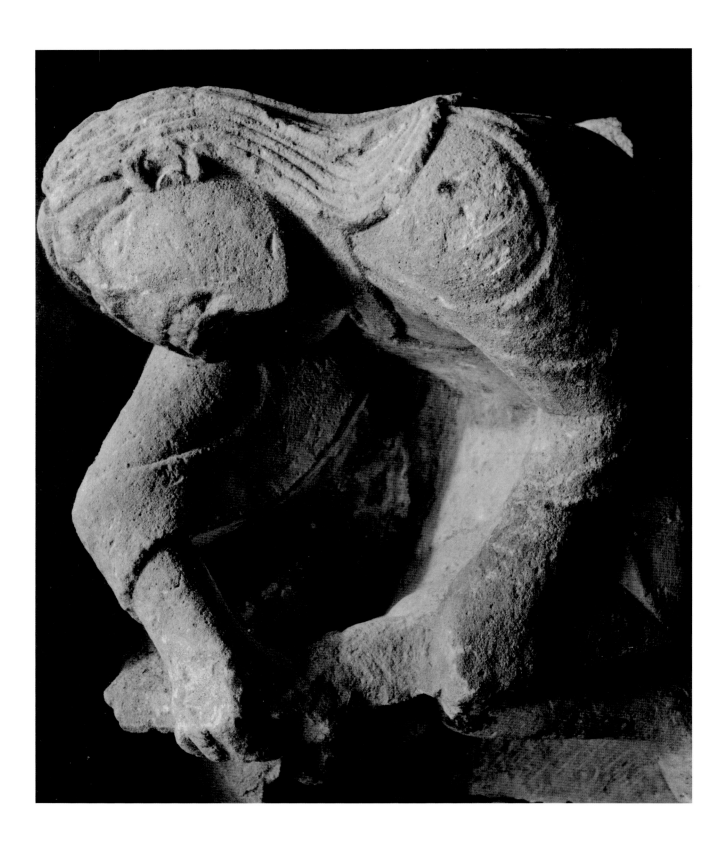

however, with the emphasis on a large and open mouth exposing rows of prominent teeth and the crisp definition of the jaw, as well as the downward-slanting eyes, bear a close resemblance to the exterior nave corbels at Anzy-le-Duc and reflect many aspects of Donjonnais sculpture.[2] In the symposium on the Brummer Collection held at Duke in 1987, Ilene Forsyth stated that this fragment might be from the destroyed abbey at Savigny,[3] a suggestion also made by Neil Stratford in *Gesta* (quoted by Cahn [1975]:70). Comparisons with fragments still at Savigny, particularly a standing headless figure variously described as an abbot or an apostle in the Musée Coquard (plate 4.3), confirm this attribution (see Cateland-Devos, 183–85). The treatment of the drapery as consisting of large, catenary folds pressed against the body

en Bourgogne," *Storia dell'arte* 34 (1978): 197–206. Jacoby, 205, dates the Anzy workshop to after 1120, in contrast to Francis Salet in his review of K.J. Conant's *Cluny, les églises et la maison du chef d'Ordre*, in the *Bulletin monumental* 127 (1969): 74–77 and 114–21.

3. See the essay above by Forsyth, notes 7 and 23.

◄Plate 4.1
Spinario, detail
Plate 4.2
Saint Peter from the north spandrel of the west portal at Cluny, Museum of Art, Rhode Island School of Design, Providence

Plate 4.3
"Abbot," Musée Coquard,
Savigny

and the awkward modeling of the anatomy (note the arms and legs of the Duke figure) suggest the same workshop that produced the Duke *spinario*.[4] A console still in the Musée Coquard with the remains of two figures who may be wrestlers or atlantids was produced by the same workshop.[5] Cateland-Devos associated this fragment of a console with the construction of the chevet and transept of the church in the first quarter of the twelfth century (p. 152), but the fragmentary state of the evidence and the absence of excavations at the site preclude any precise conclusions on the location of the work by the various workshops.[6]

The attribution to Savigny is reinforced by what we know of the provenance of this fragment. As noted by Forsyth in her article on the Samson monolith, the thornpuller was acquired by Brummer from the collector Couëlle in August 1928 in the same lot as the Samson monolith. Other fragments from Savigny passed through the same hands, such as the handsome corbel of an acrobat in The Cloisters in New York City (figure 2.13) and the fragment of a capital with a figure playing a viol at Wellesley College (Cahn and Seidel [1979]: 56–57) (figure 2.12).

The identity of the figure remains uncertain. Since he holds his left

4. According to Cateland-Devos ("Sculptures de l'abbaye de Savigny-en-Lyonnais du Haut Moyen Age au XVe siècle." *Bulletin archéologique du Comité des Travaux historiques et scientifiques*, N.S. VII [1971] 151–205), 160, there were numerous different workshops of diverse origin operating at Savigny; the Duke figure belongs to the Burgundian *atélier*. Ilene Forsyth is preparing the definitive study of the Savigny sculpture.

5. I thank Neil Stratford for bringing these figures to my attention. See Cateland-Devos, 162–63, figure 10.

6. If, however, Cateland-Devos is correct in associating the Burgundian

leg over his right knee and seems to be in considerable pain, the traditional identification of this figure as a *spinario* may indeed be correct. The pose is based on the ancient bronze lifesize figure of a young boy pulling a thorn from his foot now in the Capitoline Museum, which was on public view in the Middle Ages and was also well known throughout Europe from numerous terracotta copies.[7] All versions of the *spinario* motif have the left leg raised up over the right knee, as is also the case with the Duke figure. The theme appeared not infrequently in medieval art, where it was often used as a symbol of moral laxness. In his guidebook to Rome, Master Gregorius identified the *spinario* of Rome as Priapus, probably because of his exposed genitals (Adhémar, 191, n. 2). He also appeared in various French and Italian portal programs in series of the Signs of the Zodiac or the Labors of the Months, where he represents March, which ruled the feet.[8]

Thornpullers are not unknown in Burgundy: one can be found at Vézelay, where he forms part of the elaborate program of the narthex portal, and another handsome example appears in the exterior nave corbels of Anzy-le-Duc. At Vézelay, the thornpuller in one of the upper left compartments in the central portal has been identified by Katzenellenbogen as representing a minor ailment that can be alleviated by faith in Christ and his miracles.[9]

The unusual feature of our *spinario* at Duke, however, is the grotesque exaggeration of the implement with which he approaches his foot and the expression of extreme pain on the face of the young man. The pained expression may express the medieval view that sickness was caused by sin (Gregory of Tours describes illness as *incursio diaboli*).

Provenance. Purchased from Couëlle, August 23, 1928.

Bibliography. Cahn (1975):70, n. 3.

CB

workshop with the construction of the eastern parts of the church, our figure may have come from the south transept portal.

7. W. S. Heckscher, "Dornauszieher," *Reallexikon zur deustcher Kunstgeschichte* 4 (1941): 289–99.

8. J. C. Webster, *The Labors of the Months in Antique and Medieval Art to the End of the Twelfth Century* (Princeton Monographs 21): 1938.

9. Adolf Katzenellenbogen, "The Central Tympanum at Vézelay: Its Encyclopedic Meaning and its Relation to the First Crusade," *Art Bulletin* 26 (1944): 144.

5. Apostle

1966.48
Languedoc (Hérault)
Second quarter of the twelfth century
Marble
H: 84 (33⅛")
W: 23.2 (9⅛")
D: 12.5 (5")

Condition. Some weathering is visible on the top of the head and on parts of the face; the upper right corner has been broken off, and some breakage and chipping off the bottom edge is visible. The block has been broken in half and repaired, and considerable losses from weathering and abrasion on the front surface, especially to the book, the left hand, and the drapery in the center of the bottom half, are visible. Fragments of the face and the fingers of the right hand have been broken off and reattached. The back has been hollowed out and filled with dark grey cement. There are no traces of any pigments.

This figure of an apostle stands with his right hand raised and his left holding a book. His head is framed by a halo decorated with zigzags and radiating lines. The figure wears a long robe covered by a cloak pulled tight over the right elbow; the robe falls to the feet where it terminates in a cluster of soft folds. The entire block is carved in shallow relief; the figure projects only slightly from the enclosing arch.

One of the most striking characteristics of this work is the handling of decorative elements, such as the halo and edges of the garments; circles are drilled along the edges of the cloak and robe, and zigzag ornament enlivens the orphrey and the outer ring of the halo (plate 5.1). The curved parallel lines of the drapery have an important role in modeling the figure, as can be seen with particular clarity in the arms and the chest. The eyes are large and framed by heavily incised ridges. The hair falls in closely spaced parallel lines to the shoulders, though at the juncture with right shoulder there is a separate short segment that curves transversely.

Many of these characteristics can be associated with sculpture in the Hérault, in particular a group of capitals from the destroyed clois-

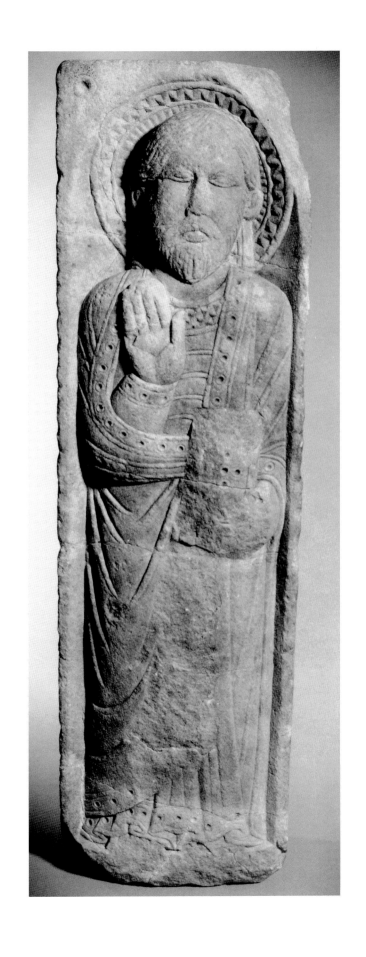

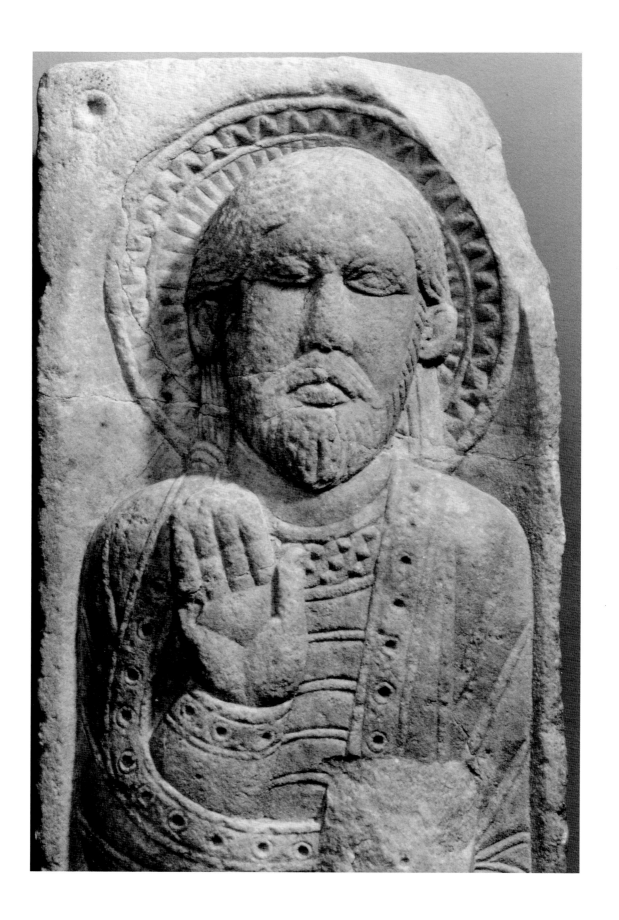

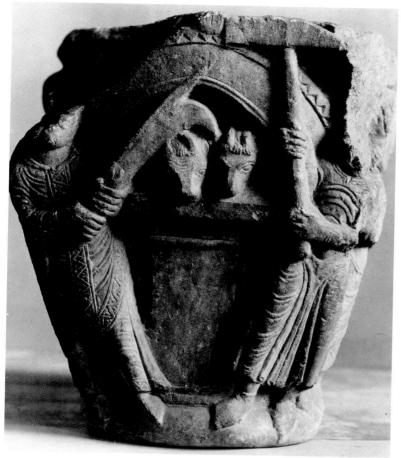

◄Plate 5.1
Apostle from Languedoc,
detail

Plate 5.2
Capital with sacrifice of
bread, Fogg Art Museum,
Cambridge, Massachusetts

ter at the abbey of St.-Pons de Thomières, which was founded in 936 by Raymond Pons, Third Count of Toulouse, in honor of his patron saint. Many of the buildings of this abbey date to the eleventh and twelfth centuries, with extensive further rebuilding and repair in the early thirteenth century.[1] Similar treatment of decorative motifs can be found in the capitals from St.-Pons in the Louvre (Aubert, 31–32) and in Fogg Museum (Cahn and Seidel [1979]:154–60; Scher, 88–92; see plate 5.2). The sculptors of the St.-Pons capitals also tend to conceive of the drapery as patterns of parallel lines; this is also striking in the twelfth-century capital from St.-Pons in Toledo.[2] The eyes of the figures in the Louvre capital are also emphasized by the heavy ridge framing the upper and lower lids. Despite these similarities, it should be noted that there are also important differences; the capitals from the St.-Pons cloister are cut in much higher relief and project more vigorously from the background. Whereas our figure is stiff and frontal, the figures in the St.-Pons capitals are varied in posture and often move energetically across the surface.

The Duke apostle has been associated with a similar relief in the

1. For the history of St.-Pons, see J. Sahuc, *L'Art roman à Saint-Pons-de-Thomières* (Montpellier, 1908); see also M. Durliat, "Saint-Pons-de-Thomières," *Congrès archéologique* 108 (Montpellier, 1950):271–89; and, more recently, Jacques Lugand, Jean Nougaret, and Robert Saint-Jean, *Languedoc roman* (Zodiaque: La nuit des temps, 1975):253–77.
2. See M. Ohl Godwin, "Medieval Cloister Arcades from St.-Pons and Pontaut," *Art Bulletin* 15 (1933): 174–85.

157

Boston Museum of Fine Arts that is said to have come from St.-Pierre-de-Rèdes at Le Poujol (Hérault) (Scher, 93–95, no. 32; Cahn [1970]:63–64, note 3; Cahn and Seidel [1979]:102, figure 100), but aside from certain questions concerning the origins of the Boston apostle, the latter is in higher relief and the pose is more dynamic than the static and subdued figure at Duke. Though there is no information on the provenance of the Duke relief beyond its acquisition from Altounian in 1938, we can suppose that it came from a workshop allied to that at St.-Pons but probably not from St.-Pons itself. The Duke apostle may once have decorated a cloister pier in the manner of the apostles of the cloister at Moissac, which was copied in the cloister of St.-Etienne at Toulouse, completed in 1117 but no longer *in situ* (now in the Musée des Augustins, Toulouse).[3] Affinities with Toulouse *atélier* suggest a date for our apostle somewhere towards the middle of the twelfth century; this date has now also been generally accepted for the St.-Pons capitals (Scher, 92, note 19).

Provenance. Purchased from Altounian, September 1938.

Exhibitions and Bibliography. Scher, *The Renaissance of the Twelfth Century* (1969): 93–5, no. 33; Cahn and Seidel (1979):102.

CB

3. L. Seidel, "A Romantic Forgery: The Romanesque 'Portal' of Saint Etienne at Toulouse," *Art Bulletin* 50 (1968): 33–42.

6. Fragment with Head

1966.128
Western France (Périgord?)
Second quarter of the twelfth century
Limestone
H: 14 (5½″)
W: 15.5 (6⅛″)
D: 13 (5⅛″)

Condition. Soft, buff-colored finegrained limestone; this is a fragment of a larger piece. The left side of the head, the chin, and part of the nose are broken. A small red spot in the hair above the nose may represent traces of polychrome.

This youthful head cranes forward, while to its left two long overlapping forms emerge from the back of the head and shoulder. The head is oval with a heavy chin (partially broken) and a long interval between the base of the nose and the upper lip. The eyes are large and encased by sharp ridges above and below. The mouth is a straight horizontal line, giving the head a severe and perhaps pained expression; the somewhat melancholy character of the head is heightened by the diagonal lines that descend from the sides of the nose to the cheeks. Tongues of hair cut in parallel grooves frame the face; they all terminate in a short curl bending to the right.

Not enough of the fragment survives to permit a precise identification of the context of the piece as a whole. In November 1986 Paula Gerson suggested that the fragment might have been a marmoset, which would explain the awkward contortion and forward thrusting position of the head. Marmosets appeared under the statue columns at St. Denis in 1137–40, so that this head would have been an early example of such a figure, presumably from an Early Gothic portal of the first generation following St.-Denis. Alternatively, the strange position of the head and the projections on the right side of the figure might permit another explanation: the young man may represent a cripple with his left arm awkwardly raised on a crutch, though the architectural setting or context for such a figure remains a problem.

159

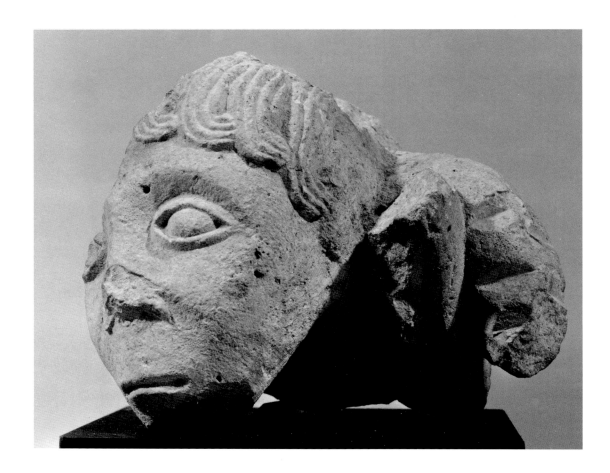

In 1973 Linda Seidel compared this Duke fragment to a corbel in the Fogg Art Museum that she linked to St.-Raphaël d'Excideuil in the Périgord (*Gesta* [1973]:75), dated to the first quarter of the twelfth century. The similarities appear in the strongly striated tongues of hair and the acutely outlined eyes; also similar is the tall chin. Yet the Duke head is more delicate and refined in character and proportions, the pupils of the eyes are not drilled, and the tongues of hair are arranged more elegantly around the edges of the face. While an origin in western France remains a strong possibility, we reserve judgment on the association with St.-Raphaël.

Provenance. Purchased from B. Hein, August 11, 1928

Exhibitions and Bibliography. Moeller, *Sculpture and Decorative Art* (1967): 18–19, no. 5; Seidel, "Romanesque Sculpture in American Collections," *Gesta* 11 (1973): 75; Cahn (1975):71, no. 5; Cahn and Seidel (1979):178.

CB

7. Corbel (?) with the Head of a Bearded Man

1966.56
French
Mid-twelfth century
Limestone
H: 20.3 (8½″)
D: 20 (7⅞″)
W: 15.4 (6″)

Condition. Coarse yellow limestone with many fossil inclusions and vertical bedding lines. The head is generally weathered and pitted, especially on the front surface of the face, the nose is chipped, and there is some damage to the upper left surface of the head. The flat surface on the top of the head appears to be original. Prior to its cleaning in 1987 the corbel showed the remains of at least two plastering phases, both of which were late additions.

This head can be associated with a series of early Gothic portals from around 1145–60, such as the royal portals of Chartres or the twelfth-century portals at St.-Loup-du-Naud, Étampes, and Le Mans. The gentle undulations of the anatomical structures of the face, the full and fleshy modeling of the cheeks, the slightly bulging pupils, and the hint of a smile on the slightly parted lips give the head an alert and animated expression reminiscent of the naturalism found in the best work in the west portals of Chartres. A few details in particular distinguish this head; the corners of the eyes are drilled to emphasize their three-dimensionality, and the ears were created by drilling two deep holes, one above the other.

Many of the characteristics of this head can be found in a variety of monuments spread out over a wide geographical area, attesting to the peripatetic careers of many of the masons and sculptors employed in early Gothic workshops. We have still much to learn about workshop production and the sequence and dating of these Early Gothic portals. The particular characteristics of this head seem closest, however, to the sculpture of the portals formerly at St.-Bénigne in Dijon, traditionally dated to around 1160.[1] As pointed out by Sauerländer, the twelfth-century portals at St.-Bénigne were incorporated into the

1. Sauerländer, *Gothic Sculpture in France* (London, 1972): 389–91. The affinities with Burgundy are closer than those with Le Mans, as had been suggested by Moeller, 28.

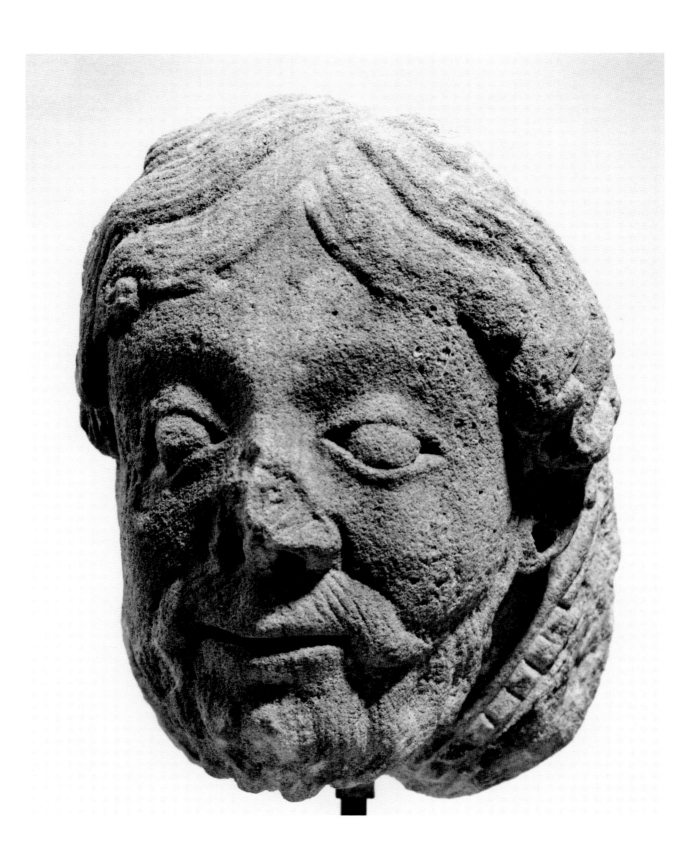

rebuilding of the church in the subsequent century but dismantled during the French Revolution. The affinities are closest with the heads in the tympanum of the Last Supper now in the Musée Archéologique in Dijon; this can be noted in the carving of the hair, with the strands terminating in tight curls, the tendency towards wide noses, the precise definition of the lips and bulging eyes, and the slight smile.

The flattened upper surface of this head appears original, and suggests that it once served as a corbel. This is also indicated by the angle of the head and beard in relation to the neck and edge of the collar below. The beaded collar has been only partially carved on the figure's right side, whereas on his left it is irregularly weathered. Perhaps the head was once placed in a context similar to that of the corbel heads supporting the ribs in the narthex of Lisieux in Normandy.[2] Deep porches were also common in Burgundian monuments (Notre-Dame in Dijon and Semur-en-Auxois still preserve fine examples), and it is possible that our head was once located in such a setting.

Provenance. Purchased from Aldo Jandolo in New York, March 1943.

Exhibitions and Bibliography. Moeller, *Sculpture and Decorative Art* (1967): 28–29, no. 8, figure 16.

CB

2. See W. W. Clark, "The Central Portal at Lisieux: A Lost Monument of the Twelfth Century," *Gesta* 11 (1972): 46–59, and figures 11 and 12.

8. Capital

1966.63
Île-de-France
First half of the twelfth century (1125–50?)
Limestone
H: 26 (10¼″)
W: 26.2 (10¼″)
D: 26.6 (10⅜″)

Condition. Pale buff-colored coarsegrained limestone with a few large fossil inclusions, very weathered in places. The astragal is partially chipped and broken; one corner mask has been lost. Some chips and damage to the remainer of the surface are visible.

Recent cleaning of this capital revealed an almost startling crispness to the surfaces of this fine example of architectural sculpture from the Île-de-France. The capital consists of heads (both human and animal) at the four corners that substitute for the scroll ornament at the angles of a classical capital. In the half-human head the pronounced features and horizontal ridges and furrows accent the structure of the face. All the heads are bound together by an interlace of thick round vines arranged in a series of "pretzel" knots that form palmettes below the heads. On the flat sides the knots are joined by transverse bands with drilled or knotted motifs of their own. Splayed, fingerlike tripartite leaves curl back to terminate the tendrils on either side of each head as well as within the center of each knot. The entire arrangement of forms emphasizes movement across the surface of the capital, binding the whole design together in a restless tension between the static positioning of the heads and the sweeping diagonal curves of the vines. At the same time, the viewer remains highly conscious of the curved core of the capital underneath the decoration of vines, knots, and leaves.

Various aspects of the decoration of this capital are reminiscent of design elements that occur on capitals in and around the city of Paris that date to around 1125–50.[1] For example, the decorated rings which hold the tendrils in the lower third of the capital may also be observed in numerous capitals at St.-Martin-des-Champs and at Ste.-Geneviève (now at Cluny), as well as at several of St.-Martin's

1. I thank Ann Zielinski for her observations on this capital, many of which are incorporated here.

164

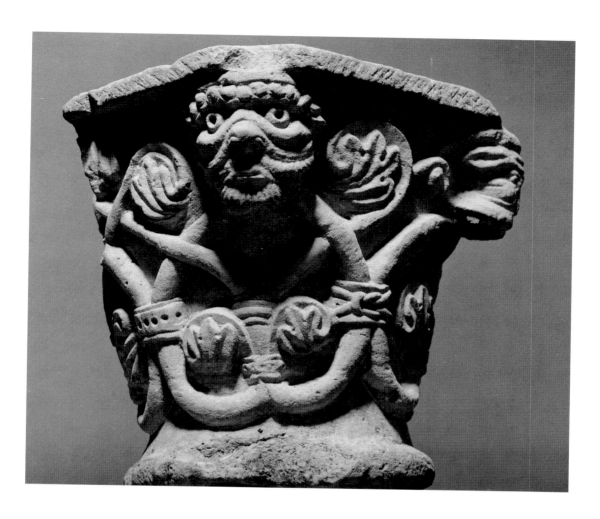

dependencies, such as Aulnay-sous-Bois. The design of the tendrils as inverted hearts also suggest a Parisian source. But the thick, fleshy, undecorated tendrils, all arranged in a simplified composition, are less complex than comparable examples is Paris, and the knotted cords are unusual. This capital should thus probably be associated with workshops outside Paris in the first half of the twelfth century, in particular those at Notre-Dame and St.-Basile at Étampes, Crépy-en-Valois, Fleury-en-Brie, Poissy, and various dependencies of the abbey of St.-Martin-des-Champs in Paris.

The size of our capital is unusually small; it might perhaps have been placed above a column in a triforium or tribune gallery, or formed part of a dado arcade in the lower part of a building.

Provenance. Purchased from Paris House, May 17, 1938.

Bibliography. Cahn (1975):no. 4, 70–71.

CB

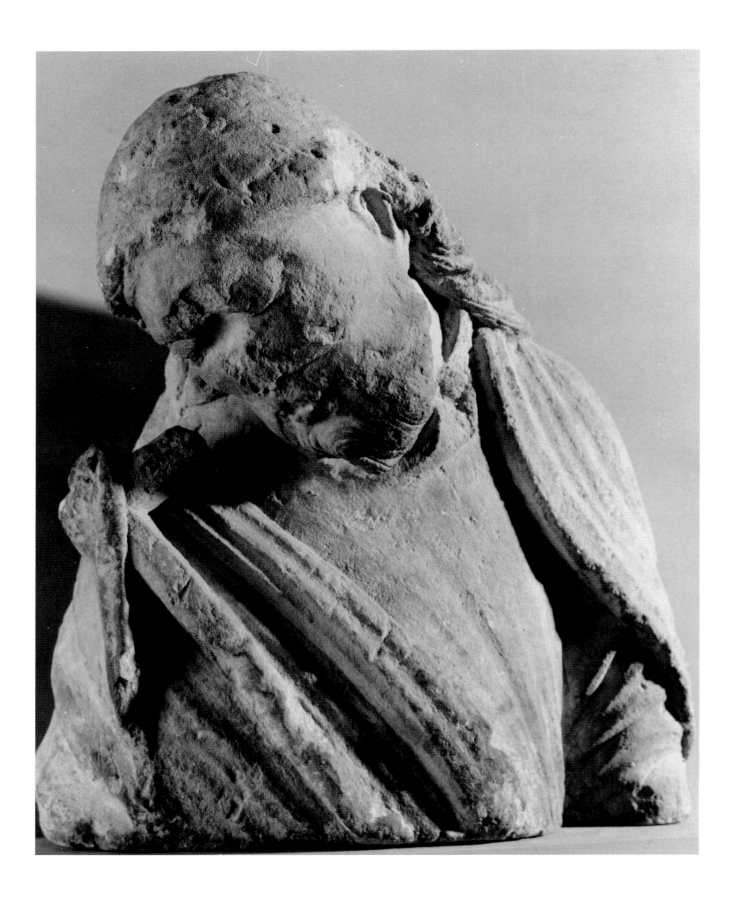

9. Half-length Figure

1966.121
Cathedral of Noyon
C. 1170
Limestone
H: 45 (17¾")
W: 43 (17")
D: 24 (9½")

Condition. Soft, grainy limestone, yellowish in color, and severely weathered and abraded. A surface coating of some unknown substance (perhaps wax) has darkened on all the figure's weathered surfaces (this coating could not be removed without possible damage). Dark stains (perhaps iron) are visible on the lower edge. The figure has been sawed in half above the waist. The drilled right pupil was made later; there is some evidence of recarving on the back of the head.

This bruised and battered head and torso are the sad remains of what must once have been a strikingly beautiful full figure. He once sat or stood with his lower body turned slightly to the left while his head twisted down to the right, looking towards the remains of an object (perhaps a cross or tau with a banner attached) on his right shoulder. The turning pose, emphasized by the heavy projecting folds of the cloak, is echoed by twisted strands of hair that pass over the ear and behind the shoulder. The back is flat, and curved at the top; in the center there is a heavy metal ring, apparently contemporary with the sculpture, which once held the figure in place.

Once thought of as an isolated and enigmatic piece, related but not identical to the striking portal programs at the cathedral of Senlis and the collegiate church of Mantes,[1] our statue at Duke has in the past two years been connected with a group of seated figures of the Virgin, Moses, and two prophets dispersed between the Dépôt Lapidaire at the cathedral of Noyon, the Metropolitan Museum in New York (one at The Cloisters, the other in the Medieval Galleries), and the Thyssen-Bornemisza Collection in Lugano.[2] Charles Little has pro-

1. In comparison with the sculpture of those two programs, both of around 1165–75, it should be noted that the drapery of our figure is less linear, and that the folds are conceived as much heavier, lumpier, projecting elements. In spite of the battered state of our figure, readers might wish to compare this head with the more sensitive, elegant handling of the head from Mantes also at Duke (Catalogue no. 11).

2. When the Metropolitan acquired the figure tentatively identified as Aaron in 1921, the prominent Swedish art historian Johnny Roosval noted its similarity to the figure of the Noyon Virgin, which had recently been severely damaged by the bombardment of the Cathedral in 1918 (*Romansk Konst* [Stockholm, 1930]: 148); see Williamson, *The Thyssen-Bornemisza Collection*, 32–39, and Hayward and Cahn, *Radiance*

posed that the entire group, including the piece at Duke, is from the north transept portal of Noyon Cathedral, a setting that would accord with the date of around 1170 suggested by the sculptural style.[3] While the pieces are clearly not all by the same hand—there is considerable variation in the handling of details of drapery and facial anatomy among the figures—the group is nonetheless characterized by the striking use of heavy drapery folds projecting strongly from the surface. These swirl and swoop over the figure, sometimes creating visual emphasis and a sense of movement when the figure is static and frontally posed, sometimes enhancing twists and turns of the body, as in the figure at Duke.[4] Williamson and Little have both pointed out that the dimensions of the figures are strikingly similar: although it is impossible to compare the height of our figure with the others, as the figure is no longer full-length, its width at 43 centimeters compares closely with that of the New York Moses (40 centimeters), the New York Prophet and the Thyssen-Bornemisza Prophet (both 44 centimeters), and the Noyon Virgin (42.5 centimeters). Little has observed that a number of vestiges of sculptural decoration still *in situ* at the cathedral corroborate an attribution of the group as a whole to Noyon and confirm a date of about 1160–70; he has noted in particular similar articulation of drapery and modeling on the corbel figures on either side of the north transept portal and the keystones of the vaults in the ambulatory and the choir tribune.

The style of this recently identified Noyon group, as well as that of the well-known statue columns at Senlis, Mantes, and the Porte des Valois at St.-Denis, derives from developments in metalwork in Lorraine and the valley of the Meuse in the mid twelfth century, in particular the work of Nicholas of Verdun (Sauerländer, 44–47). The dreamy pose of our figure, with his chin tucked against the inner corner of his right shoulder, and his pensive expression, also recalls a charming console with an angel in the Carnavalet Museum, Paris (Brouillette, 50–51, figure 48; *Sculptures médiévales du musée Carnavalet*, 64–65, figure 31). In both figures the drapery is handled in somewhat heavier, thicker folds than the figures from Mantes and Senlis. Here the folds tend to be horizontal in section, rising as a rectangular ridge against the body. The position of the head of the Duke torso continues the movement of the drapery on the left shoulder, a movement picked up and repeated in the twisting strands of hair that frame the face and the drapery on the left side.

and Reflection (New York, 1982): 116–17. The identification of the entire group is presented by Charles T. Little in his forthcoming article, "Resurrexit: A Rediscovered Monumental Sculptural Program from Noyon Cathedral." We thank Dr. Little for sending us a copy of his article prior to publication. Little has tentatively identified the figure in the Medieval Gallery of the Metropolitan as Aaron because of the long veil or "schimla" covering his head.

3. The differences in the surfaces of the figures derives from their recent history: the surface of the Lugano figure, for example, has been heavily reworked, while our own piece and that of the Moses in New York remain incrusted. On Noyon Cathedral, see Charles Seymour, *Notre-Dame of Noyon* (revised edition, 1968): 120, recently published in French translation as *La Cathédrale Notre-Dame de Noyon au XIIe siècle* (Geneva, 1975).

4. The identification of separate hands in this group of figures is in part complicated by the severe recutting of the surface of the figure in Lugano and the somewhat milder freshening of the surface of the prophet in the Medieval Gallery of the Metropolitan Museum in New York.

The features of the face are largely lost. The eyes bulge outwards, and the lips turn slightly downwards; this detail is echoed by the inverted 'U' design of the beard. The facial details, insofar as these can still be seen on the head of this figure, recall those of the Moses in the Metropolitan Museum in New York, which was also acquired from Joseph Brummer (*Radiance and Reflection*, 116–17, no. 42), but the drapery of the Moses is heavier and more complex than that visible on the truncated figure at Duke. The grave but restless lyricism of the Duke torso contrasts with the more earthbound, static repose of the New York Moses.

In his forthcoming article, Charles Little has reconstructed a possible arrangement for the "Noyon Group" on the north transept portal of the Cathedral and has emphasized the unusual character of the program. The figures were seated, not standing; they therefore cannot be considered statue columns. This vitiates the concept of the figure as a structural element in the design of the portal. If Little is correct in his reconstruction, this seated group of figures in the context of a portal is unique in Early Gothic sculpture; we know of no similar program before it, nor of any after it. As Little points out, "the originality of the design of the portal seems to have resulted in an artistic *cul-de-sac*."

The object carried on the right side of the figure remains problematic. If it was a cross and banner, as the fragmentary remains suggest, the figure could be identified with John the Baptist, who often holds the disk with the Agnus Dei surmounted by a cross and banner (Little, *Papers in Honor of The Cloisters' Fiftieth Anniversary* [forthcoming]). John the Baptist appears in this manner in the central doorway of the north transept of Chartres Cathedral. As Little has pointed out, the identification of this figure as the Baptist is consistent with a sculptural cycle of prophets who form the forerunners of Christ.

Provenance. Demotte; purchased by Joseph Brummer from Dereppe, New York, February 1943.

Bibliography. Charles T. Little, "Resurrexit: A Rediscovered Monumental Sculptural Program from Noyon Cathedral," forthcoming.

CB

169

10. Head of a King

1966.125
Île-de-France
Third quarter of the twelfth century
Limestone
H: 23 (9″)
W: 21.5 (8½″)
D: 20 (7⅞″)

Condition. White finegrained limestone with many spiral fossil inclusions. The lower lip, chin, and beard have been lost. Some chipping and abrasion is visible on the eyes, forehead, cheeks, and crown, and there are traces of mortar or cement on top of crown; plaster splatters were present over the entire surface prior to its cleaning in 1987. Some recutting of the eyes and crown may have taken place.

This fine head of a king is one of the most widely published works in the Duke University Museum, yet it remains one of the most enigmatic. Because of its beauty and monumental presence, it has been included in a number of recent exhibitions of medieval art in the United States; the authors of the scholarly catalogues that have accompanied those exhibitions have been unable to propose conclusive evidence for the origins of the piece, and in one instance resorted to a long list of the monuments to which it is *not* related (Scher, 157–58). There is, however, a consensus that it is the head of a statue column; this is evident not only from the scale and general character of the head, but also from the fact that it is not fully carved in back where it would have been concealed by the architectural setting.

The head is characterized by great precision and delicacy in the carving of the eyes, which contrast with the superficial incised diamond pattern of the crown and the somewhat sketchy striations of the hair and beard. The hair is parted in the center and frames the brow with symmetrically arranged curls that are rather heavy and lacking in subtlety. The face has high cheekbones and a long, thin, straight mouth. Unfortunately, damage to the nose, lips, and beard have obscured the original character of these details, which might have been of some assistance in establishing the origins of the piece.

This head has been compared with those of the statue columns on

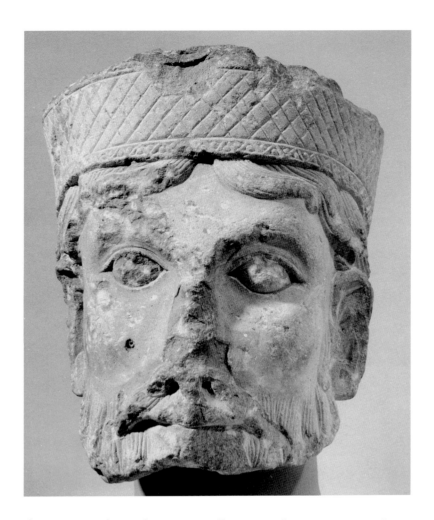

the west portals at Chartres (Moeller, 26) and at St.-Denis (Calkins, 140–41), but neither association is very compelling. Some of the problems presented by this head may be related to the little we know of its provenance, however: it was acquired by Brummer in 1936 from Demotte, a dealer widely known for his extensive reworking of original medieval pieces. Some of the problematic aspects of this head, in particular the surface pattern of the crown and the curious crispness of the carving around the eyes, may represent later recutting of the original surface, so that the head as it survives today may be a pastiche of a medieval original reinterpreted to some extent by modern hands.

Provenance. Purchased from Demotte, February 14, 1936.

Exhibitions and Bibliography. Moeller, *Sculpture and Decorative Art* (1967): 26–27, figure 15, no. 7; Scher, *The Renaissance of the Twelfth Century* (1969): 156–58, no. 54; Calkins, *A Medieval Treasury* (1968): 140–41, no. 57; Mickenburg, *Songs of Glory* (1985):80–81, no. 7.

CB

11. Head of a King

1966.114
Mantes
C. 1180
Limestone
H: 25.5 (10″)
W: 11.5 (4½″)
D: 12.7 (5″)

Condition. Yellowish finegrained limestone. Generally weathered. Much of crown chipped or broken; chipping of beard, cheeks, and left eye.

This exceptional and evocative head is one of the masterpieces in the Duke Collection. Its elongated proportions, heavy-lidded eyes, and slightly parted lips led Robert Moeller in 1967 to associate it with the figures on the archivolts of the collegiate church of Mantes ([1967], 32; see also Scher, no. 57, 166–68). Subsequent expressions of doubt about this attribution in discussions of the head were dispelled in 1975 when Moeller's identification was confirmed by Léon Pressouyre, who placed a plaster cast of the Duke head on the archivolt figure of King David in the third row of voussoirs on the south side of the central portal at Mantes (Brouillette, nos. 44, 47).[1]

As noted by Moeller, the Duke head is closest to that of Moses from a statue column at Mantes, now in the *dépôt lapidaire* at Mantes itself. Both heads have the same subtle modeling of the face, with high cheekbones, similar treatment of the eyes and lips, and similar arrangement of the hair framing the face, swept back with twisting strands that are bluntly cropped. The mustache continues down from the upper lip to form two sinuous curves of hair slightly in front of the beard which frame the mouth and the chin.

The sculpture at Mantes represents one of the high points in the development of early Gothic sculpture. Reflecting the influence of Mosan and northern French miniature painting and metalwork, the head has an animated and slightly exalted expression reminiscent of the work of Mosan artists.[2] The sculpture of the west portals at Mantes can be associated with that of the cathedral of Senlis and the Valois Portal

1. See Deuchler, *The Year 1200* (New York, 1970): no. 4, 3–4; W. Sauerländer, "Exhibition Review: The Year 1200," *Art Bulletin* 53 (1971): 509; and Pressouyre, "Séance du 16 Avril," *Bulletin de la Société Nationale des Antiquaires de France* (1975):78.

2. See on this, in particular, W. Sauerländer, "Die Marienkrönungsportale von Senlis und Mantes," *Wallraf-Richartz Jahrbuch* 20 (1958): 115ff; by the same author, "Art antique et sculpture autour de 1200. Saint-Denis, Lisieux, Chartres," *Art de France* 1 (1961): 47–56; and Louis Grodecki, "La 'Première Sculpture Gothique.' Wilhelm Vöge et l'état actuel des problèmes," *Bulletin monumental* 117 (1959): 271–89.

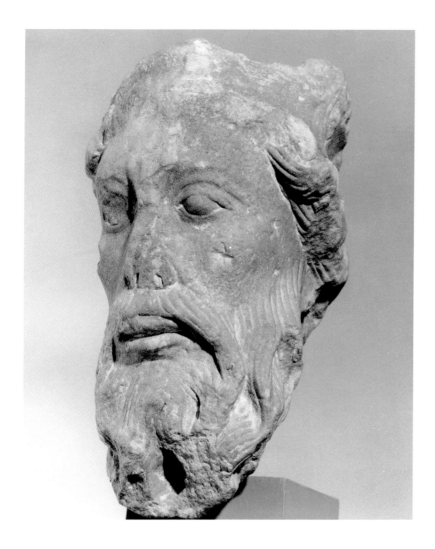

from the north transept of the abbey church of St.-Denis, both slightly earlier in date.

Provenance. Purchased from Lambert, July 20, 1931.

Exhibitions and Bibliography. Moeller, *Sculpture and Decorative Art* (1967): 32–35, no. 10, figure 18; Scher, *The Renaissance of the Twelfth Century* (1969): 166–68, no. 57; Pressouyre, "Sculptures retrouvées de la cathédrale de Sens," *Bulletin monumental* 116 (1969): 107; Pressouyre, "Un Fragment du portail central de Notre-Dame de Mantes au Duke University Museum of Art," *Bulletin de la Société nationale des Antiquaires de France* (1975): 78; Deuchler, *The Year 1200* (1970): 3–4, no. 4; W. Sauerländer, "Exhibition Review: The Year 1200," *Art Bulletin* 53 (1971): 509; Brouillette, *Senlis: Un moment de la sculpture* (1977): 47, no. 44; Bruzelius, ed., *Rediscoveries* (1983): 23.
CB

12. Head of a Patriarch or Prophet

1966.123
Île-de-France
1200–20
Limestone
H: 21 (8¼″)
W: 16.5 (6½″)
D: 18.5 (7¼″)

Condition. Buff-colored finegrained limestone, severely weathered, especially on the front of the face. The nose is missing. Some traces of gesso with black and ochre polychrome are visible on the back and sides, but this is probably not original. The head has turned dark grey from atmospheric soot; there are yellowish stains on the top of the head and above the right eye.

In spite of severe weathering, this handsome head is among the finest in the Duke Collection. Though the nose and details of the beard are lost, the subtle and delicate carving of the lips and eyes, as well as the compact force of the head as a whole, suggest that it might once have formed part of a larger sculptural program of some importance.

The head was originally positioned looking upwards and slightly to its right. On the right side the details of the hair on the back of the head have not received the same degree of finish as on the left; this is also true of the underside of the beard on the right side. The under-lifesize scale of the head, as well as its upward-looking position, indicate that it was almost certainly placed in the archivolts on the left side of a large-scale portal, no doubt forming part of such a row of patriarchs and prophets as can be found, for example, in the Judgment Portal in the center of the west facade of Notre-Dame in Paris.[1]

The style of the head is close to that of a number of works in Paris and its environs starting around the year 1200 and continuing through the first quarter of the thirteenth century. Perhaps the most compelling comparison is with the head of Saint Paul from one of the jamb statues of the central portal of Notre-Dame in Paris, now in the Cluny Museum in Paris (plate 12.2). Although the treatment of the hair is

1. On the dating and re-working of parts of this portal, see Alain Erlande-Brandenburg, "Les Re-maniements du portail central à Notre-Dame de Paris," *Bulletin monumental* 130 (1972): 241–48.

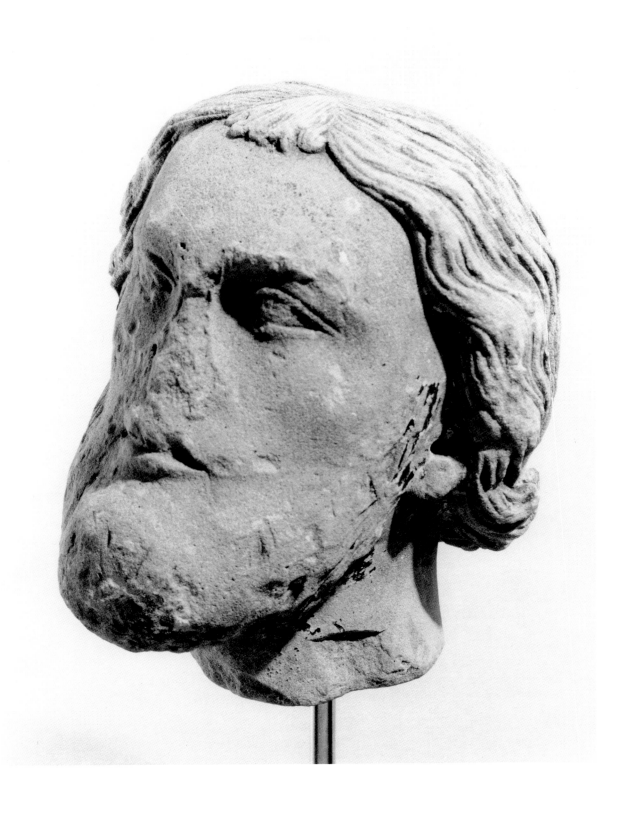

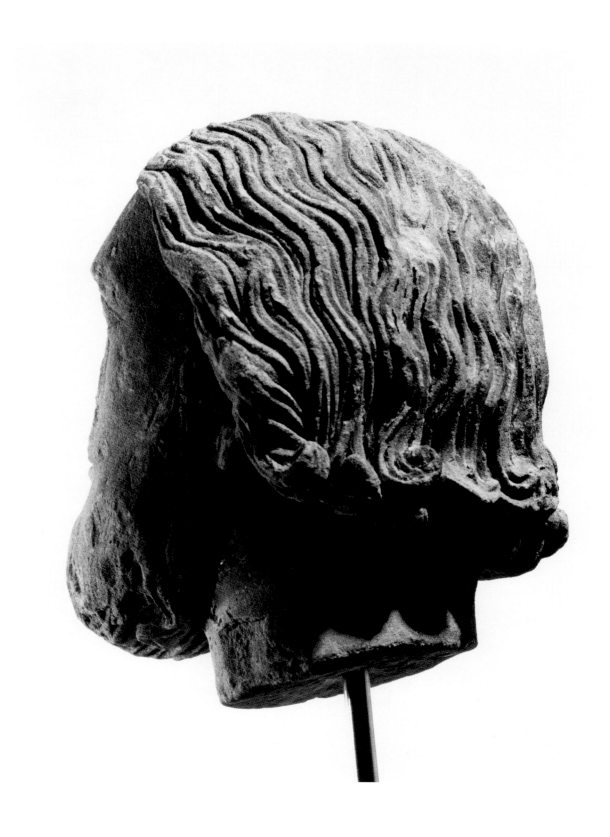

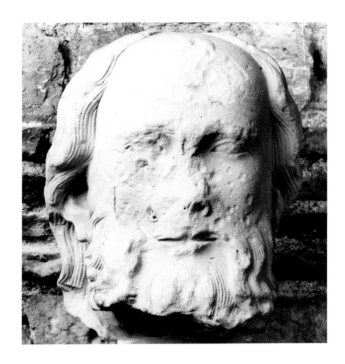

more delicate in the head from Notre-Dame than in our head, the handling of the eyes, the thin pressed lips, and the high cheekbones are clearly features in common. The jamb statues of the central portal at Notre-Dame form the earliest group of sculpture in the central and north portals at Notre-Dame, and have been dated by Sauerländer to around 1200–10 ([1959]:11ff.; [1972]:456; Erlande-Brandenburg and Thibaudat [1982]: no. 35, 33–34). The head of Saint Paul also displays a similar approach to the proportions of the head as a whole (the broad expanse of the brow, for example). The hair consists of closely striated strands that descend to the neck, where they terminate in tight curls. The small fringe of hair descending to the brow in the top center often appears in the heads in the archivolts in the central portal of Notre-Dame, as do the tightly rolled curls at the end of the hair. Some aspects of the general conception of the head and facial features are also found in the statue of St. Geneviève in the Louvre, dated by Sauerländer to 1220–30 ([1972]:459). The stone used in the head at Duke is a grey limestone, however, different from the light cream-colored stone most frequently used in the sculpture at Notre-Dame and many other Parisian monuments. It can therefore be supposed that the Duke head came from a workshop well acquainted with the sculpture of Paris but probably located outside the city. This was, of course, not uncommon, as the portals of Amiens attest.

Provenance. Purchased from Mme. A. Niclausse, July 8, 1930.

CB

◄Plate 12.1
Head of patriarch or prophet, back view
Plate 12.2
Head of Saint Paul from the central portal, Notre-Dame, Paris, Musée national des Thermes et de l'Hôtel de Cluny, Paris

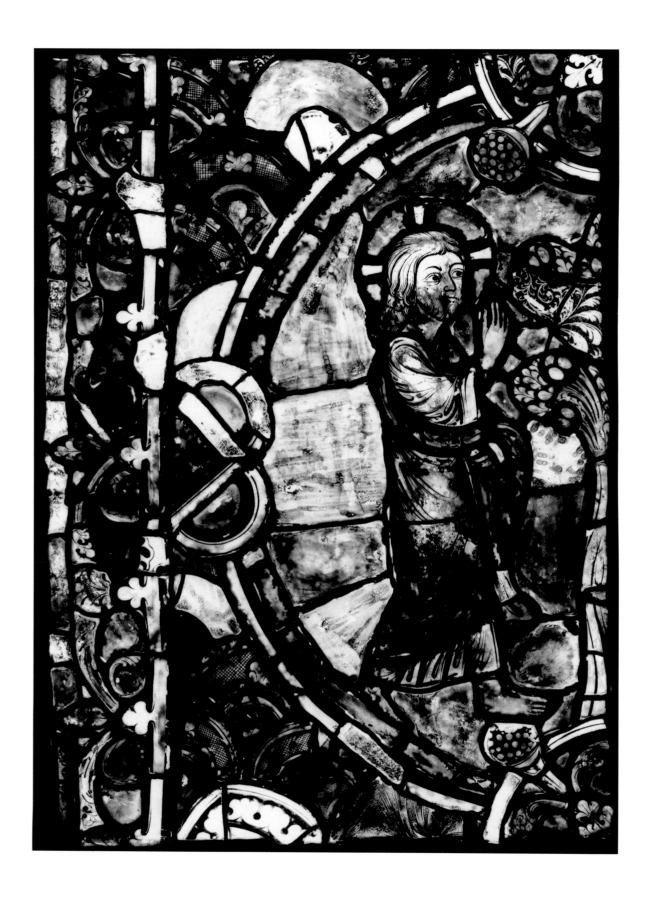

13. God Instructing Adam and Eve at the Tree of Knowledge

1978.20.9
French (Champagne?)
Second quarter of the thirteenth century
Pot-metal glass
H: 66.5 (26⅛)
W: 45.5 (17⅛)

Condition. The paint on this piece is worn: uneven patination and some severe corrosion on the back are visible. Many stopgaps and restorations are also visible; overall the piece is heavily corroded on both interior and exterior surfaces and in need of cleaning.

This panel, among the most beautiful and important of the pieces of stained glass at Duke, is badly in need of restoration and repair. It is the left half of a circular composition and contains the figure of God, who would have faced the nude figures of Adam and Eve in the lost right half. The soft *muldenfaltenstil* folds of the drapery reveal the anatomy underneath, while the features of the face in the head of God are crisply drawn in a three-quarters view.

There are good reasons to associate this panel with Troyes Cathedral.[1] Between 1837 and 1843, a local artist and antiquarian, Anne-François Arnaud, made notes on the glazing of the cathedral before a major campaign of restoration led to the loss of many windows. He noted that one of the chapels on the south side of the apse had three Creation panels, the Creation of Man and Woman, God reproaching Adam, and the Expulsion, and that these panels were made of intensely colored glass, as is our fragment at Duke.[2] Unfortunately, by the time of the Baron de Guilhermy's visit to Troyes in 1864, these panels had disappeared. Two stylistically comparable windows with scenes of the Martyrdom and Miracles of Saint Andrew survive, however, in one of the chapels on the north side of the apse. Some of the panels still at Troyes share with our fragment the narrow border with clumps of foliage at the base, and the handling of the figures as tall and energetically posed, wrapped in ample, softly folding drapery.

1. I am deeply indebted to Elizabeth Pastan and Michael Cothren for their comments on this panel. See Pastan's thesis, "The Early Stained Glass of Troyes Cathedral: the Ambulatory Chapel Glazing c. 1200–1240" (Ph.D. dissertation, Brown University [1986]).

2. Anne-François Arnaud, *Voyage archéologique dans le departement de l'Aube* (Troyes, 1843):181.

179

There are two somewhat similar panels in the Victoria and Albert Museum representing prophets from a Tree of Jesse window, also tentatively identified as coming from Troyes (Williamson [1986]:182–83). A fragment of the same window as ours at Duke is in The Glencairn Museum in Bryn Athyn, Pennsylvania.[3]

The localization of windows in the second quarter of the thirteenth century is difficult, however, because of the powerful influence exerted by the *atéliers* associated with the "courtly" monuments of Paris and because of the phenomenon of traveling workshops. Similar styles appear in Burgundy, for example, and we know that Creation windows existed in other major sites, such as Chartres, Bourges, Poitiers, Tours, and Soissons. Until further study, the exact place of origin of our lovely and damaged panel must remain uncertain.

Provenance. Demotte, date unknown.

Bibliography. Caviness et al., *Stained Glass before 1700* (1987), 16–17 and 92.

CB

3. Caviness et al., *Stained Glass before 1700*, 120.

14. Head of the Virgin from the Panel of the Adoration of the Magi

1966.74
Choir screen at Chartres
C. 1230
Limestone
H: 19.5 (7¾")
W: 15 (5½")
D: 13.5 (5⅜")

Condition. Finegrained buff-colored limestone. The head has suffered some weathering where it was exposed (when inserted in the wall of a house) on its front and right sides; the left side was presumably protected by its location in the wall and therefore reveals the original freshness of the carving and the exceptional quality of the limestone, especially on the crown. There has been some damage to the top of the crown on the front and right sides. A few dark stains—some are probably fungal, while others may be black paint or tar—are visible on the front and side surfaces of the face.

In 1970 Léon Pressouyre identified this head as that of the Virgin Mary from the panel of the Adoration of the Magi from the choir screen, or *jubé,* at Chartres Cathedral (plate 14.2).[1] The choir screen at Chartres was destroyed by the cathedral canons in 1763 as part of a remodeling of the church interior (Mallion, 23–30). A number of fragments were used as fill under the pavement of the cathedral, where they were discovered in 1837 during repairs after a fire in the preceding year. Others, including the head at Duke, were incorporated into the exterior walls of a house in the city of Chartres; this accounts for the weathering and staining of the front surfaces of the Duke Virgin. The panel of the Adoration of the Magi (plate 14.3) is now in the Saint Piat Chapel of the Cathedral along with a number of other fragments from the choir screen. According to the reconstruction of the choir screen by Jean Mallion, the panel of the Adoration was placed in the center of the *jubé,* above and to the right of the entrance from the crossing into the choir (Mallion reconstruction, 84). Pres-

1. On the choir screen at Chartres, see H. Bunjes, "Der gotische Lettner der Kathedrale von Chartres," *Wallraf-Richartz Jahrbuch* 12–13 (1943): 70–114; J. Mallion, *Le jubé de la cathédrale de Chartres* (Chartres, 1964); J. Villette, "Précisions nouvelles sur le jubé de la cathédrale de Chartres, *Bulletin monumental* 125 (1967): 419–29; as well as L. Pressouyre's studies.

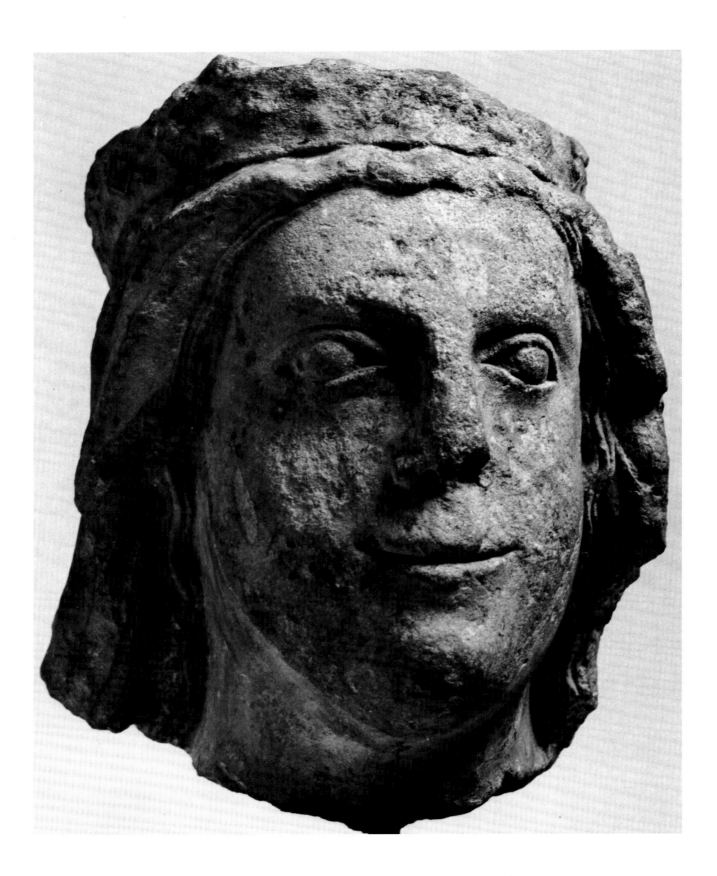

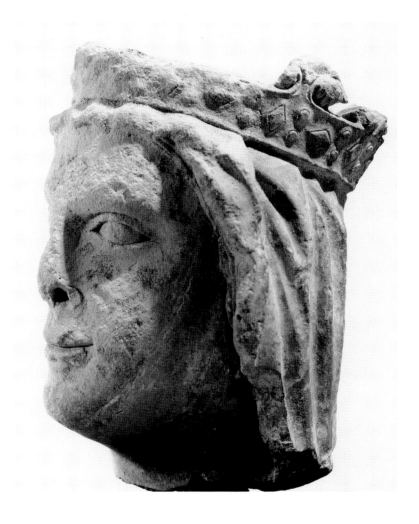

souyre's identification of our head with this particular panel from the Chartres *jubé* was originally made on stylistic grounds, but was subsequently confirmed by placing a plaster cast of the Duke head on the figure of the Virgin in the Adoration panel (*Le Figaro* [Sept. 26, 1971]; Pressouyre [1972]:71–74).

The head of the Virgin is by one of several hands that have been identified as working on the Chartres choir screen. The head of a smiling young man in the *réserves* at Chartres itself was identified by Pressouyre as the head of the African king Gaspard from the same panel of the Adoration (plate 14.4). The head of the king was carved by the same hand as the head of the Virgin at Duke: they show the same thin-lipped smile, identical treatment of the eyes, and a similar approach to the broad cheeks and thick chin. In both the face is con-

Plate 14.1
Head of the Virgin from Chartres (1966.74)

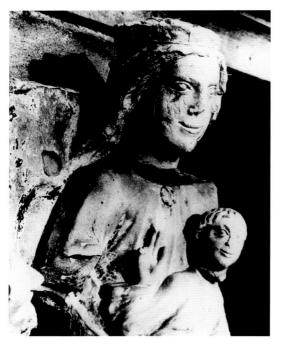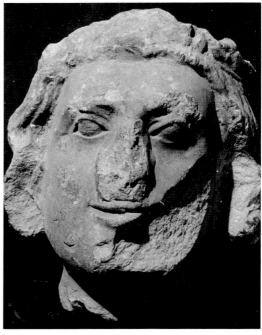

ceived as having a central vertical ridge from which the two sides slant back towards the hair and ears. Another head of a young bearded king in the collection of Bowdoin College (Deuchler, *The Year 1200* [1970]: 19, no. 24; Gillerman [1989]:336–38) is the work of a second sculptor, and has been identified by Pressouyre as belonging to a mutilated torso in the crypt of the Cathedral. Several more heads from Chartres are in private collections in Europe and in the United States; most recently (June 1985), a head of Herod from the scene of Herod receiving the Magi formerly in a private collection in New York (Pressouyre [1972]:73) was sold at auction at Christie's. This last head is the work of a third *atélier* working on the Chartres choir screen. As noted by Pressouyre ([1972]:71–74) and Sauerländer ([1972]:438–40), a number of workshops were employed on the decoration of the choir screen at the cathedral, and the surviving fragments testify to the wide variety of sources for the various sculptural styles. The heads of the Duke Virgin and King Gaspard are among the more archaic of the styles, and can probably be dated to around 1230. The construction of the *jubé* as a whole is generally placed around 1230–40 (Mallion, 16); its delicate trefoiled arcading reflected the latest trends in the Rayonnant tracery emanating from Paris.

Plate 14.2
Plaster cast of head placed on Adoration relief, Chartres Cathedral

Plate 14.4
Head of King Gaspard from the Adoration Panel

184

The head of Herod and the head of the Virgin from Duke were both in the walls of the same house, and both passed through the hands of Altounian and Brummer, though the head of Herod was in the possession of John Simon from 1926 until its purchase by Brummer in 1931.

Provenance. Purchased from Altounian, September 1938.

Exhibitions and Bibliography. L. Pressouyre, "L'Adoration des Mages du jubé de Chartres, nouveaux fragments conservés en France et aux Etats-Unis," *Bulletin de la Société Nationale des Antiquaires de France* (1971): 82–90 and 171–80; by the same author, "Des nouveaux fragments pour le jubé de Chartres," *Archéologia* 50 (1972): 71–74; Y. Chauvelin, "Une tête de Vierge de Chartres trouvée aux U.S.A." *Le Figaro* (Sept. 25–26, 1971):1; E. Wolslagel, "Missing Sculpture from Chartres turns up at Duke," *Durham Morning Herald* (June 6, 1971); Bruzelius, ed., *Rediscoveries* (1983):24–25; *Christie's Auction Catalogue* (June 13, 1985):118–19.

CB

Plate 14.3
Adoration panel from
Chartres

15. Roundel

1966.164
Italy, Veneto
C. 1225–50
Greek marble
Diam.: 41.28 (16¼")
W: 11.5 (4½")

Condition. The surface is weathered, and some side portions of the border are broken. The bottom edge has been broken and repaired with modern plaster. Cleaning in 1988 revealed lightly incised recutting of the surface around the eyes and parallel lines of the mane. There are some traces of pointing along the edges of the figures, where they meet the background.

This profiled pair of addorsed canine animals, probably wolves, touch muzzles and entwine tails in a sinuous pose which conforms to the circular field. A molded ridge encircles the wide double border of concentrically arranged bands of denticulation on the outer edge and flattened acanthus leaves on the inner, concave edge. The roundel exemplifies a popular and characteristic genre of architectural decoration in the Veneto known as *patere*.[1] These circular reliefs, together with the arched panel reliefs or *formelle,* and the *ogee* windows and arcades, comprise the rich mural decoration of the Venetian palaces which reflected Venice's prosperity and international mercantile connections. Ensembles of marble *patere*, originally brightly colored, were set into the brick wall fabric either above the arches or in the spandrels, as seen today in the facade of Ca'da Mosto (Swiechowski and Rizzi, plate 23). Their figural subjects, most commonly animal compositions, seem to have had an heraldic or apotropaic significance. Such themes, including the extremely popular confronted or addorsed animal pairs, may be derived from the decorations on the portable luxury goods, such as textiles, coffers, and bowls, which were imported from Byzantium and the Near East. A number of *patere* with addorsed wolves or dogs, comparable to the Duke example, may be found installed in Venetian buildings and in various museum collections (Swiechowski and Rizzi, nos. 30, 35, 311, 617, 670). A *patera* in the Kreuzenstein

1. See Swiechowski and Rizzi, *Romanische Reliefs* (Wiesbaden, 1982): 1–32, for the most recent discussion of the Venetian reliefs and the accompanying catalog of the *corpus* of the approximately 1000 known examples.

Castle, Austria collection (Swiechowski and Rizzi, no. 916, plate 69), depicting wolves within a wide denticulation and foliate border, provides an extremely close parallel. Although this animal composition occurs in late twelfth- and thirteenth-century examples, the distinctive border, seen also in reliefs at Ca'da Mosto and Fondaco dei Turchi in Venice, suggests a date no earlier than the second quarter of the thirteenth century.

Provenance. Purchased from L. Bernheimer, Munich, 1928.

Bibliography. Cahn (1975): 74, no. 10, figure 21; Swiechowski and Rizzi, *Romanische Reliefs* (1982): 177, no. 843a, plate 85.

JM

187

16. Smiling Head

1966.116
Reims(?)
Middle of the thirteenth century
Limestone
H: 7 (2¾)
W: 6 (2½)
D: 5 (2¼)

Condition. This head is covered with some sort of consolidant or wax which has darkened over time, giving it a brownish cast (this substance could not be removed without possible damage to the surface). The top of the head has been sawed off; it may once have had some sort of hat, or been attached to some other structure or overhead molding. The right side of the head and nose are missing. Some chipping and abrasion to the surfaces in general is visible.

The details of this small but charming head are partially obscured by its worn condition and the heavy coating of some substance that has darkened with time. Nonetheless, the naturalism and expressiveness of the head emerge clearly: the smile exposes the teeth and pushes out the cheeks, while it also reduces the eyes to narrow slits. Underneath the eyes are the puffy pouches of tear ducts. The lower cheeks on both sides have small dimples close to the lower sides of the face. The face is framed above by bangs incised with regularly spaced vertical lines, while to the sides the broadly modeled strands of hair sweep back and twist into tightly curved balls at the ends. The upper part of the head is now flat, but a projecting piece of stone on the back left side suggests that it once wore a hat of some kind or was attached to some other figure or structure.

This head can be most closely associated with the sculpture of Reims cathedral, particularly that of the west facade, which dates by and large to the middle decades of the thirteenth century.[1] Heads with similar smiles and exposed teeth can be found in the archivolts of the portals (see, for example, Kurmann, plates 605, 820), while the handling of the hair and eyes is generally found in much of the sculpture of

1. See, on the sculpture and dating of Reims in general, Peter Kurmann, *La Façade de la Cathédrale de Reims* (Lausanne and Paris, 1987); for the dating of the construction campaigns on the cathedral, see J.-P. Ravaux, "Les Campagnes de construction de la cathédrale de Reims au XIIIe siècle," *Bulletin monumental* CXXXVII (1979): 7–66.

the west facade (Kurmann, plates 243, 438, and 776, among others). In addition to details of the carving, the animated and lively expression is typical of much of the sculpture of the west portals of Reims. In October 1987 Dieter Kimpel suggested that the head might be one of the happy souls in Paradise from the tympanum of the central portal at Reims.

Provenance. Purchased from Altounian, October 7, 1927.

CB

189

17. Corbel with the Head of a Young Woman

1966.168
Île-de-France
Second quarter of the thirteenth century
Limestone
H: 31.2 (12¼″)
W: 42 (16½″)
D: 24.7 (9¾″)

Condition. Hard, coarse, buff-colored limestone, with traces of orange polychrome visible on the robe near the brooch. The nose is missing; the upper edge of the corbel is also missing but has been restored with some dark brown concretelike material. The head has been painted on several occasions. Some lichen spots, as well as grey mortar smeared on the bottom edge, are visible. The top of the corbel has two circular indentations about 3½ centimeters from the sides—one of these is blocked, the other is about 5½ centimeters deep. There are traces of whitewash in the inner folds of the hair and the edges of the face.

The round-cheeked young woman whose head decorates this corbel would have been placed in a corner supporting diagonal and/or wall ribs. She wears a diadem composed of projecting fleurons; the lower part of the crown has a pattern of lozenges and circles representing inlaid jewels. Her hair descends in long undulating waves to her shoulders. The figure disappears into the block of stone at the shoulders; a large clasp is visible on her chest.

With the exception of the loss of the nose, this piece is in excellent condition. The sculptor may not have completed the head, however, as the surfaces remain unpolished, and the lid on the right eye has not received the upper line which differentiates it from the eyelid. Chisel marks are evident on the neck and face.

A striking feature of this head is the modeling of the eyes, which bulge towards the center. The bulge is continued down into the cheeks directly below the eye. The broad rounded features of the face and the slight smile suggest a similarity to the heads on the keystones at St.-Germain-en-Laye, which dated to 1234–38.[1] The head is also similar to a number of corbel heads in the Louvre dated to the second quarter of the thirteenth century from the so-called "Chantiers de Saint-Denis" (Aubert, nos. 120–23).[2]

1. See J. de Terline, "La tête de Saint Louis à Saint-Germain-en-Laye," *Monuments et mémoires, Fondation E. Piot*, Académie des Inscriptions et Belles-Lettres, mémoires 45 (1951): 123–40.

2. It should be noted that the "Chantiers de Saint-Denis" consisted of works of sculpture from other sites that had accumulated at the abbey during the restorations of Debret and his successors.

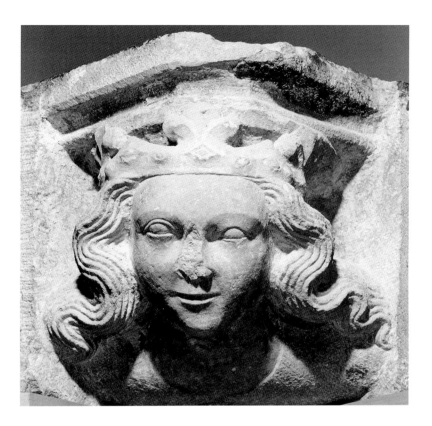

Heads were frequently used in Romanesque and Gothic art as decorative elements in vaulting systems and architectural supports (see, for example, catalogue entry number 25). They are seen, for example, in some of the keystones of the tribunes of Noyon Cathedral and at a number of other sites, especially in Rayonnant workshops associated with the reign of Louis IX, for example in the fortifications at Aigues-Mortes. Though on occasion these heads may have religious significance, representing ruling figures or possibly patrons (see J. de Terline, cited in note 1 above), it is more likely that they are generic representations of the Christian community (Gillerman [1989]: 138 and 249–50). A number of such heads attached to architectural members appear in the storerooms of the Louvre, at the *dépôt lapidaire* at the abbey of St.-Denis, and in our own storage here at Duke (see the checklist at the end of this volume). One of the intriguing questions about this large group of *membra disjecta,* as well as this head at Duke, is whether it is not the work of nineteenth-century restorers rather than medieval sculptors. On the other hand, it is also certain that a large number of these are original, as they can still be found in unrestored architectural contexts, as in the fragments of the thirteenth-century cloister at St.-Denis.

Provenance. Purchased from Jean Peslier, July 8, 1927.

CB

191

18. Seated Judge or King

1980.2.3
Île-de-France
Second half of the thirteenth century
Marble
H: 38 (15″)
W: 21.5 (8½″)
D: 8 (3⅛″)

Condition. Greyish-white, very fine marble. The head and left arm have been lost, as well as the bottom left corner and the lower right side. The surface has been badly bruised and scratched, and almost all of the original polish has been lost. Some slight chipping and abrasion on the front surface is visible. There are two holes in the back filled with lead; the upper hole also contains an iron pin.

The figure is seated on a stool or bench, the right part of which is covered with a cloth that falls to the ground. The lower body faces towards the figure's right, while the upper torso is placed frontally. The left hand holds a soft, rounded object on the thigh of the left leg, and the right foot rests on the left thigh. While at first glance the pose seems naturalistic and uncontrived, more attentive examination reveals that the figure is severely contorted to preserve the shallow frontal plane of the composition. The artful contortion of the pose serves two purposes: it emphasizes the casual placing of one leg over the other while at the same time preserving the shallowness of the piece as a whole.

The figure is clothed in a loose tunic belted at the waist. The drapery emphasizes the anatomy underneath: the musculature of the upper arm where it joins the torso, the soft swelling of the chest (though this is clearly a male figure), the gently rounded belly directly below the belt, and the clear delineation of the upper legs all suggest a sculptor interested in the human form in addition to the delicate folds and ripples of cloth that cover the figure and his chair. These drapery patterns, and in particular the triangular projections of the cloth above the belt, appear in the Île-de-France as early as around

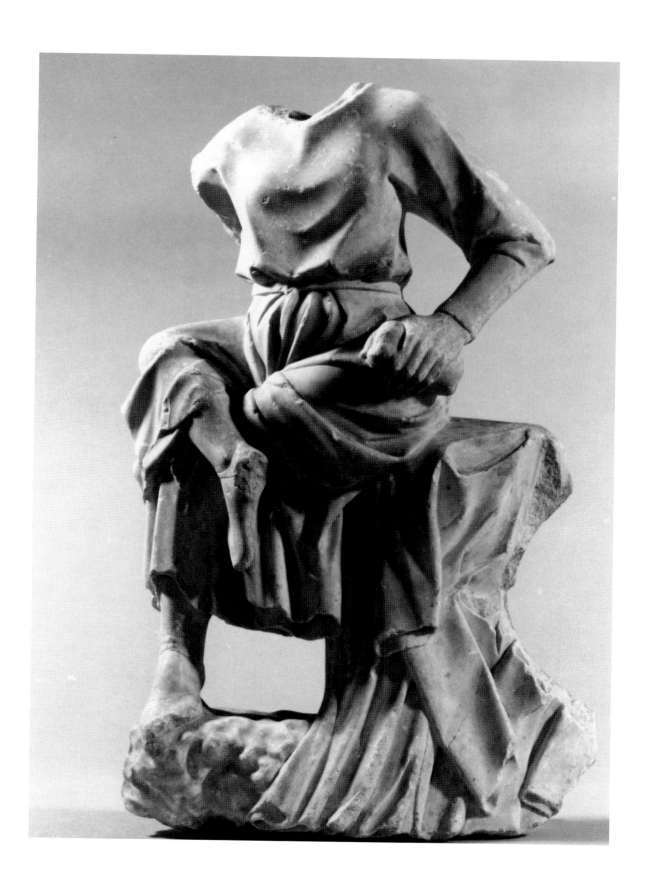

1240 and are widespread in Gothic sculpture in the second half of the thirteenth century. The treatment of the drapery, the clear expression of the human anatomy underneath, and the relaxed quality of the pose is somewhat reminiscent of the splendid Seated Virgin in the Cluny Museum (Cluny 18768), also dated to second half of the thirteenth century (plate 18.1).

It has been suggested that the use of marble may indicate a date towards 1300; certainly it is in keeping with the taste for increasingly luxurious materials in altar decorations and other church furnishings,[1] and its style is echoed in any number of even smaller-scaled precious objects, such as ivories. The shallow relief of this figure, in addition to the fact that the back remains flat, indicate that it was once attached to a larger surface, most likely an altar retable.[2] Like the altar cited above, it may have been affixed either to a patterned background (like the *jubé* from Bourges) or, more likely, to a black (Tournai) marble panel, as can be seen in the altar retable from Maubuisson in the Louvre (Aubert and Beaulieu, 131–32, nos. 189–92). The exceptionally high quality of this piece and its courtly elegance suggest that it is probably the production of a master from Paris or its environs; it can be related to the altar retable in the Louvre from St.-Denis (Aubert-Beaulieu, 131, no. 188),[3] also in marble and dated to the first quarter of the fourteenth century. Aside from a similar physical distortion of the figures to conform to the shallowness of the marble slab, the Duke figure and the figures in the fragments of the Louvre retable have in common certain physical idiosyncrasies, such as their long, attenuated fingers.

A role as a participant or protagonist in some event from a Biblical narrative is suggested by the pose and the soft object held in the left hand. In the thirteenth century, especially in and around Paris, the pose of one leg crossed over the other is frequently found in figures of judges or kings, sometimes (but not always) those playing a nefarious role in various episodes from the New Testament or in the lives of saints. It can be found, for example, in the fragmentary panel of Pilate and a servant from the choir screen of Bourges of the 1240s now in the Louvre (Sauerländer [1972]: plate 294; Aubert and Beaulieu, 115–18, plate 169), the figure of Herod on the tympanum of the north transept portal of Notre-Dame in Paris of 1244–55 (Sauerländer [1972]:472–73, plate 186), and in the figures of the Disputation with Saint Stephen on the left side lower register of the south transept portal at the

1. I thank Fabienne Joubert, Director of the Cluny Museum, for this suggestion. See also F. Baron, *Sculptures françaises du XIVe siècle* (Paris, 1985):9–10. For a general discussion of certain tendencies in sculpture of the second half of the thirteenth century, see Gillerman, "The Arrest of Christ," *Metropolitan Museum Journal* 15 (1981): 67–90.

2. For a thorough discussion of Gothic altar retables, see H. Bunjes, *Die steinernen Altaraufsätze der hohen Gotik und der Stand der gotischen Plastik in der Ile-de-France um 1300* (Marburg, 1937): especially 8ff.

3. See also F. Baron in the *Revue du Louvre* (1985):5–6.

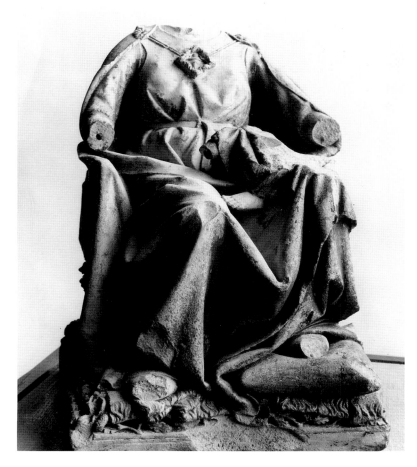

Plate 18.1
Seated Virgin, Musée
national des Thermes et de
l'Hôtel de Cluny, Paris

same cathedral (Sauerländer [1972]:488–89, plate 269). Solomon is depicted in this pose in the far right gable of the Cathedral of Auxerre (Sauerländer, 499, plate 283), as is a king from the archivolts of the now-destroyed church at Charroux (Sauerländer, 508, plate 302). The pose appears in a similar context in manuscript illumination, for example, in the scene of the Coronation of David (in Pierpont Morgan Glazier MS 25), an example somewhat earlier in date than the other works in sculpture cited above (Deuchler, *The Year 1200* (1970): volume I, 259–60, no. 258).[4]

The object in the figure's left hand is difficult to identify, as is one other enigmatic element, the drapery to the right of the figure, which looks something like a robe with the neck and one sleeve visible. If the figure represented King Herod, the robe might be that described in Luke 23:11 in which Christ is arrayed after his meeting with the king, but this still does not explain the soft rounded object in the seated figure's hand.

CB

4. It is my suspicion that the frequency of this pose and its clear association with figures of judges or rules may be tied to conventions of posture for certain types of figures that were developed in mystery plays. I have been unable to confirm this, however.

19. Capital and Corbel Head

1966.256
France, Champagne, or Normandy(?)
Last third of the thirteenth century
Limestone
H: 23.5 (9¼″)
W: 44 (17⅜″)

Condition. This piece shows minimal weathering, but it has suffered many small losses. The left part (the capital with leaves) has been badly damaged; some crockets on the central capital are chipped and broken. The edges of abacus are chipped and broken, especially on the lateral edges; the nose and chin on the head are also broken.

This corbel and the one that preceeds it (1966.168) are handsome examples of the kind of architectural ornament that proliferated in both religious and secular contexts in the last third of the thirteenth century. The capitals on the left side of this piece would have been placed above narrow shafts framing a door or window and would have supported the inner part of a trefoil arch, while the head on the far right would have supported the enclosing pointed arch. The treatment of the inner surface of the capital as the tubelike prolongation of the shafts below and the highly detached leaves are characteristic of capital styles in the second half of the thirteenth century, as can be found in more elegant versions in parts of St.-Urbain at Troyes, for example.

The face and capital decoration are fairly typical of sculptural decoration in the second half of the thirteenth century and are therefore difficult to localize. A somewhat similar capital with a head in the Yale University Art Gallery (Gillerman [1977]: 28–29, no. 2; [1989]: 315, no. 233) was at one time identified as possibly Norman in origin. But one of the dominant characteristics of architectural sculpture in the second half of the thirteenth century is its generic character, which derived from the immense prestige of monuments associated with Paris and the royal court; localization of a piece such as this one is therefore very difficult. It is, however, a handsome and well-preserved example

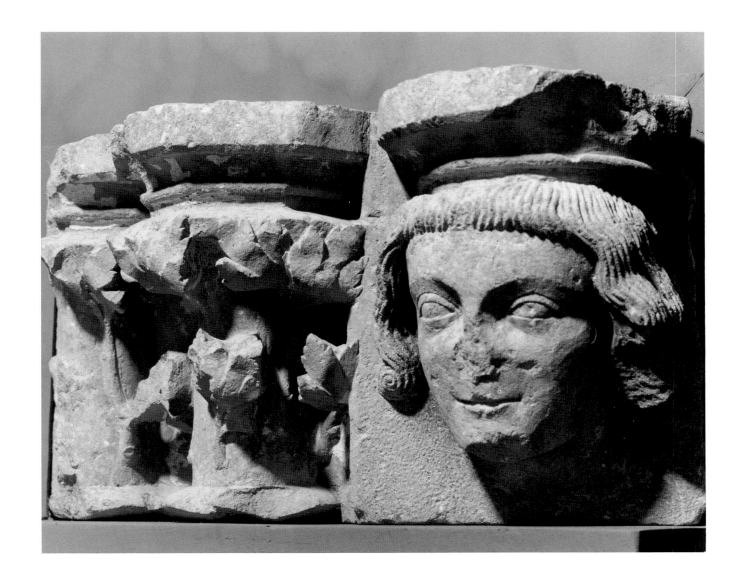

of the genre, and may well have come from a secular rather than a religious context.

Provenance. Purchased from J. Demotte, October 15, 1936.

CB

20. Two Border Sections with Fleur-de-lis

1978.20.8 a–b
France (Champagne: St.-Urbain at Troyes?)
C. 1270
Pot-metal glass
H: 110 (43¼″)
W: 10.5 (5⅞″) each

Condition. Excellent; these panels contain only a few replacement pieces.

These two handsome borders with fleur-de-lis ornament have been associated with the collegiate church of St.-Urbain at Troyes largely because similar borders from St.-Urbain have been published in Lewis F. Day's *Windows: A Book about Stained Glass* (London, 1967):161, and by O.-F. Jossier, *Monographie des vitraux de Saint-Urbain de Troyes* (Troyes, 1912):73. Unfortunately, information on the provenance is minimal and these suggestions cannot be confirmed.

On stylistic grounds the borders can be dated in the last third of the thirteenth century, a date which would be consistent with the construction of St.-Urbain.[1] As the fleur-de-lis was the French royal symbol, these borders may date not to the first phase of the work in the 1260s, but to the second campaign of the 1270s which was undertaken with the support of Charles of Anjou, younger brother of King Louis IX of France and King of Naples since 1266 (Bruzelius, [1987]).

Fleur-de-lis borders have often been dismissed as having much significance for patronage, and it has been suggested that borders of this type were used frequently in contexts where no royal patronage could be documented. Recent and as yet unpublished scholarship is tending to indicate, however, that the use of heraldic motifs such as this one was not indiscriminate, but to the reverse, rather tightly restricted to monuments to which the family in question had made contributions.

Provenance. Acquired from Wegener, November 3, 1930.

Bibliography. Caviness et al., *Stained Glass before 1700* (1987):92.

CB

Color plate XII.
1. St.-Urbain was founded by Pope Urban IV in 1264. See Michael M. Davis, "On the Threshold of the Flamboyant: The Second Campaign of Construction of Saint-Urbain, Troyes," *Speculum* 59 (1984): 847–84; and C. Bruzelius, "The Second Campaign at Saint-Urbain at Troyes," *Speculum* 62 (1987): 635–40.

198

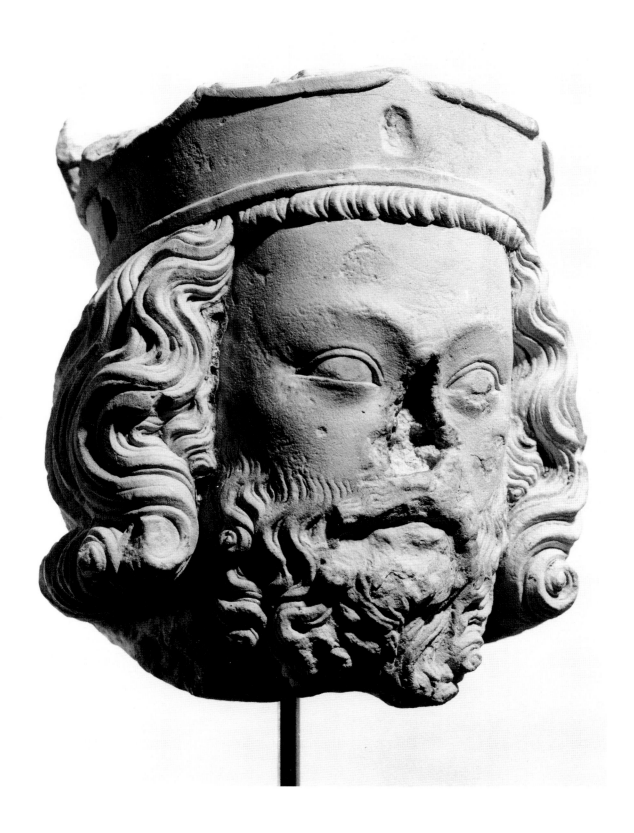

21. Head of a King

1966.76
France
Early fourteenth century
Limestone
H: 24 (9½")
W: 18 (7⅛")
D: 19 (7½")

Condition. Finegrained white limestone; the fleurons on the crown have been broken; some pieces of the lips and beard have been chipped off. The concavity in the area of nose indicates an older repair, now removed. Traces of polychromy are visible at the intersection of the head and hair on sides.

The refinement and delicate precision of this head are typical of many works produced around 1300 and in the first quarter of the fourteenth century in Paris and its environs (Gillerman [1981]:71). The curls of the hair and beard are arranged with perfect symmetry, framing a face that is flat and unmodulated. The features of the face are small and rendered with almost fussy precision. The entire head is contained in the square formed by the crown and bangs on top, the hair to the sides, and the beard. The curls of the hair and beard are set in complex yet neatly arranged corkscrew curls that serve as a foil to the broad flat surfaces of the face.

The preciousness of the features of the face and the elaborate coiffure of the hair and beard are elements that can be found in the well-known wooden figure of Christ in the Louvre of the early fourteenth century (*Les Fastes*, no. 2, 63–64; Aubert and Beaulieu, no. 194, 133). The heads share the same preciousness in the handling of the hair and facial features. Some of these features can be traced back to the statue of King Childebert from St.-Germain-des-Prés, now in the Louvre, dated to about 1240 (Sauerländer [1972]: 467–68; Aubert and Beaulieu, no. 109, 87–89). However, it has also often been noted that many characteristics of sculpture in the early fourteenth century are derived from ivory carving and manuscript illumination (*Les*

Fastes, 56); this is of particular interest in relation to this head at Duke because it is unusual in being carved from white limestone, a material perhaps deliberately chosen because it is evocative of ivory carving. White limestone is somewhat unusual, but was used, for example, in a fragmentary relief of Christ's entry into Jerusalem in the Louvre (Aubert and Beaulieu, no. 249, 171), identified by Françoise Baron as a fragment from the now-destroyed choir screen at Amiens.[1]

The original context for this head remains unresolved. It is roughly carved in back, and was thus meant to be freestanding but placed against a wall surface or in a niche. The location of the unfinished surfaces suggest that the head was intended to turn slightly towards the left. As noted by Gillerman ([1977]: 36), the head is probably too large to have been part of a choir screen. On the other hand, the suggestion that the head may have formed part of a "jamb program of donors" seems unlikely in view of its scale (slightly under lifesize), and the absence of any indications of weathering. Could it have formed part of an interior decoration commemorating donors or royal figures, a type of decoration possibly derived from that once located in the interior transept terminal walls at the destroyed church of St. Louis at Poissy?[2] Erlande-Brandenburg, who emphasized the originality of the sculptural program at Poissy, states that these figures were probably in place by the death of Philip the Fair in 1304, a date which accords well with the style of the Duke head.[3] Indeed, it might also be noted that there are certain general similarities between the style of the king at Duke and the surviving figures of Isabelle and the angel now in the Louvre and Cluny museums in Paris. For example, the lower eyelid tends to remain horizontal while the upper lid is amply curved, the facial features are concentrated in the center of a large but flat face, and the curls of the hair are arranged in ornate and symmetrical patterns.

Provenance. Purchased from Daguerre, October 5, 1929.

Exhibitions and Bibliography. Moeller, *Sculpture and Decorative Art* (1967): 38–39, no. 12, figure 23; Gillerman, *Transformations of the Court Style* (1977): 36, no. 6; Heckscher and Moeller, "The Brummer Collection" (1967–68): 184, figure 10; Grimme, "Die gotischen Kapellenreliquiare im Aachener Domschatz" (1969): figure 57; *The Medieval Sculptor* (Bowdoin College Museum of Art, Brunswick, Maine, 1971), no. 30.

CB

202

1. I thank Françoise Baron for sharing this information with me prior to publication. White stone similar to that in Duke's heads can be found in the Oise and in the Somme.

2. See Erlande-Brandenburg, "La Priorale Saint Louis," (1971): 102ff.

3. The construction of the church at Poissy was begun in 1297; see *ibid.*, 90 and 104. This program was of course related to the earlier decoration of the Grande Salle of the Palais de la Cité in Paris, but none of the original sculpture from the latter survives. Gillerman, *Transformations* (1977): 36, dated this head of a king at Duke to around 1325–35.

22. Head of the Christ Child

1966.127
France, Lorraine
Early fourteenth century
Polychromed limestone
H: 14 (6")
W: 13 (5")
D: 16 (6¼")

Condition. Excellent, with the exception of some chipping and abrasion, especially to the nose and lips. Some of the gilding and polychrome may be original, but there is also evidence of some repainting, as in the eyes. Part of the collar survives on the right side.

This charming head of a young child was once part of a Madonna-and-Child pair. The round, solid head might have looked upwards towards his mother, or towards some object held in his or her hands. He would have been held in his mother's left arm. The full, fleshy face is framed by a short curly cap of hair adhering closely to the skull. The hair is arranged in a series of identically repeated lozenge-shaped segments, each of which terminates in a tight curl towards the face; the carving of the hair is more fully finished on the right side and back of the head.

The geographical origins of a head of this type are difficult to pinpoint with great precision: lifesize figures of the Virgin and Child were produced in great quantities in the later thirteenth and the fourteenth centuries. However, the rather narrow eyes with slightly puffy pouches underneath and the cap of hair which frames the face with a horizontal line across the upper brow can probably be associated with an origin in the Lorraine.[1] The heads of the Christ child in the Virgin and Child from Epinal (Vosges) in the Boston Museum of Fine Arts (Gillerman [1989]:21–23) and the Virgin and Child from Châtenois (Vosges) in the Metropolitan Museum of Art in New York are very similar to the head of the Duke Christ Child (Forsyth [1936]:235–36). Comparison can also be made with another Virgin and Child in the Louvre (Aubert-Beaulieu, no. 258), dated by Françoise Baron to the

Color plate VII.

1. I thank Françoise Baron for this suggestion. Certain parallels exist between Duke's head and the Virgin and Child from Lorraine now in the Louvre recently acquired from Georges Ryaux (1979)—for example, the narrow eyes with slight pouches underneath the thin lips. See F. Baron, "Une Vièrge lorraine du XIVe siècle," *La Revue du Louvre* (1980):174–75. For another extensive discussion of Virgins from the Lorraine, see Forsyth, "Mediaeval Statues of the Virgin," *Metropolitan Museum Studies* 5 (1936), and Gillerman, *Gothic Sculpture in America*, volume I (New York and London, 1977):21–23.

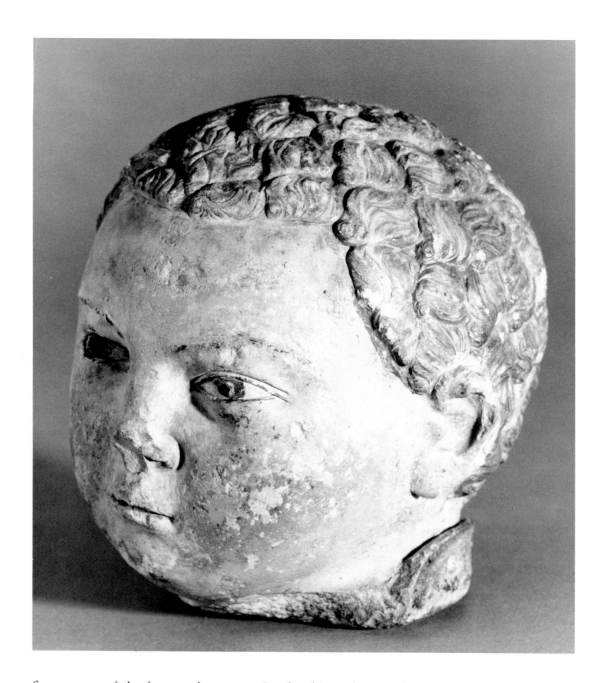

first quarter of the fourteenth century. Our head is striking in that it preserves some of its original polychrome, attesting to the important role of color in the original appearance of this important type of medieval sculpted figures.

Provenance. Purchased June 17, 1929, from Maurice Bigorie.

CB

204

23. The Visitation

1978.20.5
Austria, Carinthia(?)
C. 1350(?)
Pot-metal glass
H: 61.5 (24⅛)
W: 27 (10⅝)

Condition. This piece shows extensive stopgaps (mostly of old glass) and restorations due to the great amount of abrasion and loss on the original surfaces. Some of the paint is fragile, while some is missing altogether.

Although somewhat worn, this handsome panel reflects the kind of glass decoration that was commonly found in provincial churches in the fourteenth century. The beaded border, which survives only over the heads of the two women, the large foliate nimbi, and the drapery modeled with lines terminating in hooklike folds are characteristic of fourteenth-century provincial glass in Austria. The figures of the Virgin Mary and Saint Elizabeth have been elongated by the insertion of additional pieces of glass, distorting the original design. Nonetheless, the tender embrace of the figures and the juxtaposition of Elizabeth's slightly kneeling posture with Mary's more erect position evoke the original composition and attest to the quality of much of the glass produced by itinerant craftsmen in the Austrian provinces.

The subject is a common one in cycles of the infancy of Christ or the life of the Virgin, as it represents the first recognition of Christ's divinity. There is some evidence, however, that, starting in the fourteenth century, the theme of the Visitation became more popular and was sometimes represented on its own. On occasion, communities of pious women were dedicated to the Visitation, a theme that symbolized women's companionship and association.[1]

Provenance. Pollak and Winternitz.

Exhibitions and Bibliography. Gomez-Moreno, *Medieval Art* (1968): no. 197; Caviness et al., *Stained Glass before 1700,* 93.

CB

Color plate X.

1. See, for example, Marty Martin McLaughlin, "Creating and Recreating Communities of Women: The Case of Corpus Domini, Ferrara, 1406–1452," *Signs: The Journal of Women in Culture and Society* XIV (1989): 301.

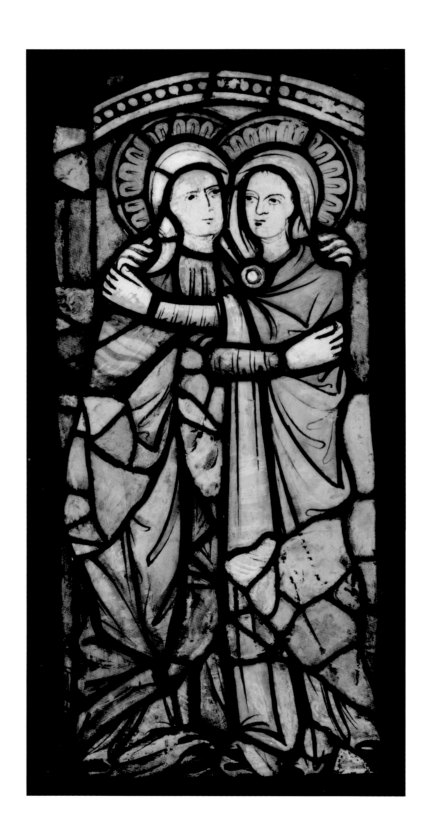

24. Engaged *Muqarnas* Capital

1966.41
Spain, Granada (?)
Mid-fourteenth century
Grey marble
H: 16.2 (6⅜")
W: 19.1 (7¾")
D: 20 (7⅞")

Condition. The front lower edge has been recut with chamfer for a subsequent architectural function. There is some minor surface damage to the corners visible, and one broken and repaired edge. Modern paint covers the sides, consisting of a layer of powdery red color beneath a thick, dark brown paint. In 1987 the paint was removed from one corner "stalactite," and the cleaned area was lightly waxed to minimize the effect of surface damage from previous attempts at cleaning and to restore the luster of the polished surfaces.

A symmetrical arrangement of delicate, deeply cut niches and scalloped arches on this capital produces the distinct cells called *muqarnas* or "stalactites," the characteristic feature of late Medieval architecture in Islamic Spain (Tabbaa, 61). Formed from stucco, such elaborate pendants were used to veil ceilings and domes with a richly tactile network and came to inspire the distinctive transformation of Hispano-Moorish capitals. During the twelfth century *muqarnas* were adapted to replace the traditional forms of capital decoration such as classicizing foliage (Bornstein and Soucek, 80). The complex "stalactite" articulation of this capital illustrates the fully developed phase as exemplified by capitals at the Alhambra Palace in Granada (Grabar, 85, 146–48, plates 49–50, 99). Early parts of the palace complex, built between 1334 and 1354, contain both freestanding and engaged capitals of this type set upon reed-slim columns. The small circular depression on this capital's underside reveals the slender proportions of its original vertical support. Additional flat and incised spiralling vinescroll designs, known as *arabesques,* indicate that the capital was installed against a wall in a fairly high location as part of a deco-

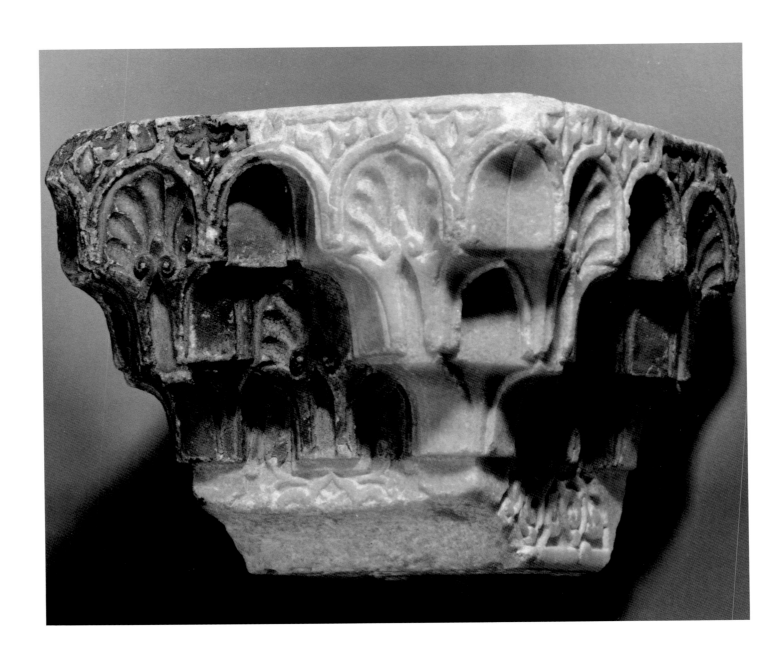

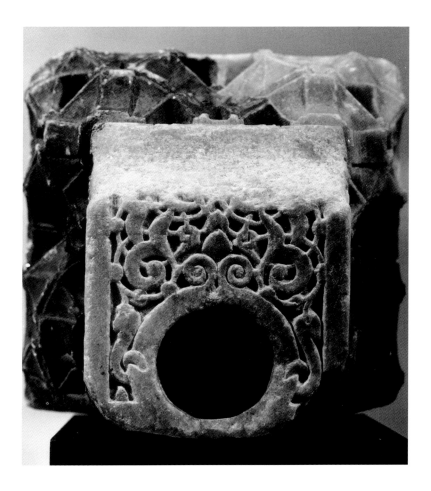

ative rather than supportive ensemble. The combination, here, of
highly plastic *muqarnas* and the calligraphic *arabesques* reproduces
in miniaturized form the rich stucco decoration of the Hall of the Two
Sisters at the Alhambra. The recent partial cleaning removed some
of the thick modern paint and grime which obscured the fine quality
of the marble with its refined carving and highly polished planes.
These newly revealed reflective surfaces heighten the coloristic effects
produced by the deep recesses and contribute to the capital's fragile,
jewel-like quality.

Provenance. Purchased from Brimo de Laroussilhe, Paris, on Au-
gust 1, 1928.

Exhibitions and Bibliography. Moeller, *Sculpture and Decorative Art*
(1967):70–71, no. 26; Bornstein and Soucek, *The Meeting of Two
Worlds* (1981):80, no. 52.

JM

Plate 24.1
Muqarnas capital, view
from below

25. Architectural Canopy

1978.20.7
Austria, Leoben, Waasenkirche
C. 1420
Pot-metal glass
H: 74 (29⅛)
W: 48 (18⅞)

Condition. Good. This piece has recently (1988) been restored, and pieces that were reversed have been turned around. New leading has been provided and the entire surface has been cleaned.

Color plate VIII.

This handsome architectural canopy emerges with new splendor after its cleaning and releading. The ambitious structure soars upwards with a series of perspectival recessions (several now correctly positioned after restoration) which create the illusion of a three-dimensional structure. The frontal plane is emphasized by the handsome finial at the bottom center of the piece, which, with its heavy, undulating leaves, is typical of architectural sculpture in the fifteenth and early sixteenth centuries (see, for example, the architectural sculpture in the nave of Troyes Cathedral).

This panel has been attributed by Eva Frodl-Kraft to the Waasenkirche in Leoben. It is also similar to several windows in the Cathedral of Gratz, several of which are in the United States in the Walters Art Gallery in Baltimore and in the Los Angeles County Museum.

The range of colors used in the stained glass here is severely restricted to the architectural elements, mostly in white (*grisaille*), with red, blue, yellow, and purple details and background. This reduced palette is typical of late medieval glass, and tended to enhance the ambitious pictorial representations and perspective schemes that often appear in the late Middle Ages.

Provenance. Acquired from Richard Leitner, Vienna, August 19, 1930.

Bibliography. Eva Frodl-Kraft, "Die Bildenster des Waasenkirche in Leoben," *Österreichische Zeitschrift für Kunst und Denkmalpflege* 25 (1971): 51–73; Caviness et al., *Stained Glass before 1700* (1987), 94.

CB

26. Figured Candleholder

1966.26
Germany
Early fifteenth century
Bronze
H: 24.8 (9¾")
W: 13 (5⅛")
L: 14 (5½")

Condition. This piece shows some surface wear and nicks. The candle socket is missing from the left hand, and a ring or some other object is missing from right hand.

A bearded man in tight-fitting buttoned tunic and cowl kneels on one knee on a triangular platform borne by three human feet. He holds up his right arm, which bends slightly at the elbow, while he extends his left arm away from his body. Originally he held a candle socket like a torch in his left hand. His right hand is pierced and held either another candle socket or some other object.

Bronze figured candleholders were produced in Flanders and Germany for domestic use in well-to-do households. These objects often assumed the form of standing or kneeling men in contemporary costume. This man's closely tailored garments and pinched-in waist resemble fashions current in late-fourteenth and early-fifteenth-century Germany, as exemplified by a detail from the Nuremberg Fountain of around 1380 (Metropolitan Museum of Art [1986]: 136–37, no. 16). The Duke candleholder relates closely to a group of figured candleholders including examples now in Berlin and Leningrad (von Falke and Meyer [1935]: 88, no. 527, plate 213), Boston, and Providence (Moeller [1967]: 80, nos. 1, 2), which are generally attributed to southern Germany in the early fifteenth century.

The postures exhibited by these candleholders can vary, sometimes displaying the reverse arrangement of this figure. Probably such objects were arranged on the table as confronted pairs or in multiple groups. There they might be joined by another related genre of bronzework, an aquamanile or water pouring vessel for washing the hands sometimes made in the form of a kneeling man.[1]

1. von Falke and Meyer, *Bronzegeräte*, plate 526, for the St. George aquamanile in the Bargello Museum in Florence.

212

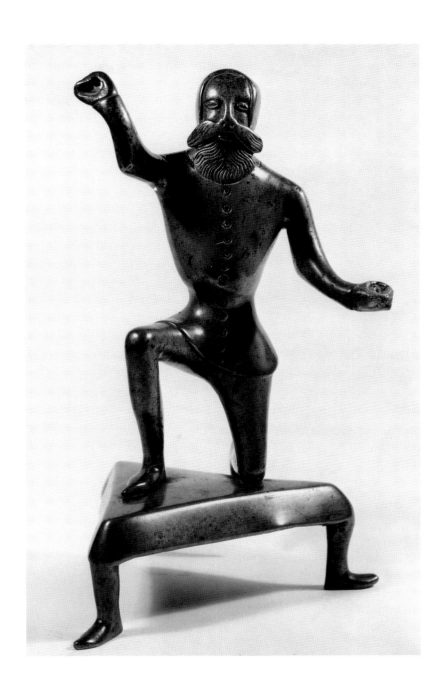

Provenance. Purchased from Pazzagli and Nesi, September 1928.

Exhibitions and Bibliography. Joseph Brummer (1949):II, 90, no. 382; Moeller, *Sculpture and Decorative Art* (1967): 80, no. 31, figure 44; Calkins, *A Medieval Treasury* (1968): 162, no. 88.

JM

27. Triptych of the Crucifixion

1966.30
Italy, Veneto
Embriachi workshop
Early fifteenth century
Bone, wood, and horn
H: 32 (12⅝″) [open]
W: 24.1 (9⁹⁄₁₆″) [open]

Condition. The figured bone panels are in good condition, retaining the original polychromy details of the eyes, the floral decorative motifs on the drapery, and the architectural borders. Some breakage and loss of intarsia on the upper left and right corners of the central panel is visible. Loose and misplaced intarsia pieces were repaired when the piece was cleaned in 1987.

This portable household altarpiece consists of three parts: a central panel depicting the Crucifixion and two lateral wings which contain single figures of saints, all within a wood, bone and horn intarsia framework. The cross with the body of Christ is surrounded by a kneeling Mary Magdalene and a pair of soldiers. To the left the Virgin Mary and three soldiers look on, while St. John stands to the right of the Cross with bowed head. St. Paul occupies the left wing and St. James the Less stands at the right; each is hooded by architectural canopies with arched openings.

This is one of two triptychs at Duke (see 1966.29) that can be attributed to the important workshop of ivory carvers founded by Baldassare degli Embriachi in Venice shortly before 1400. Until the atelier was disbanded in around 1433, it mass-produced hundreds of portable devotional and secular objects, such as altarpieces, chests, boxes, mirror backs, and combs, decorated with either religious or literary subjects.[1] In most cases the figures were carved from convex plaques of bone, as they are here, instead of the more costly ivory. The narrow rectangular field tended to limit the carvings to vertical, somewhat static compositions. This triptych displays many characteristic Embriachi workshop details, including the pedestal-like ledges beneath the figures, the horizontally articulated domical pine trees,

Color plate VI.

Plate 27
Detail

1. J. Schlosser, "Die Werkstatt der Embriachi in Venedig," *Jahrbuch der kunsthistorischen sammlungen des alterhöchsten Kaiserhauses* (1899): 220–82.

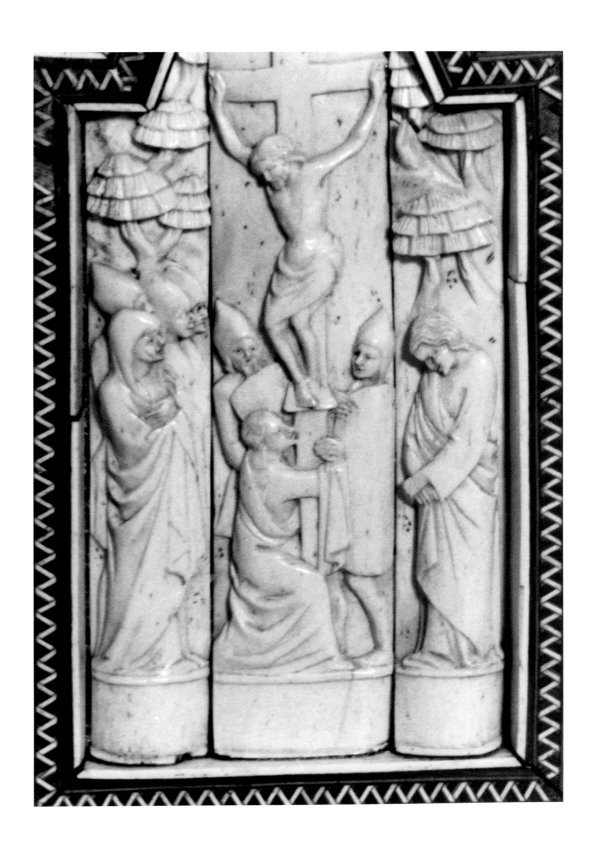

and the architectural canopies. Fortunately it retains numerous traces of the original polychrome decoration usually missing from many surviving Embriachi works—even from the more elaborate and accomplished examples. Here the composition has been enriched by red-dot floral designs patterning the drapery and background, parallel red lines underscoring architectural cornices, and red lips and black pupils animating the thin, angular faces.

The smaller size and compositional discontinuity of the Duke Crucifixion triptych suggest that it was one of the more routine productions of the workshop. Like the bulk of the atelier works it was created in a modular fashion—individual plaques of saints and the components of standard religious scenes were carved in advance and later assembled to suit the buyer. This modular quality is most apparent in the figures. The three plaques comprising the main panel remain discrete units; their smaller, densely packed figures never extend beyond the edge. Even the domical Tuscan pines end abruptly at the edge of their respective plaques. The larger saints on the wings, like their counterparts on the other Duke triptych (1966.29), typify the range of saints who populate the multitiered wings of larger Embriachi altarpieces. In general design and subject matter this piece can be compared to the Crucifixion triptychs at the Walters Art Gallery in Baltimore (Randall [1985]: 236, no. 356), the Museo Nazionale in Florence (Egbert [1929]: 174), and the Victoria and Albert Museum in London.[2] These altarpieces, however, exemplify the more elaborate type containing subsidiary scenes and numerous saints arranged paratactically in rows on the multiregister wings and beneath the central Crucifixion scene. While the Duke triptych compares in carving and decorative quality to these more complex examples, its modest, five-plaque format suggests a compact version intended for domestic use by a more budget-conscious consumer.

Like other Embriachi altarpieces it would have been opened only for private devotions. The reverse of the wings is painted, revealing, in its closed position, a lion (plate 28.1), the symbol of St. Mark, the patron saint of Venice.

JM

2. The Duke triptychs comprise two of the three Embriachi folding altars in American collections—the third being the Walters example. These will appear in the forthcoming census by Richard H. Randall, Jr., *A Corpus of Gothic Ivories in American Collections.*

28. Triptych of the Virgin and Child

1966.29
Italy, Veneto
Embriachi workshop
Early fifteenth century
Bone, wood, and horn
H: 33.5 (13⅛) (open)
W: 26 (10¼) (open)

Condition. Some slight surface wear on the bone plaques is visible; there are cracks behind the saints' heads on the left wing and on the central panel. A piece is missing to left of the head of the right saint on the central panel. Traces of the original polychromy include a blue-green color in the windows of architectural canopies, a red-dot background, and a gold halo behind the head of the left saint on the central panel. Pieces of the intarsia have been lost on the lower border and pedestal; the piece has suffered severe paint losses on the reverse surface of triptych wings.

Like its companion piece in the Brummer collection (1966.30), this three-part portable altarpiece consists of a gabled central portion and a pair of lateral wings with figured bone plaques surrounded by an intarsia framework of geometric designs. At the center the Virgin Mary sits and nurses the infant Christ. She is surrounded by standing male saints who turn toward her as witnesses. St. James the Greater, with a pilgrim's cloak and staff, and a youthful warrior saint, probably St. Paul, join her on the central panel. St. James the Less, with book and staff, at the left, and St. Francis pointing to one of his stigmata, at the right, occupy the lateral wings. As on other Embriachi altarpieces the figures stand on pedestals, however the Virgin's pedestal is raised by an additional base to elevate her above the other figures. Pierced and crenellated overlapping blocklike forms suggest a fantastic towered cityscape projecting out over the heads of the figures. This complex architectural canopy is interrupted at the center by a delicate pointed trefoil arch with tracery which frames and distinguishes the Virgin and Child. This oddly interpolated Gothic architectural detail was adapted from the ornate trefoil arches which commonly frame holy

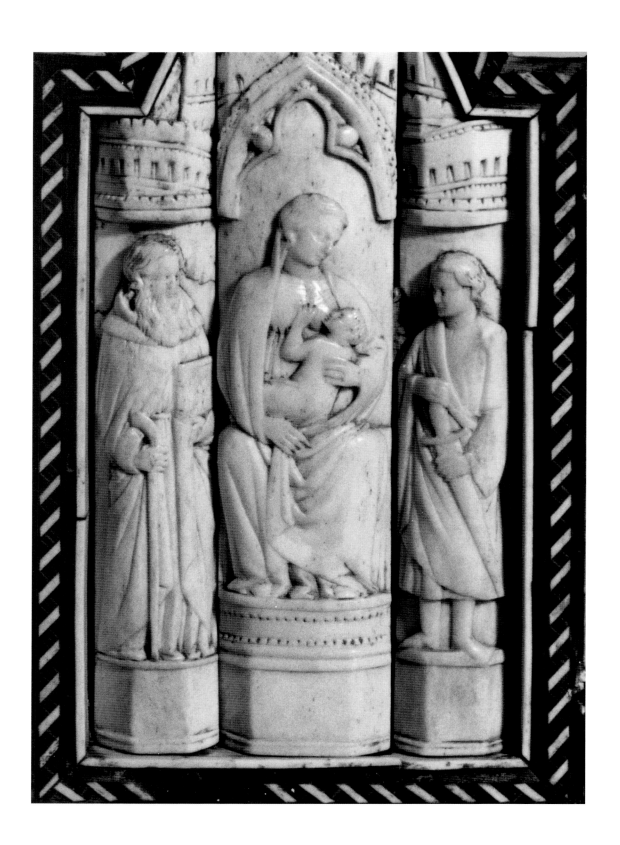

figures on late-fourteenth-century French and German ivory reliefs. The bulkier, monumental figure of the Virgin in a tender maternal pose derives from late-fourteenth-century Northern Italian panel and fresco painting.

When not used for private devotions the wings were folded in to close the altarpiece (plate 28.1). The reverse sides of the wings are painted in grisaille with white and red details and depict two confronted figures. Their poor condition hampers ready identification; however, surviving details of their halos, extended wings, and drapery suggest that they are a pair of angels comparable to those on the exterior surface of the Walters Art Gallery triptych (Randall [1985]: 236, no. 356).

JM

◄Plate 28
Detail

Plate 28.1
View of triptychs with wings closed: Crucifixion, left; Virgin and Child, right

29. Relief of a Martyrdom

1966.47
Netherlandish-Rhenish or English
1450–1500
Alabaster, polychrome, gilt
H: 40 (15½″)
W: 45 (17¼″)
D: 4.5 (2″)

Condition. This piece was previously broken in half, but it has been
mended and mounted on a wooden board, although it is still missing
the lower right corner and a large triangular piece from the back-
ground. Prominent breaks are visible in the upper left portion, and
the right hand of the crowned figure has been sawn off. The panel re-
tains its original gilding and polychrome as well as subsequent paint;
several gaps were poorly filled and inconsistently colored. In 1987 the
gap-fills were repaired and painted a uniform warm grey to achieve a
more uniform appearance, and the very discolored stone was cleaned
with moderate success.

This damaged alabaster relief of martyrdom depicts two praying
female saints and a third headless figure, possibly male. Behind them
a youthful executioner stands with drawn sword, about to behead the
kneeling female. At right, a crowned male figure consults with the
supervising executioner. The missing lower right corner undoubtedly
contained the severed head of the first martyr in addition to the legs of
the two men at right. The remaining traces of gilding and polychrome
attest to its original luxurious appearance. Gilding highlights the gar-
ments' hems, the floral brocade and hair of the kneeling female, the
crown and the hat worn by the men, and the vinescroll decoration
of the sword sheath. Originally a jewel-like floral pattern covered the
gilded background but the raised gesso dots have long since fallen off,
leaving telltale blank spots of alabaster where the gesso was applied.
Other portions of the figures display a greenish-blue color which may
be secondary paint.

This devotional panel from a retable exemplifies an extremely popu-

Color plate V.

Plate 29
Detail

220

lar type of late medieval religious sculpture which was produced in vast quantities for voracious middle-class consumers. England, particularly Nottingham, was a major center of the alabaster industry, exporting sculptures together with its famous excellent cloth to markets all over Europe (Cheetham, 45–49). These goods were shipped through London and Antwerp; the exchange of artistic influences coincided with this commerce between England and the Low Countries and the Rhineland. Although specific centers of production have not been determined, areas of northern France, Flanders, and the Rhineland also produced similar alabaster relief retables.

The Duke relief presents a puzzle regarding its attribution since it displays English sculptural and decorative techniques as well as Netherlandish-Rhenish features. The jewel-like, floral-patterned background and gilding are distinctively English. The relationship between figure and ground is also typical of English work; here the figures are partially submerged in the background, whereas in most Continental works the figures are more substantial and appear to stand before the background. Unlike the English works, which are usually vertically rectangular, this work is more square in format, following Netherlandish custom. The horizontal disposition of the figures across a single ground plane links the Duke relief to Continental rather than English alabasters, in which the figures are arranged on different levels to suggest recession in three-dimensional space or a more complex iconographic relationship. While English narrative reliefs tend to be more densely populated with expressionless but animated thin figures, the figures on the Duke relief appear more solid and static. The figure style and facial details, moreover, recall German and Netherlandish sculpture and painting, especially the tendency to individualize the faces. The softly modelled drapery folds with gilded hems can be compared to Flemish or German works such as the Boston Lamentation relief of around 1450 (Gillerman [1989]: 64). The varied faces with their highly detailed eyes suggest distinct individuals—a style and visual impression very different from the generic facial types of the English alabaster reliefs. The faces here are expressive and realistic, much like German wood altarpiece statuary of this period.

While most alabaster reliefs depict scenes from the Life of the Virgin or the Passion of Christ, the Duke relief portrays the martyrdom of a female saint, perhaps one part of a longer narrative cycle. The subject of this panel resembles the execution of St. Catherine, a saint

second only to John the Baptist in popularity as a subject of English alabaster reliefs. As in other examples of her beheading (Cheetham, 19), here the saint kneels in prayer before the executioner, who raises his sword, about to deliver a mortal blow. The usual accompanying witnesses, including the crowned Emperor Maxentius, complete the scene. While the Duke relief contains many of the compositional elements which typify St. Catherine's martyrdom, there are two haloed women differentiated by costume and pose plus a third, beheaded, possibly male figure. This panel depicts a group martyrdom scene like that of St. Ursula and her companions, using iconographic details adapted from the more common St. Catherine depictions. The standing female martyr turns her head to the viewer's left, suggesting a narrative connection to figures in a preceding panel. Perhaps the identifying details were contained in other reliefs of the altarpiece. If this relief can be attributed to England then it is more likely that St. Catherine's martyrdom is depicted here. However, if this relief is of Netherlandish or German manufacture under the influence of English alabaster traditions, it may well depict the martyrdom of St. Ursula and her companions outside the city of Cologne as described in medieval legends (Réau, 1296–1301). Her cult became popular in the fifteenth century in the Rhineland and the Low Countries, especially in the vicinity of Cologne, where she was invoked for head ailments. Perhaps, in order to depict St. Ursula, the legendary British princess who became the patroness of Cologne, a local alabaster workshop turned to English prototypes. This iconographic interpretation and hypothetical Cologne origin would account for the Rhenish painting features, as exemplified by the Cologne master Stefan Lochner, that Moeller noted in this relief (Moeller, 44).

Provenance. Purchased from André, June 23, 1929.

Exhibitions and Bibliography. Moeller, *Sculpture and Decorative Art* (1967): 44–47, no. 15, figure 26; Heckscher and Moeller, "The Brummer Collection" (1967–68): 186.

JM

30. Frog Sand Container

1966.28
Germany (Nuremberg?) or Flemish
Sixteenth century
Bronze, lead
L: 7.6 (3″)
H: 3 (1¼″)
W: 5.5 (2¼″)

Condition. This piece shows surface wear and numerous nicks throughout. The anatomical details of the lid have been worn smooth, and the bottom of the interior has corroded through. There is some evidence of lead solder on the bottom inner and outer surfaces, probably from earlier repair.

Function and anatomical form have been cleverly combined in this little bronze frog container. His head and back comprise the lid, hinged in the rear, so that his mouth appears to "swallow" or "disgorge" the contents. The characteristic anatomical details, rendered somewhat schematically in low relief, include the circular eyes, a striated ridge to denote the spine, and the webbed feet. Biomorphic containers, such as ewers in the forms of lions and griffins, were used in the High Middle Ages primarily as liturgical objects. By the late Middle Ages utilitarian objects for secular use—most commonly as decorative tableware—assumed a variety of animal forms. By the sixteenth century not only mammals, but also birds and reptiles, joined the repertory of the metalsmiths who depicted animal forms and postures with a high degree of naturalism. Desk sets with reptiles and insects seem to have been especially popular with German gold and silversmiths. An inkwell from Nuremberg by Wenzel Jamnitzer (1508–85) at the Vienna Museum realistically swarms with lizards, insects, and toads. Another reptile container, a gaping crocodile of gilded silver at the Fogg Art Museum, was also part of a desk set and dispensed sand from its removable head to dry the ink (Kuhn [1965]: 94, no. 49, plate xlv).

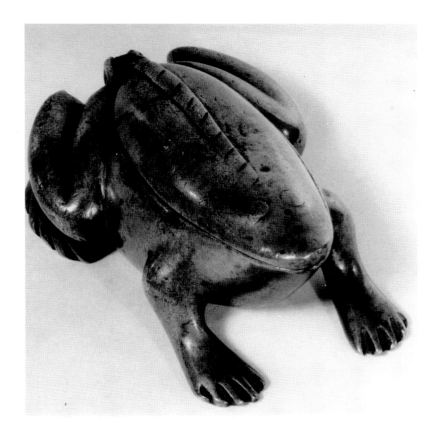

This frog sand container probably also belonged to a desk set. Because it is not formed from precious metal, presumably only gilded, and because its anatomical features are rudimentary rather than astonishingly lifelike, the frog has the stamp of a more widely produced item intended for less affluent consumers. As its marked surface wear suggests, unlike its more precious silver and gold counterparts, this frog was used constantly. Yet whatever the anonymous metalsmith lacked in material and artistic refinement he made up for in wit.

Provenance. Purchased from H. Garnier, July 25, 1929.

Exhibitions and Bibliography. Parke-Bernet, *Joseph Brummer* (1949): II, no. 90, 382; Moeller, *Sculpture and Decorative Art* (1967).

JM

31. St. John from an Entombment Group

1966.173
France (Burgundy?)
Late fifteenth century/early sixteenth century(?)
Limestone with polychrome
H: 93 (36⅝")
W: 46 (18⅛")
D: 29 (11½")

Color plate XIV.

Condition. Extremely finegrained white limestone, polychromed; there are some traces of pink paint on the face, some red paint with a gilded floral design is visible on the robe, and there is some gilding on the tunic, in addition to some blue paint on the underside of the robe, all above a yellow gesso layer. Both hands have been broken off, and the rest of the piece has suffered general chipping and breakage. The face, the hair, and the rest of the figure have been somewhat abraded. The head has been broken off and reattached. The neck in the area of the repair has been reworked and a yellow-orange pigment has been applied to cover the repairs; the right arm has received similar treatment at the elbow. The lower third of the figure is missing.

This young man, who stands in an exaggerated contrapposto pose, looks down towards his left with a sober and thoughtful expression. Almost concealed underneath the voluminous folds of his cloak is the "S"-curve typical of sculpture in the preceding centuries. A fifteenth century date for this figure is indicated, however, by the treatment of the drapery, the man's rather stocky proportions, and the intense realism of his face.

The pose of the figure suggests that he was not meant to exist in isolation as he is seen today; he undoubtedly formed part of a group of figures, most likely an Entombment. Entombments were groups of large-scale figures who represented the events associated with the preparation and burial of Christ's body after the Crucifixion; the iconography was based on the New Testament. Standard participants in these groups included the grieving Virgin comforted by Saint John, Joseph of Arimathea, Nicodemus, Mary Magdalene, and

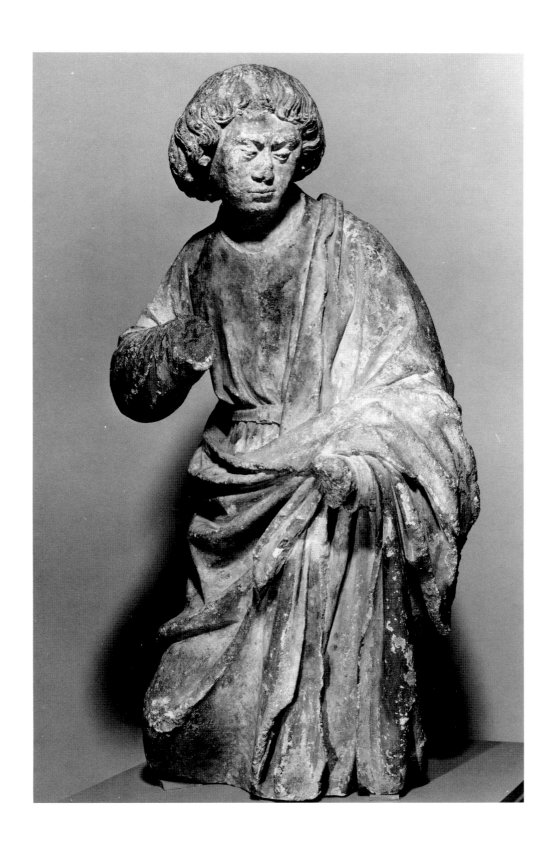

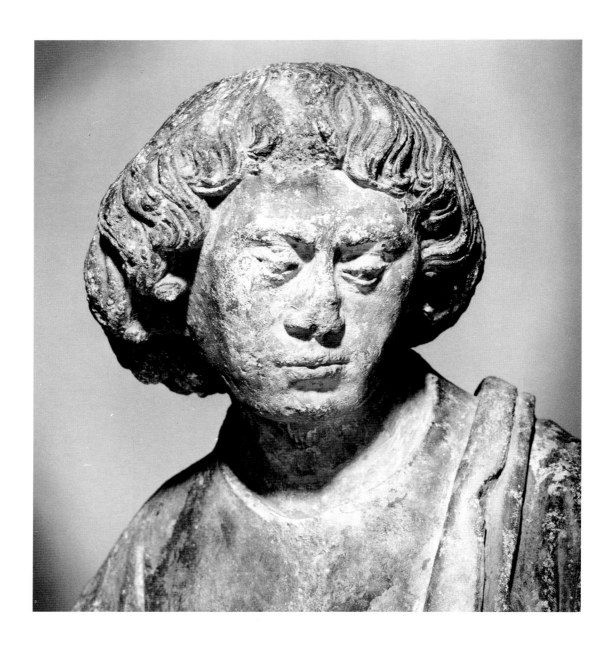

Plate 31.1
Saint John, detail of face

often other Holy Women. The groups could consist of as many as ten figures assembled either within a niche in a specially constructed half-subterranean chamber (as at Tonnerre) or in a chapel. They were popular forms of church (and palace) decoration in the fifteenth and sixteenth centuries. Many were destroyed after the French Revolution and the figures were dispersed in museums throughout the world. The youthful features of our figure and pose of our figure suggest that he is John, who usually stands to the left of the Virgin in Entombment Groups. After the Italian campaigns of Charles VIII and Louis XII in the late fifteenth and early sixteenth centuries, these sculptural groups

228

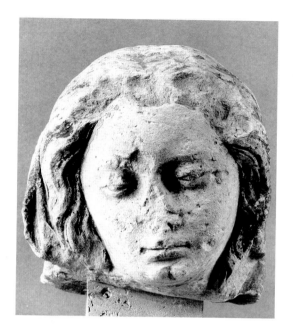
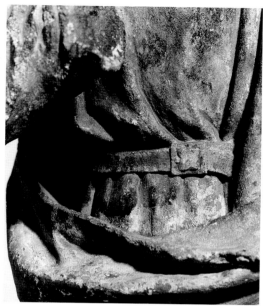

became increasingly italianate in character; this led to freer and more open groupings of the figures and a new classicism in pose and detail. It is interesting to note that this figure of Saint John was obviously not supporting the Virgin, as he consistently does in earlier Entombments, but was instead freestanding. This suggests that our figure may be somewhat later in date (early sixteenth century) than we might otherwise suppose.

As noted by William Forsyth in his study of Entombments (1970), this type of sculptural group was ubiquitous in France. They were often inter-regional in character; surviving figures or fragments are often difficult to localize because the sculptors were itinerant (Forsyth [1970]: 140). Certain details of the face in this figure are reminiscent of those sculpted in the workshops of well-known Burgundian sculptors such as Jean de la Huerta. This is particularly true of the slightly bulging eyes and the handling of the lids. On the other hand, our head at Duke is particularly close to one of three heads supposedly from a destroyed Entombment group in the Collège de Cluny in Paris (now the Cluny Museum, no. 23222) (plate 31.2). However, the Cluny Entombment, formerly located in the chapel where these heads can still be found, was slightly larger in scale than our figure (the heads at Cluny are between 22 and 27 centimeters tall, as opposed to the smaller dimensions of our head).

CB

Plate 31.2
Head of female figure from an entombment group, Musée national des Thermes et de l'Hôtel de Cluny, Paris

Plate 31.3
Saint John, detail of drapery and belt buckle

32. Bust of Christ, Fragment of a Palmesel

1966.55
Germany, Swabia (?)
Late fifteenth century
Polychromed limewood
H: 52.5 (20¼")
W: 36 (14")
D: 17 (7")

Condition. This was originally formed from three pieces: the head and central torso, comprising the main piece, and two separate pieces for each arm and shoulder (plates 32 and 32.1). The shoulder pieces were attached to the torso piece with glue and two vertically arranged nails, whose holes are still apparent. The figure's left arm retains two one-inch-deep sink holes for the nails. Its right shoulder and bust are broken off and traces of original glue and square nails are evident. The lower tendrils of the locks of hair which originally fell across the shoulder and front of the torso were also separate pieces and have broken off. Traces of salmon-pink paint denote the undergarment, whose neckline forms a V-shape in front. The dark blue-green painted folds of the outer garment can be seen in fair preservation in back. They were formed from heavy fabric glued to the wood, modelled with added gesso, and painted. The front now consists of rough un-painted wood below the edge of the undergarment collar. These areas, however, originally contained the same thick folds of drapery seen on the reverse; traces of the glue and patches of the coarse fabric used to mold the bulky drapery can be seen in places. The piece has suffered moderate insect damage, wormholes, and cracks throughout.

This bust-length effigy of Christ came from a larger composition which originally consisted of a full-length figure of Christ astride a donkey for His entry into Jerusalem. The gaunt face bears a serene, almost wistful expression, as though resigned to His inevitable martyr-dom on the Cross.

Painted wood sculptures of this type, termed *Palmesel* for the Palm Sunday donkey, formed the centerpiece of late medieval Palm

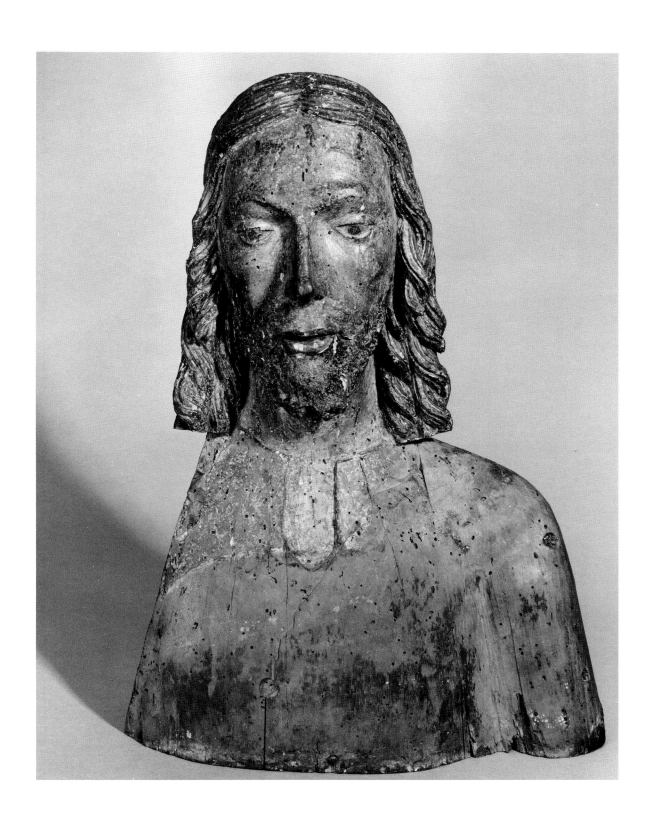

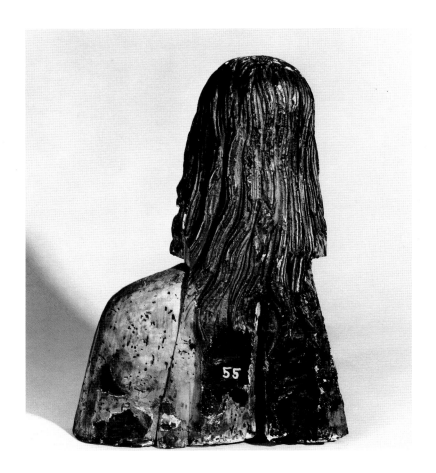

Plate 32.1
Torso of Christ, back view

Sunday observances in northern Europe until the Reformation.[1] A *Palmesel* was pulled on a wooden platform with wheels and accompanied by a colorful procession of townspeople and clergy who carried crosses, banners, and palms, sang appropriate hymns and hosannas, and spread garments on the ground. This festive liturgical parade, which re-enacted Christ's triumphal entry into Jerusalem, was part of the civic pageant which culminated in the Passion plays of Holy Week. The origin of the Palm Sunday procession is obscure and may derive from ceremonies practiced in Jerusalem in the early Christian period.[2] A detailed literary reference to a *Palmesel* effigy and observances in Germany occur in a mid-fifteenth-century life of the Bishop of Augsburg, St. Ulrich (932–73), but reflects local practice going back to the tenth century.[3]

Palmesels were produced by local, anonymous artists for monastic foundations, cathedrals, and parish churches, most commonly in Germany, Alsace, Austria, and Switzerland during the thirteenth to sixteenth centuries. About fifty such groups remain today and these vary in scale from miniature toylike versions to the near lifesize ones like the Duke example.[4] Christ usually wears a long, plain tunic and raises

1. J. A. von Adelmann, "Christus auf dem Palmesel," *Zeitschrift für Volkskunde* 63 (1967):182–200.
2. L. Duchesne, *Christian Worship* (London, 1949): 247, 553–54.
3. Vera K. Ostoia, "A Palmesel at the Cloisters," *MMA Bulletin* XIV/7 (1956): 172.
4. Frank R. Horlbeck, "Gloria, Laud and Honor: The *Palmesel* and Palm Sunday," *University of Wisconsin-Madison, Elvehjem Museum of Art Bulletin* (1977–78):26–37, figures 1–4, 9, 11, 12, for examples in European collections at Zurich, Munich, Basel, and Ulm.

His right hand in benediction while His left hand holds the donkey's reins. This stock format was repeated for centuries. Chronological distinctions can be seen mainly in the articulation of the tunic's drapery folds, which evolved from the geometric schematism of the early thirteenth century to the bulky, complex, and organically arranged compositions of the early sixteenth century. Considered idolatrous during the Reformation, most *Palmesels* were destroyed or mutilated. The donkeys were thought particularly offensive, but the revered figure of Christ might be sawn off and preserved, as in this case.

The incomplete state of the Duke *Palmesel* does not permit a geographic or chronological attribution in any more than general terms. The smoothly rendered tunic, rigid pose, and sharply defined facial features recall Swabian sculpture from around 1450 to 1520, particularly in the tradition of Hans Multscher, the only known master carver to create a *Palmesel*.[5] This bust of Christ joins a rather limited group of *Palmesel* figures in American collections. Three complete examples may be found at The Cloisters, the Detroit Institute of Art, and the University of Wisconsin's Elvehjem Art Center (plate 32.2).[6]

Provenance. From the collections of Emile Molinier, Alphonse Kann; purchased from John Simon, February 21, 1931.

Exhibitions and Bibliography. Moeller, *Sculpture and Decorative Art* (1967): 52, no. 18, figure 29; Portland Art Museum, *Masterworks in Wood* (1975): no. 28.

JM

233

5. Horlbeck, 34, figure 11, and Karlsruhe, Badisches Landesmuseums, *Spätgotische Bildwerke* (Karlesruhe, 1962): figures 16 and 17, of a Virgin and Child associated with Hans Multscher, c. 1460–70. See also Baxandall, *Limewood*, figure 32, for another Swabian *Palmesel*.

6. For illustrations, see Ostoia, 171; C. Corgan, *Bulletin of the Detroit Institute of Art* XXXVII/1 (1957–58): 66; Horlbeck, figure 5.

Plate 32.2
Palmesel, Elvehjem Art Center, University of Wisconsin, Madison

33. Crucified Bad Thief

1978.20.4
Upper Brittany (?)
Early sixteenth century
Pot-metal and white glass with silver stain
H: 57 (22½)
W: 43.5 (17⅛)

Condition. Good, overall; the left foot has been restored.

Color plate XI.

The figure would have been part of a larger crucifixion scene which included the Crucified Christ and the Good Thief. The custom of including the crucified thieves began in the mid fourteenth century; their contorted bodies and the dislocation of their limbs, usually bound to T-shaped crosses, often served as a foil to the more peaceful and dignified figure of Christ in the center (G. Schiller [1972]:II, 156–57). The arms of the Thieves were usually bent back at the elbow behind the cross to further distinguish them from the position of Christ with outstretched arms in the center. Angels and devils receiving the souls of the thieves appear from the late fourteenth century onwards; in our panel the demon receiving the bad thief's soul is placed in the upper left corner.

The juxtaposition of the white body of the thief against the blue background is typical of late Medieval and Renaissance glass. The use of the white glass known as *grisaille*, in particular, provided artists with the opportunity to explore nuances of anatomy and shading that would not have been visible in brightly colored glass. The bright blue background with its yellow stars is frequently found in German sixteenth-century glass.

Provenance. Purchased from A. Semail, Paris, September 24, 1928.

Bibliography. Caviness et al., *Stained Glass Before 1700* (1987), 94.

CB

234

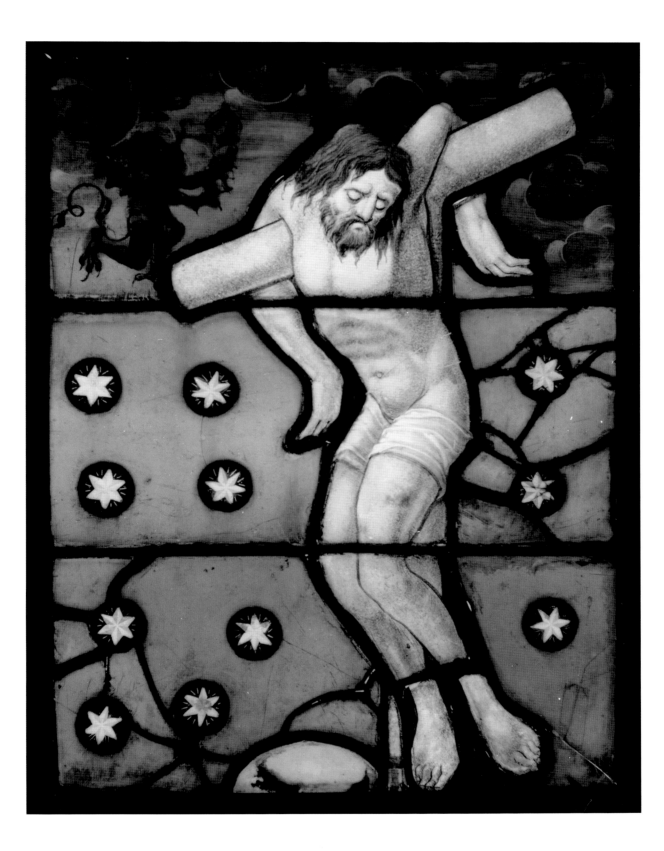

34. Statue of St. Anne (?)

1966.22
German, Swabia (?)
Early sixteenth century
Wood, polychrome, gilt
H: 38.1 (15″)
W: 14.6 (5¾″)

Condition. In good condition, retaining much of the original poly-
chrome. The gilded surfaces of the cloak are mostly worn, revealing
red underpainting. Some polychrome chips are missing from the veil,
back, and drapery edges.

Color plate IV.

Like its companions in the Brummer collection (1966.23, 1966.108),
this small wooden statue exemplifies the wide range of subjects and
stylistic variety found in the multifigure altarpieces produced by south
German workshops in the early sixteenth century. From her frontal
stance this figure turns her head to her right; her sweet, dreamy ex-
pression suggests some private thought. The tight bodice and vertical
gathers of her red dress define her female form, which is otherwise
obscured by the layers of cloth. Her arms emerge from the heavy folds
of her golden cloak with blue lining. She clasps her hands below her
midriff, bunching together the thick drapery of her garments. A white
wimple and veil frame her delicate features and fall in softly curving
folds around her face and over her shoulder.

Now an isolated figure, without a narrative context or any at-
tributes, her identity remains hypothetical. Although Moeller pro-
posed that she might represent the Virgin from a Crucifixion group,
her "rather wistful gaze" seems too subdued for such a context. The
Virgin usually displays a more dramatic, mournful expression and ges-
ture; in addition, her head, turned to witness the Crucifixion, would
imply placement at the right of the Cross, the reverse of the usual
arrangement. It is equally unlikely that she is a martyred female saint,
because she carries no identifying attribute, crown, or martyr's palm
leaf. Her distinctive headgear, however, recalls the type worn by St.
Anne in numerous seated family groupings with the Virgin and the
infant Christ (*Marienbild*, 191–204). In standing versions, the larger
figure of St. Anne (Didier and Krohm, 74) often holds her progeny,

236

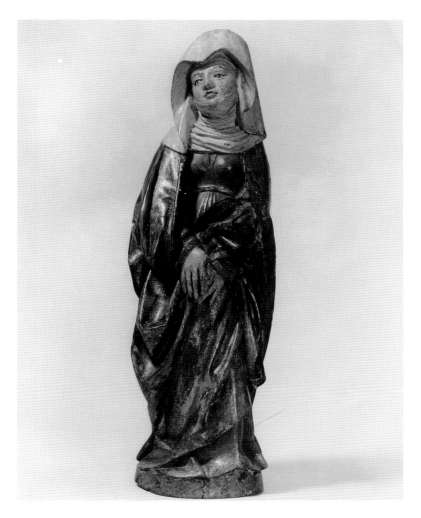

who are shown in miniature scale. The turned stance of this solitary figure suggests that she may have been part of a multifigure group in an altarpiece, perhaps accompanying a standing Virgin and Child like the statuette from the upper Rhineland or Swabia (Didier and Krohm, 67), which exemplifies a common type. Like the Duke female figure, this figure of the Virgin displays a similar drapery treatment which emphasizes her smooth, rounded bodice with vertical folds below the girdle, the rich sweeps of heavy drapery of her outgarments, and serene facial features. Both works are comparable also in size and figure proportions. If this figure depicts St. Anne, then her physical resemblance to the Virgin Mary would be appropriate to such a grouping stressing their genealogical relationship.

Exhibitions and Bibliography. Moeller, *Sculpture and Decorative Art* (1967): 56–60, no. 21, figure 32.

JM

35. Statue of St. Cyriacus

1966.23
German, Thuringia or Saxony (?)
Early sixteenth century
Wood, gilt, polychrome
H: 39.4 (15½")
W: 11.1 (4⅝")
D: 9 (3½")

Condition. In good condition, with considerable polychrome. The gilding of the chasuble is cracked and worn. The figure is missing his right hand, which was a separately glued piece. The devil's left arm and left foot, also separate pieces, have been lost, and his left ear has been broken off.

Color plate II.

This statue portrays a plump young man dressed as a deacon holding a book and figure of a devil in his left hand. Soft ringlets of hair encircle his round face. His delicate facial features display little emotion and convey a sense of contentment. His attributes identify him as St. Cyriacus, a deacon of the Church who was martyred during the reign of the Roman Emperor Diocletian even though he exorcised the demons possessing the Emperor's daughter Artemia (Braun, 178–81). Here he displays his book of exorcisms and a gravely wounded devil with gashed legs. St. Cyriacus's missing right hand may have held an emblem of his martyrdom—either the sword with which he was beheaded or a palm leaf.

His rigid frontal posture and bland expression indicate that he came from an altarpiece much like a late-fifteenth-century Thuringian altarpiece (Didier and Krohm, 75, no. 31), which contains a series of a dozen saints horizontally disposed on either side of the Virgin and Child, who were solicited in prayer for their intercession in special circumstances; these include some of the saints comprising the Fourteen Helpers in Need who were invoked frequently in Germany. St. Cyriacus was one such "helper," addressed to ward off bad spirits. In keeping with their devotional purpose, such figures look out toward the viewer with a benign gaze and tend to be grouped paratactically as a visual litany. Such altarpieces, therefore, provided an accessible and legible arrangement of saints, each bearing an identifying attribute. The visual impact of such works differs greatly from the dramatic,

238

self-absorbed, and emotionally intense narrative scenes found on the complex, multilevel altarpieces.

Like several other wooden sculptures in the Brummer collection, this work exhibits the combination of stylistic elements from several regional traditions, which often occurred in the later, *rétarditaire* workshop productions of the first quarter of the sixteenth century. Although the general format and drapery arrangements resemble figures of saints from Thuringia and Saxony (Gillerman, 207, no. 167), the rotund face and ringletted coiffure recall sculpture from further west—for example, the angel from an upper Rhenish Nativity group (Gillerman, 196–97, no. 158).

Exhibitions and Bibliography. Moeller, *Sculpture and Decorative Art* (1967): no. 20, figure 31; Portland Art Museum, *Masterworks in Wood* (1975): no. 44; Heckscher and Moeller, "The Brummer Collection" (1967–68):186, figure 13.

JM

Plate 35.
St. Cyriacus, detail

36. Bust of St. Luke

1966.101
Southern Germany, Ulm School
C. 1500
Limewood
H: 54.3 (21⅜")
W: 34.3 (13½")
D: 11.5 (4½")

Condition. Salmon-pink and blue-green traces of polychromy are visible in the drapery folds of the left arm. There are some incised lines around the crown of the head, and some large cracks on the face, book, and shoulders, and on the ox's legs, as well as evidence of some minor repairs on the ox's leg. Some repairs are visible along the glue joins of the original pieces of wood. The piece has suffered wormholes and surface abrasion throughout.

The Apostle and Evangelist St. Luke can be identified by his attributes, a Gospel book and the ox which emerges from the folds of his cloak. Like many of the finer works of this period, this statue conveys a sense of personality in the extraordinary realism of the face with its pensive, almost melancholy gaze. Typically, he is dressed in local period garb rendered in complex volumes and naturally falling drapery folds.

This figure exemplifies the many bust-length depictions of saints and donors, which were grouped in vivid, conversational poses on choir-stall rails and multilevel altarpieces. Its hollowed-out back indicates its original use in an altarpiece, possibly grouped with other apostles much like the predella figures from the High Altarpiece, dated 1498, at Kilianskirche, Heilbronn, and attributed to Hans Syfer (Baxandall, plate 59), as suggested by Bier and Moeller.[1]

Formal comparisons for this work can be found in sculptures associated with the Syrlin workshop responsible for the furnishings of Ulm Minster in the last quarter of the fifteenth century. The hollow cheeks, heavy-lidded eyes, and expressively wrinkled fingers of the Duke figure recall the choir stall busts at Ulm Minster, particularly the classical author portrait of Ptolemy (Baumhauer, figure 44) assigned

Color plate III.

1. Moeller, 50, n. 2. Justus Bier considered this bust stylistically close to the Heilbronn busts of the Church fathers, see letter to W. S. Heckscher, February 15, 1967, in the DUMA files.

to Jörg Syrlin the Elder, c. 1470.[2] The Duke St. Luke derives from the Ulm workshops of about a generation later, which synthesized many of the formal conventions introduced by these and other earlier masters; it may be linked with works such as a sculpture of two saints at the University of Michigan Museum of Art (Bornstein, figure 1) and an Ulm workshop sculpture of St. Anthony (Baum, plate 43), as noted by Moeller and Bornstein. These works exhibit comparable contemplative expressions, finely articulated hands holding books, crisply defined drapery, and an animal attribute.[3]

Like several other wooden statues in the Brummer collection, this bust of St. Luke was produced during the great flowering of southern German sculpture between 1475 and 1520. Only a fraction of these works survived the iconoclastic fury of the Protestant Reformation which culminated in the destruction of "popish" religious images. Hundreds of wood sculptures were piled and burned in cathedral squares, including at least sixty altarpieces from Ulm Minster alone. This work stems from the intellectual and artistic milieu in Ulm just prior to this upheaval. The sculptor has emphasized the scholarly personality of the subject—here, the Gospel author who pauses in thought, holding his place in his book. As Bornstein has suggested, this may reflect contemporary humanists, the teachers at the Latin School at Ulm, whose progressive outlook inspired the portraits of the Classical sybils and authors on the Ulm choirstalls (Bornstein, 36).

Provenance. Purchased at Henry Morgenthau sale, Parke-Bernet, February 12, 1947.

Exhibitions and Bibliography. Joseph Brummer (1949):I, 128, no. 509; Moeller, *Sculpture and Decorative Art* (1967): 50, no. 17, figure 28; Bornstein (1980): 35.

JM

2. Hermann Baumhauer, *Das Ulmer Münster* (Stuttgart and Aalen, 1977):62–65.

3. Correspondence from Christine Verzár Bornstein, July 2, 1979; in the DUMA files regarding #1958.1.59.

37. Virgin and Child on the Crescent Moon

1966.100
German
C. 1500
Wood, polychrome, gilt, silver
H: 42 (16½")
W: 18 (7")
D: 13 (5")

Condition. This piece is in fair condition, although previously con-
served. Some of the polychrome layers were found cracked, shrinking,
and detaching when it was cleaned and conserved in 1987 (see figure
1.1, before conservation). Loose fragments of polychrome were re-
inforced. The fragments that had been readhered out of place were
removed and correctly repositioned. The raised edges of the drapery
have lost their paint and gilding altogether. The gilding and silvering
were cleaned, although the latter still remains somewhat tarnished. A
distracting gap on the Child's forehead was filled and inpainted. The
child's foot is partially broken off, and the base is not original.

The Virgin holds the infant Christ in her lap propped against her
left shoulder. Both face the viewer, and the Child holds up a sphere.
Instead of the contemporary fashion often worn by patron saints in
this period, the Virgin wears the traditional tunic and mantle. Her
longsleeved dress and veil were originally silver. The heavy hem of
her gold cloak flutters up revealing a rich blue lining and a crescent
moon under her feet. Her glittering finery sets off the fleshy details
of the Infant's nude body; the proud mother tenderly offers up a
plump little leg for display to the viewer. Both figures exhibit the same
clearly defined, sweet features of widely set eyes and pinched mouths
set within rounded faces. The more naturalistic gestures, winsome
expressions, and softly defined drapery are characteristic of early-
sixteenth-century south German workshop productions.

The strictly frontal posture of this Virgin and Child statue distin-
guishes it from such groupings in the predellas of larger multifigure
altarpieces which depict the Adoration of the Magi (Didier and

Color plate I.

243

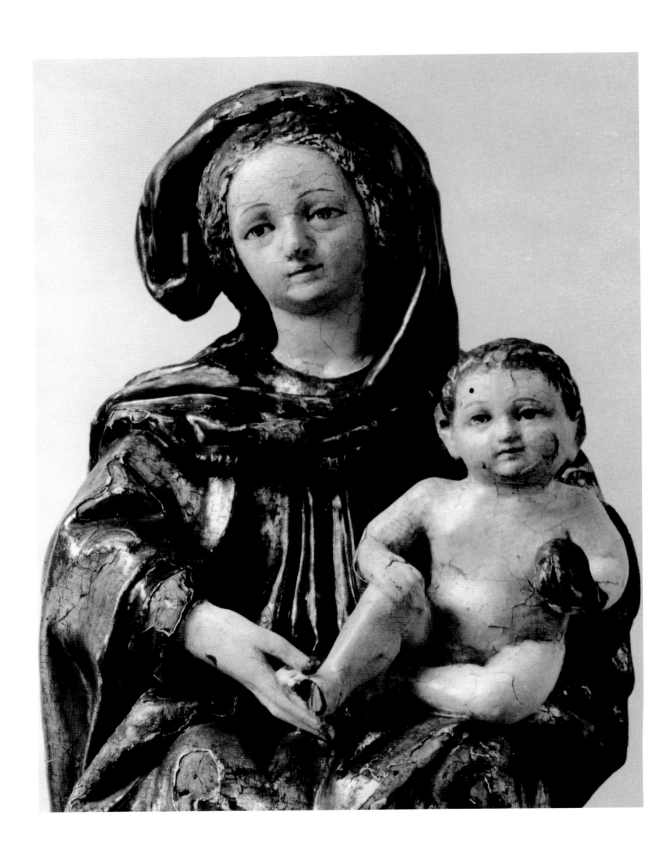

Krohm, fig. 25). In those examples, the Virgin and Child display some involvement in the narrative scene by a turned pose or gesture towards the adoring Kings. However, here the figures engage only the viewer, suggesting an iconic rather than narrative purpose.

◄Plate 37
Detail

The crescent moon under the Virgin's feet and her animated drapery indicate that this grouping probably came from a rosary altarpiece, perhaps a modest version of the late-fifteenth-century example from Nuremburg (Metropolitan Museum of Art [1986]:no. 37). In such works the Virgin's "seated" posture and fluttering drapery are formal conventions to depict her hovering above the crescent moon. The gilded costume and silvery veil draped across her shoulders and her head also typify this representation of the Virgin, presenting her as a heavenly apparition.

Altarpieces of the rosary stem from the rise of the cult of the rosary in the fifteenth century encouraged by the rosary brotherhoods, whose lay members came from the upper classes of society (Metropolitan Museum of Art, *Nuremberg* [1986]:164). The format of these altarpieces often reflects the prayers. The central composition is framed by a wreath of gilt roses, signifying the repeated *Ave Maria*s of the prayer. Angels and other emblems of the Passion or the Infancy of Christ included in the meditations might also be incorporated. The hollowed-out back and iconographic features of the Duke Virgin and Child suggest its original use in a rosary altarpiece. Although the accompanying elements remain uncertain, more complete examples such as the Nuremburg altarpiece provide a key to the original configuration.

JM

38. Statue of the Wild Man

1966.172
Upper Rhine, Basel (?)
C. 1500
Red sandstone
H: 103 (40½")
W: 37 (15")
D: 32 (12½")

Condition. In fair condition, since the stone is very soft and crumbly in many areas and has suffered poor conservation in the past. The lower third of the man's staff has been replaced with an octagonal section of stone; his ankles have broken in several places and have been repaired with cement covered with red-tinted sandy plaster. The surface details are weathered and covered with lichen stains and growth. The piece was cleaned in 1987 to remove considerable dirt and lichen, and excessive amounts of previous mortar and cement repairs were carved down and toned in.

This figure of the mythic wild man, armed with a bark-covered staff and shield, leans against an upended log. His identity is indicated by his extreme hairiness—his beard, his long, windblown hair, and the shaggy thick tufts which cover his entire body.[1] Although he is carved completely in the round, his pose and sculptural detail emphasize a front view, suggesting an original installation in a niche or against a wall. The red color and coarse texture of the sandstone, although probably once painted, now contribute to the rude vigor of the piece. Bearing his attributes he becomes the brutish counterpart to contemporary patron saints. And yet, like them, wild men (and wild women) were ubiquitous in late medieval art, where they appeared in every conceivable artistic medium and a variety of mostly secular contexts.

Originally creatures of legend, wild people were considered a monstrous race of hairy, cavedwelling hermits who lived in the remote woodlands and brandished clubs or uprooted trees for protection. They were widely feared and often blamed for natural calamities. Unlike civilized man, they were primitive, aggressive, lustful, irrational, and godless. Over the centuries notions of wild people evolved,

Color plate XV.

1. Regarding the physical appearance, lifestyle, and cultural significance of wild people in legend and art, see Bernheimer, *Wild Men* (New York, 1970): 1–20 and, more recently, Husband, *Wild Man* (New York, 1980): 1–18, which prefaces an extensive catalog devoted to wild man images in medieval art.

2. Husband, *Wild Man*, no. 11, figures 34, 35, 67ff., regarding a mid-fourteenth century French ivory casket with scenes from courtly romances; no. 14, figures 42–44 and 77ff., for German and Alsatian tapestries of around 1400 with wild men storming castles; no. 13, figure 40, 74ff., with an early sixteenth-century stained-glass roundel from Cologne of the Castle of Love surrounding a family coat of arms.

3. See Bernheimer, *Wild Men*, 49–84, for an extensive discussion of the various wild man dances, performances and rituals. See also Husband, no. 39,

mirroring the changing values of medieval society. By the fifteenth and sixteenth centuries, however, humanistic philosophy had rehabilitated the wild man, who came to embody primeval strength and endurance pitted against the unyielding forces of nature. Once abhorred, their rustic lifestyle was now considered utopian, free from the corrupting influence of mankind's social constraints. This carefree woodland existence—peaceful days filled with simple agrarian activities and uninhibited lovemaking—appealed especially to the urban middle classes. The erotic associations of the wild man were explored in fourteenth and fifteenth-century courtly literature, illuminated manuscripts, caskets, and tapestries, where libidinous wild men storm castles, abduct fair ladies, and do battle with knights, often satirizing feudal social conventions.[2] Wild men, enacted by humans in hairy disguises, also performed in a variety of civic pageants, nature rites, and courtly dances much like the "Wilde Ma" pageant still celebrated annually in Basel.[3]

When the wild man bore heraldic devices, as exemplified by this statue, his legendary superhuman strength and virility acquired special significance.[4] His physical and procreative power ensured the protection and continuity of the noble family or guild whose coat of arms he displayed. In this talismanic context this statue relates to a number of smaller metal objects, especially silver table vessels and bronze chandeliers and candleholders which incorporate wild men as figural supports.[5] Although large-scale architectural versions are more unusual, the main portal of the late-fifteenth-century church of San Gregorio in Valladolid, Spain displays shield-bearing wild men as jamb figures (Bernheimer, 180–81, figure 49). The Duke wild man would have occupied an exterior niche at the entrance to a noble home, guild hall, or other civic building, which often displayed a patron saint. No coat of arms remains to identify the patron or precise locale. This sculpture probably comes from a city along the Rhine River between Speyer and Basel, a region known both for red sandstone architecture and wild man depictions on aristocratic and civic coats of arms.

Provenance. Purchased from Demotte, December 18, 1937.

JM

colorplate XII, for the wild man dance of Charles VI from the *Grandes chroniques de France* of Jean Froissart.

4. Bernheimer, *Wild Men*, 176–85, discusses the significance of wild men as heraldic emblems adopted by over two hundred European families, as well as the even more numerous examples of wild men as shield supporters guarding the coats of arms of noble families in Denmark, Prussia, Pomerania, Brunswick-Wolfenbüttel, and Hanover-Brunswick, beginning at the end of the fourteenth century and supplanting guardian patron saints such as St. Michael. Shield-bearing wild people were adopted as printer's marks, and Husband, in *Wild Man*, 178–91, illustrates examples in metalwork, stained glass, and engravings.

5. See Husband, *Wild Man*, no. 51, figures 120–21, 179ff., for a German silver beaker with shield-bearing wild man supports from about 1470; no. 52, figure 123, plate XIV, 181ff., for silver ewers with wild man heraldic finials ascribed to Nuremberg, c. 1500.

39. Standing Male Figure, St. Sebastian

1966.61
Bavaria
1500–25
Limewood
H: 94 (37")
W: 28.9 (11⅜")
D: 21 (8½")

Condition. Traces of a salmon-pink color are visible in the drapery folds of the cloak below the arms. The piece is cracked in places, with earlier repairs evident on the wrist and chest. It has suffered considerable insect damage to its lower portions and base; there are fewer wormholes on the upper portions.

This standing male figure wears the heavy cloak, polygonal cap, and bobbed hair typical of a middle-class burgher. He holds a tree branch before him as an attribute, but otherwise there is little indication of his holy status. Indeed, as was typical at this time, this holy figure looks much like the prosperous citydwellers who comprised the growing class of art patrons in northern Europe. The male subject here stands firmly and gazes out beyond the viewer revealing the hint of a smile. His hands rest on the roughly cut branch before him. Only the lower right hem of his garment, upswept by some unseen breeze, animates this dignified depiction.

 Although the typical portrayal of St. Sebastian usually includes evidence of his martyrdom—arrows held or piercing his body—this male figure offers an alternative iconography. He is shown as a young man in a cap and heavy outer cloak holding the sapling to which he was bound, as in Swabian sculpture from the first quarter of the sixteenth century.[1] Perhaps this less grisly and more elegant version accomodated local taste.

 This figure has been attributed to a Bavarian sculptor familiar with the formal conventions of the Master of Rabenden.[2] In general terms the Duke piece recalls the standing saints such as Simon from the Rabenden altarpiece (Halm, figure 46) in its calm repose, its slightly

1. See Braun, *Tracht und Attribute* (Stuttgart, 1943): 644, figure 345, for a St. Sebastian statue from the Ennetach parish church attributed to the workshop of Jörg Syrlin the Younger.
2. See Moeller, *Sculpture and Decorative Art* (Raleigh, 1967): 54, who cites the suggestion of Justus Bier; see also Halm, *Studien zur Süddeutschen Plastik* (Augsburg, 1927): 42–66, regarding the Rabenden workshop.

tilted head with far-gazing eyes and hands clasped around the top of a sticklike attribute (Simon's is a saw), and the vertical folds of its undergarment. These masterful works, however, display a greatly varied and textured play of drapery which balances the more expressive mournful look of the faces. The Duke figure more closely resembles the workshop productions, such as the statues of St. James, a youthful saint (possibly St. Sebastian), and a seated saint (Halm, figures 54–56) in Munich. All three are comparable in size (about 1 meter) and display a similar reduction of the Rabenden style. The vertical hair arrangement of St. Sebastian is a simple, stiffened version of the coiffure of the seated saint. His dramatically flounced hem recalls the hem treatments of both standing saints. However, on these other examples this arc of cloth is integrated with other drapery movement, whereas on this sculpture it merely provides a graceful note to an otherwise limp drapery arrangement. While the sculptor of the Duke figure can be related to the circle of the Rabenden Master, the more restrained emotional quality he conveys may depend upon the influence of Swabian traditions, as seen in a slightly earlier statue of Mary Magdalene at The Cloisters.[3]

By analogy with the Rabenden altarpiece (Halm, figure 45) and related works, the Duke St. Sebastian was probably part of a similar multifigure grouping. He would have joined one or two other statues under an elaborate carved canopy flanked by wings with painted scenes to form a rather restrained composition in comparison to the crowded and complicated altarpieces produced further north.

Exhibitions and Bibliography. Moeller, *Sculpture and Decorative Art* (1967): no. 19, figure 30; Heckscher and Moeller, "The Brummer Collection," (1967–68): 185, figure 12; North Carolina Museum of Art, *North Carolina Collects* (1967): no. 19.

JM

3. New York, The Cloisters collection #63.13.1, ascribed to Swabia, late fifteenth century; for citation and illustration, see *MMA Bulletin* XXII/2 (October 1963): 76.

40. Statue of St. Barbara

1966.108
Lower Saxony, Hildesheim
C. 1520
Wood, gilt, polychrome
H: 34 (13⅜")
W: 14.6 (5¾")
D: 6.5 (2½")

Condition. This piece is in fair to good condition, although the poly-chrome is cracked and worn throughout. The cloak retains a little gilding and some red underpainting. The dress has lost most of its blue color and some white underpainting, revealing bare wood beneath. All but two of the crenellations in St. Barbara's crown have broken off, and a hole has been drilled in her right hand, possibly in order to attach an attribute.

Color plate IX.

The dainty figure of St. Barbara stands counterpoised before her at-tribute, the tower with three windows, and glances up from her prayerbook held by her left hand. Her right hand probably held a martyr's palm. Like several other small wooden sculptures in the Brummer collection, this figure was probably part of a retable con-taining figures of various saints on pedestals flanking a central com-position such as the Virgin and Child (Didier and Krohm, no. 31). The gentle swaying of her body provides a lyric contrast to the static vertical emphasis of the tower. Her sweet features, fashionable con-temporary dress, and elegant stance denote her as an ideal of femi-nine beauty. According to accounts of her life, she attracted many suitors, whom her father discouraged by shutting her up in a tower (Braun, 178–81). There she found her faith in the Trinity, symbolized by the three windows carefully depicted on her prop. After at least one miraculous reprieve, she was killed by her father, who was im-mediately reduced to ashes by a lightning bolt. One of the popular saints in the later Middle Ages, she was invoked against the danger of lightning and was the patroness of gunners and miners.

In German sculptures of the late fifteenth and early sixteenth cen-

252

tury, the voluminous garments were frequently arranged into complex patterns of drapery which enlivened the otherwise stock postures of their wearers. Here the activity of her tautly pulled drapery and billowing hem enhances her lithe movement. The visual effect of strong diagonals against a vertical axis produced by this expressively arranged drapery characterizes sculptures from the vicinity of Hildesheim in Lower Saxony around 1520.[1] Particularly comparable are several standing figures of the Virgin and Child which parallel the contrapposto stance and swath of diagonal drapery that falls in a V-formation across the lower torso and flairs out at the sides (Stuttmann, plates 1, 59). Statues associated with the Hildesheim workshop of the so-called Benedict Master, such as those from the Holtrup altar, offer close parallels for several formal details. The apostle figures (Stuttmann, plate 61), especially, similarly pull at their drapery and loop the hem over one hand, as does St. Barbara even more dynamically. In addition, St. Barbara's diminutive facial features, closely set within the wide round face, strongly recall the figure of Mary Magdalene in the Roemer Museum in Hildesheim (Stuttmann, plate 58). It seems reasonable to associate this anonymous sculptor with the workshop of the Benedict master of Hildesheim and to date this work to around 1515–25. Like many of the lesser, anonymous sculptors of this period, our artist has synthesized many of the formal conventions current in this workshop and imbued them with a distinctive dynamic energy and sweetness.

Provenance. From the collection of Geheimrat Ottmar Strauss; sold by H. Helbing, Frankfurt-am-Main, November 6–10, 1934 (no. 63).

Exhibitions and Bibliography. Moeller, *Sculpture and Decorative Art* (1967): 60, no. 22, figure 33; Portland Art Museum, *Masterworks in Wood* (1975): no. 6; Heckscher and Moeller, "The Brummer Collection" (1967–68): 186.

JM

1. Moeller's attribution to the Hildesheim workshop was first suggested by Dr. Justus Bier. The Hildesheim sculptures cited above seem to provide closer stylistic analogies for this statue of St. Barbara than do the Hannover reliefs cited by Moeller.

41. Cutlery Case

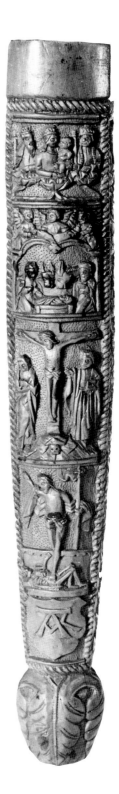

1966.103
Germany
1572
Boxwood
H: 20.9 (8¼")
W: 2.8 (1⅛")

Condition. The carvings are in good to excellent condition, with several small darkly stained spots and some holes drilled at the base and at the top, behind the projecting head, for attachment of fittings. There are a few surface nicks near the top.

This sheath, with a single opening for a knife, displays carving on all four sides and terminates in a bulbous knob with flat acanthus leaves. Separated from the side panels by a cable border, historiated panels arranged in superimposed registers fill the front and back. A high relief bust-length figure of the Fool projects from the upper portion of the rear side. The registers on the front depict New Testament scenes, complemented on the rear side by selected Old Testament scenes prefiguring Christ and His sacrifice. The Fool at the back oversees the Biblical scenes below: the temptation of Adam and Eve, Moses and the Brazen Serpent, Jonah praying in the mouth of the whale, and Jesse, the father of King David, who sleeps sitting upright. A stem sprouts from his chest, bifurcates, and undulates up the two narrow sides, forming the Tree of Jesse. Alternating on these narrow sides, vinescroll tendrils contain bust-length figures of the Old Testament kings, the genealogical ancestors of Christ. Below the Tree of Jesse on one side is inscribed "WGW," with a corresponding date, "1572," inscribed on the other narrow side. The front depicts significant events from the life of Christ, proceding from top to bottom chronologically with the Nativity, the Crucifixion, and the Resurrection. A shield bearing the monogram "AK" occupies the register beneath the Resurrection.

The more refined guests of the later Middle Ages, those who did not eat with their fingers, brought their own table setting—a knife and

255

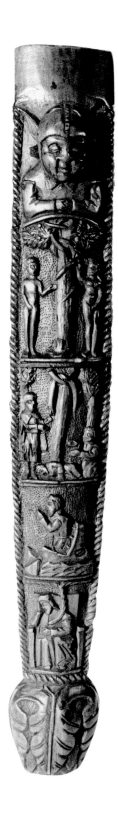

that medieval innovation, the fork. Depending upon the wealth and status of the owner, the cutlery sheath ranged from a modest leather holder to an extravagant case of precious metal. Middle-class consumers purchased decorated boxwood cases of varying quality and complexity, which could be on display attached to their belt or girdle. The hole drilled behind the head of the Fool once contained a belt ring or loop. Although purely utilitarian objects, cutlery cases were frequently covered with minutely rendered religious images. The tiny scenes of this cutlery case offer succinctly and in microcosm the religious themes current throughout the Gothic period. The appearance of the Fool injects a note of satire into the otherwise solemn religious themes of sin and salvation.[1] This sheath and its companion in the Brummer collection (plate 42) demonstrate how inseparable the religious and secular worlds had become by the end of the Middle Ages.

The inscriptions at the bottom of the narrow sides, "WGW" and the date "1572," link this work with other sheaths of the "WGW" series which remain in a number of European and American collections, such as the sheath with twelve Apostles at the Busch-Reisinger Museum, Boston.[2] The Brummer sheath appears to be the earliest known example of the series, with the others ranging in date from 1577 to 1626. The initials have been thought to signify a master's monogram or a workshop.[3] However, as Kuhn has suggested, it may be an acronym for a current motto, "Wenn Gott Will, so ist mein Zeil" (As God wills, so is my aim). The monogram "AK," prominently displayed on the shield on the front side, probably identified the owner and would have been added after the purchase.

Exhibitions and Bibliography. Moeller, *Sculpture and Decorative Art* (1967): 78, no. 30, figure 43.

JM

1. Ernst Kris, "Der Stil 'Rustique,'" *Jahrbuch der kunsthistorischen Sammlungen in Wien* n.s. I (1926): 137ff; H. Meier, *Die Figur des Narrens in de Christliche Ikonographie des Mittelalters. Das Munster*, volume 8 (1955): 1–11; W. Willeford, *The Fool and His Scepter* (New York, 1969).

2. Kuhn, no. 56, plate xlv, for a "WGW" knife sheath dated 1626. Other examples cited include cases in Munich, Amsterdam, Paris, Graz, and Schloss Steyr.

3. Edward Pinto, *Treen or Small Woodware Throughout the Ages*, (London, 1969) 38, cites several dated examples in private British collections ranging from 1577 to 1615.

42. Cutlery Case

1966.104
Flanders or Netherlands
1660
Boxwood
H: 20.3 (7⅞″)
W: 3.7 (1½″)
D: 3 (1¹⁄₁₆″)

Condition. The carvings are in excellent condition, although the original metal fittings and mounts are missing.

This utensil sheath, with two ovoid openings in the top surface, once held a knife and a fork. Like the other Brummer sheath (plate 41), it contains vertically disposed panels with related religious images and mottos, all carved in minute details. The scenes here, however, are more densely populated and compressed with added details of architecture and landscape. A caption with the name of the principal Biblical figure identifies each scene. The first scene of the rear side, with men feasting, captioned "ABRAHAM," refers to the patriarch's hospitality toward the three angelic visitors who foretold the birth of his son, Isaac. The inscription "ABRAHAM" refers as well to the subsequent scene, Abraham's attempted sacrifice of Isaac. Below is Judith holding the head of Holophernes, with a witnessing handmaiden, inscribed "IVDYCK." "BARSABE" labels the scene of David secretly viewing Bathsheba at her bath. Below them, Samson prays before destroying the temple of the Philistines; the great pillars bear the inscription "SAMSOM." Like the other Brummer cutlery case, New Testament scenes fill the front side, but these are limited to the Infancy of Christ. The first inscription, "GEBOERTENYS" (birth), refers to the top and second scenes, the Annunciation and Nativity. The first is given greatest prominence with a larger and more complex composition partially undercut above the heads of the principals. The second inscription, "BESNIDINGE" (circumcision), refers to the third panel. The Adoration of the Magi follows, captioned "DIE WYSEN"

(the wise men), and the scenes conclude with the Flight of the Holy Family, "IOSEPMARIA" (Joseph, Maria), at the bottom. Both the front and back of the terminal knob at the base contain a tiny musician, one with a harp, the other with a psaltery. A motto and date fill the two narrow sides:

> The time is short
> Death is fast
> Stay away from sin
> So you do well
> Honor God
> Where ever you are
> Know yourself
> Whatever you do
> Think about the end
> Year +60.[1]

Carved boxwood cutlery cases were often given at the time of a wedding (Randall, 247). Such a purpose seems to be consistent with the decoration and inscriptions of this particular sheath. The festive scenes, the men banqueting at top and miniature musicians below, may have been included as generic representations of wedding celebration as well as for their usual Biblical associations. Throughout, the particular choice of Old and New Testament scenes seems to emphasize wholesome family values. Marital fidelity and faith in the Lord are equated, and the unfortunate end that comes to those who succumb to lust is inferred. The succinct motto exhorts proper behavior, perhaps intended for the bridegroom.

Close analogies for this cutlery case are provided by a boxwood sheath dated 1698 at the Walters Art Gallery in Baltimore (Randall, 256, no. 395, plate 83) and a pair of sheaths at the Philadelphia Museum of Art with similarly arranged Biblical scenes and captions, concluding with musicians on the terminal bases.

JM

1. "DIE TIT IS CORT DIE DOET IS SNEL WACHT UU VAN SONDEN SOE DOET GHY WEL ERTT GOD WAER DAT GHY SIT UU SELWEN KENT WAT DAT GHY DOET DENCKT OP HET ENT ANNO +60." Transcription and translation provided by Dr. Hans van Miegroet.

Checklist

The following checklist includes all the items of sculpture, painting, or decorative art acquired from Mrs. Ella Brummer in 1966. We simply record the information provided by the museum files, with the occasional addition of the Brummer inventory numbers when they can be established and other information on provenance available from the Brummer files in the Metropolitan Museum of Art in New York. All measurements here are in inches. A "P" before the Brummer number indicates that it was acquired in Europe, an "N" that it was acquired in the United States, usually New York. We have placed an asterisk in front of the objects that receive longer discussion in either the essays or catalogue entries; these are not illustrated in the checklist. Except for the occasional addition of a question mark next to dates or places of origin, we do not include any remarks on authenticity.

1
1966.1 Transenna Panel
Marble
North Italian (Veneto?)
8th–9th century (?)
22¼ x 32⅛ x 1¼"
Brummer #P15113–#2
Purchased from
Altounian, September
23, 1938

***2**
1966.2 Capital
Italian (Lazio? Rome?)
See plate 1.
Brummer #P14046–#3
Purchased from Pacifici,
August 29, 1937

3
1966.3 Bust of a
youthful saint
Fresco fragment
mounted in plaster
Greek
16th–17th century
15 x 13 x 2"
Brummer #P1444–#58
Purchased from
E. Vlachos (arrived in
New York February 17,
1925)

4
1966.4 The Mother of
God
Fresco mounted on
plaster
Greek
16th–17th century
23⅝ x 20"
Brummer #P3618–#55
Purchased from Zoum-
poulakis, summer 1926

5
1966.5 Head of a
bearded saint
Fresco mounted on plaster
Greek
16th–17th century
7⅛ x 8"
Brummer #P3624–#56
Purchased from Zoum-
poulakis, summer
1926

6
1966.6 Bust of a Church
Father
Fresco mounted on plaster
Greek
16th–17th century
14⅛ x 11⅝"
Brummer #P1443–#57
Purchased from
E. Vlachos, arrived
February 17, 1925

7
1966.7 Half-length
figure of a saint
Fresco mounted on plaster
Greek
16th–17th century
11 x 9¼"
Brummer #54

8
1966.8 Head of a
bearded saint
Fresco mounted on plaster
Greek
16th–17th century
10 x 8"
Brummer #P3619–#60
Purchased from Zoum-
poulakis, summer
1926

9
1966.9 Head of a
youthful saint
Fresco mounted on
plaster
Greek
16th–17th century
9½ x 9⅛″
Brummer #P3623–#59
Purchased from Zoum-
poulakis, summer 1926

***10**
1966.10 a–i Sections
from an archivolt
Marble
Alife, Campania
See figures 4.1–4.7
Brummer #P4685–A664
Purchased from Pietro
Tozzi, New York,
March 6, 1928

***11**
1966.11 Transenna panel
Marble
Italian (Lazio? Rome?)
See plate 2.
Brummer #P14047–
A666
Purchased from de
Cresci, August 29, 1937

12
1966.12 Lion
Marble
Italian
16th–19th century (?)
25 x 18 x 9″
Brummer #P4433–608
Purchased from P. Affai-
tati, Naples, September
1927

9

14

12

15

16

***13**
1966.13 Impost capital
Marble
Italian
See plate 3.
Brummer #545

14
1966.14 a–b Bowl and
base
Marble bowl on
sandstone base
Italian (?)
(a) 4th–5th century;
(b) 14th–16th century
32 x 30″
Brummer #N5347–B644
Purchased from Gimpel
Bros., July 1, 1942;
from the collection of
William R. Hearst

15
1966.15a Female figure
with basket
Encaustic on wood
Coptic
5th–6th century (?)
9 x 12″
Brummer #N6409–511
Purchased from Frank
Tano, September 14,
1945

16
1966.15b Two putti
Painting on wood
Coptic
5th–6th century (?)
22¼″ long
Brummer #N6407–511
Purchased from Frank
Tano, September 14, 1945

17
1966.15c Rosette
Painting on wood
Coptic
5th–6th century (?)
12 x 9"
Brummer #N6436–511
Purchased from Frank
Tano, September 14,
1945

18
1966.15d Painted
decoration
Painting on wood
Coptic
5th–6th century (?)
12"
Brummer #N6437–511
Purchased from Frank
Tano, September 14,
1945

19
1966.16 Lion (pair with
1966.12)
Marble
Italian
16th–19th century (?)
25 x 18 x 8"
Brummer #P4434–572
Purchased from P. Affai-
tati, Naples, September
1927

20
1966.17 Wine jar
Terracotta
Coptic
5th century (?)
22½ x 15"
Brummer #P6399–#588

17

18

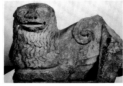

19

20

21

22

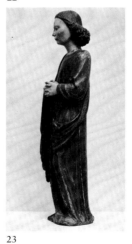

23

Purchased from Bauer,
Vienna, September 5,
1929

21
1966.18 Bust of St.
Andrew
Oak
Northern French (?)
Late 15th century (?)
13 x 14"
Brummer #1
Purchased from Henri
Daguerre, 1958

22
1966.19 Statue of an
Abbess
Polychromed wood
15th–16th century
31"
Purchased from
Daguerre, 1958

23
1966.21 St. John
Polychromed wood
Italian
15th century
29¾"
Brummer #P12030–#14
Purchased from Brimo,
July 31, 1935

***24**
1966.22 St. Anne (?)
Polychromed wood
South German
See plate 34.
Brummer #19

264

*25
1966.23 St. Cyriacus
Polychromed wood
South German
See plate 35.
Brummer #21

26
1966.24 Christ from a
Crucifix
Fruitwood
North French
18th century
19 x 13 x 6″
Brummer #P14020–
#22
Purchased from Ratton,
July 8, 1937

27
1966.25 Censer
Bronze
Italian
13th century
6¾″ high
Brummer #23

*28
1966.26 Candleholder in
form of kneeling man
Bronze
German
See plate 26.
Brummer #P5625–#25
Purchased from Pazzagli
and Nesi, September
1928

29
1966.27 Double
candleholder
Bronze

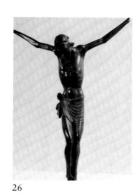

26

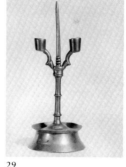

29

27

33

Flemish
15th century
12⅛″ high
Brummer #P8032–#27
Purchased from Hein,
July 27, 1931

*30
1966.28 Frog
Bronze
Flemish or German
See plate 30.
Brummer #P6221–#28
Purchased from
H. Garnier, July 25,
1929

*31
1966.29 Triptych
Bone and wood
Italian
See plate 28.
Brummer #29

*32
1966.30 Triptych
Bone and wood
Italian
See plate 27.
Brummer #30

33
1966.31 Engraved cross
Copper with traces of
gilding
Italian
12th century (?)
12½ x 9⅞″
Brummer #N6538–#31
Purchased at Parke-
Bernet, February
1946

34
1966.32 Double
candlestick
Brass
Flemish or German
15th century
11¼″ high
Brummer #N2640–#32
Purchased from Gold-
schmidt Galleries,
March 8, 1929

35
1966.33 Head of a young
woman
Fragment of a fresco
Italian
14th century
18⅜ x 13⅞″ (in modern
frame)
Brummer #N6024–#38
Purchased from
William R. Hearst, July
28, 1944

36
1966.34 Head of young
woman
Fragment of fresco
Italian
14th century
18⅜ x 13⅞″
Brummer #N6023–#39
Purchased from
William R. Hearst, July
28, 1944

37
1966.35 Capital
Oak
French
15th century
2⅛ x 5½ x 3¼″

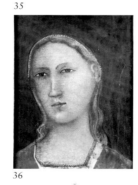
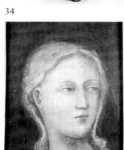
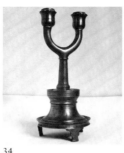

34

35

36

37

38

39

40

41

Brummer #P4367–#40
Purchased from Dalbret,
September 29, 1927

38
1966.36 Marriage chest
Leather
French or Spanish
15th century
17¼ x 10″
Brummer #N3723–#42
Purchased from
Demotte, December 21,
1935

39
1966.37 Tile
Terracotta
European
15th century
9¼ x 5 x 2¾″
Brummer #P10051–#58
Presented by Romano,
September 7, 1933

40
1966.38 Saint Matthew
Marble
Spanish
16th–18th century
46 x 16 x 12″
Brummer #282

41
1966.39 Christ
Fresco
Italian
14th century (?)
6′4″ x 35″
Brummer #P7325–#61
Purchased from Ugo
Jandolo, September 8,
1930

266

42
1966.40 Head of a
woman with turban
Limestone with traces of
polychrome
French
15th century
11½ x 8 x 8″
Brummer #N5408–#63
Purchased from
Altounian, 1931; from
the collection of Robert
Woods Bliss/Dumbarton
Oaks

*43
1966.41 Capital
Alabaster
Hispano-Moorish
See plate 24.
Brummer #P5016–#66
Purchased from Brimo,
August 1, 1928

44
1966.42 Lectern
Forged iron
Central Europe (?)
15th century
10½ x 12½ x 3¾″
Brummer #P10058–#68
Purchased from Blumka,
Vienna, September 9,
1933

45
1966.43 Corbel of David
Slaying Goliath
Oak
German
15th century
14¾ x 13 x 13¼″
Brummer #P5181–#69

42

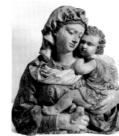

44

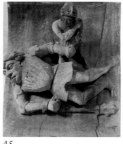

45

46

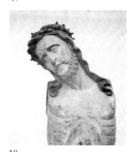

47

48

Purchased from Sydney
Burney, London,
September 28, 1928

46
1966.44 Seated St. Peter
Limestone
French
15th century (?)
38 x 22 x 7½″
Brummer #P6958–B634
Purchased from
Lambert, March 2, 1930

47
1966.45 a–b Relief of
Virgin and Child
Polychromed terracotta
Italian (Florence)
Late 15th–early 16th
century
17¾″
Brummer #N5176–#73
Purchased at Parke-
Bernet, Pulitzer sale,
June 12, 1941

48
1966.46 Christ from a
Crucifix
Polychromed oak with
traces of gilding
French
16th century
17½ x 9 x 8″
Brummer #74

*49
1966.47 Martyrdom
Alabaster
German or Nether-
landish
See plate 29.

Brummer #P6128
Purchased from André,
June 23, 1929

*50
1966.48 Apostle
Marble
French
See plate 5.
Brummer #P15104–#76
Purchased from
Altounian, September
23, 1938

51
1966.49a–b Head of a
Prophet
Polychromed limestone
on dark marble base
French
13th century (?)
14 x 8¼ x 9¾"
Brummer #284

*52
1966.51 Addorsed heads
Alabaster
South Italian
See plates 5.1–5.4.
Brummer #P8049–#82
Purchased from Brimo,
September 14, 1931

53
1966.52 Male Saint
Polychromed wood
South German
Early 16th century
45½" high
Brummer #83–47182 (?)

51

55

53

54

54
1966.53 Virgin and
Child
Polychromed wood
Spanish
Late 13th century
34½ x 14 x 10¼"
Brummer #164–#84
Purchased from
Daguerre, August 1958

55
1966.54 Head of an
Apostle
Sandstone
French
13th century (?)
11 x 9 x 9"
Brummer #P11035–#85
Purchased from Char-
noz, September 21,
1934

*56
1966.55 Bust of Christ
Polychromed limewood
German
15th century
See plate 32.
Brummer #86
Purchased from John
Simon, February 21,
1931; from the collec-
tions of Emile Molinier
and Alphonse Kann

*57
1966.56 Head (corbel)
Limestone
French
See plate 7.
Brummer #N5490–#87
Purchased from Aldo
Jandolo, March 1943

58
1966.57 Bust of a man
Limestone
French
15th century (?)
20 x 21 x 9½″
Brummer #P15002–#88
Purchased from Brimo,
July 16, 1938

59
1966.58 St. Anne, the
Virgin, and Christ child
Polychromed limestone
Austrian or German
15th century (?)
52 x 19 x 11½″
Brummer #P5554–#89
Purchased from Gluck-
selig, September 12,
1928

60
1966.59 Female Saint
Marble
Italian
14th century (?)
24 x 9¼ x 7¼″
Brummer #P6658–#90
Purchased from Lenard,
Budapest, September 4,
1929

61
1966.60 Head of
Bacchus
Limestone
Cypriot
19th–20th century
14½ x 9½ x 12″

58

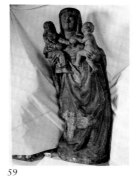

59

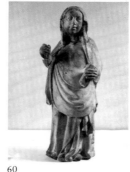

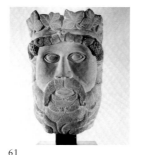

61

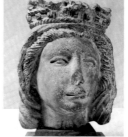

60

63

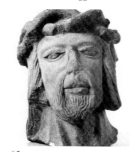

65

***62**
1966.61 St. Sebastian
Limewood
South German
See plate 39.
Brummer #92

63
1966.62 Head of the
Virgin
Limestone
French (from St.
Reverion, Nièvre?)
15th century (?)
11¼ x 9 x 7¼″
Brummer #P15053–#94
Purchased from Peslier,
August 15, 1938; from
the collection of Chauve

***64**
1966.63 Capital
Limestone
French
See plate 8.
Brummer #P14125–#95
Purchased from Paris
House, May 17, 1938

65
1966.64 Head of Christ
Red sandstone with
traces of polychrome
French (?)
Late 14th–15th cen-
tury (?)
15 x 10 x 12″
Brummer #P15060–#98
Purchased from
Mme. Vaury (mère),
August 19, 1938

66
1966.65 Head of a king
Limestone
French (?)
19th century
13 x 7 x 10½″
Brummer #N5341–#104
Purchased from Jandolo,
June 14, 1942; from
the collection of Lucien
Demotte

67
1966.66 Virgin and Child
Stone
Northern Italy (?)
12th–13th century (?)
37 x 17″
Purchased from Gluck-
selig, September 6,
1929

68
1966.67 Triptych
Polychromed oak
Venetian or Austrian
14th century
15 x 15″
Brummer #P3107–#106
Purchased from Gar-
nier, July 19, 1926;
from the collection of
Dupont-Auberville

69
1966.68 a–h Twelve
figures from a choir stall
Oak
German
19th–20th century (?)
From 7½ to 11¼″ high

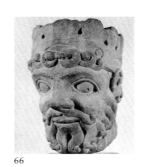

66

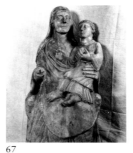

67

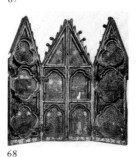

68

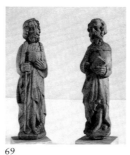

69

70

71

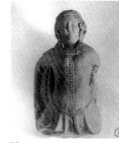

72

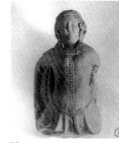

73

70
1966.69 Incense burner
Bronze
Spanish
14th–15th century
6¾ x 3½″
Brummer #11107–#110
Purchased from Ruiz,
May 31, 1935

71
1966.70 Lamp hook
Brass
Flemish
Early 17th century
4 x 1⅝ x 1⅛″
Brummer #P11087–
#113
Purchased from Paris
House, October 6, 1934
(originally from Otto)

72
1966.71 Bracket sconce
Brass
Flemish
Second half of the 15th
century
12 x 5⅝ x 10¾″
Brummer #N5195–#119
Purchased from Inter-
national Studio Art
Corporation, Au-
gust 1941; Lambert
d'Audenarde Sale, Lot
#314, Article #8

73
1966.72 Fragment of a
corbel with female figure
Polychromed limestone
Netherlands (?)
14th–15th century (?)
8½ x 6½ x 5¾″

Brummer #N3023–#122
Purchased from the
Delannoy Collection,
April 5, 1932

74
1966.73 Head of a Saint
Polychromed limestone
French
13th century
7¾ x 7 x 4½"
Brummer #P8054–#123
Purchased from Joret,
September 4, 1931

*75
1966.74 Head of the
Virgin from the Chartres
jubé
Limestone
French
See plate 14.
Brummer #P15100
Purchased from
Altounian, September
23, 1938

76
1966.75 Corbel with
head (of a monk?)
Limestone
French
14th century
10 x 8 x 5¾"
Brummer #126
Purchased from L. C.
Pichon, July 9, 1927

*77
1966.76 Head of a king
White limestone
French
See plate 21.

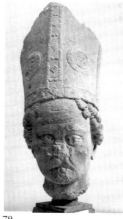
74

76

78

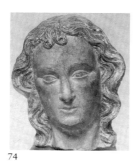

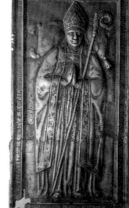
79

80

Brummer #P6682–#129
Purchased from
Daguerre, October 5,
1929

78
1966.77 Head of an
Apostle
Limestone and poly-
chrome
French
14th century (?)
12 x 6¾ x 9"
Brummer #N5267–#130
Purchased from Paul
Sachs Collection,
November 7, 1941;
from the collection of
Kelekian

79
1966.78 Head of a
bishop
Limestone
French
14th–15th century (?)
17 x 6½ x 6"
Brummer #P1340–#131
Purchased from
L. Jaquet, September
1924

80
1966.79 Tomb effigy of
Don Bernabe, Bishop of
Osma
Bronze
Spanish
16th century
6'8½" x 39½" x 1½"
Brummer #P5758–#144
Purchased from Garnier,
November 26, 1928

81
1966.80 Square tile
Clay
French
14th–15th century
4½″ square
Brummer #P7199–#145
Purchased from
Wegener, August 6, 1930

82
1966.81 Figure of a man
picking up a stone
Polychromed oak
Flemish
Ca. 1500 (?)
7⅛ x 6⅛ x 2″
Brummer #P4098–#146
Purchased from E. Berr,
May 31, 1927

83
1966.82 Triptych in
wood
Oak
French (?)
15th century
16½ x 25″
Brummer #P5405–#148
Purchased from Hein,
August 14, 1928

84
1966.83 Figure of Christ
from a Crucifix
Boxwood or fruitwood
French or German
18th century
15¾ x 3¼ x 3″
Brummer #P6659–#20
Purchased from the
collection of Dr. Simon
Meller, Munich,
September 19, 1929

81

82

83

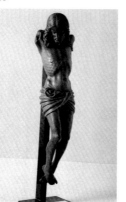
84

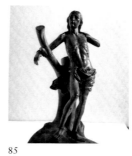
85

86

87

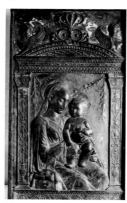
88

85
1966.84 Saint Sebastian
Fruitwood
Flemish
Ca. 1700
14½ x 8 x 6¼″
Brummer #N837–#26
Purchased from Sumner
Healey, November 3,
1925

86
1966.85 Candlestick
figure of a Landsknechts
Brass
German
Second half of the 16th
century
12½ x 7¼ x 4″
Brummer #P6153–#33
Purchased from Ratton,
July 8, 1929

87
1966.87 Candlestick
figure of a Landsknechts
Brass
German
Second half of the 16th
century
12¾ x 4 x ¾″
Brummer #36

88
1966.88 Terracotta relief
of the Virgin and Child
Terracotta
Italian (Florence)
Late 15th century
2′8½″ x 1′5½″
Brummer #N2283–#37
Purchased at American
Art Galleries, January
28, 1928

272

89
1966.89 Bust of a
woman
Marble
Flemish
17th century
13 x 8½ x 5¾″
Brummer #N2114–#54
Purchased from Sumner
Healey, May 13, 1927

90
1966.90 a–j Tabernacle
attributed to Silvestro
dall'Agnola
Marble
Italian
Late 15th century
Various dimensions
Brummer #P5713
Purchased from Simo-
netti, September 10,
1928

91
1966.91 Candlestick
Brass
Origin unknown
16th century
8½ x 5⅝″
Brummer #P4253–#108
Purchased from Weil,
October 6, 1927

92
1966.92 a–b Pair of
candlesticks
Brass
French
Early 17th century
6½ x 4¼ x 4¼″
Brummer #P4595 a–b
#111

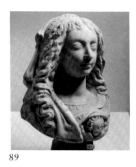
89

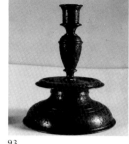
93

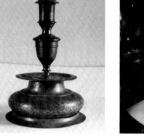
90

94

91

95

92

Purchased from Lam-
bert, January 29, 1928

93
1966.93 a–b Pair of
candlesticks
Bronze
French
Ca. 1630
8½ x 6¾″
Brummer #N5311 a–
b–#112
Purchased at Parke-Bernet,
Speyer sale, April 1942

94
1966.94 Portrait
miniature
Wax on slate
Italian
17th century
5¼″ (diam. of frame)
Brummer #N6058–#114
Purchased from W. R.
Hearst, July 28, 1944;
from the collection of
National Magazine
Company, London, lot
#100, art. #57, October
26, 1927

95
1966.95 Portrait minia-
ture of a banker by
Thomas Wells
Wax
English
1780
9½ x 7¾ x 1½″ (frame
and glass included)
Brummer #N6449–#115
Purchased from Kende
Galleries, Mrs. Merry
Moorhouse et al. sale,
October 6, 1945

96
1966.97 Missal case
Leather
Spanish or Venetian
16th century
9½ x 8½"
Brummer #P4158–#147

***97**
1966.100 Seated Virgin
and Child
Limewood
German
Ca. 1500
16½ x 7 x 5"
See plate 37.
Brummer #155

***98**
1966.101 Half-length
figure of Saint Luke
Limewood
Swabian
See plate 36.
Brummer #N6777–#159
Purchased at Henry
Morgenthau sale, Parke-
Bernet, February 12,
1947

99
1966.102 Bust of a
scholar
Terracotta
Florentine
15th century
15½ x 14½ x 6½"
Brummer #N4962–#160
Purchased at Parke-
Bernet sale of Lambert-
Rothschild et al.,
March 7, 1941, no. 159;

96

99

102

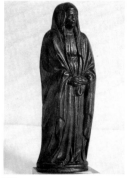

103

from the collection of
Sir George Donaldson,
Bart., Hove, Sussex

***100**
1966.103 Knife sheath
Boxwood
German
See plate 41.
Brummer #163

***101**
1966.104 Fork sheath
Boxwood
German
See plate 42.
Brummer #164

102
1966.105 Star-shaped
pierced pendant
Olivewood with silver
frame
Greek
17th century
2¾ x 2⅝"
Brummer #N5683
Purchased from
Mrs. Otto H. Kahn,
October 12, 1943

103
1966.106 Door knocker
in form of the Mourning
Virgin
Cast iron
Spanish
16th century
10½ x 3¾ x 1¼"
Brummer #N5739–#177
Bought at Parke-Bernet,
Bashford Dean et al.,
October 14, 1943

104
1966.107 Crucifix figure
Bronze
German (?)
12th century (?)
5¾ x 5¾"
Brummer #N4822–#156
Purchased at Parke-
Bernet, Shipman sale,
November 23, 1940

***105**
1966.108 St. Barbara
Wood, polychrome, and
gilding
German
See plate 40.
Brummer #157
Purchased from
H. Helbing, November
6–10, 1934; from the
collection of Geheimrat
Ottmar Strauss

106
1966.109 Candlestick
Bronze
North German (?)
Late 12th–early 13th
century (?)
7¾ x 6⅛ x 5¾"
Brummer #P7321–#158
Purchased Albert Figor
sale, Vienna, June 14,
1930, no. 467; from the
collection of S. Braida

107
1966.110 Head of a
bearded man
Limestone
Italian (?)
12th century (?)

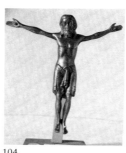
104

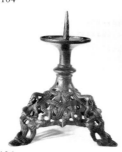
106

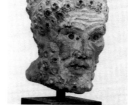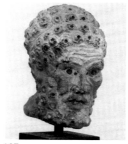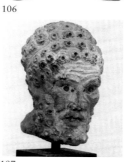
107

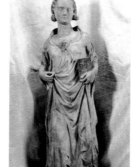
108

109

8½ x 4½ x 6"
Brummer #14109–#161
Purchased from Bruschi,
August 27, 1937

108
1966.112 Virgin and
Child
Wood, polychrome,
gilding, fabric
French (Auvergne?)
12th century (?)
28½ x 11⅞ x 9"
Brummer #N5856–#166
Purchased from the
Mrs. Edgar Speyer
collection, February 29,
1944

109
1966.113 Standing
female saint
Limestone, polychrome,
and gilding
Italian (?)
14th century (?)
42½ x 16 x 7"
Brummer #P12031
Purchased from Brimo,
July 31, 1935

***110**
1966.114 Head of a king
Limestone
French, Mantes
See plate 11.
Brummer #P8027
Purchased from
Lambert, July 20, 1931

111
1966.115 Corbel head
Sandstone
French (?)
12th–13th century (?)
8½ x 5½ x 5¾″
Brummer #P11010
Purchased from
Altounian, July 23, 1934

***112**
1966.116 Smiling head
Limestone
French
See plate 16.
2½ x 2½ x 2¼″
Brummer #P4533–#174
Purchased from
Altounian, October 7,
1927

113
1966.117 Head of a king
Stone
14th century (?)
21½ x 15 x 11″
Brummer #N2848–#175
Purchased at Anderson
Galleries, Habemeyer
Sale, April 12, 1930;
from the collection of
Lucien Demotte

114
1966.118 Capital with
intertwining monsters
Marble
Italian (?)
12th century (?)
9 x 7 x 6½″
Brummer #5640–#506
Purchased from Carrelli,
September 1928

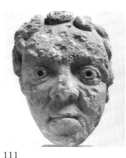

111

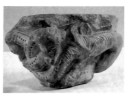

113

114

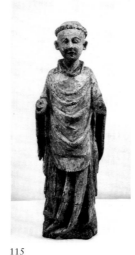

115

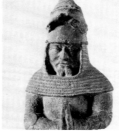

116

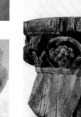

118

115
1966.119 Figure of monk
Limewood with
polychrome
South French
15th century
20½ x 7 x 5¼″
Brummer #5704–#508
Purchased from
Mrs. Otto H. Kahn
collection, October 12,
1943

116
1966.120 Finial
Oak
French
14th century
8¾ x 10½ x 5¼″
Brummer #7298–#509
Purchased from Taille-
mas, September 26,
1930

***117**
1966.121 Half-length
figure
Limestone
French
See plate 9.
Brummer #N5485–#513
Purchased from Gabriel
Dereppe, February 20,
1943

118
1966.122 Half-length
figure of knight
Stone
12 x 8½ x 4½″
Brummer #P6056–#514
Purchased from
Bachereau, June 1929

*119
1966.123 Male head
Limestone
French
See plate 12.
Brummer #P7099–#515
Purchased from
Mme. Niclausse, July 8,
1930

120
1966.124 Female head
Marble
Italian (?)
13th century
8 x 5½"
Brummer #N4866–#516
Purchased from Tozzi,
January 3, 1941

*121
1966.125 Head of a king
Limestone
French
See plate 10.
Brummer #N3788–#518
Purchased from
Demotte, February 14,
1936

122
1966.126 Head of a
saint
Sandstone
French (?)
13th century (?)
10½ x 8½ x 9½"
Brummer #P13186–
#519
Purchased from Paul
Weigt, February 1, 1937

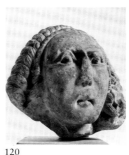
120

122

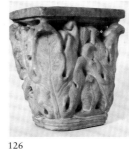
125

126

*123
1966.127 Head of Christ
Child
Limestone with poly-
chrome and gilding
French
See plate 22.
Brummer #P6082–#521
Purchased from Maurice
Bigorie, June 17, 1929

*124
1966.128 Fragment with
head
Limestone
French
See plate 6.
Brummer #P5012–#526
Purchased from B. Hein,
August 11, 1928

125
1966.129–132 Three
columns with capitals
and bases
Marble
Italian
13th century
Various dimensions
Purchased from Bertolo
through Altounian,
March 1929

126
1966.134 Small capital
Marble
Italian
12th–13th century
6½ x 5¾ x 3½"
Brummer #P3536–#542
Purchased from
Ciardiello, summer 1926

127
1966.135 Head of the
Madonna
Limestone, polychrome
French (?)
14th century (?)
10 x 7 x 6"
Brummer #P5111−#549
Purchased from Hein,
August 14, 1928

128
1966.136 Head of the
Madonna
Limestone
French
13th−14th century
16 x 10 x 9"
Brummer #P6008−#551
Purchased from Hein,
June 11, 1929

129
1966.137 Fragment of a
corbel or of a capital
Sandstone
French (?)
12th century (?)
12 x 11½ x 5¾"

130
1966.138 Female head
Limestone
French (?)
14th−16th century (?)
14 x 11 x 9"
Brummer #P10013−
#553
Purchased from
Altounian, September
20, 1933

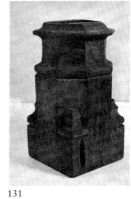

127

128

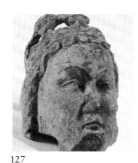

129

130

131

132

133

134

131
1966.139 Base
Oak
French
15th−16th century
11¾ x 6 x 6"
Brummer #P8043−#561
Purchased from Joret,
August 7, 1931

132
1966.144 Capital
Reddish marble (?)
Italian (?)
12th−13th century (?)
15 x 19 x 8"

133
1966.145 Female head
Terracotta
Egypto-Roman (?)
8½ x 7½ x 7½"

134
1966.146 a−b Capital
and base
Marble
Italian
13th century
(a) 7 x 6¼ x 6¼" (b) 5¾
x 5¼ x 5¼"
Purchased from
Mrs. Rainey Rogers,
May 1937

***135**
1966.147−150 Apostles
Limestone
South central France
First half of 12th century
See figures 3.1−3.4
Purchased from

278

Altounian, December 31,
1928

136
1966.151 Corbel head of
a man
Limestone
French (?)
12th century (?)
9⅝ x 17½ x 7½"
Brummer #P4066–
#B604
Purchased from
Lemaire, July 22, 1927

137
1966.152 a–b Pair of
Gothic finials
Wood
French
13th–14th century
(a) 45" (b) 27"
Purchased from Tri-
chard, March 2,
1930

138
1966.153 a–b Bishop
saint
Marble
Italian
14th–15th century (?)
50 x 14¾ x 12"
Brummer #P13176–
#607
Purchased from
Demotte, October 15,
1936

139
1966.154 Baptismal font
Stone

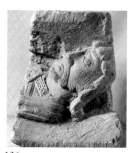

136

137

138

139

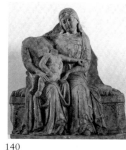

140

141

142

North French
12th–13th century
31 x 41"

140
1966.155 Madonna and
Child with St. Anne
Marble
Italian, Pisa
Early 14th century
27 x 22¼ x 9¼"
Brummer #N2841–
#B616
Purchased from Canessa
Sale, March 1930; from
the collection of Duca
Giovene de Girasole,
Naples

141
1966.156 Figure of a
monk
Wood
Italian
17th century (?)
61 x 17 x 16"
Purchased from Haim in
Paris, July 1934

142
1966.157 Corbel head of
a woman
Limestone
French
15th century (?)
17 x 27 x 12⅛"
Brummer #P5193–#619
Purchased from Amou-
roux, September 26,
1928

279

143
1966.158 Capital and plinth
Marble
South French
12th century (?)
9½ x 12 x 12″
Purchased from a friend of Ruiz, September 18, 1933

144
1966.160 a–b Pair of carved spandrels
Wood
German
Late 15th century
19½ x 27½ x 2¼″
Brummer #P7005–#B622
Purchased from the Figdor collection, Vienna, June 14, 1930, #516

145
1966.161 Lifesize figure of Winter
Marble
French
Late 17th century
68 x 21½ x 18″
Purchased from Mme. Hein, June 28, 1937

146
1966.162 Corbel head
Limestone

143

144

145

146

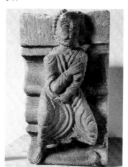

147

149

French (?)
13th century (?)
13 x 10 x 11¾″
Brummer #N4535–#B625
Purchased from Poly and Cie, July 17, 1930

147
1966.163 Seated St. Peter
Limestone
French (?)
Early 14th century (?)
39 x 20½ x 10″
Purchased from Mme. Bigorie, August 13, 1936

***148**
1966.164 Roundel
Marble
Italian
See plate 15.
Brummer #P5587–#630
Purchased from L. Bernheimer, September 3, 1928

149
1966.166 Corbel
Limestone
French (?)
12th century (?)
20½ x 12½ x 9″
Brummer #P9026–#72
Purchased from Emile Blaise, September 6, 1932

150
1966.167 Corbel
Limestone
French (?)
12th century (?)
20½ x 12½ x 9″
Brummer #B632
Purchased from Emile
Blaise, September 6,
1932

***151**
1966.168 Corbel head of
a woman
Limestone
French
13th–14th century
See plate 17.
Brummer #P4069–
#B635
Purchased from Jean
Peslier, July 8, 1927

152
1966.169 Corbel head of
a man
Limestone
French
13th–14th century (?)
11¾ x 15 x 8″
Brummer #P4068–#636
Purchased from Jean
Peslier, July 8, 1927

153
1966.170 Waterspout
Limestone
French

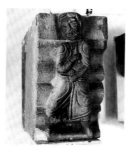

150

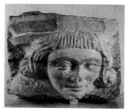

152

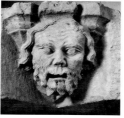

153

154

13th century
15½ x 24 x 17¼″
Brummer #N5970–
#B641
Purchased from Gabriel
Dereppe, May 31, 1944

154
1966.171 Corbel head of
a man
Limestone
French
13th–14th century
10½ x 21⅛ x 10¾″
Brummer #P5074–
#B643
Purchased from Rey,
Beaune, August 20, 1928

***155**
1966.172 Wild Man
Red sandstone
German
See plate 38.
Brummer #P13158–
#B647
Purchased from
Demotte, December 18,
1937

***156**
1966.173 St. John from
an Entombment Group
Limestone with poly-
chrome
French
See plate 31.
Brummer #P12036–
#B648

157
1966.174 Statue of a saint
Polychromed limestone
Italian
15th century
46 x 17 x 9"
Brummer #P13163–#649
Purchased from
Demotte, October 15, 1936

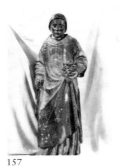

157

158
1966.175 Standing saint
Polychromed limestone
Upper Rhenish or
Burgundian
Late 15th century
51 x 18 x 17½"
Brummer #P12035–#B650
Purchased from
Demotte, August 2, 1935

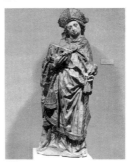

158

159
1966.176 Octagonal column
Limestone
15th century
53 x 10¼ x 10¼"
Purchased from
A. Lambert, October 1929

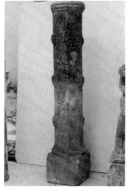

159

160
1966.178 Head
Limestone
French
14½ x 13 x 14"
Brummer #P14024–#539
Purchased from

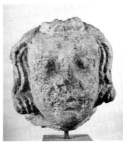

160

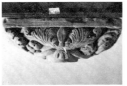

162

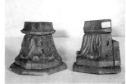

163

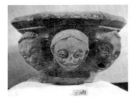

164

Mme. Chassot (Charnez), July 22, 1937

***161**
1966.179 Head
Limestone
French
13th century
See Figures 6.1–6.4
Purchased from
Mme. Chassot (Charnez), July 22, 1937

162
1966.180 Capital
Marble
Italian
12th–13th century
8 x 19 x 8¾"
Brummer #P4483–#571
Purchased from
A. Barsanti, Rome,
September 8, 1927

163
1966.181a–b Pair of bases
Walnut
Italian
15th century
6 x 13"

164
1966.182 Capital with three grotesque heads
Limestone
French (?)
13th century (?)
14 x 21 x 24"
Brummer #P13100
Purchased from
Demotte, September 16, 1936

282

165
1966.183 Capital with three grotesque heads
Limestone
French (?)
13th century
14½ x 23¾ x 16″
Brummer #P13175
Purchased from Demotte, October 15, 1936

165

166

166
1966.184 Capital
Marble
Spanish (?)
End of 12th century (?)
16⅜ x 19½ x 19½″
Purchased from Claude Anet, November 9, 1928

167
1966.185 Statue of a female saint
Limestone
French
15th century (?)
6′1″ x 22½″ x 13″
Brummer #P11028–#649
Purchased from Escuret, Bourges, September 10, 1934

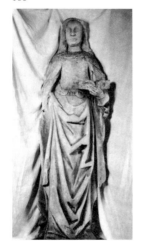
167

*168
1966.187 Samson monolith
Limestone
French
See figures 2.1–2.5
Purchased from Couëlle, August 23, 1928

169

170

171

169
1966.188 Bust of Christ
Polychromed terracotta
Spanish
17th–18th century
20 x 16 x 9½″
Purchased from Satori, September 6, 1929

170
1966.189 a–f Six crouching lions
Bronze
Flemish
15th–16th century
6½ x 4½ x 8¾″
Brummer #N4730 a–f–#120
Purchased from International Studio Art Corporation, October 24, 1940; from the collection of Daguerre

171
1966.190 Spigot in the shape of a dog's head
Bronze
17th–18th century
9½ x 7½″
Brummer #N4656–#524
Purchased from International Studio Art Corporation, September 1940; from the collection of Daguerre

172
1966.191 Spigot in the
shape of a dog's head
Bronze
17th century
15¼ x 10¼ x 3″
Brummer #N4657–
#524A
Purchased from International Studio Art
Corporation, September 1940; from the
collection of Daguerre

173
1966.192 Wall bracket
Oak
French
Ca. 1700–20
14¼ x 13 x 10½″
Brummer #P1503–#533
Purchased from Landau,
January 3, 1927

174
1966.193 Madonna and
Child
Limestone
Italian
15th century
20 x 19¼ x 6¼″
Brummer #N6123–#538
Purchased from
Dr. Edgar Apolant,
September 26, 1944

175
1966.194 Lusterwiebchen figure
Wood, polychrome

172

173

174

175

176

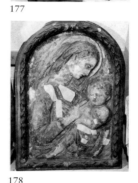
177

178

German
17th century
15 x 19½ x 26″
Brummer #P11091–
#546
Purchased from Maquet,
November 7, 1934

176
1966.195 Beggar
Wood, textiles, leather
Italian, Neapolitan
18th–19th century
18 x 6¼ x 6¼″
Brummer #P6535–#579
Purchased from Addeo,
August 19, 1929

177
1966.196 a–b Pair of
columns
Carved and gilded wood
Spanish
16th century
6′2″ x 10″
Purchased from American Art Association,
Shipman sale, November
20, 1936

178
1966.197 Relief of the
Virgin and Child
Stucco, polychrome
Italian
Ca. 1500 (?)
38 x 26 x 3″
Brummer #N6598–#623
Purchased from
Mrs. Edgar Speyer, May
13, 1946

179
1966.199 Capital with
heads
Limestone
13th–14th century (?)
6½ x 9¾ x 9″

180
1966.200 Relief of the
Virgin and Child and
Saints
Walnut
Italian
16th century
31 x 21″

181
1966.201 St. John
Polychrome, limestone
French
Late 15th century
54 x 19 x 14″
Brummer #P10016–
#B653
Purchased from Han-
nier, Amiens, July 19,
1933

182
1966.202 Head of a king
Walnut, polychrome
South French (?)
16th century (?)
14 x 10½″
Brummer #254

179

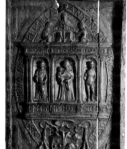
180

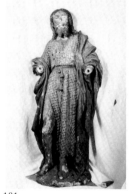
181

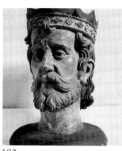
182

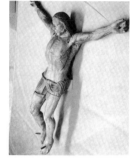
184

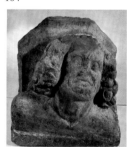
186

***183**
1966.203 *Spinario*
Limestone
French
See plate 4.
Brummer #276
Purchased from Couëlle,
August 23, 1928

184
1966.204 Lifesize
crucifix figure
Oak, polychrome
18th century
70″
Brummer #293

***185**
1966.256 Corbel head
with Gothic finials
Limestone
French (?)
See plate 19.
Brummer #P13168
Purchased from
J. Demotte, October 15,
1936

186
1966.257 Corbel head of
a man
Limestone
French (?)
13th century (?)
15¾ x 14¼ x 11¾″

285

187
1966.260 Column base
Marble
Italian
12½ x 12½ x 12½″

188
1966.261 Capital
Marble
Italian
13th–14th century
12 x 10″

189
1966.262a Column base
Marble

187

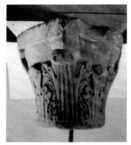

188

189

190

Italian
13th century
7 x 5 x 5″
Purchased from Bertolo
through Altounian,
March 1929

190
1966.262b Capital
Marble
Italian
13th century
6 x 7 x 7″
Purchased from Bertolo
through Altounian,
March 1929

Selected Bibliography

von Adelmann, J. A. "Christus auf dem Palmesel," *Zeitschrift für Volkskunde* 63 (1967): 182–200.

Adhémar, Jean. *Influences antiques dans l'art du Moyen-Age Français*, Studies of the Warburg Institute 7 (London, 1939).

Arslan, Eduardo. *Venezia gotica. L'architettura civile veneziana* (Milan, 1970).

Aubert, Marcel, and M. Beaulieu. *Description raisonée des sculptures du Moyen Age, de la renaissance et des temps modernes*. Volume 1, *Moyen Age* (Paris, 1950).

Baron, Françoise. *Sculptures françaises du XIVe siècle*, Cahiers Musée d'Art et d'Essai, Palais de Tokyo (Paris, 1985).

Baumhauer, Hermann. *Das Ulmer Münster* (Stuttgart, 1977).

Baxandall, Michael. *The Limewood Sculptors of Renaissance Germany* (New Haven, 1980).

Bernheimer, Richard. *Wild Men in the Middle Ages: A Study in Art, Sentiment, and Demonology* (New York, 1970).

Bornstein, Christine Verzar, "A Late Gothic Sculpture of the Ulm School," *Bulletin of the Museums of Art and Archaeology The University of Michigan* 3 (Ann Arbor, 1980): 31–50.

Bornstein, Christine Verzar, and Priscilla Parsons Soucek. *The Meeting of Two Worlds: The Crusades and the Mediterranean Context*, exhibition catalogue (Ann Arbor, 1981).

Braun, Joseph. *Tracht und Attribute der Heiligen in der deutschen Kunst* (Stuttgart, 1943).

Broccoli, Umberto. *La Diocesi di Roma: il suburbio, 1*, Corpus della scultura alto-medievale VII (Spoleto, 1981).

Brouillette, Diane. *Senlis: Un moment de la sculpture gothique*, exhibition catalogue (Senlis, 1977).

Bruzelius, Caroline, ed. *Rediscoveries: A Selection of Medieval Sculpture at the Duke University Museum of Art*, exhibition catalogue (Durham, 1983).

Cahn, Walter. "Romanesque Sculpture in American Collections. VI. The Boston Museum of Fine Arts," *Gesta* IX (1970): 62–76.

———. "Romanesque Sculpture in American Collections. XIV. The South," *Gesta* XIV/2 (1975): 63–77.

———. *Romanesque Sculpture in American Collections*, volume I: *New England Museums* (New York, 1979).

Calkins, Robert. *A Medieval Treasury: An Exhibition of Medieval Art from the Third to the Sixteenth Century*, exhibition catalogue (Ithaca, 1968).

Les Capétiens et Senlis, exhibition catalogue (Senlis, 1987).

Cattaneo, Raffaele. *Architecture in Italy from the Sixth to the Eleventh Century, Historical and Critical Researches*, I. Curtis-Cholmeley, trans. (London, 1896).

Caviness, Madeline H., et al. *Stained Glass before 1700 in American Collections:*

Mid-Atlantic and Southeastern Seaboard States, Corpus Vitrearum Checklist II (Washington, 1987).

Cheetham, Francis. *English Medieval Alabasters* (Oxford, 1984).

Deuchler, F., ed. *The Year 1200*, exhibition catalogue (2 volumes) (New York, 1970).

Didier, R., and H. Krohm. *Les Sculptures médiévales allemandes dans les collections belges*, exhibition catalogue (Brussels, 1977).

Duchesne, L. *Christian Worship* (London, 1949).

Duval, Cynthia. *500 Years of Decorative Arts from the Ringling Collections 1350–1850*, exhibition catalogue (Sarasota, 1981).

Egbert, D. D. "Northern Gothic Ivories in the Vatican Library," *Art Studies* (1929): 169 ff.

Erlande-Brandenburg, Alain. "La Priorale Saint-Louis de Poissy," *Bulletin monumental* 129 (1971): 85–112.

———. "Les Remaniements du portail central à Notre-Dame de Paris," *Bulletin monumental* 130 (1972): 241–48.

———. "Nouvelles remarques sur le portail central de Notre-Dame de Paris," *Bulletin monumental* 132 (1974): 287–96.

———. "La Tête de Saint Paul provenant du portail central de Notre-Dame de Paris," *Bulletin de la Société de l'histoire de Paris et de l'Île de France* 105 (1979): 47–53.

Erlande-Brandenburg, Alain, and Dominique Thibaudat. *Les Sculptures de Notre-Dame de Paris au musée de Cluny* (Paris, 1982).

The Ernest Brummer Collection: Medieval, Renaissance and Baroque Art (auction catalogue in 2 volumes) (Zurich, 1979).

von Falke, Otto, and Erich Meyer. *Bronzegeräte des Mittelalters*. Volume I. *Romanische Leuchter und Gefässe. Giessgefässe der Gotik* (Berlin, 1935).

Les Fastes du Gothique: Le siècle de Charles V, exhibition catalogue, Galeries nationales du Grand Palais, (Paris, 1981).

Folda, Jaroslav, and John M. Snorrenberg. *A Medieval Treasury from Southeastern Collections*, exhibition catalogue (Chapel Hill, N.C., 1961).

Forsyth, William H. "Mediaeval Statues of the Virgin in Lorraine Related in Type to the Saint-Dié Virgin," *Metropolitan Museum Studies* 5 (1936): 235–58.

———. "The Virgin and Child in French Fourteenth Century Sculpture," *Art Bulletin* 39 (1957): 171–82.

———. *The Entombment of Christ: French Sculptures of the Fifteenth and Sixteenth Centuries* (Cambridge, Mass., 1970).

Giess, Hildegarde. "The Sculpture of the Cloister of Santa Sofia in Benevento," *Art Bulletin* 41 (1959): 249–56.

Gillerman, Dorothy. *The Clôture of Notre-Dame and its Role in the Fourteenth Century Choir Program* (New York, 1977).

———. *Transformations of the Court Style: Gothic Art in Europe 1280 to 1330*, exhibition catalogue (Providence, 1977).

———. "The Arrest of Christ: A Gothic Relief in the Metropolitan Museum of Art," *Metropolitan Museum Journal* 15 (1981): 67–90.

Gillerman, Dorothy, ed. *Gothic Sculpture in American Collections*. I. *The New England Museums* (New York, 1989).

Gnudi, Cesare. "Le Jubé de Bourges et l'apogée du 'classicisme' dans la sculpture de l'Île-de-France au milieu du XIIIe siècle," *Revue de l'art* 3 (1969): 18–36.

Gomez-Moreno, Carmen. *Medieval Art from Private Collections*, exhibition catalogue (New York, 1968).

Grabar, Oleg. *The Alhambra* (Cambridge, Mass., 1978).

Grimme, Ernst Günther. "Die gotischen Kapellenreliquiare im Aachener Domschatz," *Aachener Kunstblätter* 39 (1969): 7–76.

Halm, Philipp Maria. *Studien zur süddeutschen Plastik*, 3 volumes (Augsburg, 1926–28).

Harding, Anneliese. *German Sculpture in New England Museums* (Boston, 1972).

Haseloff, A. *Pre-Romanesque Sculpture in Italy* (Florence, 1930).

Hayward, Jane, Walter Cahn, et al. *Radiance and Reflection: Medieval Art from the Raymond Pitcairn Collection*, exhibition catalogue (New York, 1982).

Heckscher, W. S., and Robert C. Moeller III. "The Brummer Collection at Duke University," *Art Journal* 27 (1967–68), 180–90.

Horlbeck, Frank R. "Gloria, Laud and Honor: The *Palmesel* and Palm Sunday," *University of Wisconsin-Madison, Elvehjem Museum of Art Bulletin* (1977–78): 26–37.

Husband, Timothy, and Gloria Gilmore-House. *The Wild Man. Medieval Myth and Symbolism*, exhibition catalogue (New York, 1980).

Joubert, Fabienne. "Les Retables du milieu du XIIIe siècle à l'abbatiale de Saint-Denis," *Bulletin monumental* 131 (1973): 17–27.

———. "Le Jubé de Bourges, remarques sur le style," *Bulletin monumental* 137 (1979): 341–69.

Kantorowicz, Ernst H. *Kaiser Friedrich der Zweite* (2 volumes) (Berlin, 1927–31; Erganzungsband 2. unverändert Aufl.: Stuttgart, 1980); translated by E. O. Lorimer as *Frederick the Second* (New York, 1957).

Karlsruhe, Badisches Landesmuseums. *Spätgotische Bildwerke* (Karlsruhe, 1962).

Kautzsch, Rudolf. "Römische Schmuckkunst in Stein von 6 bis zum 10 Jahrhundert," *Römische Jahrbuch für Kunstgeschichte* 3 (1939): 1–74.

———. "Die Langobardische Schmuckkunst in Oberitalien," *Römisches Jahrbuch für Kunstgeschichte* 5 (1941): 1–48.

Kimpel, Dieter. "Le Sort des statues de Notre-Dame de Paris: Documents sur la période révolutionnaire," *Revue de l'art* (1969): 44–47.

Kimpel, Dieter, and Robert Suckale. "Die Skulpturenwerkstatt der Vierge Dorée am Honoratusportal der Kathedrale von Amiens," *Zeitschrift für Kunstgeschichte* 36 (1973): 217–65.

Kuhn, Charles Louis. *German and Netherlandish Sculpture, 1280–1800, The Harvard Collections* (Cambridge, 1965).

Kurmann, Peter. *La Façade de la Cathédrale de Reims* (Paris and Lausanne, 1987).

Lefrancois-Pillion, L., and J. Lafond. *L'Art du XIVe siècle en France* (Paris, 1954).

Mallion, Jean. *Chartres: Le jubé de la cathédrale* (Chartres, 1964).

Mann, Vivian. "Samson vs. Hercules: A Carved Cycle of the Twelfth Century," *The High Middle Ages*, ACTA 7 (1983): 1–38.

Marienbild in Rheinland und Westfalen, exhibition catalogue (Villa Hügel, Essen, 1968).

Masterworks in Wood: The Christian Tradition, exhibition catalogue (Portland, 1975).

The Medieval Sculptor, exhibition catalogue, Bowdoin College Museum of Art (Brunswick, Maine, 1971).

Meredith, Jill. "The Revival of the Augustan Age in the Court Art of Emperor Frederick II," in *Artistic Strategy and the Rhetoric of Power. Political Uses of Art from Antiquity to the Present*, David Castriota, ed. (Carbondale, Ill., 1986): 39–56.

Metropolitan Museum of Art and Germanisches Nationalmuseum. *Gothic and Renaissance Art in Nuremberg, 1300–1550*, exhibition catalogue (New York and Nuremberg, 1986).

Mickenburg, David. *Songs of Glory: Medieval Art from 900–1500*, exhibition catalogue, Oklahoma Museum of Art (Oklahoma City, 1985).

Möbius, Friedrich, and Ernst Schubert. *Skulptur des Mittelalters* (Weimar, 1987).

Moeller, Robert C. III. *Sculpture and Decorative Art: A Loan Exhibition of Selected Art Works from the Brummer Collection of Duke University* (Raleigh, 1967).

The Notable Art Collection Belonging to the Estate of the Late Joseph Brummer (3 volumes), Parke-Bernet Galleries (New York, 1949).

Ostoia, Vera K. "A Palmesel at the Cloisters," *Metropolitan Museum of Art Bulletin* XIV/7 (1956): 170–75.

Pani Ermini, Letizia. *La Diocesi di Roma*, 2 volumes, Corpus della scultura altomedievale VII (Spoleto, 1974).

Quarré, Pierre. "Les Statues de la Vièrge à l'enfant des confins Burgundo-Champenois au début du XIVe siècle," *Gazette des Beaux-Arts* 71 (1968): 193–204.

Randall, Richard H., Jr. *Masterpieces of Ivory from the Walters Art Gallery* (New York, 1985).

Raspi Serra, Joselita. *Le Diocesi dell'Alto Lazio*, Corpus della scultura altomedievale VIII (Spoleto, 1974).

Réau, L. *Iconographie de l'art chrétien* (6 volumes) (Paris, 1955–59).

Ricci, C. *Romanesque Architecture in Italy* (New York, 1925).

Sauerländer, Willibald. "Die Kunstgeschichtliche Stellung der Westportale von Notre-Dame in Paris," *Marburger Jahrbuch für Kunstwissenschaft* 17 (1959): 1–56.

———. *Gothic Sculpture in France 1140–1270* (London, 1972).

Saulnier, Lydwine, and Neil Stratford. *La Sculpture oublié de Vézelay*, Bibliothèque de la société française d'archéologie XVII (Geneva, 1984).

Schaefer, Claude. *La Sculpture en rond-bosse au XIVe siècle dans le duché de Bourgogne*, Cahiers d'archéologie et d'histoire de l'art (Paris, 1954).

Scher, Stephen. *The Renaissance of the Twelfth Century*, exhibition catalogue (Providence, 1969).

Schiller, Gertrud. *Iconography of Christian Art* (2 volumes) (New York, 1971).

Schlosser, Julius. "Die Werkstatt der Embriachi in Venedig," *Jahrbuch der kunsthistorischen sammlungen des alterhöchsten Kaiserhauses* (1899): 220–82.

Sheppard, Carl D. "Pre-Romanesque and Romanesque Sculpture in Stone," *Art Quarterly* 23 (1960): 341–58.

————. "Subtleties of Lombard Marble Sculpture of the Seventh and Eighth Centuries," *Gazette des Beaux-Arts* 63 (1964): 193–206.

Stuttmann, Ferdinand, and Gert von der Osten. *Niedersächsische Bildschnitzerei des späten Mittelalters* (Berlin, 1940).

Swiechowski, Zygmunt, and Alberto Rizzi. *Romanische Reliefs von venezianischen Fassaden "patere e formelle"*, Forschungen zur Kunstgeschichte und christlichen Archäologie 11 (Wiesbaden, 1982).

Tabbaa, Yasser. "The Muqarnas Dome: Its Origin and Meaning," *Muqarnas: An Annual on Islamic Art and Architecture* 3 (1985): 61–74.

Tagliaferri, Amelio. *Le diocesi di Aquileia e Grado*, Corpus della scultura altomedievale X (Spoleto, 1981).

Terry, Ann. "The Early Christian Sculpture at Grado: A Reconsideration," *Gesta* XXVI (1987): 93–112.

Trinci Cecchelli, Margherita. *La Diocesi di Roma*, IV, Corpus della scultura altomedievale VII (Spoleto, 1976).

Valentiner, W. R. "A Relief from Aversa," *The Art Quarterly* 16 (1953): 181–94.

Verdier, Philippe, Peter Brieger, and Marie Farquhar Montpetit. *Art and the Courts: France and England from 1259 to 1328*, exhibition catalogue in two volumes (Ottawa, 1972).

Vöge, Wilhelm. *Jörg Syrlin der Altere und seine Bildwerke* (Berlin, 1950).

Webster, James Carson. *The Labors of the Months*, Princeton Monographs in Art and Archaeology 21 (Princeton, 1938).

Willemsen, Carl A. *Kaiser Friedrichs II. Triumphtor zu Capua* (Wiesbaden, 1953).

Willesme, Jean-Pierre. *Sculptures médiévales: XIIe siècle-début du XVIe siècle* (Paris, 1979).

Williamson, Paul. *The Medieval Treasury. The Art of the Middle Ages in the Victoria and Albert Museum* (London, 1986).

————. *The Thyssen-Bornemisza Collection: Medieval Sculpture and Works of Art* (London, 1987).

Württembergisches Landesmuseum, Stuttgart. *Die Zeit der Staufer. Geschichte Kunst, Kultur, Katalog der Ausstellung* (4 volumes) (Stuttgart, 1977).

Ziegler, J. E. *The Word Becomes Flesh*, exhibition catalogue (Worcester, Mass., 1985).

Index

Jandolo, Aldo (Rome), 163, 268, 270
Jandolo, Ugo (Florence), 266
Jaquet, Louis (Paris), 271
Joret (Paris), 271, 278
Kelekian, Dikran, 271
Kende Galleries, 273
Lambert, 173, 267, 273, 275, 282
Landau, 284
Leitner, Richard (Vienna), 210
Lemaire, 279
Lenard (Budapest), 269
Maquet (Paris), 284
Niclausse, Mme., 177, 277
Otto, 270
Pacifici, 143, 262
Paris House, 165, 269, 270
Parke-Bernet Gallery (New York), 6,
 265, 267, 273, 274, 275
Pazzagli and Nesi, 213, 265
Peslier, Jean, 191, 269, 281
Pichon, L. C., 271
Pollak and Winternitz, 205
Poly and Cie, 280
Ratton, Maurice (Paris), 265, 272
Rey (Beaune), 281
Romano, 266
Ruiz, 270, 280
Satori, 283
Semail, A., 234
Simonetti, 273
Taillemas, 276
Tano, Frank, 263, 264
Tozzi, Pietro (New York), 263, 277
Trichard, 279
Vaury, Mme. (mère), 269
Vlachos, E., 262
Wegener, 198, 272
Weigt, Paul, 277
Weil, 273
Zoumpoulakis, 262, 263

Museums

Ann Arbor: Museum of Art, Univer-
 sity of Michigan, 242
Baltimore: Walters Art Gallery, 210,
 214, 216, 219, 260
Boston: Boston Museum of Fine
 Arts, 3, 8, 64, 67, 70, 158, 203,
222; Isabella Stewart Gardner
 Museum, 2, 3
Brive-la-Gaillarde: Musée Ernest
 Rupin, 61
Brunswick, Me.: Bowdoin College
 Museum of Art, 184
Brussels, 52 n.33
Bryn Athyn, Pa.: Glencairn Mu-
 seum, 3, 4, 11 n.9, 180
Budapest: Budapest Museum,
 54 n.47
Cambridge, Ma.: Busch-Reisinger
 Museum, 257; William Hayes
 Fogg Art Museum, Harvard Uni-
 versity, 3, 40, 42, 44, 54 n.47, 157,
 160, 224
Chapel Hill, N.C.: Ackland Art
 Museum, 101, 110, 119 n.5
Châteauroux, 54 n.47
Cleveland: Cleveland Museum of
 Art, 3
Cologne: Schnütgen Museum,
 52 n.32
Detroit: Institute of Fine Arts, 3, 233
Dijon: Musée Archéologique, 163
Florence: Museo Nazionale del
 Bargello, 216
Hartford, Ct.: Hartford Museum of
 Art, 29, 36
Hildesheim: Roemer und Pelizaeus
 Museum, 254
London: British Museum, 52 n.33,
 54 n.44; Victoria and Albert
 Museum, 1, 11 n.8, 52 n.33,
 180, 216
Los Angeles: Los Angeles County
 Museum of Art, 210
Lyon: Musée Gadagne, 26
Madison, Wi.: Elvehjem Art Center,
 University of Wisconsin, 233
Munich: Bayerisches Staatsmuseum,
 1, 54 n.47
New Haven, Ct.: Yale University
 Art Gallery, 196
New York: The Cloisters, 3, 27, 28,
 31, 33, 36, 152, 167-68, 203, 233,
 251; The Metropolitan Museum
 of Art, 3, 6, 11 n.21, 52-53 n.36,
 63-64, 119 n.2, 167-69, 203, 212,
 245, 261
Northampton, Ma.: Smith College
 Museum of Art, 59, 69, 70, 71, 73
 n.21
Paris: Durand and Révoil collection
 (Louvre), 1; Musée Carnavalet,
 168; Musée du Louvre, 1, 157,
 177, 190-91, 194, 201-2, 203;
 Musée national des Monuments
 français, 10 n.4; Musée national
 des Thermes de l'Hôtel Cluny,
 1, 125, 130, 132, 134, 136, 138,
 139 n.12, n.17, 164, 174-75, 194,
 202, 229
Philadelphia: Philadelphia Museum
 of Art, 3, 260
Providence: Rhode Island School of
 Design, 59, 69, 71, 72 n.15, 212
Raleigh: North Carolina Museum of
 Art, 8, 21, 59
Rochester, N.Y.: Memorial Art Gal-
 lery, University of Rochester, 59,
 69, 71, 72 n.6
Rome: Museo Capitolino, 153
Rouen: Musée des Antiquités de la
 Seine Inférieure, 2
Savigny: Musée Coquard, 33,
 151, 152
Stuttgart: Württembergisches
 Landesmuseum, 119 n.2
Toledo: Toledo Museum of Art,
 3, 157
Toulouse: Musée des Augustins, 158
Udine: Museo Civico, 52 n.32
Washington, D.C.: Dumbarton
 Oaks, 267
Wellesley, Ma.: Wellesley College
 Museum, 33, 152
Williamstown, Ma.: Williams Col-
 lege Museum of Art, 66, 70,
 73 n.19
Worcester, Ma.: Worcester Art
 Museum, 38

Regional Provenance

Aigues-Mortes, 190
Aisne, 5
Aix-en-Provence, 21, 23, 33, 48 n.1,
 49 n.10, 50 n.15
Alatri, 75-78

Saints

Andrew, 179, 264
Anne, 236–37, 264, 269, 279
Anthony, 242
Apostles, 9, 17–18, 26, 57–73, 171, 240, 254, 257, 268, 271, 278
Barbara, 252–54, 275
Catherine, 222–23
Cyriacus, 238, 265
Elizabeth, 205
Fourteen Helpers in Need, 238
Francis, 217
Geneviève, 177
James the Greater, 217, 251
James the Less, 214, 217
John, 214, 226, 228–29, 264, 281
John the Baptist, 169, 223, 285
Joseph, 260
Joseph of Arimathea, 226
Luke, 240–42, 274
Mark, 216
Martin, 132
martyrs, 220, 252
Mary Magdalene, 214, 226, 251, 254
Matthew, 266
Michael, 87, 94 n.23
Nicodemus, 226
Paul, 48, 174, 177, 214, 217
Peter, 59, 68–69, 73 n.19, 75, 267, 280

Sebastian, 249–51, 269, 272
Simon, 249, 251
Stephen, 194
Ulrich, 232
Ursula, 223

Secular Subjects

apes, 22, 51 n.31
arabesques, 207, 209
Artemia, 238
ass, 80
Atlas, 42
Augustus, 101, 106, 112–13, 114–15
birds, 80, 86, 142, 224
Childebert, 201
crocodile, 224
Custodia, 111–12
Dea Roma, 112
Deianira, 43
Diocletian, 238
Dionysos, 114
Dioscuri, 122 n.45
dog, 81, 87, 283, 284
donkey, 75, 230
dragon, 52 n.33
elephant, 80
fleur-de-lis, 198
fool, 255, 257
frog, 224–25, 265

griffins, 224
Hercules, 42–44, 54 nn.44–45
herms, 110, 114
Janus, 5, 9, 97–123
Jupiter, 116
Labors of the Month, 102–5, 120 n.14, n.16, 153
leviathan, 86
lion, 21, 22, 38, 39, 52 n.33, 79, 80, 216, 263, 264, 283
Maxentius, 223
muquarnas, 207, 209
Nessus, 43
Petrus della Vigna, 109, 122 n.39
Portunus, 118
Priapus, 153
Ptolemy, 240
putto, 100
reptiles, 224
rosettes, 144, 264
Silenus, 114
spinario, 50 n.23, 149–53, 285
Thaddeus Suessa, 109
Theophilus, 127
Vesta, 101
whale, 255
Wild Man, 246, 248, 281
wolves, 187
zodiac, 54 n.47, 153

297 Index

RITTER LIBRARY
BALDWIN-WALLACE COLLEGE

Illustration Credits and Acknowledgments

All color plate photographs are by David Page, Fine Arts Photographer for the Department of Art and Art History, Duke University. All checklist photographs are by Hendrik A. van Dijk. Unless otherwise noted below, figures and plates are also by David Page.

Figures

1.1–1.3 Hendrik A. van Dijk. 2.6 Ilene H. Forsyth. 2.7–2.8 Metropolitan Museum of Art, New York. 2.9–2.11 Neil Stratford. 2.12 Jewett Art Center, Wellesley College, Wellesley, Massachusetts. 2.13 Metropolitan Museum of Art, New York. 2.14 Ilene H. Forsyth. 2.15–2.17 Fogg Art Museum, Cambridge, Massachusetts. 3.5 Smith College Museum of Art, Northampton, Massachusetts. 3.6–3.7 Museum of Art, Rhode Island School of Design, Providence. 3.8–3.9 Memorial Art Gallery, University of Rochester, Rochester, New York. 3.10–3.13 Jean M. French. 4.8–4.9 Bibliotheca Hertziana, Rome. 4.10 Dorothy F. Glass. 4.11–4.12 Bibliotheca Hertziana. 4.13 A. Prandi, ed., *L'Art dans l'Italie méridionale. Aggiornamento dell'opera di Émile Bertaux* (Rome, 1978), 5:653, figure XVIII. 4.14 Bibliotheca Hertziana. 4.15 Trustees of the National Museums of Scotland. 4.16–4.17 G. Chierici, *Le sculture della basilica di San Michele Maggiore a Pavia* (Milan, 1942), plate CLXXXIII. 4.18 Bibliotheca Hertziana. 5.5 A. C. Quintavalle, *Romanico padano, civiltà d'Occidente* (Florence, 1980), figure 304. 5.6 Jill Meredith. 5.7 Württembergisches Landesmuseum, Stuttgart, *Die Zeit der Staufer. Geschicte Kunst, Kultur, Katalog der Ausstellung* (Stuttgart, 1977), II: figure 627. 5.8 Württembergisches Landesmuseum, Stuttgart, *Die Zeit der Staufer. Geschichte Kunst, Kultur, Katalog der Ausstellung* (Stuttgart, 1977), II: figure 639. 5.9 A. M. Romanini, *Federico II e l'arte del duecento italiana* (Rome, 1980), figures 12–13. 5.10 C. A. Willemsen, *Kaiser Friedrichs II. Triumphtor zu Capua* (Wiesbaden, 1953), figure 55. 5.11 David Castriota. 5.12 Sam Gruber. 5.13 David Castriota. 5.14 Kevin Herbert. 5.15 Steve Cerruti. 6.5 Hirmer Fotoarchiv, Munich. 6.6 Musée national des Thermes et de l'Hôtel de Cluny. 6.7–6.14 Dieter Kimpel. 6.15–6.16 Musée national des Thermes et de l'Hôtel de Cluny. 6.17 Arch. Phot. Paris/S.P.A.D.E.M.

Catalogue Plates

4.2 Museum of Art, Rhode Island School of Design, Providence. 4.3 Caroline Bruzelius. 5.2 Fogg Art Museum, Cambridge, Massachusetts. 12.2 Musée national des Thermes et de l'Hôtel de Cluny. 14.2 Léon Pressouyre. 14.3–14.4 Arch. Phot. Paris/S.P.A.D.E.M. 18.1 Musée National des Thermes et de l'Hôtel de Cluny. 26, 30, 34 Hendrik A. van Dijk. 31.2 Musée national des Thermes et de l'Hôtel de Cluny. 32.2 Elvehjem Art Center, University of Wisconsin, Madison, Friends of the Elvehjem Art Center purchase through the Glenn McHugh Bequest. 39–42 Hendrik A. van Dijk.

DATE DUE

WITHDRAWN

DEMCO 38-297